EYEWITNESS COMPANIONS

Photography

TOM ANG

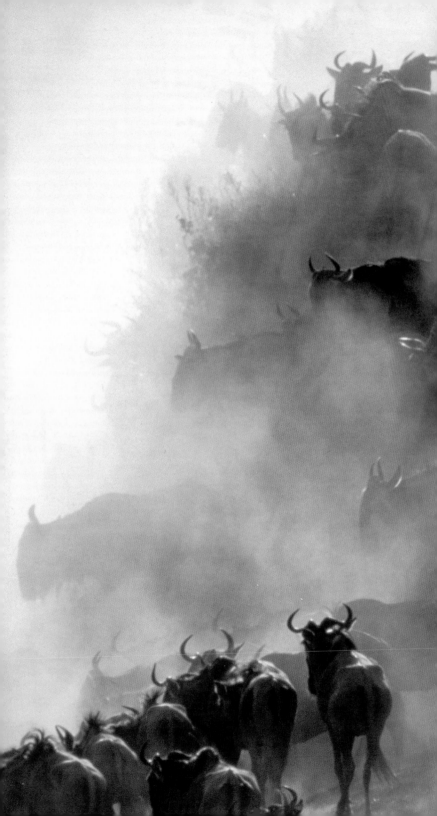

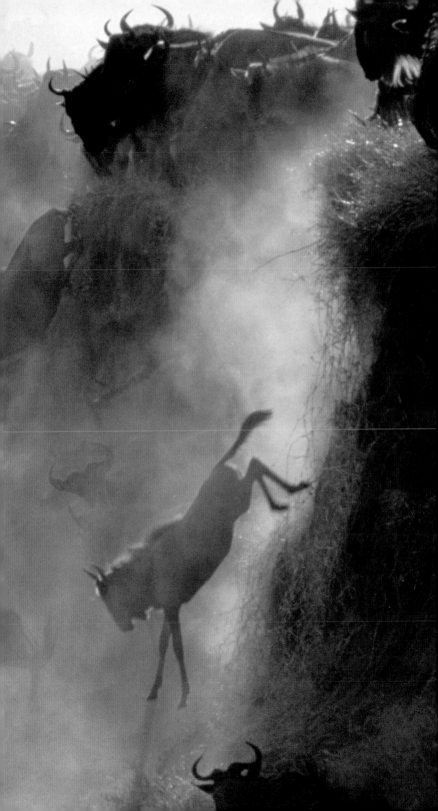

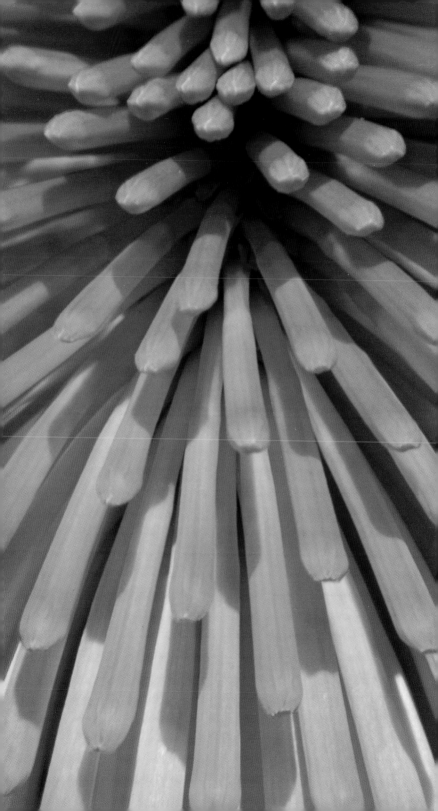

LONDON, NEW YORK,
MUNICH, MELBOURNE, DELHI

This book is dedicated to those who have
taught me photography

Project Editor	Nicky Munro
Art Editor	Jenisa Patel
Editor	Richard Gilbert
Design Assistant	Hiren Chandarana
Picture Researchers	Carolyn Clerkin, Anna Bedewell
DTP Designer	Vania Cunha
Production Controller	Heather Hughes
Managing Editor	Stephanie Farrow
Art Director	Bryn Walls

With assistance from
Departure Lounge

First published in 2005 by
Dorling Kindersley Limited
80 Strand, London WC2R ORL

A Penguin Company

2 4 6 8 10 9 7 5 3 1

Copyright © 2005 Dorling Kindersley Limited
Text copyright © 2005 Tom Ang

A CIP catalogue record for this book is
available from the British Library

ISBN-13: 978-1-40531-076-6
ISBN-10: 1-40531-076-6

Colour reproduction by Media
Development Printing, UK
Printed and bound in China by L. Rex
Printing Company Ltd.
See our complete catalogue at
www.dk.com

CONTENTS

Introduction 12

Chapter One
GALLERY OF
PHOTOGRAPHERS

Introduction *22*

An A–Z of some of the
world's most influential
photographers *26*

Chapter Two
THE STORY OF
PHOTOGRAPHY

Introduction *70*

The dawn of
photography
(1830–60) *74*

Commanding the
medium (1860–90) *80*

Expanding horizons
(1890–1920) *86*

Awareness and vision
(1920–50) *92*

Innovations and
rebellions (1950–70) *98*

Divergences
(1970–90) *104*

Dispersions & digital
promises (1990–) *110*

Chapter Three
PHOTOGRAPHIC
TOOLS

Introduction *118*

Film-using cameras
122

Film and formats *128*

Setting up a darkroom
130

Black-and-white
processing *132*

Black-and-white
printing *134*

Digital cameras *138*

Lenses *144*

Camera accessories
146

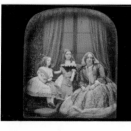

CONTENTS (continued)

Chapter Four

WORKING WITH DIGITAL IMAGES

Introduction *150*

Setting up a digital workroom *154*

Transferring and storing digital images *156*

Converting film to digital *158*

Image manipulation software *160*

Controlling size, shape, and brightness *164*

Controlling colour *166*

Adjusting sharpness *168*

Filter effects *170*

Select, copy, and paste *174*

Layers and blends *176*

Printers *178*

Creating the perfect print *180*

Chapter Five

ELEMENTS OF PHOTOGRAPHY

Introduction *184*

The art of composition *188*

Using colour *196*

Working in black and white *202*

Working with light *208*

Controlling exposure *214*

Using lenses *222*

Focusing and depth of field *224*

Filters and in-camera effects *226*

Chapter Six
TAKING SUCCESSFUL PHOTOGRAPHS

Introduction *230*

Portraits *234*

Animals *240*

Events *246*

Documentary *252*

Children *258*

Travel *264*

Landscapes *270*

Plants and gardens *276*

The nude *282*

Architecture *288*

Art *294*

Chapter Seven
TAKING PHOTOGRAPHY FURTHER

Introduction *302*

Turning professional *306*

Commercial photography *308*

Creating a portfolio *314*

Exhibiting photographs *316*

Diagnosing problems *318*

Glossary 323

Directory 329

Index 337

Acknowledgments 343

IT IS WELL KNOWN THAT PHOTOGRAPHY MEANS "WRITING WITH LIGHT". HOWEVER, THAT IS AN UNDERSTATEMENT ON A SCALE EQUAL TO SAYING THAT LITERATURE IS SIMPLY "WRITING WITH A PEN". PHOTOGRAPHY MEANS SO MUCH MORE THAN THAT. TO CONTEMPLATE THE TRUE EXTENT OF ITS SOCIAL REACH AND CULTURAL IMPACT IS AWE-INSPIRING.

Photography is inextricably interwoven into modern life. Photographs are all around us, we see them everywhere, and, since cameras have become a commonplace feature of mobile phones, we are increasingly taking photographs on a daily basis. But photography is not just about pictures – much of technology relies on photographic processes. The creation of microprocessors, circuitry, and the masks used in manufacturing microchips and processors – writing with light onto a light-sensitive substrate – is fundamentally photographic.

At the same time, the power of photography to shape our lives is as strong as ever. A single photograph – such as the shot of missiles being deployed in Cuba in 1962 – can take the world to the brink of war. An image can create worldwide notoriety: consider the many celebrities over the years whose misbehaviour with each other has kept the paparazzi busy.

Working with light
This image is not just about children on their way to church for their first communion. It is a joyous celebration of the power of light.

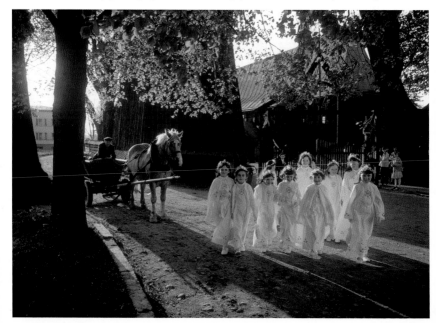

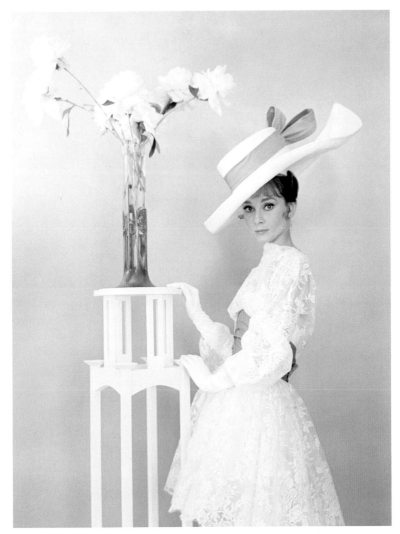

Born out of the Victorian era's obsession with the mechanization of all industrial practices, photography was, still is, the product of a triumvirate of art, science, and technology. The tremendous advances made by digital photography in only a few years, for example, have been built on the bedrock of imaging sciences that were developed for inter-stellar observation, satellite surveillance, and multi-spectral imaging of the Earth's surface.

Consummate art
Photography can preserve ephemeral gestures and beauty forever, as in this timeless image of Audrey Hepburn by Cecil Beaton.

Photography has taught us so much. From the telescopic images of the far reaches of the universe to the microscopic images of the intricacies of nature, photography has opened our eyes to the beauty of our own and other worlds, showing us things that were previously beyond human vision.

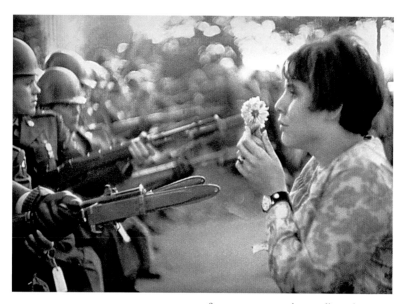

Flower power
At once a literal representation of the power of a flower against armed forces, this image was also a rallying point for anti-Vietnam war protests.

Photographs can capture meaningful memories, or be distorted to abet deceit. They can be used to seduce, or insult, and are capable of bringing great joy or sorrow. Furthermore, photographs can communicate highly complicated realities: images of disease or injury are sent routinely to specialists for diagnosis, while forensics teams rely on photographs to record vital evidence.

We admire and value photography because of its ability to inspire individual vision, and are awed by its capacity to change universal perception. For the former, we must give credit to the physicists, chemists, and engineers who made it all possible: it is thanks to their skills that anyone able to pick up a camera, put it to their eye, and press a button can take a photograph. Skill is not needed. Nonetheless, photography's attraction grows with its ability to empower the photographer. A small investment in learning is rewarded with rich returns. There is enormous satisfaction to be found in producing an image that matches your original vision and communicates that vision to others. It is little wonder that taking photographs is one of the world's favourite pastimes; and a career in photography is an aspiration nurtured by millions.

Illustrating another world
Images taken from space appear so perfect and stunning, some people find it hard believe they are genuine.

Photography's capacity for immediacy of impact and honesty of presentation gives it the power to enhance our understanding of situations, and influence our opinions. This is because of the primacy of visual perception: we depend on sight more than on any other sense for our survival. Moreover, a photograph can convey almost any human emotion, even complicated inter-personal tensions, in an instant. As a result, despite the power of the written word, it is still true that pictures dominate international communication. The point is not that a picture is worth a thousand words, but that it can be understood in a thousand languages.

While you may not agree with philosopher and cultural theorist Paul Virilio (1932–) that photographs are a virus on the planet, it is true that the typical city-dweller is bombarded by photographs every waking moment of his or her life. From the carefully chosen print that adorns the bedroom wall, to the pictures of happy, healthy families on the cereal packet; from the gritty images in our newspapers to the glossy images in the junk mail; from the advertising posters along the roads,

A universal language
Images can be understood in any language or culture, like this joyful picture of dancers outside a jazz club taken by Malian photographer Malick Sidibe (1935–).

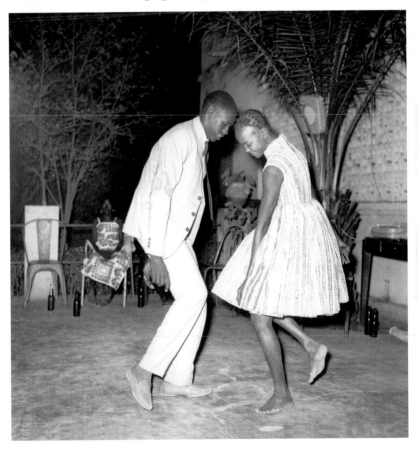

and in the stations selling products and lifestyles to the celebrity portraits and paparazzi shots that fill countless magazines, we simply cannot escape from photographs.

It could be argued that advertising photography is the medium that powers many industries. Scenic views of exotic locations whet our appetites for travel, while seductive and sophisticated images arouse our desire to own a particular make of car, or kitchen, or camera. It is photography, perhaps more than any other single factor, that informs and influences our choices as consumers.

One of photography's most alluring characteristics is its potential to cause change. For decades it has been at the cutting edge, influencing the politics of war, shocking the world into action over famine, and revealing abuses in strife-torn areas of the world. It can also inspire us to push ourselves further. Pictures of great sporting achievements and acts of heroism or courage show us what we are capable of and give us something to aspire to. Photographs can tell us so much about ourselves and mankind as a whole – both good and bad: our strengths and weaknesses, our bravery and cowardice, our kindness and cruelty.

This book is a tribute to those photographers who have changed the world, both through their vision and through their committed, sometimes

Action-packed images
Photography allows us to examine a split-second of action. We can admire the power and grace of the athlete (*right*) but an expert can also analyze it for any slight imperfections.

Fashioning styles
It is hard to imagine how modern fashion could have developed without the help of photography (*below*): no other medium can depict so clearly while suggesting much else.

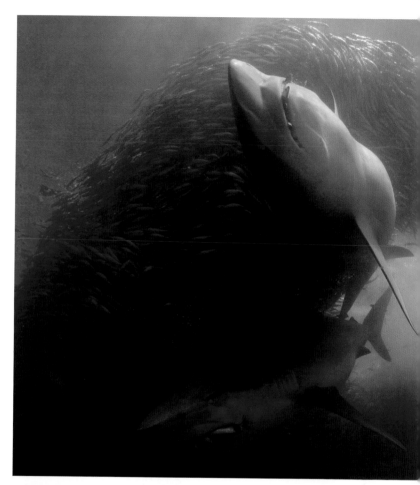

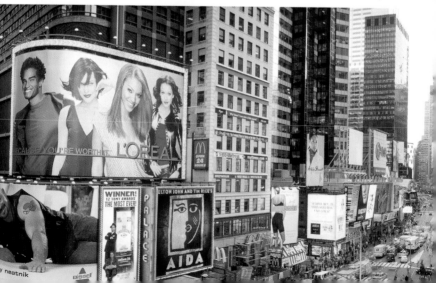

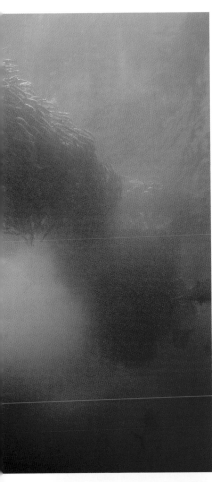

painful pursuit of truth and beauty. It celebrates the great, the good, the terrifying, and the glorious.

The emotional span of photography is as wide as any person can experience. I hope that when reading the book you will be awed, troubled, and inspired by turn. At the same time, the book offers you a resource: how to equip for and improve your own photography, how to take it further, and where to go to learn more. Above all, I hope that this book will open your eyes to see beneath the surface of the photograph, to reach the truths within the image.

Natural vision
Our vision of the natural world has been shaped by stunning images made by skilled, and sometimes extremely brave, photographers, such as this award-winning shot of sharks (*left*), taken by Doug Perrine.

A world of images
Photographic images have become an integral part of the urban world. Times Square, New York (*below*) is covered with billboards, which bring unprecedented colour to the cityscape.

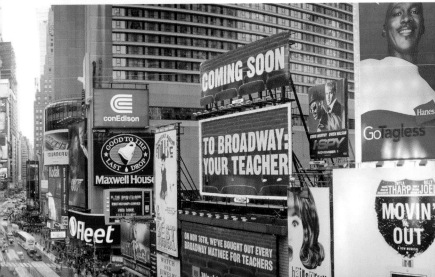

GALLERY OF PHOTOGRAPHERS

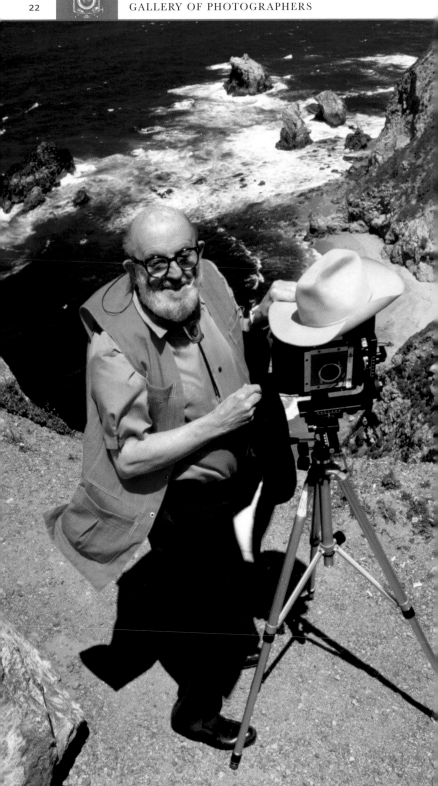

THE GREATEST PHOTOGRAPHERS HAVE CHALLENGED AND EXPANDED OUR VISUAL HORIZONS. THEY HAVE TAUGHT US TO SEE THE WORLD IN A DIFFERENT WAY, THE BETTER TO APPRECIATE AND UNDERSTAND IT. AS PHOTOGRAPHERS WE CAN LEARN SO MUCH FROM THESE ARTISTS WHO INSPIRE US TO SEEK EXCELLENCE IN OUR OWN WORK.

The shining beacons in the history of photography are those creative and technical geniuses whose work demonstrates not only a total control over their medium, but also combines clarity of vision, determination, invention, and a receptiveness to new ideas. Much, though not all, of the history of photographic output is written by the originators of the art, and their work continues to inspire all who follow them.

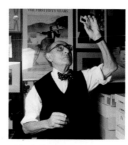

Alfred Eisenstaedt
Eisenstaedt is considered by many to be the father of photojournalism (see p.44).

However, one of the great appeals of photography is shared with other arts such as music and theatre: one does not need to be an original creator to enjoy photography, work professionally, and even win great acclaim. The vast majority of published and exhibited photography is in fact the work of the elaborators – superlative artists who were often inspired to take up photography by the originators, and who have themselves become great photographic artists in their own right. Most photographers create their own images through the exploration and exploitation of the work of photographic pioneers. Indeed, part of the creative struggle for many photographers is to find an individual style or to make their own distinctive mark which is different and sets them apart from those who inspired them.

This gallery of photographers celebrates both those who have defined and beaten new paths – whether artistic, conceptual, or technical – and also those photographers who have taken well-trodden paths to a new level of creativity or expertise.

Some have circumnavigated the globe many times in pursuit of grandiose photographic projects. Others have literally put their life on the line and endured hardships and physical violence in order to use their photography to act as an advocate for the dispossessed or vulnerable.

Yet others have ventured no farther than their city limits, leading self-contained lives. And while some have

Ansel Adams
This acclaimed landscape photographer recorded some of the most beautiful places on the planet (see p.26).

concentrated all their energy on the same subject for their entire career, you will also find photographic polymaths who work comfortably from the documentary to the commercial, from landscapes to still-life.

The artists on the following pages demonstrate that there are many paths to photographic greatness. However, if there is one trait that great photographers share, it is that time and again they show themselves to be humble and accepting of their chosen subjects. There is re-invention and renewal in every imitation. In photography, what matters most is not believing in yourself, but believing in the integrity of your subject.

Stephen Dalton
Dalton uses cutting-edge technology and high-speed photography to shoot the natural world (see p.42).

In a world that is swarming with images, the power of a truly great photograph to become rooted in the memory is a magical and admirable thing – the image's greatness defined by its time in history, and its synthesis of form, light, and, of course, its momentary significance. The photograph is a physical, tangible link to one moment in history, a point of revelation, and artistic birth. Whatever the subject, a great photograph requires one fundamental thing: that a photographer – fully aware, highly skilled, and suitably equipped to preserve the image for posterity – was present at the crucial moment.

Eve Arnold
Arnold (*below*) was revered for her documentary images – especially her film stills. Working on a film set required her to work unobtrusively yet quickly to capture telling moments (see p.30).

Margaret Bourke-White
This intrepid photojournalist (*right*) would go to extraordinary lengths to get her picture, and here she shows no fear while working high on the Chrysler Building, New York (see p.35).

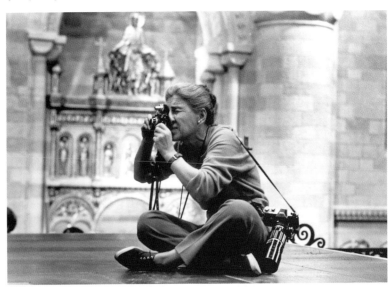

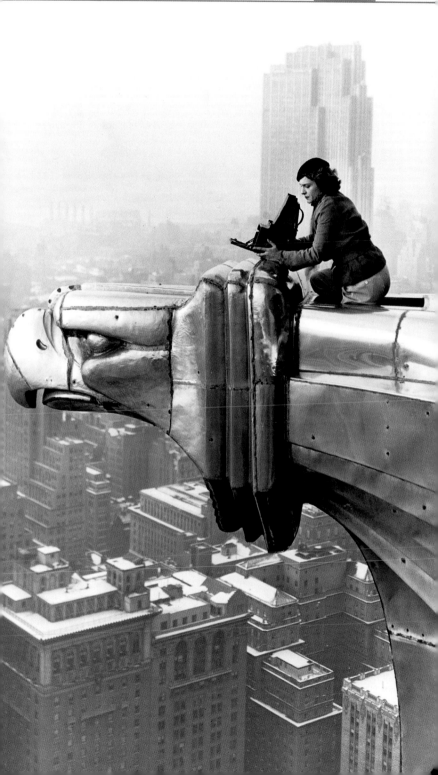

Ansel Adams

American 1902–1984

Best known for the matchless monumentality of his landscape photography, Ansel Adams was a versatile photographer, who was widely influential. He had a flawless command of photographic technique.

As Adams said "You don't take a photograph, you make it." The most enduring examples of his contribution to photography are his richly detailed, pin-sharp, and exquisitely lit landscapes – almost all of them created on large-format film. Thanks to the impact of his landscape works, which exulted in and celebrated the beauty of the American wilderness, Adams' photography entered the political sphere, playing a part in the conservation movement in the USA.

Adams was influenced by the pictorialist and precisionist ideals of contemporary photographers, such as Paul Strand and Edward Weston. He contributed to the development of the Zone System (*see opposite*), which has influenced generations of photographers at both professional and amateur levels throughout the world.

A prolific photographer, Adams also founded a gallery in Yosemite National Park, set up an academic department for photography in San Francisco, and helped to establish the photography department at the Museum of Modern Art in New York. His many books have become classics.

CAREER HIGHLIGHTS

1916 Takes his first photographs of Yosemite National Park, California

1927 First portfolio *Parmelian, Prints of the High Sierras* published

1931 One-man show at Smithsonian Institute, Washington D.C.

1935 *Making a Photograph*, first in a classic series of books, published

1948 Awarded the Guggenheim Fellowship

1960 *Portfolio 3: Yosemite Valley* published

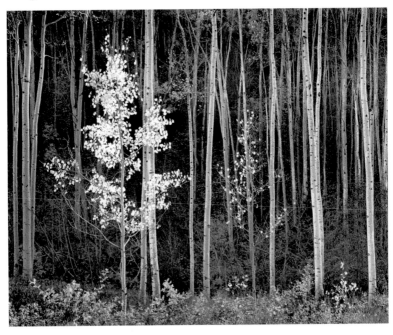

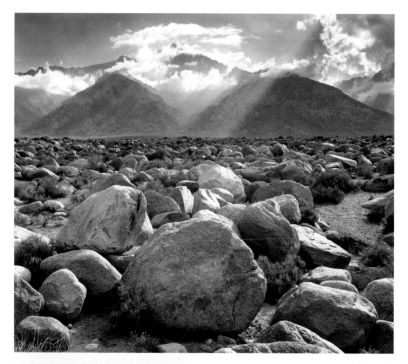

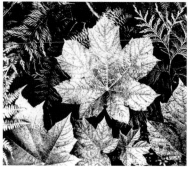

Mount Williamson, from Manzanar, California
Exploiting an extensive depth of field created
by using camera movements, Adams captures
a distant sunburst while keeping the foreground
rocks sharply detailed (*top*).

Leaves, Glacier National Park
Even when working close up, Adams succeeds
in conveying the monumental. He achieves this
through strong composition and by ensuring
all major elements are sharply detailed (*centre*).

Aspens, Northern New Mexico
One of his most celebrated images (*left*), seeing
this print in the original in order to appreciate
the delicate spectrum of silvery tones should
be part of every photographer's education.

ZONE SYSTEM

The Zone System helps the photographer
to translate a scene into the photographic
medium. It is a three-stage process –
of previsualization, exposure, and
development – based on analyzing the
scene according to a scale of ten zones of
brightness ranging from deep shadow to
bright highlight. Previsualization is the
technique of picturing the desired result
before a photograph is taken: by doing
this against the range of brightness, the best
camera exposure for the film can be set.
The film is developed to compensate for
the range of zones in the scene in order
to produce a desired contrast. The print
is then made, trying to match the result to
the previsualized image. With the rise of
miniature formats and automatic exposure,
the Zone System has retreated into a niche.

Zone system scale
This system divides
the brightness
spectrum into 10
equally spaced
steps, each one a
stop apart. Zone V
is the crucial middle
grey – tanned skin,
grass in the sun
and so on.

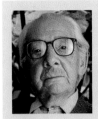

Manuel Alvarez Bravo

Mexican 1902– 2002

Combining Mexican and European influences, Alvarez Bravo's work straddles surrealist and documentary styles. His images – described by Nobel laureate Octavio Paz as "realities in rotation" – can be read on several levels.

A self-taught photographer, Alvarez Bravo was a child at the time of the Mexican Revolution of 1910. He began working professionally for the journal *Mexican Folkways* in 1928, documenting Mexican cultural history. Bravo's style arose from the traditions and myths of *mestizo* Mexico – the blend of indigenous Indian with Spanish – but was also influenced by ideas brought from Europe by visiting photographers such as Cartier-Bresson (*see pp.40–41*). His work gave a poetic vision of modern Mexico, validating it as an emerging nation. His centenary in 2002 as Mexico's greatest living photographer was a cause for national celebration.

X-ray Photograph
One of the earliest pioneers of using the x-ray for art photography, here (*right*) Alvarez Bravo offers a teasingly pseudo-scientific and objective treatment of the theme of murderous love.

CAREER HIGHLIGHTS

1930	Teaches at San Carlos Academy
1943	Starts work as stills photographer for films
1975	Awarded the Guggenheim Fellowship
1984	Awarded Victor & Erna Hasselblad Prize

Invented Landscape from *Fifteen Photographs*
A common theme for surrealists was the interplay between the man-made and the natural. In this image (*below*) the shadows do all the suggesting and none of the explaining.

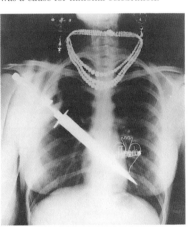

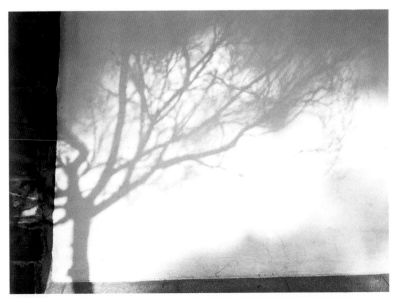

Nobuyoshi Araki

Japanese 1940–

One of Japan's most controversial photographers, Nobuyoshi Araki's work crosses from observation of modern Japan to pornography, and back. His snapshot style is unashamedly voyeuristic and widely influential.

After years in advertising, Araki turned his observant eye to women – particularly those working in nightclubs, and as prostitutes. Celebrated for holding up a mirror to the moral ambiguities of Japanese society, Araki has been subjected to the attention of censors unwilling, or unable, to distinguish documentary photos from pornography.

CAREER HIGHLIGHTS

1972 *Tokyo Autumn* series published

1989 *Tokyo Nude* published

1999 *Vaginal Flowers* series published

Telephone Booth from *Tokyo Nostalgia*
Even when seen individually, Araki's images hint at narrative. At the same time, we cannot tell if the image is candid or not.

Diane Arbus

American 1923–1971

The powerful images of Diane Arbus haunt the viewer like no other; they are a benchmark of unflinching honesty in portraiture. Yet she said "A photograph is a secret about a secret. The more it tells you the less you know."

Having developed an excellent reputation as a fashion stylist helping out her husband, fashion photographer Allan Arbus, Diane Arbus only began photographing in her mid-30s. A successful career in advertising and fashion followed. Arbus was one of the first photographers to use on-camera flash balanced with daylight in her portraiture.One of the hallmarks of her work, it helps to flatten and make the light artificial, bringing the subject unfettered and unflatteringly to the fore.

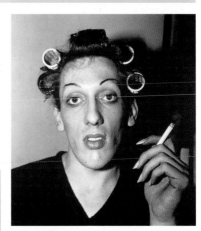

CAREER HIGHLIGHTS

1960 First pictures published in *Esquire* magazine

1963 Awarded the Guggenheim Fellowship (and then again in 1966)

1967 Exhibits at Museum of Modern Art, New York

A Young Man in Curlers
Arbus's portrait at first appears uncompromising, but reveals itself to be tender and sympathetic of the subject's defiant unease.

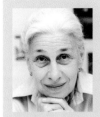

Eve Arnold

American 1913–

At the top of her profession for more than 50 years, Eve Arnold's approach to documentary photography is one that is self-effacing almost to a fault. Her work tells all about the subject and nothing of the photographer.

Arnold's rapid rise has made her a legend amongst photographers. After a mere six weeks of study with the famously hard-to-please Alexey Brodovitch, then art director at *Harper's Bazaar*, she was given her first commission for the magazine. Within three years, she had been approached by the equally fastidious Magnum agency and was made a full member in 1955 – the first woman to be admitted. While her work took her all over the world – most notably to China, working for *LIFE* and *The Sunday Times Magazine* – she is best known for her work on film sets. By winning the trust of those she worked with, Arnold achieved a special intimacy with stars such as Marilyn Monroe and Joan Crawford. She brought the genre of production stills to a standard that few, if any, have since attained.

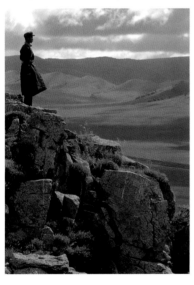

CAREER HIGHLIGHTS	
1980	Awarded Master Photographer by International Center of Photography
1986	Won Krasna-Krausz Book Award for *In Retrospect*
2003	Awarded honorary OBE

Cowboy, Inner Mongolian Steppes, China
This image (*left*) displays Arnold's fine instincts for magazine photography. The composition reveals atmosphere and suggested movement, yet it still has ample space for titles or text.

Anthony Quinn and Anna Karina
The stars relaxing on the set of *The Magus* in 1976 (*below*) are depicted in documentary style. This is a revealing image that conveys the charisma and charm of the actors.

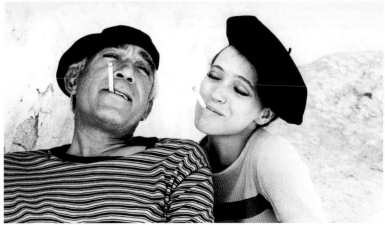

Felice Beato

British c.1825–1906/8

One of the great pioneers of travel photography, Felice Beato was a tireless documentarist whose importance is only now being recognized. His views of Japan provide a unique record of the country in the 1860s and 70s.

Born in Italy but naturalized British, Beato was incorrigibly restless throughout his life. He recorded the aftermath of the Crimean War in the Mediterranean and went on to document the Indian Mutiny of 1858. In 1863 he moved to Japan, where he spent 14 years photographing daily life. He eventually settled in Burma.

CAREER HIGHLIGHTS

1856	Exhibits photographs in London of the Battle of Balaclava
1863	Starts photographing in Yokohama
1878	Photographs in Burma

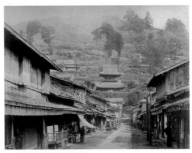

Temples, Nagasaki
This road of temples at Nagasaki with the Kazagashira mountains behind shows Beato's artistic and documentary style.

Karl Blossfeldt

German 1865–1932

An untrained and amateur photographer who used his photography to teach art students about natural forms, Karl Blossfeldt celebrated nature's beauty, creating a unique body of work of matchless consistency.

In 1890 Blossfeldt began to cast models of botanical specimens and photograph plants. Treating the plant as a "totally artistic and architectural structure", his photographs grew into a collection of thousands of botanical studies. He explained: "Since only simple forms lend themselves to graphic representation, I cannot make use of lush flowers."

Young Shoots
Working at magnifications of nearly 30 times life-size, Blossfeldt stunned the art world with the beauty of the forms he revealed.

CAREER HIGHLIGHTS

1898	Starts teaching at Kunstgewerbemuseum, Berlin
1928	*Uniformen der Kunst* published
1932	*Wundergarten der Natur* published

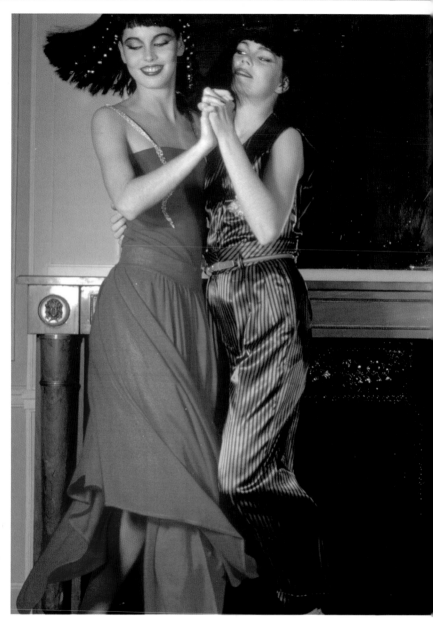

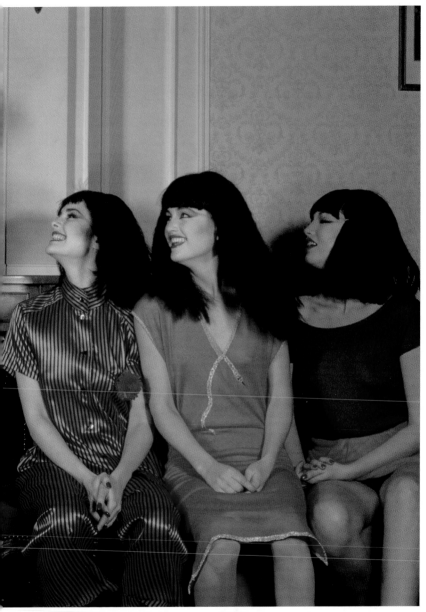

Guy Bourdin
Although he was noted for staging his fashion
photographs in intense, dramatic tableaux,
Bourdin did sometimes relax. This light-
hearted shot combines fun and frivolity with
superb depiction of the clothes.

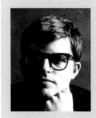

Guy Bourdin

French 1928–1991

One of the most accomplished fashion photographers of his generation, Guy Bourdin gained notoriety through images that were considered shocking at the time. Today, his work appears light-heartedly stylish and polished.

First exhibited as a fine artist, Bourdin's surrealist and elegantly anarchic images soon caught the attention of *Vogue* magazine. He insisted his photographs be viewed in their intended context and for the following 33 years, his work was never seen outside the pages of fashion magazines. The first solo photographic exhibition of his work was shown only 10 years after his death, but throughout his career he continued exhibiting his drawings. From the mid-1970s he worked on advertising campaigns, most notably for Miyake, Jourdan, and Chanel. Bourdin had a reputation as a hard taskmaster, testing the endurance of his models to the limit. Indeed, violence – expressed as shocking colours and contrasts – is never far from the narrative of his pictures.

CAREER HIGHLIGHTS	
1952	Exhibits at Galerie 29, Paris
1955	Starts photographing for *Vogue*
1975	Photographs campaign for fashion designer Issey Miyake
1988	Receives Infinity Award, International Center of Photography

Charles Jourdan, Spring 1978
Bourdin's advertising work set new standards for its knowing, artistically self-referential wit. Here (*right*), a Polaroid proof displaces the main image creating a tension between picture planes.

Charles Jourdan, Summer 1977
Bourdin's mastery of composition is evident in this image (*below*). Despite its numerous interlocking elements and elaborate lighting, the viewer's gaze is still led straight to the shoes.

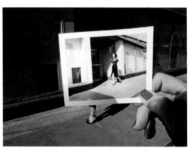

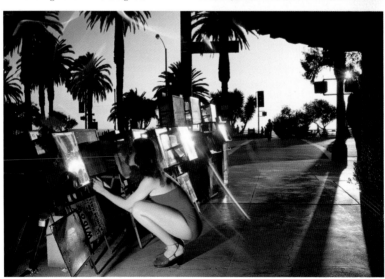

Margaret Bourke-White

American 1904–1981

Epitomizing the notion of an uncompromising photojournalist, Bourke-White went to extreme measures to get a picture. A technical virtuoso, she could work in the toughest conditions, and still bring back flawless images.

In 1929, two years after graduating from Cornell University, Bourke-White landed a staff job as an industrial photographer for *Fortune* magazine, then became one of the founding staffers on *LIFE* magazine, where she worked for the rest of her career. Bourke-White was infamously aggressive in pursuit of both assignments and pictures, once saying: "If you banish fear, nothing terribly bad can happen to you." In the 1930s, she photographed in the Soviet Union and her work provided an early record of the emerging nation.

Bourke-White's tenacity was demonstrated when she met Mahatma Ghandi. Before agreeing to pose for photographs next to a spinning wheel, he requested she learn to spin. She duly did and got her picture.

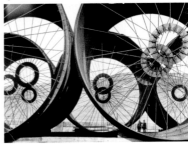

Construction of Fort Peck Dam
Bourke-White's early industrial photographs, such as this shot of giant pipes used to divert the Missouri River, combined visual sophistication and technical prowess.

CAREER HIGHLIGHTS

1936 Becomes photographer for *LIFE*

1937 Takes images for Erskine Caldwell's book *You Have Seen Their Faces*

1945 Photographs General Patton's visit to the Buchenwald camp

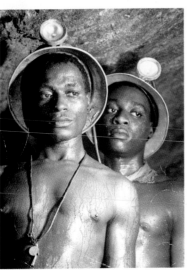

Gold miners, Robinson Deep
Despite the harsh conditions, Bourke-White used a large-format camera to deliver this technically perfect and powerful image of miners working deep underground.

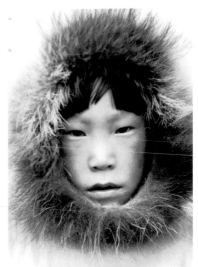

Eskimo, Canada
This portrait shows Bourke-White's later, sparse approach to photography. Characteristically, she chose to cover this story in the depths of winter, eschewing the comforts of working in summer.

Bill Brandt

British 1904–1983

The subjects of Bill Brandt's photography seem to speak clearly and with directness through the print. Given his status as a master of photography, Brandt's output was surprisingly small, but much of his work remains iconic.

Born into wealth and privilege in Germany, Brandt turned to photography while studying architecture. His time as assistant to Man Ray (*see p.62*) laid the foundations for a non-purist attitude to the photographic process, and a surrealist streak that was to characterize his work.

On settling in England in 1931, he worked as a documentary photographer, motivated by a combination of humanist and left-wing ideals, while also making use of actors and models.

After World War II, he became disillusioned with documentary work and turned to nudes, portraiture, and abstracts. Brandt's series of nudes in landscapes, exploiting the projection distortion effects of a wide-angle lens used closeup, were shocking at the time, their references to the works of Picasso and Henry Moore notwithstanding. His understanding of light and form found eloquent expression in print, making him one of the most widely collected of photographers.

CAREER HIGHLIGHTS	
1929	Assists photographer Man Ray
1936	*The English at Home* published
1951	*Literary Britain* published
1961	*Perspective of Nudes* published
1983	Curates *The Land* exhibition at Victoria and Albert Museum, London

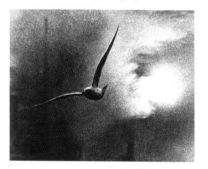

Fog, London Bridge
Brandt's reportage of London, like this image of a gull soaring over the Thames (*right*), defined the image of the city as dreary and fog-bound.

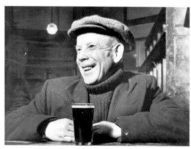

Man in Pub, London
Brandt regularly used models in his work. This shot of a man in a pub (*above*) illustrated a 1946 *Picture Post* essay titled *The Doomed East End*, which covered post-war rebuilding in London.

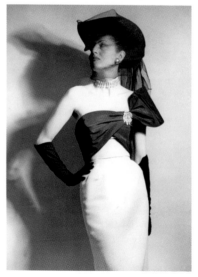

Afternoon and Evening
Even Brandt's fashion photography – here of a model in evening dress, published in *Picture Post* in 1951 (*right*) – has menacing undertones: the shadows appear to close in on the model.

Julia Margaret Cameron

British 1815–1879

It was her eye for the intimate and the intensity of her portraiture that made Julia Margaret Cameron unique. With a productive period of just 14 years, her career is the shortest of any world-class photographer.

Cameron could be regarded as the patron saint of amateur photography. She photographed out of love, although in her case it bordered on obsession. She was given her first camera by her daughters when she was 48 years old. Unfettered by niceties, she made family, servants, and visitors to her home in England – including luminaries such as historian Thomas Carlyle – pose for her to create portraits or romantic tableaux. She coaxed an extraordinary intensity of emotion from her subjects, creating images with a defined sense of style, working her sitters to the limit. Alfred Tennyson allegedly left the poet Henry Longfellow with the warning, "Do whatever she tells you. I shall return soon and see what is left of you."

Working in the dim, soft light she favoured, Cameron used glass plates requiring exposures that often lasted several minutes. The photography establishment were, she reported, "manifestly unjust" in their criticism of her work, but by the 1870s her prints were in great demand. Cameron left England for Ceylon (now Sri Lanka) in 1877, and all but gave up photography. Her modern reputation has been assured by her inclusion in Alfred Stieglitz's *Camera Work* magazine in the early 1900s.

CAREER HIGHLIGHTS

1863	Receives first camera as gift
1865	First exhibitions
1867	Exhibits in Paris
1868	Exhibits in London
1874	Illustrates Alfred Lord Tennyson's *Idylls of the King*

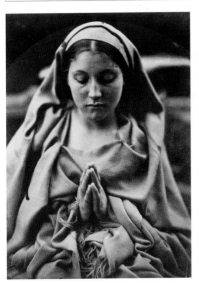

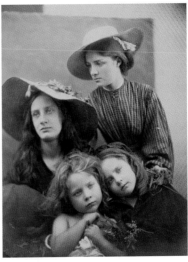

Summer Days
This image (*above*) shows that Cameron was an early master of the group photo. The grace and poise of her groupings is remarkable given the lengthy preparations and long exposures needed.

St Agnes
This tableaux of the martyred saint (*left*) combined classical themes with a covert Victorian sensuality, mirroring the tension in John Keats contemporaneous poem, *The Eve of St Agnes*.

Robert Capa

Hungarian 1913–1954

The photojournalist as hero, Robert Capa characterized the notion of the swashbuckling photographer who braved bullets with a winning grin, always getting his picture with an uncanny ability to be in the right place at the right time.

Born André Friedman, Robert Capa studied political science in Berlin in the early 1930s, during which time he took his first published photograph, of Trotsky. With the rise of Hitler, he was forced to move to Paris where he invented the persona of the "famous American photographer Robert Capa" in order to justify charging a premium rate. He moved through the heady high-art circles of pre-war Paris, meeting luminaries such as Ernest Hemingway and Pablo Picasso, and influential photographers such as Henri Cartier-Bresson (*see pp.40–41*).

His coverage of the Spanish Civil War (1936–39) is justly hailed as a most perfect example of rounded, passionate, and humanist photojournalism, producing the iconic image of a soldier at the moment of his death. His technique was shorn of inessentials, powered by his dictum "If your pictures aren't good enough, you're not close enough", and was shaped by the Leica camera's abilities and limitations. Despite his derring-do reputation, he loathed war, confessing once that "It's not always easy to stand aside and be unable to do anything except record the sufferings around one", and fervently

hoped to be "unemployed as a war photographer till the end of my life."

Besides his images, one of his lasting contributions to photography was the founding of photographic agency Magnum (with Polish photojournalist David "Chim" Seymour, Frenchman Henri Cartier-Bresson, the Briton George Rodger, and American William Vandivert). The agency's combination of hard-nosed commercialism and humanist idealism bears Capa's mark.

CAREER HIGHLIGHTS	
1936	Photographs Spanish Civil War
1938	Portfolio published in *Picture Post*
1942	Hired by *Collier's Weekly*
1943	Hired by *LIFE* magazine
1947	Co-founds the Magnum picture agency

Chinese Teenage Soldier
Capa photographed this teenage soldier in Hankow (now Wuhan) in China in 1938. The low perspective mocks the threatening nature of the soldier, whose youth is all too obvious.

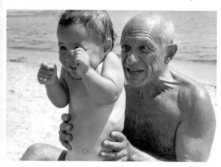

Picasso and Son
Capa was an intelligent editorial photographer. His few images of Picasso and Matisse have become iconic, including this shot of Picasso with his son Claude, taken in 1948.

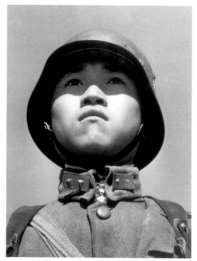

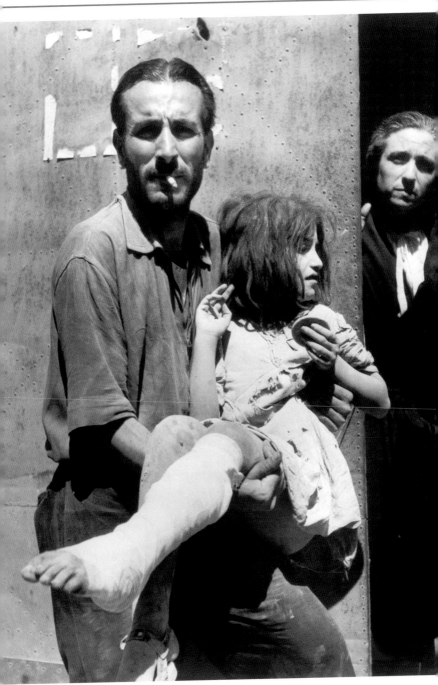

The Battle of Troina, 1943
Capa's interest was in exploring the human side of war and his genius lay in his innate ability to capture people's emotions. This moving image, taken during World War II in the aftermath of the American bombing of the German-held town of Troina in Sicily, draws in the viewer by clearly depicting the fear, anger, and pain of the three subjects.

Henri Cartier-Bresson

French 1908–2004

The greatest inspiration to countless photographers, Cartier-Bresson was an elusive person and yet one of the most approachable photographers. His work is a perfect union of the intellectual and the humanist.

Inspired by Hungarian photojournalist Martin Munkacsi's vivacious image of black youths running into the sea, Cartier-Bresson forsook his art studies and took up photography. He was passionate about his work and would prowl the streets of Paris with his camera from morning until night, as his prolific output testifies. Much of Cartier-Bresson's greatest work was produced in a few productive years during the 1930s. Blessed with determination (and good luck), he covered the Spanish Civil War, escaped from the Nazis, worked for the French Resistance, and then went on to film the liberation of Paris and its return to French hands in 1944.

After World War II, Cartier-Bresson helped found the Magnum photographic agency, remaining its father-figure and best-known photographer throughout its early years – itself a remarkable achievement. His own words that "no one thing is independent of another…one thing rhymes with another, and light gives them shape", explain the philosophy behind his photography more clearly than volumes of analysis ever could.

Balthus with his Wife and Daughter
This seemingly informal family shot of the artist Balthus (*right*) shows Cartier-Bresson's compositional sophistication. Balthus's gaze separates him from the women and their source of amusement, which lies out of frame.

Hyères, France
Even without the perfectly positioned cyclist, the lines of the stairs, railing, and road would form a pleasing composition (*below*). An optical illusion makes the cyclist seem smaller than reality.

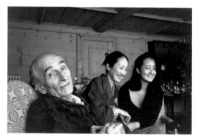

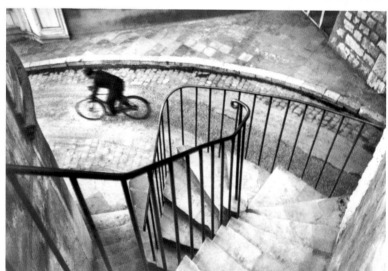

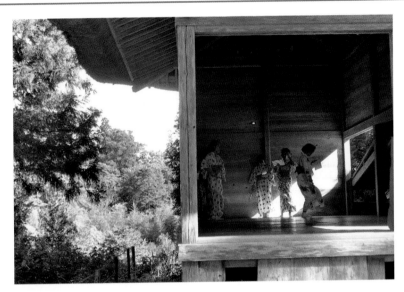

CAREER HIGHLIGHTS

1935	Studies film with photographer Paul Strand; assists film-maker Jean Renoir
1937	Makes documentary film of Spanish Civil War
1947	Co-founds the Magnum agency
1952	Exhibits major retrospective *Decisive Moment* in the Louvre, Paris
1973	Menil Foundation of Houston commissioned to edit his life's work
2003	Retrospective at Bibliothèque Nationale de France, Paris

STANDARDIZING THE LENS

Although Cartier-Bresson did use various focal lengths, the vast majority of his work was "taken" (his word) through a 50mm lens. Only by paring back his equipment to the barest minimum could he work the camera like a "sketchbook, an instrument of intuition and spontaneity, the master of the instant which, in visual terms, questions and decides simultaneously."

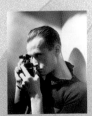

Viewfinder
An early portrait of Cartier-Bresson shows him looking through a universal viewfinder attached to his favoured Leica camera. The viewfinder shows fields of view for different lenses.

Japan, 1965
Photographing the rehearsal of a Noh play from the side rather than the front, Cartier-Bresson demonstrates lateral thinking. The frame of the rehearsal room encloses the artificial dramatic world, while the pine trees reflect the *kagami-ita* (painting of a pine tree) used as a backdrop.

Atomic Energy Plant in India, 1997
Cartier-Bresson's later work lost none of its ability to surprise. The three planes of this image shift and incline at different angles, rendering it more unsettling the closer it is examined.

Valdir Cruz

Brazilian 1954–

The images of Valdir Cruz reveal that documentary photography, when carried out with simplicity, conviction, and purpose, still retains the power to plead the case of the under-represented and dispossessed.

Turning to professional photography in his late 30s while he was living in New York, Cruz rediscovered his Brazilian roots and so found a focus for his work. His images helped publicize the plight of the remote, threatened tribes of the Brazilian rainforest. Cruz's approach to photography was deceptively naive, straightforward, and free of visual gimmickry.

CAREER HIGHLIGHTS

1980	Starts to photograph
1996	Exhibits at Fotofest, Houston; awarded the Guggenheim Fellowship
2003	*Faces of the Rainforest* published

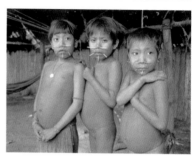

Irokai-teri, Venezuela, 1997
Cruz did not use artifice or clever camera angles to achieve this image; instead he allowed the children's naturally graceful poses and dignified expressions to speak for themselves.

Stephen Dalton

British 1937–

Taking high-speed nature photography to new heights by using technical invention and artistic vision, Dalton reveals the beauty of the natural world by capturing movements that are too quick for the human eye to see.

While high-speed photography is nothing new – Harold Edgerton photographed bullets in flight in the 1930s – Dalton used the techniques on unpredictable live subjects, tiny insects such as moths, bees, and wasps, as well as birds. This requires flash exposures of 1/25,000 of a second or shorter, of extremely high power, with responsive switching devices. Although mainly shot in the studio, his work has brought a new beauty and realism to this type of photography.

CAREER HIGHLIGHTS

1970	Starts high-speed photography work
1975	*Borne on the Wind* published
1978	Becomes Honorary Fellow of the Royal Photographic Society
1999	*Secret Worlds* published

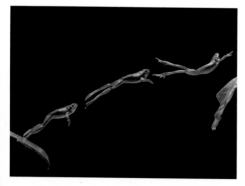

European Tree Frog
The beauty of the frog's leap is perfectly revealed with three stroboscopic flashes exposed on 35mm colour film.

David Doubilet

American 1946–

Visual awareness and technical prowess have made David Doubilet the greatest of underwater photographers. His work has inspired many to explore the wonders of the marine world and influenced the style of nature films.

Having taken up snorkelling at a very young age, Doubilet was only 12 years old when he began to scuba dive and just 13 when he started photographing underwater using a Brownie camera wrapped in a watertight bag. By 1972, at the age of 26, he was working regularly for *National Geographic*, and has since completed over 60 assignments for the magazine.

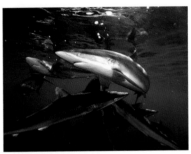

Slick Swimmers
Breathtaking composition and clarity of detail, the hallmark features of Doubilet's work, are evident in this image. Subtle lighting and careful use of flash focus the viewer's gaze.

CAREER HIGHLIGHTS

1989	*Light in the Sea* published
1992	*Pacific: an Undersea Journey* published
2001	Becomes Honorary Fellow of the Royal Photographic Society

Max Dupain

Australian 1911–1992

The most important documentary photographer of Australian life and architecture, Max Dupain left a finely crafted legacy of photographs, producing iconic work with a uniquely Australasian "voice".

Influenced by Modernism, Dupain fused a love and understanding of his country with a minimalist style of photography, often using the harsh lighting conditions that he regularly encountered in Australia to his advantage. In the course of a long career, he moved comfortably between architectural, industrial, and portrait photography, working both commercially and as a documentary photographer.

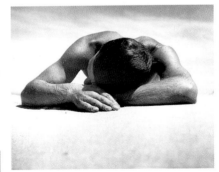

Sunbaker, 1937
This, Dupain's signature image, rose quickly to iconic status. With its stark composition, Dupain exploits a tension between the ambiguous position of the body – the person could be injured – with its bronzed physical perfection.

CAREER HIGHLIGHTS

1934	Starts working professionally
1948	*Max Dupain Photographs* published
1975	Retrospective at Australian Centre of Photography, Sydney
1982	Receives an OBE

Alfred Eisenstaedt

German 1898–1995

Considered by many to be the father of photojournalism and the greatest of photographers, Alfred Eisenstaedt was above all a consummate professional who retained his modesty, as well as his capacity to be amazed by life.

Throughout a long career spent mostly in the top ranks of photojournalism, Eisenstaedt was sparing in his use of equipment, frequently only working with one camera. This, and the ability to disappear into the background, made him a master of candid photography. He contributed some 2,500 stories to *LIFE* magazine, and nearly 90 covers. Less well known is the fact that Eisenstaedt pioneered the celebrity profile, giving publicity shots the respectability of the picture essay. His down-to-earth approach is exemplified by his advice that "the most important thing is not clicking the shutter, it is clicking with the subject."

CAREER HIGHLIGHTS	
1927	Sells first photograph
1935	Buys Rolleiflex; emigrates to USA
1954	Exhibits at George Eastman House, Rochester, New York
1966	*Witness to Our Time* published
1971	*Photojournalism* published
1981	*Germany* published
1989	Receives National Medal of the Arts

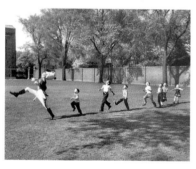

Drum Major, Ann Arbor, 1950
This photograph of children imitating a drum major during his practice is one of Eisenstaedt's best-loved images. It shows his knack of being in the right place at the right time.

Sophia Loren
The formal presentation of the room, characteristic of an architectural photograph, is thrown awry by the relaxed figure on the bed.

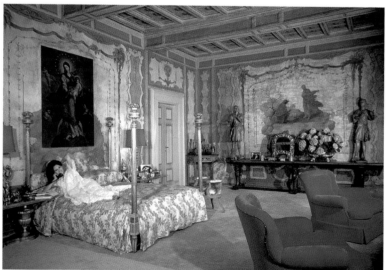

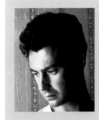

Elliott Erwitt

American 1928–

With a rare ability to capture a fleeting moment, Elliott Erwitt's work ranks him unequivocally among the photography greats. It demonstrates photojournalism of the highest order of observation, prediction, and timing.

Erwitt studied photography during World War II, serving as a photographer in Germany and France before continuing with film studies. By the 1960s he was gaining a reputation as the funny man of photography, sealed in 1974 with his book on dogs *Son of Bitch*, which remains unchallenged as the most humorous photography book ever published. While continuing his work as a stills photographer, Erwitt started making films in the 1970s. He is a sensitive documentarist and highly successful advertising photographer, with a reputation for having a deceptively laid-back approach. He advises "Keep working, because as you go through the process…things begin to happen."

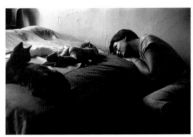

New York City, 1953
This warmly intimate image of Erwitt's family was taken early in his career. Already, his eye for richly subtle composition and the emotionally charged moment is evident.

St Tropez, France, 1968
Erwitt's classic study of the seafront blends a sharp eye for the mildly surreal with a warm humanity. His images incite laughter not in mockery but from sharing the absurdities of life.

CAREER HIGHLIGHTS

1942	Studies photography at Los Angeles City College
1948	Studies film at New School for Social Research, New York
1950	Begins freelance photography
1954	Joins Magnum
1971	Films *Beauty Knows No Pain*
1977	Films documentary *Glassmakers of Herat, Afghanistan*

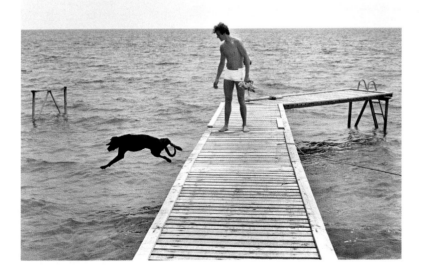

Ernst Haas

Austrian 1921–1986

The most articulate of photographers – both in words and images – Ernst Haas taught us virtually everything we know about using colour in photography. He was a technical pioneer with a painter's eye.

A dropout from medical school who took up painting, Haas was 26 before he found his calling. When he did, he was unstoppable. His first picture essay – of the homecoming of soldiers to his native Vienna in 1947 – was a stunning debut: nearly every shot on the first roll of film was publishable. It led to an invitation to join the photographic agency Magnum, and another to work for *LIFE* magazine.

While working in the USA, Haas was captivated by the colours of New Mexico and gave up black-and-white photography to use only Kodachrome and Leica equipment. He went on to discover

blurred motion photography while shooting a rodeo in light deemed useless by other photographers.

Haas travelled throughout the world and many of his picture essays still set standards for photographers today. A recipient of an honour almost each year of his professional life, Haas proclaimed: "The limitations of photography are in yourself, for what we see is only what we are." A fine source for photographic *bon mots*, his genius is perhaps best defined by his rhetorical question: "If the beautiful were not in us, how would we ever recognize it?"

IMAGES OF MOTION

By using very slow (12 ASA) colour film in indoor arenas, Haas was exploring new territory. Low light called for long exposures, which smears the moving image over a single frame, thus depicting motion in a way inaccessible to any other medium. Haas used a viewfinder camera so that he could watch the action during the exposure (it is blacked out in an SLR camera). This helped him control the otherwise highly unpredictable results.

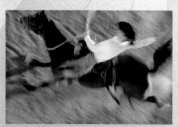

Bronco Rider, California, 1957
With the very-fast-moving action of a bronco rider, only the very shortest of exposure times will freeze action. Conversely, a moderately short exposure time – 1/8 or 1/4 of a second – will be sufficient to induce a blurred image. A longer exposure time could render the image unintelligible. Here, Haas exposed generously while keeping the outlines of the subject clear.

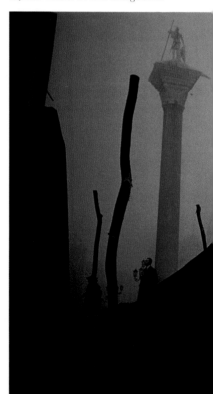

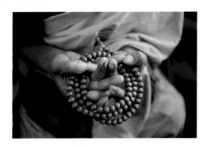

Mandala Mudra Prayer Beads, India, 1974
Combining a harmonious composition of colours with informative content, this image (*left*), shows a monk's *mandala mudra* symbol of enlightenment expressed through the hands.

Raindrop on Leaf
In a development of the traditional still-life aesthetic, Haas delved deep into detail to compose deceptively simple images of plants (*below*). These have become some of his best-known and most widely published works.

CAREER HIGHLIGHTS

1943	Studies photography at Graphischen Lehr- und Versuchsanstalt, Vienna
1945	Photographs for American Red Cross
1953	*Magic Images of New York* published in *LIFE*
1962	Has retrospective at Museum of Modern Art, New York
1962	The film, *The Art of Seeing* is made
1971	*The Creation* published
1975	*In America* published
1986	Wins Hasselblad award

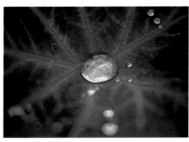

Doge's Palace, Venice, 1955
To make this photograph *(below)*, Haas worked in the most unpromising lighting conditions to deliver a timelessly elegant image.

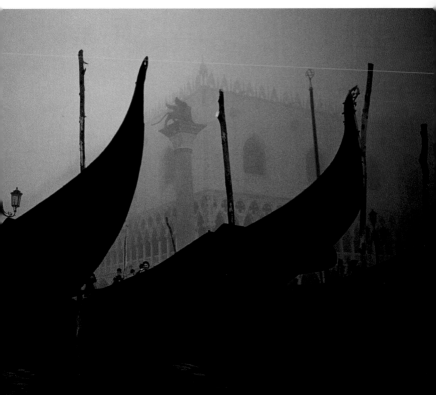

John Heartfield

German 1891–1968

Powered by political passion and using a subversive Dadaism all of his own, John Heartfield's photomontages remain powerful and barbed. His images demonstrate an acute sensitivity and a sardonic humour.

Born Helmut Herzfeld, Heartfield initially led a career as an artist and in the interwar years he became increasingly rebellious. Under the influence of Dadaism, he found a channel, through photomontage, for his protest at the Weimar Republic and the rise of the Nazi party.

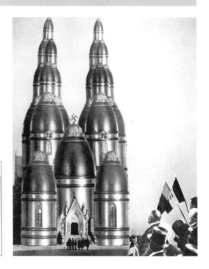

We Pray to the Power of the Bomb
Heartfield's 1934 photomontage of artillery shells at different scales made to look like a cathedral was shockingly striking in its time.

CAREER HIGHLIGHTS	
1920	Organizes First International Dada Fair, Berlin
1940	*One Man's War Against Hitler* exhibition, London
1954	Elected to Deutsche Akademie der Künste

Eric Hosking

British 1909–1991

As the founding father of modern nature photography, Eric Hosking was a technical innovator. His dedication to wildlife preservation led the way for using photography for conservation campaigning.

Through a deep respect for wildlife, together with infinite patience and meticulous technical skills, Hosking compiled the first comprehensive library of bird images. He became an expert in bird behaviour and was one of the first to use colour film – Kodachrome – for natural history photography. In 1948 he was also the first photographer to use electronic flash to capture birds in flight.

CAREER HIGHLIGHTS	
1929	Embarks on nature photography career
1944	*Birds of the Day* published
1955	*Birds* published

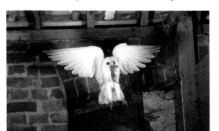

Barn Owl
This celebrated image of a barn owl caught in midflight with a vole hanging from its beak is the most widely published nature photograph from the 1950s.

Eikoh Hosoe

Japanese 1933–

The work of Eikoh Hosoe is rich with significance, as art object, as investigation into sexual separateness, as representation of identity anxiety, even as symbolist theatre, but all his images have a powerful impact.

Hosoe's images appear at first merely to be nude or tableaux studies, but the totality of his work reveals a preoccupation with identity. His widely acclaimed books reveal a sure touch in picking collaborators. The legendary writer Yukio Mishima was the subject of his darkly erotic images in the book *Barakei (Ordeal by Roses)*. Hosoe revealingly said: "The photographer who wields [the camera] well can depict what lies unseen in his memory."

CAREER HIGHLIGHTS

1960	*Man and Woman* published
1963	*Barakei (Ordeal by Roses)* published
1984	*The Cosmos of Gaudi* published
1998	Has retrospective at International Center of Photography, New York

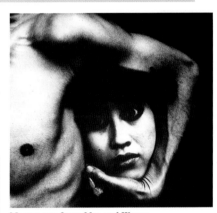

Manwoman from *Man and Woman*
Hosoe's work dramatically combines allegory with dance and theatre, as in this image from his collaboration with the dancer Tatsumi Hijikata.

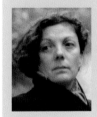

Graciela Iturbide

Mexican 1942–

Imbued with with an insider's understanding, Graciela Iturbide's photographs of her native Mexico expose the shallowness of mainstream travel photography that is motivated only by the stunning image.

An apprenticeship with Manuel Alvarez Bravo (*see p.28*) inspired Iturbide to document Mexico's indigenous peoples. One of her most famous photo essays focuses on the matriarchal values of the Zapotec Indians. Her work examines the tensions between native and modern cultures, Catholicism, and pre-Hispanic beliefs. It has a nascent discomfort, as if constantly in search of resolution.

CAREER HIGHLIGHTS

1990	Exhibits at MoMA, San Francisco
1996	*Images of the Spirit* published
1998	Has retrospective at Philadelphia Museum of Art

Mujer Angel (Angel Woman)
This incongruous image of a woman in a rocky landscape carrying a portable radio poses more questions than it actually answers.

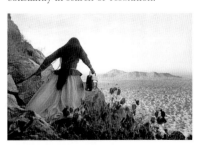

André Kertész

Hungarian 1894–1985

Master of the epigrammatic composition, André Kertész delighted in the poetry of the street, exposing the elegance of chance occurrences. Henri Cartier-Bresson admitted "Whatever we have done, Kertész did it first."

Kertész was one of the first to master the Leica camera and to recognize its potential. He moved in the circles of interwar Paris's artistic elite, where his spontaneous approach to photography was a revelation for the time, influencing Brassaï, Capa (*see pp.38–9*) and Cartier-Bresson (*see pp.40–1*). After emigrating to the USA, he became a successful editorial photographer for Condé Nast magazines, but he is best known for his timeless and quietly stylish personal work.

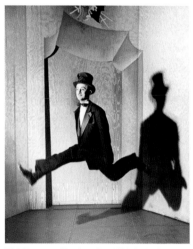

CAREER HIGHLIGHTS

1917	First photograph published: *Erkedes Ujsag (Interesting Newspaper)*, Budapest
1936	Works for Keystone Studios, New York
1962	Wins Gold Medal, Venice Biennale
1975	Awarded the Guggenheim Fellowship

Well in Puszta, Hungary
Kertész's early documentary work in his home country forms a remarkable collection. This image (*below*) wraps a sign of poverty – the well – in sunshine to make a lightly ironic comment.

Hal Sherman Performing Mid-air Splits
With a whimsicality rare in photography, Kertész caught the dancer and comic Hal Sherman performing (*above*). For this work, the Leica's precise shutter release was indispensable.

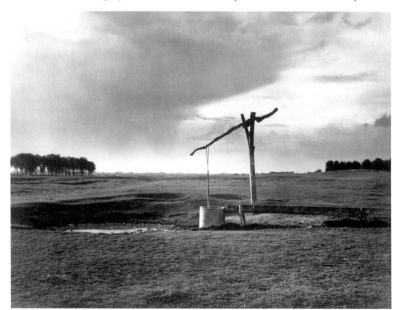

Frans Lanting

Dutch 1951–

One of the most stylish and innovative of nature photographers, Lanting's sensitive photographic approach is guided by his training in environmental science. He has given the public a deeper understanding of wildlife.

Abandoning a career in environmental studies in 1980, Lanting combined his love of photography and the natural world. Approaching his assignments with scientific thoroughness, he spends weeks with his subjects getting to know them.

He has pioneered the wide-angle, closeup view of animals simply by learning how to get closer to them than anyone else. For him, success in nature photography is "part science, part expedition skills, and part human relations skills".

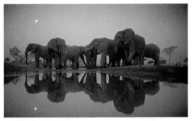

African Elephants
Slow-moving elephants allow Lanting to use a long exposure, enabling him to record colours that low light renders invisible to the naked eye.

Giant Water Lilies
Judicious use of electronic flash lighting balanced with a long exposure for the low light bring out the stillness of this pond.

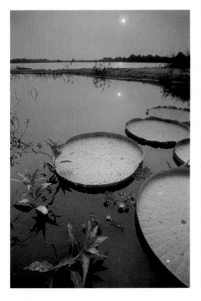

CAREER HIGHLIGHTS

1972	Starts to photograph
1980	Leaves post-graduate environmental studies to concentrate on photography
1985	Starts working for *National Geographic* magazine
1988	Wins World Press Photo award
1991	Wins BBC Wildlife Photographer of the Year award
1994	*Okavango, Africa's Last Eden* published
1995	Wins Kodak Fotokalender Preis

FLASH IN THE FIELD

One of Lanting's contributions to nature photography is his skilful use of flash balanced with existing light. The colouring of light that he achieves can bring out incredibly accurate detail. Elaborate set-ups are required to avoid results that look artificial, so Lanting travels with six or more portable flash units, stands, and soft-boxes (to soften the lighting).

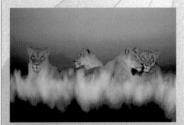

African Lions
Lanting's inventive use of flash is well illustrated in this picture, taken in Botswana. The lower part of flash coverage has illuminated the out-of-focus grasses in the foreground, making them glow like a fire.

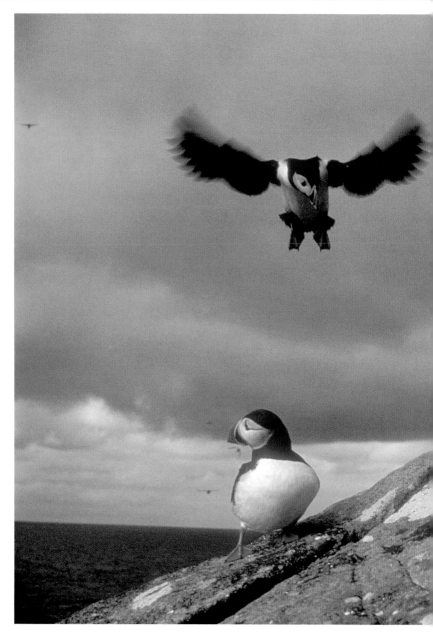

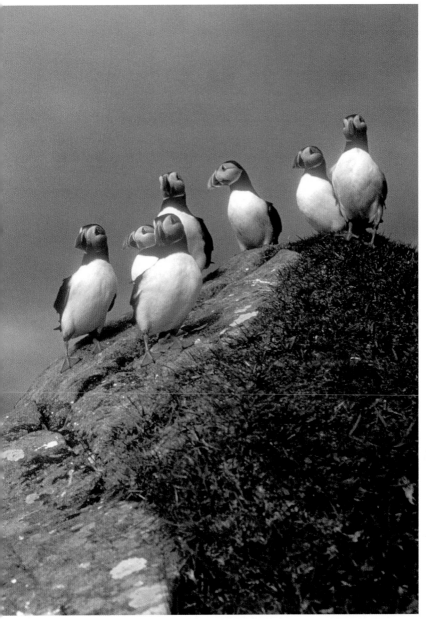

Frans Lanting
Deep knowledge of animal behaviour enables
Lanting to make stunning photographs
seemingly without effort. This picture of a group
of puffins gathering off the coast of Scotland is
perfectly timed and full of character.

Annie Leibovitz

American 1947–

Annie Leibovitz's whole-person portraiture – a highly evolved style of posing with precision lighting and staging – has never lost its ability to surprise. A remarkable number of her photographs have become modern icons.

While her professional origins as a rock-band photographer will occasionally resurface mischievously in her images, Leibovitz is best known for her elaborate celebrity portraits, which are essentially modern tableaux. Using complex lighting – often flash balanced with daylight in outdoor locations – and theatrical settings, yet still allowing herself to respond to the spur of the moment, Leibovitz contrives to hide all technical artifice while making the subject the main focus of the image. At best, her work reaches below the surface and captures something of the subject's inner self.

Leibovitz's style of photography is ideal for her most influential showcase, *Vanity Fair* magazine, as her images serve to iconize the subjects with the photographer's own editorial comment, their brilliance often overshadowing the accompanying feature articles themselves.

Her outlook is revealed in her own words: "I'm pretty used to people not liking having their picture taken...if you do...I worry about you." In 1991, the National Portrait Gallery, Washington, honoured her with a retrospective that toured the USA, Europe, and Asia.

CAREER HIGHLIGHTS

1971	Graduates in Fine Arts from San Francisco Art Institute
1973	Chief photographer for *Rolling Stone* magazine
1983	First contributing photographer to *Vanity Fair* magazine
1984	Wins Photographer of the Year award
1987	Wins Clio award
1990	Wins Infinity award from the International Center of Photography
1999	Inducted into Art Directors Club Hall of Fame, New York

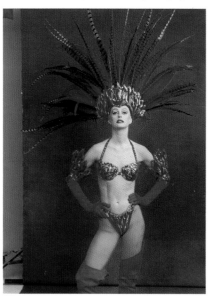

Akke Alama
Leibovitz shows the dancer Akke Alama in a bold, flaunting pose. The intrusion of the edge of the background paper enhances the sense of theatrical artifice.

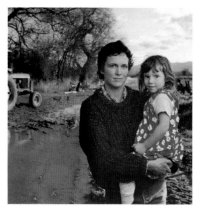

Trini Campbell
Leibovitz's portrait of mother and child, from her *Women* series, is typical of her treatment of "ordinary" people. The image is shorn of glamour in contrast to her "celebrity" images.

Herbert List

German 1903–1975

A man of contradictions, Herbert List was a coffee merchant turned photojournalist. He was a perfectionist, whose enduring images are hedonistic celebrations in a style that is both avant-garde yet formalist.

The turning point in List's ordered life as a Hamburg merchant was his meeting with German photographer Andreas Feininger in 1929, which led him into photography. He started with experiments in surrealism and other avant-garde ideas, concentrating on the male figure in a spirit influenced by the *Jugendbewegung* movement (*see p.326*), which extolled a romantic vision of youth. While Europe erupted into full-scale war, he photographed boys amongst the ruined temples of Greece, exploring surreal interpretations of classical Hellenic ideals. Forced to return to Germany, where he was drafted to design maps for the army, he photographed the ruins of Munich at the end of the war. An associate member of Magnum from 1951, he was sufficiently wealthy to refuse assignments, funding his own projects that were published in *LIFE*, *Picture Post*, and other magazines. Since the 1920s, List had been collecting drawings, and by 1965 he had given up active photography to concentrate on curating what had become one of the world's most important private collections.

CAREER HIGHLIGHTS

1929	Starts to photograph
1933	Exhibition at Galerie du Chasseurs des Images, Paris
1936	Works for *Verve* and *Vogue* magazines
1951	Joins Magnum
1953	*Licht über Hellas* published
1958	*Caribia* published
1965	Gives up photography to curate own Old Master drawings collection

Man and Dog, Portofino
This relaxed seaside shot (*below*) is one of List's best known images thanks to its arch sensuality and perfect composition.

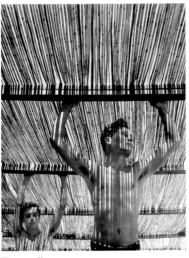

Torremolinos
List's portrait of young men under a reed roof combines formalist elements (graphic lines of light and shadow) and surreal elements (the viewpoint and the pose) with homoeroticism.

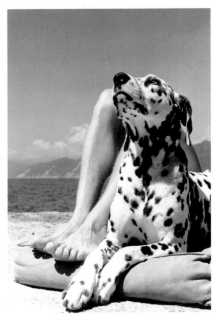

Leo Mason

British 1952–

A love of sport and adventure permeates all of Leo Mason's images. He has embraced new technology, from the super-telephoto lens to the remote control, to push the artistic limits of sports photography.

One of the first to photograph sports with a creative vision that extended beyond the actual event to abstract shape and colour, Mason started his career in advertising before turning to sports photography. His intelligent questing style – always in search of a different and surprising view – was so striking that in 1975, only one year after changing tack, he joined the *Observer* magazine as chief sports photographer. He explains: "From the beginning, I hunted alone, always looking for a personal statement of a particular sport or athlete...always prepared to try anything...in an attempt to create an image that might... encapsulate the beauty and grace of sport. I try to be the 'eye' for the viewer who could not be present."

CAREER HIGHLIGHTS

1981 Exhibition at Shelly Gallery, London

1984 Wins Colour Portfolio sports photographer of the year

1993 Exhibition at Icon Gallery, London

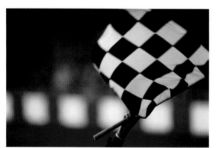

Chequered Flag
Mason has used a long focal length set to a wide aperture to throw the background out of focus to counterpoint the blurred row of rectangles against the black and white of the flag (*left*).

Crew Race
Capturing the movement of many oarsmen in this image (*below*) is technically simple in principle, but difficult in practice. The length of exposure must be timed perfectly so that it is blurred enough but not too much. Photographic skill and knowledge of the sport are needed.

Don McCullin

British 1935–

Anguished and articulate, in words as well as images, McCullin's work reveals his compassionate vision and his innate ability to uncover dignity in utter desperation, giving a voice to those who suffer.

Having learned how to use a camera in the Royal Air Force, McCullin's photographic break came early in his career, when his pictures of a street gang, later linked with the murder of a policeman, were published in the *Observer* newspaper. This led quickly to war assignments for the leading British Sunday newspapers. Taking enormous risks, he soon achieved his ambition to be known as a photographer. While best known for his war images (most notably from the Congo, Vietnam, and Cambodia), McCullin's work at home on the underclass of English society, his haunting landscapes, and darkly luminous still-lifes are all part of the man and his photography. Through his autobiographical accounts, we know more about his anxieties and pains than those of any other photographer. He once said that "when human beings are suffering, they tend to look up, as if hoping for salvation. And that's when I press the button." Still passionate about his work, he has been photographing the effects of AIDS in Africa since 1999. Of this ongoing project, he has said "I could do this work for the rest of my life, until we got some doors kicked in, not just opened."

CAREER HIGHLIGHTS

1953 Becomes photo assistant in RAF

1959 Pictures published in the *Observer*

1964 First assignment covering the civil war in Cyprus for the *Observer*

1966 Joins *The Sunday Times Magazine* (until 1984)

1977 Becomes Honorary Fellow of the Royal Photographic Society

1980 Has retrospective at Victoria and Albert Museum, London

1993 Awarded CBE; Honorary Doctorate from University of Bradford; Dr Erich Salomon Preis

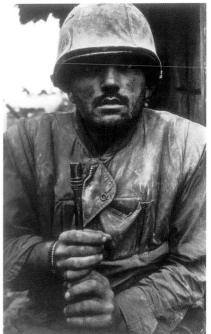

Shell-shocked Soldier, 1968
McCullin's lasting legacy is his face-to-face depiction of the pain of war. The haunting strength of this image is matched by McCullin's written account about this marine in Vietnam.

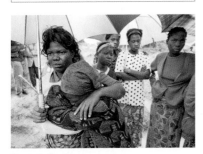

Funeral, Zambia
Shown in Christian Aid's *Cold Heaven* exhibition, this image records the funeral of an AIDS victim. Like the best of McCullin's work, deeper layers are revealed with repeated viewing.

Steve McCurry

American 1950–

A photographic craftsman with the instincts of a journalist, Steve McCurry's work appears to be carried on waves of serendipity, uncovering the humanity in even the most extreme situations of war and privation.

McCurry is the consummate photo-journalist with a knack of being in the right place at the right time. Working in locations such as India, Pakistan, and Afghanistan, which suit his colour-rich style, he has produced some of the late-20th century's iconic images, in particular the mesmerizing portrait of an Afghan girl, which first appeared on the cover of *National Geographic*. His stories tend to have a humanist slant and his images speak convincingly of his personal involvement with the subjects. With a willingness to engage in their lives, if only briefly, he is rewarded by a clear sense of humanity in his work. He once explained: "If you wait…the soul would drift up into view."

Buddhist Monk Studying, 1998
Tact and faultless technique are evident in this study made in Aranyaprathet, Thailand (*right*). With an almost palpable heat and silence, the image's ability to make you feel you are there is a perfect example of great travel photography.

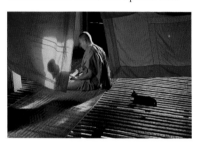

CAREER HIGHLIGHTS

1978	Freelances as photojournalist in India
1984	Wins four World Press Photo prizes
1988	*Monsoon* published
1999	*Portraits* published

THE POWER OF THE IMAGE

This image from McCurry's book *Monsoon* reveals that photography can sometimes have unexpected results. McCurry spotted this man wading through the floodwaters carrying his ruined sewing machine. When the picture appeared on the cover of *National Geographic*, the machine manufacturers sent the man a new one.

Indian Tailor with Sewing Machine, 1983
Despite the adverse conditions this man is smiling: this speaks as much for the power of the camera as McCurry's rapport with his subjects.

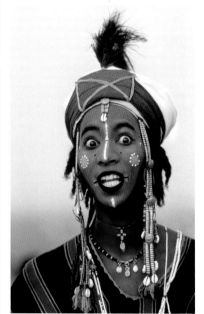

Tahoua, Niger, 1986
McCurry's travel portraiture is characterized by the subject's strong eye contact. This image shows an elaborately decorated woman.

Susan Meiselas

American 1948–

One of the leading exponents of photojournalism, Susan Meiselas is renowned for her uncompromising documentary style. She shows enormous physical courage and patient tenacity in her work.

Meiselas began her career as a photography teacher, but turned a corner when she met photojournalist Gilles Peress, who guided her towards membership of Magnum with her study of showgirls and strippers. At the age of 30, she travelled to Nicaragua where – with a mixture of naive foolhardiness and genuine courage – she documented the civil war. Her coverage has become the best record extant of the internecine conflicts. Gaining a taste for such work, Meiselas went on to cover the civil war in El Salvador, where her bravery and reportage gained her a Robert Capa Gold Medal in 1979. Her much published and award-winning work is extending into multimedia publishing with a website complementing her book on Kurdistan. Active in her espousal of the underprivileged, she says of her work that it is "about bearing witness to an indigenous people who face extinction".

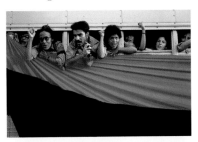

Managua, Nicaragua, 1979
Taken near the central plaza, this image (*above, left*) shows photojournalism and spot-news photography at their best. It is symbolic, strongly composed, and ideal for use in magazines in any reproduction size.

CAREER HIGHLIGHTS	
1978	Travels to Nicaragua
1980	Joins Magnum
1981	*Nicaragua* published
1982	Wins Leica Award for Excellence
1994	Awarded Hasselblad Prize
1997	*Kurdistan: In the Shadow of History* published

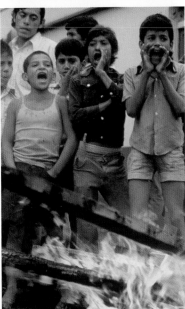

Matagalpa, Nicaragua, 1978
Meiselas positioned herself amongst the protagonists to capture this image of children shouting at the National Guard.

Managua, Nicaragua, 1979
This colourful mural could have made a great travel photograph. But the menacing subject matter shows its true meaning.

Raghu Rai

Indian 1942–

Powered by perceptive intelligence and a profound love of his country, Raghu Rai's pictures often ask more questions than they answer. His work shows a rare mastery of both black-and-white and colour photojournalism.

As a photographer, Rai has concentrated on the single subject of India all his working life. This approach has enabled him to examine his homeland and its people at leisure, lovingly, and with the greatest of subtlety. At the same time, Rai's technique is classically minimal. Most of the time, he uses a wide-angle lens and a 35mm camera, and occasionally a panoramic camera.
He has worked as both a photography director and a photographer, and is equally at home working in black and white and in colour.

Widely exhibited and published, Rai's work includes coverage of major figures, such as Indira Gandhi and Mother Theresa. He describes photography as "an intense passion" and his pictures reflect his deep emotional response to his subjects. His most famous work explores the aftermath of the 1984 Bhopal mass poisoning when the Union Carbide chemical factory leaked, killing thousands of people. His book on Bhopal, *Exposure: Portrait of a Corporate Crime*, demonstrates the enduring nature of visual investigation when technical virtuosity is combined with a need to say something passionately. Rai confesses: "I am always exploring… If I relax I am bound to miss some great photo opportunities… There are thousands of themes left."

Nihang at Amritsar
Rai's portrait of a young Nihang in a camp at Amritsar uses a panoramic camera to locate his subject in a composition of elegantly static forms. The boy, who belongs to the Guru Gobind Singh – the tenth Guru's army – wears a typical blue Sikh dress.

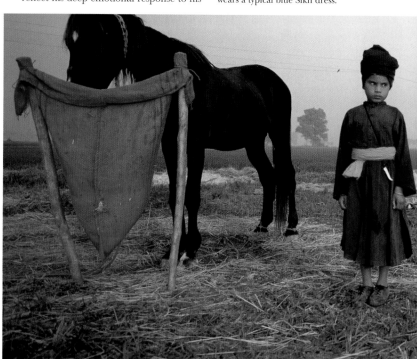

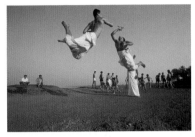

Kalarippayat Demonstration
Two masters of the Indian martial art of
Kalarippayat – a precursor of the better-known
martial arts of the Far East – demonstrate
their agility during a mock fight (*above*). Rai
locates himself low and deep in the action.

CAREER HIGHLIGHTS	
1965	Photographs for *The Statesman*
1974	*A Life in the Day of Indira Gandhi* published
1977	Has retrospective at National Gallery of Modern Art, Delhi
1982	Director of Photography, *India Today*
1993	Wins Photographer of the Year, USA
1996	*Mother Theresa* published
1997	Joins Magnum
2002	*Exposure: Portrait of a Corporate Crime* published

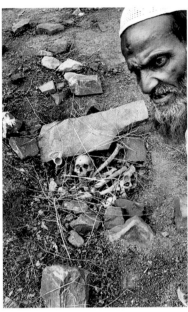

Cemetery, Bhopal
Mohammed Aziz is shown returning to the
cemetery where 4000 people were buried in
the first days after the 1984 Bhopal disaster
(*above*). Rai depicts his subject from an
unusual angle: it confronts the living with the
dead in a hauntingly powerful composition.

Man Ray

American 1890–1976

Remarkable for its technical range, intelligence, and wit, Man Ray's work shows a penchant for experimentation. Yet photography for him was as an adjunct to his art. He once said, "I photograph what I do not wish to paint."

Emmanuel Radnitsky started his career as a draughtsman in 1912, but was soon drawn to the emerging art movements of Europe. Changing his name to Man Ray on his marriage in 1914, he also initiated a change in artistic direction. Although his work is often associated with the artistic developments of Paris from the 1920s to the 1950s – Ray lived in the city from 1921 until his death – his first major influence was the visionary American photographer, publisher, and gallery director Alfred Stieglitz (*see p.65*). By 1923, Ray had received numerous commissions from leading fashion magazines of the time, and had become an established photographer.

Almost as famous for his assistants, who included photographers Berenice Abbott and Lee Miller, Ray was a prolific experimentalist both with the camera and in the darkroom. His mischievous working principle was "to do what one is not supposed to do" and his work conferred respectability to darkroom curiosities such as the Sabattier Effect and photograms.

CAREER HIGHLIGHTS	
1915	Buys a camera to photograph his paintings. First one-man show at the Daniel Gallery, New York
1920	Collaborates with artist Marcel Duchamp
1925	Photographs for French and American editions of *Vogue*
1928	Films *L'Etoile de Mer* (*The Star of the Sea*)
1967	*Salute to Man Ray* exhibition at the American Center, Paris

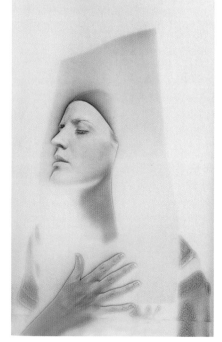

Jacqueline Goddard as a Nun
Goddard (neé Barsotti) was one of Ray's favourite models (*left*). The Sabattier Effect used on the print disguises the nun's habit, turning it into a cubist-like form.

Rayograph 19
This image (*below*) was made using the rayograph technique in which objects are placed on photographic paper and exposed to light.

Alexandr Rodchenko

Russian 1891–1956

It was Alexandr Rodchenko's injunction "to take several different shots of a subject from different points of view... as if one examined it in the round" that has guided photographers and cinematographers ever since.

A painter, graphic designer, and sculptor, Rodchenko took to photography in his early 30s, and quickly realized that the camera's ability to look at objects from any angle made it the mechanical equivalent of the human eye. This fitted well with his Constructivist ideals, leading him to declare that "In order to educate man to a new longing, everyday objects must be shown with totally unexpected perspectives."

At the Telephone, 1928
Rodchenko's search for unusual viewpoints not only reveals fresh perspectives, it also conceals the ordinary, forcing the obvious underground.

CAREER HIGHLIGHTS	
1915	First Suprematist works
1923	Photographs appear in *LEF* magazine
1932	Photographs sports and parades

Sebastião Salgado

Brazilian 1944–

A magisterial presence in the world of photojournalism, Sebastião Salgado has turned the picture essay into the picture magnum opus, composing vast edifices of imagery around themes of the disadvantaged masses.

With a doctorate in economics, Salgado approaches his photography with the thoroughness of a disciplined academic. The intelligence of his picture-making – exclusively in 35mm black-and-white film – is evident in the craftsmanship of every image. As a UNICEF special representative, he campaigns to save the Brazilian rainforest.

CAREER HIGHLIGHTS	
1979	Joins Magnum
1990	*Uncertain Grace* published
2000	*The Children* published

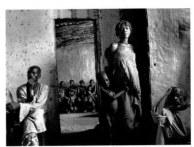

Doctor's Waiting Room, Chad
Salgado's images are often masterpieces of composition. There is an almost painterly quality about the figures in this doctor's waiting area.

August Sander

German 1876–1964

An advocate of photography's power to document, August Sander was made famous by his monumental portraiture project. This rich and vastly influential work has inspired artists, filmmakers, and photographers alike.

Although Sander produced significant work in architecture and landscape, he is best known for his lifelong project *People of the 20th Century*. This was a series of portraits that he took to document German society. His heterogeneous depiction of the German nation clashed with Nazi ideology and the plates for his book *Face of our Time* were seized and destroyed.

CAREER HIGHLIGHTS

1925 Starts *People of the 20th Century*

1929 *Face of our Time* published

1952 Inclusion of works into MoMA collection

Young Farmers, 1914
In this celebrated portrait (*right*), the dapper young men appear too polite to refuse to pose, but are clearly impatient to keep going.

William Eugene Smith

American 1918–1978

Inspirational in his ability to speak through a narrative spun from superbly crafted images, William Eugene Smith perfected the picture essay genre and brought photojournalism to new heights of artistry.

An early starter, Smith sold photographs to newspapers while still in his mid-teens. He was the archetypal humanist who once asked: "What use is having a great depth of field, if there is not an adequate depth of feeling?" His 1956 picture essay on Pittsburgh, USA, is a pinnacle of the genre. This laid the foundation for his major work in Minamata, Japan, which gave rise to many iconic images.

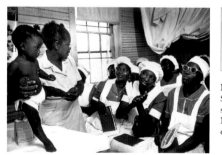

CAREER HIGHLIGHTS

1939 Works for *LIFE*

1957 Joins Magnum

1971 Photographs in Minamata, Japan

Maude Callen, Midwife, 1951
Smith's work fused rich editorial content with strong composition. Here a midwife in rural North Carolina teaches colleagues how to examine babies for abnormalities.

Alfred Stieglitz

American 1864–1946

A measure of the greatness of Alfred Stieglitz is that no one can decide which of his contributions to photography is the greater: his own work or his influence, as editor and gallery director, on the course of American photography.

Born in the USA but educated in Germany, Stieglitz considered himself wholly American, yet he was instrumental in bringing European influences across the Atlantic. A tireless campaigner for modern photography, he poured money and monumental energy into publishing projects and exhibitions. Nonetheless, he concentrated on fine art towards the end of his life. His legendary, painstakingly produced magazine *Camera Work* was as important for the painters it published as for the photographers. While full of praise for the objective clarity of Edward Weston's work (*see p.95*), his own images were sentimentally pictorialist, ranging from romanticized urban views to the tender eroticism of his Georgia O'Keeffe studies. His credo is evident from a letter in which he writes "No school, no church, is as good a teacher as the eye understandingly seeing what's before it."

CAREER HIGHLIGHTS

1902	Founds Photo-Secession group
1903	First issue of *Camera Work* published
1905	Founds Photo-Secession Gallery

Georgia O'Keeffe: A Portrait
Stieglitz photographed his wife, artist Georgia O'Keeffe, with a rich visual vocabulary that was emotive and celebratory. Even here (*left*), a study of her hands is sketched with sexual innuendo.

Two Towers – New York, 1911
While championing the crisp modernity of photographers such as Weston and Strand, Stieglitz also produced dreamy cityscapes, such as this snowy scene (*below*).

CAMERA WORK

Published irregularly by Stieglitz between 1903 and 1917, *Camera Work* was an influential showcase for Stieglitz's circle of leading painters, writers, and photographers. All but ignored on its publication, the magazine has had an enormous influence on 20th-century art practice and has become the art magazine by which others are judged.

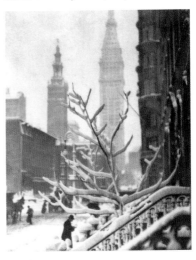

Josef Sudek

Czech 1896–1976

For a photographer to gain the sobriquet "Poet of Prague", in a city replete with artistic genius, is remarkable. For Josef Sudek to do so with an oeuvre founded in his garden shed and with subjects within its vicinity is an inspiration.

Sudek was unable to continue his career as a bookbinder when he lost his arm in World War I. Having taken up photography some years earlier, he began to take it more seriously on his return from the war. Sudek's photography found its truest expression in work created at his modest home and in Prague. Despite his disability, he used large format cameras almost exclusively. He worked patiently: some themes occupied him for as long as ten years. In addition to documenting subjects such as the reconstruction of Prague's St Vitus's Cathedral, he published eight books, which are full of quiet studies of light, hinted-at forms, and deserted spaces in which he seems to breathe life into the inanimate.

Melnick Chateau, 1957
This is one of 284 panoramas of Prague and its surrounding countryside (*below, left*) that made up Sudek's monograph *Panoramic Prague*.

Glasses and Eggs
Sudek made many extraordinary still-lifes of ordinary objects (*below, right*). They range from the sharply detailed to the softly atmospheric.

CAREER HIGHLIGHTS

1927	Works in his garden studio in Prague
1933	First one-man exhibition
1961	First photographer to receive Artist of Merit Award
1974	Has retrospective at George Eastman House, Rochester, UK

Shoji Ueda

Japanese 1913–2000

Seeming to inhabit a parallel universe, Ueda's images are full of emptiness and space – implied and manifest. Using understatement and suggestion, his work is celebrated as a response to photography that is truly Japanese.

Starting conventionally by attending photography school, opening a studio, and establishing a local photography group, Ueda's career was interrupted by World War II, but resumed in 1946. His best-known work centres on the extensive sand dunes of Tottori in western Japan, and shows Surrealist tendencies (he has said that Renée Magritte was an inspiration) as well as a Zen-motivated preoccupation with form. Ueda amply demonstrates that the subtle variations and linear forms of sand dunes make superb backgrounds. Working in black and white, Ueda left some 60,000 prints to the photography museum in Kishimoto, which was founded in his name in 1995.

CAREER HIGHLIGHTS	
1951	Exhibits in Ginza, Tokyo
1960	Exhibits in Museum of Modern Art, New York
1975	Teaches photography at Kyushu Sangyo University
1983	Has retrospective at Tokyo State Gallery

Self-Portrait with Balloon
This early self-portrait from 1948 (*right*), is both a tribute to Magritte and a question about the nature of reality. Where exactly is the balloon?

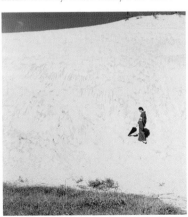

No Title, Sand Dunes
Ueda's image (*above*) is singular in its exploration of the photographic possibilities of these sand dunes in western Japan.

No Title, Sand Dunes
This innovative photograph (*right*) is a carefully staged tableaux. Ueda uses the photographic illusion of space to create visual confusion.

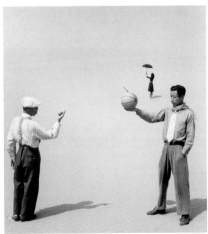

THE STORY OF PHOTOGRAPHY

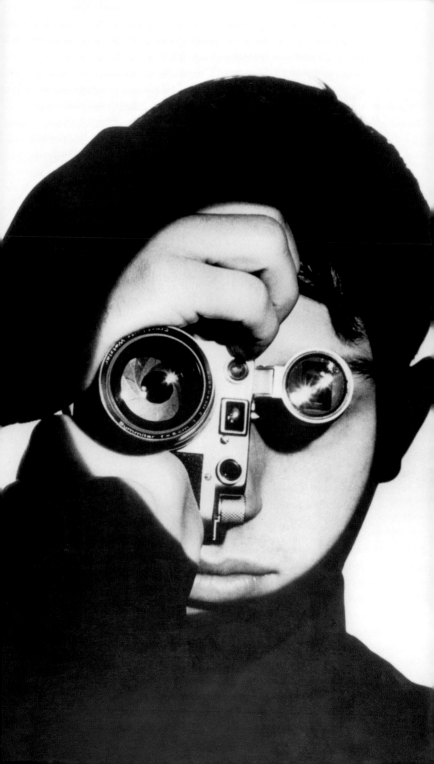

PHOTOGRAPHY AROSE FROM THE WORK OF ARTISTS, SCIENTISTS, AND TECHNOLOGISTS IN THE 19TH CENTURY, AND HAS GROWN TO BECOME A MEDIUM THAT TOUCHES EVERY PART OF HUMAN ACTIVITY. FROM THE EARLIEST BLACK-AND-WHITE PRINTS TO THE LATEST DIGITAL IMAGES, PHOTOGRAPHY HAS THE POWER TO CHALLENGE, INSPIRE, INFORM, AND AMUSE.

Photography is a multi-faceted medium, and its history is made up of the interweaving of three major strands. The artistic movements that influenced and were influenced by photography gave it an identity separate from the other visual arts. Cultural exchanges between photography and society, which had a lasting effect in newspapers and magazines, have broadened public knowledge and understanding of issues and events. And technological developments, such as the explosion in digital image capture and manipulation in the late 1990s, have enabled photographers to continue to break new ground.

A variety of art movements have institutionalized a diverse range of artistic practices in photography. For example, the effect of Dadaism on photography in the 1920s was to inspire the creation of images tinged

Green-winged Macaw
This image by Stephen Dalton (see p.42) shows the fine detail and vivid colours that can be captured by high-quality lenses.

with an iconoclastic mischievousness and wit. This was in marked contrast to the brooding, introspective style of photography motivated by Post-Modernist insecurities. And that was different again from Secessionist responses – all grain and grief – to the shiny objectivity of Modernism.

Like the phases of a personal history, different aspects of photography vary in importance at different stages of its development. The early impact of photography was entirely restricted to the wealthy, leisured classes. The cost of materials such as silver, and hand-made optical equipment, was far too high to allow the average person to take advantage of the new technology. As a result, the social influence of photography at that time was arguably negligible. Once photography became industrialized in the 20th century, it was able to reach the mass market, becoming accessible to all but the poorest and most disadvantaged. Its influence on social awareness and debate grew to be all-powerful (until

Andreas Feininger portrait, 1950s
Feininger's iconic portrait of Dennis Stock portrays the photographic eye as intensely scrutinising and slightly threatening.

television became the primary medium of mass communication). Documentary photography was increasingly used as a means of campaigning, and became an influential tool in lobbying for change.

From the early use of the camera obscura as a drawing aid to the discovery of the first photo-sensitive compound, new technology has been at the forefront of artistic creativity. The arrival of roll film and miniature cameras in the early 20th century freed photographers from the studio and heralded a new age of photojournalism, documentary reporting, and candid photography. Similarly revolutionary was the introduction of colour. This brought new challenges – both artistic and technical – while allowing photographers to cover subjects with greater realism. As technology continued to march on, long focal-length, large-aperture lenses revolutionized nature and sports photography by greatly extending

Me and Cat, 1932
This image was made by superimposing two photographs – a self-portrait by Wanda Wulz and an image of her cat.

the optical reach of cameras. More recently, the emergence of computer technology has democratized photography. Even people with little interest in photography can take pictures instantly on their mobile-phone cameras, and then share them via the internet. On a larger scale, satellite imaging has given us new insights into the universe and our planet.

Photography in the 21st century is more widespread and diverse than at any other time in its history. Modern photographers are in an enviable position – the interplay of artistic, cultural, and technological influences are perfect for creativity and innovation.

Satellite imaging
This false-colour image of Lake Carnegie in Western Australia (*right*) was taken by NASA's Landsat satellite in 1999.

The changing face of portraiture
Changing social trends can be seen (*below*) in a Victorian calling card, a 1940s fashion picture, and a modern-day digitally enhanced image.

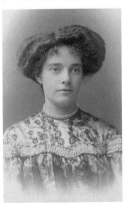
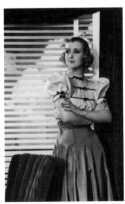

The dawn of photography (1820–60)

Working with light was well understood as early as the 5th century BC, when the first experiments using the principle of the camera obscura were recorded. Building on this principle, Joseph Nicephore Niépce (1765–1833) created the first photograph, but it was his associate Louis Daguerre (1787–1851) who invented the world's first widely used photographic process, known as the daguerreotype.

Camera obscura

The camera obscura (Latin for "darkened chamber") was a building block in the development of the camera. It is a box with a hole in one side through which light enters and projects onto the opposite side, creating an upside-down image of the

Giroux Daguerreotype camera
The first type of camera to be placed on public sale, this model was made in 1839 in Paris.

scene. In about 1826 Niépce used a camera obscura to project light onto a glass plate coated with light-sensitive bitumen to capture the view from his window. It was the first photographic image but the process involved an eight-hour exposure, and the image soon lost contrast.

Daguerreotype

Fellow Frenchman Louis Jacques Mandé Daguerre was a set designer and showman. He created a show called a Diorama, in which painted scenes of up to 20m (66ft) in width were illuminated to create a visual spectacle. He created many of these scenes using a camera obscura, and began to experiment with ways of fixing the image without having to trace and paint. By 1837 he had created fairly successful images, with the considerable help of Niépce, who sadly died before his contribution to the partnership was acknowledged. They created small images with exquisite

Table-top camera obscura
This Victorian woodcut shows a camera obscura – a forerunner of the first cameras – being used as a drawing aid by an artist.

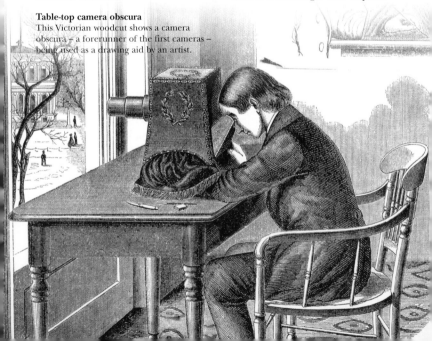

Daguerreotype image, 1837
This image was captured with the daguerreotype method, a positive-only photographic process that allowed no further reprints of the original.

metallic tonality and surprisingly sharp detail. Daguerre named his process the daguerreotype, and demonstrated his invention to the public in 1839.

Calotype process

At about the same time others were attempting to create a permanent record of an image. In England, William Fox Talbot (1800–77) had been experimenting with semi-transparent paper sensitized in a chemical solution to make a negative, from which he then made a positive print. He announced his calotype process in 1841. The English claim to have truly invented

photography, since Fox Talbot's was the first negative-positive process from which any number of prints could be made from a negative. The disadvantage of this method was that the exposure time was often as long as an hour.

Patenting the process

By the mid-1800s, inventors recognized the power of patents, and both Daguerre and Fox Talbot were determined to profit from the inventions that had cost them time and money to develop. With commendable generosity and vision, the French government bought the rights to the daguerreotype and put them into the public domain. As a result, daguerrotype portrait studios soon started opening all over Europe and the Americas.

Latticed Window
(with the Camera Obscura)
August 1835

When first made, the squares
of glass about 200 in number
could be counted, with help
of a lens.

Fox Talbot's negative
Made in the summer of 1835, the first negative ever created was surprisingly detailed despite its postage stamp size. Fox Talbot notes that it is possible to make out the 200 individual squares in the latticed window.

Improving processes

In its early days, photography was a technical handicraft, albeit one easily mastered by the dedicated amateur. In part due to Fox Talbot's firm hold on the use of the calotype process, and in part because of its inability to record detail, many photographers were driven to search for other techniques. Often they concealed new discoveries for fear of giving away an advantage to competitors. For instance, it is thought that Louis Daguerre kept his use of especially large aperture lenses secret.

By the 1850s, the basic principles of photography were understood: the initial image was captured by exposing paper sensitized with silver salts to light. The resulting image was "latent" (invisible to the naked eye), but could be developed into a visible negative when processed in an alkaline developer. The image had to be "fixed" by washing away the silver salts that were not developed as their presence would fade the image. Light-sensitive paper was then placed under the negative and exposed to light. Further processing produced a positive print.

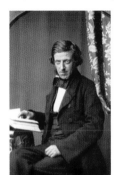

Frederick Scott Archer
A hero of early photography, Archer put his invention in the public arena, but died in poverty.

The wet collodion process

The first competition to Fox Talbot's calotype process was the wet collodion process, invented by Frederick Scott Archer (1813–57) . It had one key advantage over the calotype process – it used large sturdy glass plates to produce beautifully clear images. The size of the print was limited only by the size of the plate. However, its big drawback was that it had to be "worked in the wet", by dipping the glass plates, just before exposure and in the dark, in a sensitizing solution of silver nitrate. Exposure then took place while the plates were still damp. Processing of the image followed immediately afterwards.

In heart-warming contrast to the greed of his fellows, Archer placed his invention in the public arena in 1851. However, it was another year before photographers were able to take advantage of the technique, as Fox Talbot tried to claim that his patent covered Archer's invention. Nonetheless, wet collodion cameras swept calotypes and daguerreotypes out of photographic studios within a few years.

EARLY WAR IMAGES

The Crimean War (1853–56) was the first military conflict to be photographed, but even then it was subject to censorship. Pictures of the battlefield and the dead were not permitted. Instead, we have pictures of soldiers posing for the camera. The wet collodion process made war photography possible. Even though the apparatus had to be transported in a large wagon, it did liberate photographers from the confines of the studio.

Group of Soldiers in the Crimean War (1855)
English photographer Roger Fenton (1819–69) was restricted to taking formal group photographs behind the lines in the Crimean War, due to the cumbersome photographic apparatus of the wet collodion process (*see above*).

The rise of the portrait

The relatively instant and painless creation of a print that bore full human likeness caught the Victorian public's imagination, and the direction that popular photography first took surprised its inventors. People were not the most obvious subjects for photography, because it was hard for live subjects to keep sufficiently still for the long exposures (two or more minutes) that were needed to produce the images. But a few minutes of immobility were nothing compared to the hours of sitting required for a portrait painter.

Far more important, however, was the fact that the mechanized nature of the photographic process meant that portraiture was no longer the preserve of the wealthy. Creating an accurate record of a person's appearance – formerly the domain of the skilled painter – was now all but automatic. As a result, the earliest photographers, studios, and accessories all focused on portraiture.

In France it became popular to leave a calling card printed with the owner's likeness. When Queen Victoria adopted the practice, the craze spread quickly

Miniature portraits
These calling cards show Scottish explorer David Livingstone and German botanist von Naegeli, and were popular in the late 19th century.

throughout England. The demand for these *cartes de visite* could only be met by production-line methods, which meant that portraiture was the first area of photography to be mass-produced. Calling-card cameras were developed in the 1860s, and soon models were available with four or more lenses, which took four or more pictures at a time. Mass printing and card-trimming facilities sprang up in major cities around the world.

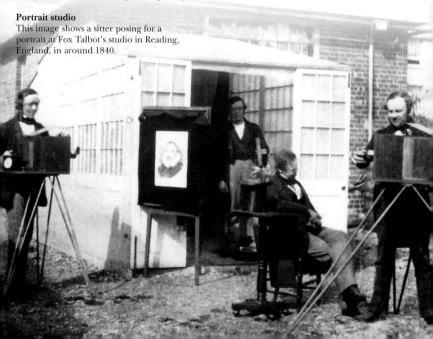

Portrait studio
This image shows a sitter posing for a portrait at Fox Talbot's studio in Reading, England, in around 1840.

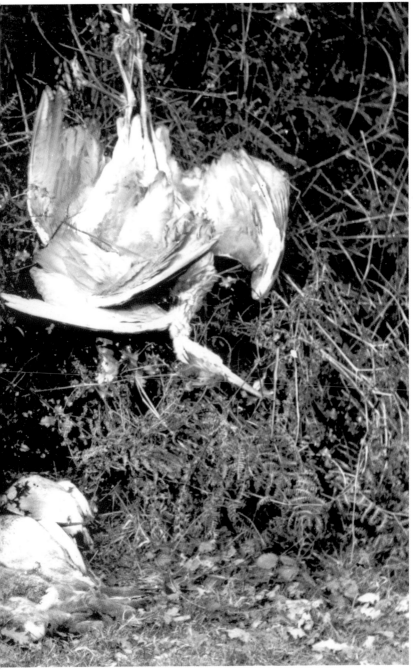

Pot shot
This carefully posed picture of a hunter with
his catch of rabbits and birds was made by
William Grundy, active in the 1850s and 1860s.
He was best known for stereoscopic images.

Commanding the medium (1860–90)

In step with their growing command of the medium, photographers began to diversify and split into camps with opposing artistic ideologies. Soon, photographers were able to extend their visual language by using colour. Techniques were also invented to analyze motion, helping to establish the value of photography as a scientific tool.

Innovation

The growing mass-production of photographs meant that what had started out as a handicraft evolved into an industrial discipline focused on quality control. There was a further scramble to make money from patents, and scientists, recognizing the commercial potential, began to experiment with photography. At the forefront of research were Englishmen Vero Charles Driffield and Ferdinand Hurter, who laid the foundation for sensitometry – the study of photographic responses to light – and the accurate measurement of film speed. In 1890 they published the "characteristic curve", a graph showing a light-sensitive material's response to light and processing. The curve is still used today, even in digital photography.

Ferdinand Hurter
Hurter (1844–94) invented the actinograph, an early type of exposure meter, with Vero Driffield (1848–1915).

An artistic approach

From the rather defeatist declaration "from today, painting is dead" (attributed to the French painter Paul Delaroche [1797–1856], on seeing a daguerreotype for the first time) to the clichéd sneer "but is it art?", relations between photography and art have always been strained. Nonetheless, it was not long before photographers started to imitate artists, and artists started toying with cameras (if only in private).

As photographers began to pursue an artistic direction, they soon found themselves divided in their aims and techniques. Some chose to imitate fine

Henry Peach Robinson's Lady of Shalott (1882)
To illustrate Tennyson's poem, Robinson used multiple exposures and collaged elements. The photograph resembles Millais' painting *Ophelia*.

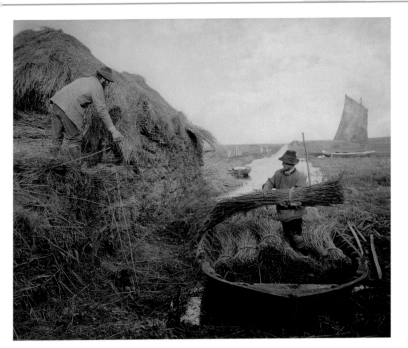

Pictorialist representation
Peter Henry Emerson's espousal of the natural led him to depict rural scenes in a light that conveyed the beauty but hid the hardships. This image entitled *Ricking the Reed*, taken in England in around 1886, is a good example.

art directly, partly due to the inherent need for static poses, and the similarities between the portrait and painting studio. Their work sought to out-do fine artists, and was often costumed elaborately, lit in chiaroscuro with strong contrast between light and dark, and pregnant with literary references. Oscar Gustav Rejlander (1813–75), Julia Margaret Cameron (*see p.37*), and Henry Peach Robinson (1830–1901) embraced this approach. This period also saw the inception of photographic perfectionism – the ambition to create the perfect negative and the perfect print. This required meticulous, studio-based techniques, and posed subjects. In reality it was an attempt to establish a photographic élite.

In contrast to the approach of fine-art practitioners, some photographers exploited the improving ability of the medium to capture the

Fine-art portrait
A portrait of an unknown woman, taken by Swedish photographer Oscar Gustav Rejlander in London in around 1870.

spontaneous occurrences of everyday life. They wanted to photograph the people, life, and light of their world in a natural context, without manipulation or artifice. Their ideology was that photography did not need to refer to classical works, but should be an art form in its own right. The most vociferous proponent of this style was Peter Henry Emerson (1856–1936), who published books and gave lectures on the subject. Ironically, he renounced photography as an art form in 1900, complaining that new technology produced images that "look like the photograph of a painting... it is hand work, and not photography."

The birth of colour

Barely had the water dried off the first prints before photographers began to clamour for a way to record in colour. The first method was to apply colour by hand. Suddenly, painters who had felt sidelined by the explosion in popularity of portrait photography found their fine art skills back in demand. The images were small and delicate, and some surviving examples are exquisite portrait miniatures.

The work of Louis Ducos du Hauron (1837–1920) provided important developments in the search for a photographic method of recording

Hand-coloured daguerreotype image
This image was made for stereoscopic viewing by Antoine Claudet, which, when seen through a special viewer, appeared as a single 3D image.

colour. Building on the earlier findings of physicists Thomas Young and James Clerk Maxwell, who published papers on light and colour theory, he developed the "trichrome" theory of colour photography in 1869, which used filters to separate red, green, and blue light in three separate exposures. Predating practical equipment and techniques by decades, Ducos du Hauron's work also included schemes of subtractive and additive colour mixing.

Additive-colour image
After exposure, Ducos du Hauron's three colour negatives were each used to make an engraved colour plate, which were used to make a print. This laid the foundation for the mass-printing process that is still in use today.

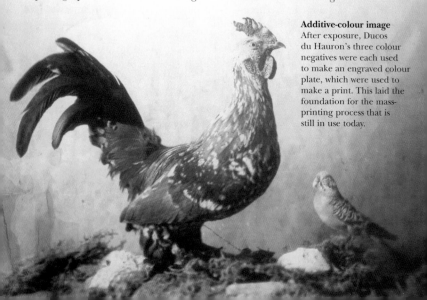

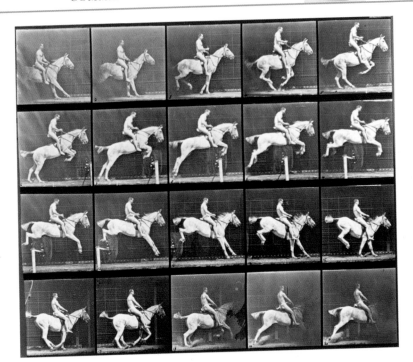

Early travel photography

As the quality of equipment and materials improved and processes became easier to manage, photographers could travel further afield. Some scoured the world for pictures that were eagerly consumed by a public keen to learn about distant lands. For instance, William Henry Jackson hauled huge cameras – some large enough to expose 20 x 24-inch glass plates – into the Wild West of his native America, creating many revelatory landscape images. It was his pictures that inspired the US government to create national parks.

High-speed sequence
This photographic sequence of a rider jumping a hurdle on a horse formed part of Eadweard Muybridge's *Animal Locomotion* project.

Capturing movement

By the 1870s, the technology existed to allow exposures in small fractions of a second. This was crucial to the work of Englishman Eadweard Muybridge (1830–1904), who was trying to prove that a galloping horse raises all four feet off the ground at once. To do this he used a battery of cameras activated by trip wires to photograph a fast-moving horse. This inspired the 11-volume work *Animal Locomotion*. Muybridge also realized that his sequential images could represent movement, and in 1879 he invented the Zoopraxiscope, a spinning drum with a sequence of pictures inside. When the images were viewed through a hole they gave the impression of continuous movement.

Early travel picture
This image shows the gateway of the Hoospinad Bazaar in Lucknow, India, photographed by Samuel Bourne (1834–1912) in around 1860.

Ambulance Wagon in the Desert
Timothy O'Sullivan (1840–82) made this study
in the Carson Desert, Nevada, in 1867 while
working on the Geological Exploration of the
Fortieth Parallel.

Expanding horizons (1890–1920)

The late 19th and early 20th centuries saw photography reach the mass market. Audiences were attracted by magic lantern shows and easy-to-use cameras were widely available. Technological advances enabled photographers to explore an increasingly wide range of styles, from candid and investigative photography to humour and fashion.

Illustrated newspapers

In the 1890s, the use of pictures of any sort in newspapers was a source of lively debate. Photographs first appeared in newspapers as woodcuts or engravings, but following experiments by the *Daily Graphic* in 1880, these artist-mediated processes were replaced by the photo-mechanical process of half-toning. Initially rejected as unintellectual, the use of occasional images grew into fully illustrated reportage. Documentary photography was in use from 1890 and by 1919 the use of photography in newspapers was routine.

Illustrated news
The front cover of the illustrated newspaper the *Daily Graphic*, published in London, England in 1909.

Projecting the image

Enabling a crowd of people to see the same picture at the same time was an important stage in the development of photography. The magic lantern was invented in the mid-17th century, but it was not until the Victorian era that it became a popular source of education and entertainment for large audiences. Images were produced as prints made on glass, known as "positives", which

Magic lantern projector
An image placed on a transparent plate between a light source and a lens projects a sharp image onto a flat surface. Modern projectors still adhere to the same principles of this oil-fired lantern of 1895.

PHOTOGRAPHIC HUMOUR

By 1900, technological and economic advances meant that people from all walks of life could take "snapshots" of their lives and activities. The first artist of the snapshot was Jacques Henri Lartigue (1894–1986). His best-known images show his acute observation and sense of humour.

The Fall
This image was taken by Lartigue in 1913, ten years after he received his first camera. His images are taken off-the-cuff, and often dramatize the ordinary.

allowed light to pass through. A gas or oil lamp with multiple wicks produced light that was collected by a mirror and light-gathering box, and reflected onto the slide. A focusing lens projected the image onto a white wall or screen. At the turn of the 19th century, this method of projection was the public's main source of visual information on foreign lands, and even on aspects of life in their own country, such as architecture. The magic lantern laid the foundation for the slide projector and photographic enlargers.

Cameras for the masses

George Eastman (1854–1932) of Rochester, New York was one of the many people to take up photography as a hobby in the late 19th century. However, it was still an expensive pastime that required cumbersome equipment and complicated techniques, so Eastman began to experiment with ways of making the process simpler and more affordable.

Fortunately, the technology existed to enable Eastman to conduct his experiments and realize this ambition. He developed and marketed dry plates coated with gelatin, before applying the same gelatin coating to celluloid film rather than glass plates. This led to the creation of the first roll-film, which Eastman used in a pre-loaded camera, the "Kodak", in 1888. Users returned the camera, for the exposed film to be processed and the camera returned to the user with a new film.

Eastman's success was partly due to his inspirational marketing ideas, including the slogan "You press the button, we do the rest", which accompanied the release of

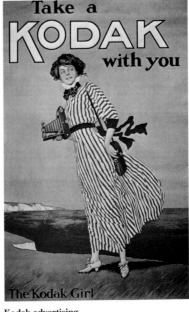

Kodak advertising
George Eastman had a great skill in coining slogans and product names, such as the meaningless "Kodak", chosen because Eastman liked the letter "K" and wanted a unique word.

Early Kodak image
This seaside scene was taken by an unknown photographer at the end of the 19th century, probably on the Kodak No.1 camera, which produced circular images.

the Kodak. It was cheap to manufacture, easy to use, and gave good results. However, at US$25, the first mass-produced camera was still a luxury item. But it was immensely popular and it democratized photography for the first time.

One of Eastman's most successful cameras was the Box Brownie (named after Frank Brownell, its designer). Launched in 1900, it was made of card and wood, and cost only US$1. By the time Eastman died (taking his own life in 1932 and leaving the final message "My work is done – why wait?") Kodak was one of the best-known brand names in the world.

Autochrome portrait
Old Familiar Flowers, taken by Mrs G.A. Barton in 1919, shows how the soft pastel colours of autochrome transparencies lent themselves well to portraits, giving accurate skin tones.

Improving colour

While the Kodak and Box Brownie cameras had made photography available to the masses, enthusiasts were still searching for innovations and improvements. Even so, it took 35 years from Du Hauron's initial work on trichrome colour photography (*see p.82*) before an industrial method of recording colour images on a large scale was developed.

The autochrome process arrived in 1904. It was invented by the industrious French brothers Auguste (1862–1954) and Louis (1864–1948) Lumière, who discovered the technique while refining their method of cinematography, which they had invented in 1895. Starch grains extracted from potatoes were coloured with red, green, and blue dye, then scattered on a glass plate. A light-sensitive

bromo-iodide silver emulsion was applied to the plate, and the film was exposed through the coloured grains. It could be viewed as a positive transparency after processing, and gave luminous images with wide tonal gradation. At its height, output reached a million plates a year, despite the laborious production methods. War photographers such as Jean-Baptiste Tournassoud (1866–1951) even took autochrome plates at the frontline in World War I, bringing back colour images that have a clarity and realism rarely seen in pictures of the conflict.

The power of the image

As early as the 1850s, photographs had been used for ideological and political aims. Herbert Ingram (1811–60), MP for Boston, Lincolnshire, from 1856, used the *Illustrated London News* to publicize Liberal reformist ideals. After his death, the publication continued to use photographs to highlight social welfare issues, such as factory conditions, child labour, and poverty.

In the 1890s, the ability to capture raw, irrefutable images led to the emergence of documentary photography as a discipline in its own right. In New

The Lumière brothers
Louis and Auguste Lumière tried many substances for carrying red, green, and blue dyes for their autochrome process, before settling on potato starch granules.

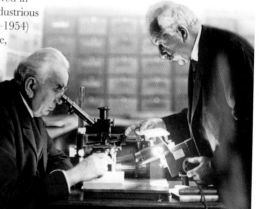

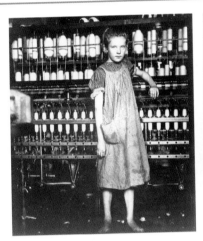

Investigative photography
This portrait of a 10-year old cotton-spinner in New England, taken in 1910, was one of many taken by Lewis Hine that forced the US government to reform child labour legislation.

Exposing poverty
This image of a junk man's living quarters in a New York tenement house was taken by Jacob Riis in 1891, and supported his campaign to improve living conditions of the poor.

York, a Danish immigrant named Jacob Riis (1849–1914), who worked as a crime reporter for the *New York Tribune*, began campaigning on behalf of the city's slum residents. His photographs – only intended as a record of poverty – have matured into a body of work that has had a lasting influence on modern-day documentary photographers.

Lewis Hine (1874–1940), also appalled by the poverty of New York's immigrant underclass, began work as an investigative photographer for the National Child Labour Committee in 1908. Hine often hid his large Graflex camera in a lunch-box, in order to gain access to areas that photographers were prevented from visiting.

Paul Martin (1864–1942) took candid photographs of Victorian London using a "Facile", a hand-held camera disguised as a large parcel. Best known for his 1895–96 series "London by Gaslight", Martin's studies of daily life and poverty were derided by the photography establishment, which felt that "a plate demanded a noble subject – a cathedral or a mountain".

EARLY FASHION PHOTOGRAPHY

As a medium, photography has a natural tendency to turn the ugly into the beautiful. But it was not until photographs could be published in mass-distribution media such as newspapers that its power to glamorize was realized. The trend continues to this very day – fashion is inextricably linked with fashion photography.

Feet Wearing High Heel Shoes
Taken in 1919 by the Frenchman Baron de Meyer, this image is one of the first examples of the use of photography to sell fashion.

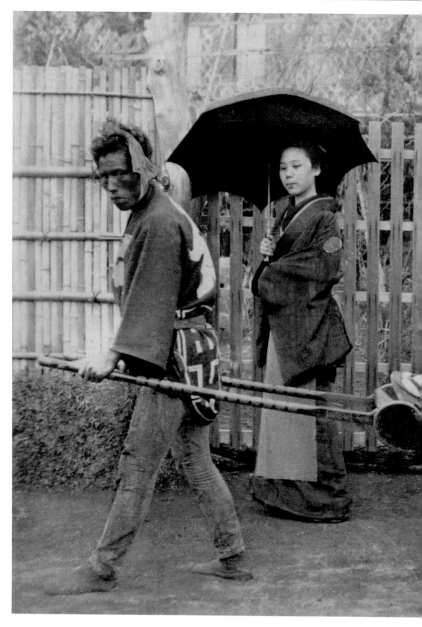

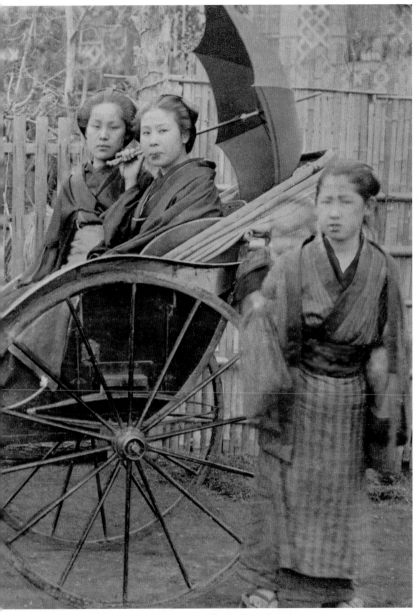

Hand-coloured study
This unidentified hand-coloured picture was
taken between 1900 and 1920. The intense red
shades of light areas suggest that the colouring
was intended to be artistic rather than realistic.

Awareness and vision (1920–50)

As photography became less expensive and more widely available, a diverse range of people found their voice in the visual image. Propagandists and social reformers alike used photography to spread their message. Artists, too, were quick to take advantage of new equipment, and used innovative techniques to push the boundaries of self-expression.

A revolution in equipment

The 1920s saw the introduction of 35mm film, one of the most important inventions in the development of photography. From 1911 to 1913, German designer Oskar Barnack (1879–1936) had worked on cutting 70mm-wide ciné film in half to create 35mm film. Regarded as tiny at the time, the resulting 24 x 36mm frame needed enlargement, which meant that any defects were also magnified, making precision manufacturing and high-quality lenses necessary.

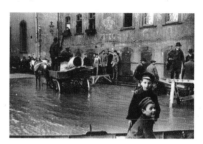

Early 35mm Leica image
Oskar Barnack, the inventor of the Leica, was an accomplished photographer. The very first rolls of film taken using his camera, including this image taken in the early 1920s, show him taking full advantage of the mobility it afforded.

People were sceptical about the practicality of 35mm film. As a result, the first compact camera, produced in 1924, was the German Ermanox, which used 60mm roll film. It was equipped

Early 60mm Ermanox image
Erich Salomon, who took this picture of Marlene Dietrich in 1929, was the first to master using the Ermanox for candid shots.

with a large-aperture lens, which made it possible for photographers to work indoors using only the available light as the light-source. The success of the Ermanox prompted production of the Leica in 1925. More compact and easier to use than the Ermanox, it soon became the essential tool for photojournalism.

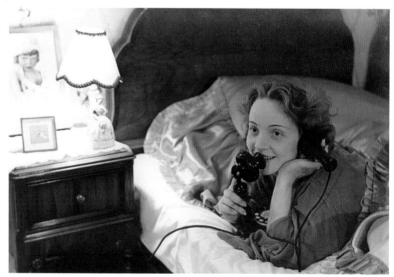

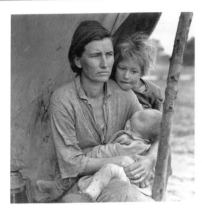

FSA documentary image
One of the most famous images in the Farm Security Administration series was a portrait of this migrant worker and her children, taken by Dorothea Lange in 1936 at a camp in Nipomo, California.

Photography and propaganda

The use of photography as a powerful means of conveying a political point of view flourished. Never before had the world been so closely scrutinized. One of the most celebrated documentary exercises was the photography commissioned in the 1930s by the sociologist Roy Stryker, at the US government's Farm Security Administration (FSA), which was set up to help the rural economy after the Depression.

Stryker selected a team of photographers that included Ben Shahn, Walker Evans, Dorothea Lange, and Carl Mydans. Their work was (and still is) widely exhibited and published, surpassing its original purpose.

At this time amateur photography had become so widespread that in Germany it was exploited for political ends by the Propaganda Ministry run by Joseph Goebbels. Photographs reinforcing the concept of the Aryan German family – happy, healthy, strong – were used for propaganda purposes. This was achieved by encouraging amateurs to photograph their lives and produce attractive images of themselves.

But the Aryan ideal was not the only side of the story – Russian-born Jew Roman Vishniac (1897–1990), a distinguished scientist and art historian, photographed the plight of the Jews in western Europe between 1933 and 1939. He is best known for his images of the Warsaw ghetto.

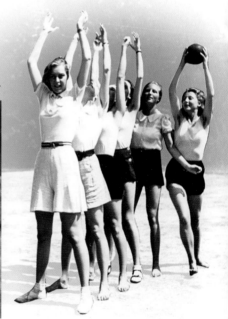

Exposing the truth
Roman Vishniac often posed as a peddler to avoid arrest. He photographed this emaciated Polish boy after the Nazi invasion of 1939.

Nazi propaganda
Taken in 1939 in Berlin, this image of women exercising in the *Bräuteschule* (school for brides) is typical of propaganda of the Nazi regime.

New camera designs

In response to Leica's success and the acceptance of its "ultra-miniature" format, and in part because Leica had secured the patent around its design, manufacturers sought new ways to design cameras. This led to the development of the single-lens reflex (SLR), in which a mirror in the light-path of the lens reflected the image onto a focusing screen. Just as the picture was about to be taken, the mirror flipped out of the way before the shutter closed so that what was seen was captured on film. The first 35mm SLR camera to be produced was probably the Kine Exakta in April 1936, although the Russian Sport may have been released a year earlier.

Twin-lens reflex camera
The Rolleiflex from Rollei (1929) was one of the first TLR cameras.

Single-lens reflex camera
The Kine Exakta was the first production single-lens reflex camera for 35mm format. It offered a range of interchangeable lenses.

A separate evolutionary line was the twin-lens reflex (TLR) camera. Mechanically simpler than the SLR, its operation was almost silent. It used medium-format roll-film to produce high-quality images. Favoured by professionals, it was quick to use and could be precisely focused.

However, the early SLRs and TLRs shared a defect; the image was reversed left-to-right. This was corrected by a 1948 SLR camera that used a pentaprism, which folded the light-path to rectify the image (*see p.124*).

Artistic development

In Europe in the 1920s, the increasing influence of modernistic thinking and the rebellion against the philosophical thought and artistic forms of the 19th century, led to a flowering of art movements. Of these, Dadaism and Surrealism – both of which sought

Eliezer Lissitzky's *Runner in the City*
This superimposed image was taken in 1930 by Lissitzky, a Russian artist, architect, teacher, and designer who worked with photomontages.

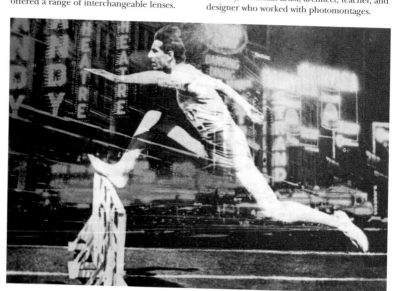

Edward Weston's *The Shell*
Weston and his associates often took close-ups of objects like seashells, vegetables, and rocks, which are now revered for their timeless quality.

inspiration from the subjective and the unconscious – had the greatest impact on photography, since the directness of the medium suited their radical agenda. This is perhaps most evident in the work of Man Ray (*see p.62*).

It was also at this point that the photographic technology of films and lenses reached a level sufficient for

photographers to truly explore the limits of their vision. This can be seen in the faultless technical quality of the work of photographers Ansel Adams (*see pp.26–27*), Paul Strand, and Edward Weston. Such was their concentration on nature that the usually taciturn Henri Cartier-Bresson (*see pp.40–41*) is reported to have exclaimed "The world is going to pieces and people like Adams and Weston are photographing rocks!" Despite such derision, Weston, Adams, and other photographers formed Group f/64 (misleadingly named after an aperture setting that cannot produce the sharpest image) in 1932, with the aim of achieving the perfect print.

Instant photography

In 1944 American Edwin Land (1909–91) experimented with the technique of combining developing-fluid and fixing-fluid in the same solution. By using an innovative process that caused silver to migrate from one layer (the film) through a thin gel to another layer (the print), he invented the peel-apart photograph. His first Model 95 Polaroid camera was sold in 1948. Colour polaroids were introduced in 1963 and by 1972 the peel-apart design was replaced by a single print the size of a postcard.

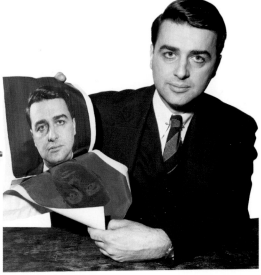

Land's Polaroid Camera
The camera design was as ingenious as the instant prints themselves. With precision rollers, complicated paper paths, and paper engineering, they were processing labs as well as cameras.

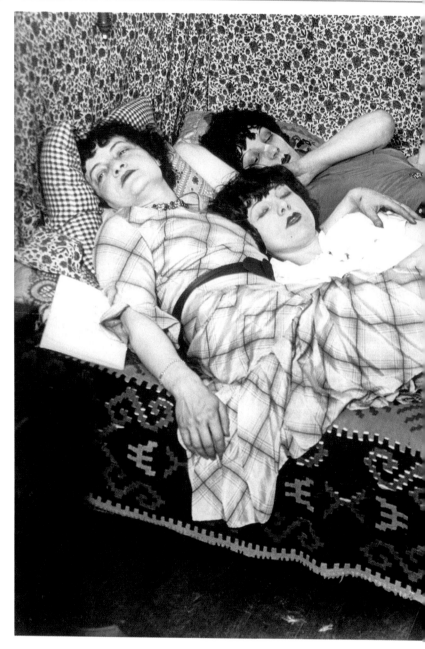

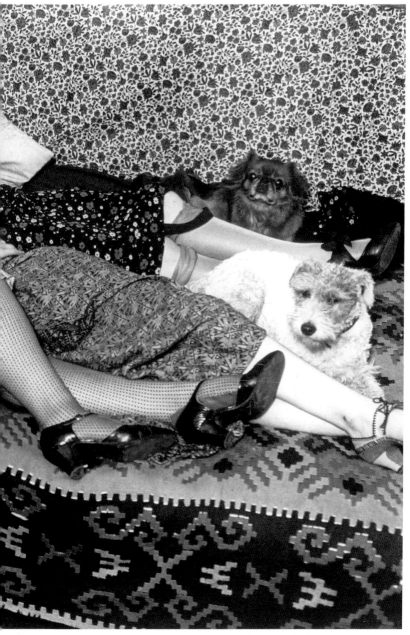

Three prostitutes on a bed
Born Jules Halasz in Hungary, Brassaï
(1899–1984) moved to Paris in 1925. His most
celebrated work centred on the nightlife of the
city, a project he started in the early 1930s.

Innovations and rebellions (1950–70)

As a war-weary world took stock, a mix of cynicism and reformist energy gripped photographers. Using the highly mobile Leica camera, photojournalists worked undercover to reveal stories that would otherwise have gone unreported. Meanwhile, a revolution in fashion photography was at the forefront of the style rebellion of the late 1960s.

Family of Man exhibition

Central to the humanist impact on photographic practice was the 1955 exhibition *The Family of Man*, curated by Edward Steichen (1879–1973). A vast and ambitious project, it contained 503 images from 273 photographers around the world. The aim of the exhibition was to show that "the art of photography is a dynamic process of giving form to ideas and of explaining man to man." The exhibition proved that photography was the premier means of communication of the age. During its eight-year tour it travelled to 37 international centres, drawing nearly 10 million visitors.

Visiting *The Family of Man*
For many visitors, drawn by the humanist spirit of the images, this was their first contact with exhibition-quality photographs.

The Family of Man
Possibly the most successful photographic exhibition ever, its catalogue was also an immensely successful publication that remained in print for over fifty years.

The era of the photojournalist

The public appetite for news magazines, which grew during World War II, did not wane in peacetime. The circulation of the UK magazine *Picture Post* (already 1 million during the war) rose by 30 per cent in the following years. The period from 1950 to 1970 saw the peak of magazine publishing, from consumer fashion titles such as *Harper's Bazaar* and *Vogue*, to natural and social history titles such as *National Geographic*, and news

EARLY IMAGE MANIPULATION

Weegee was born Assher Fellig in 1899 in the Ukraine. After emigrating to the USA in 1909, he found work as a newspaper photographer. He adopted the name Weegee, from the "Ouija" divination board, in tribute to his uncanny intuition. In 1948 he started to experiment with image distortions, which became a full-time occupation by the late 1950s. He used a variety of techniques, including printing through curved glass, boiling negatives to distort them, and photographing through ash-trays.

Marilyn Monroe
This image is from a series from 1963. The pictures were made by shooting through a plastic lens that gave different distortions as it was moved.

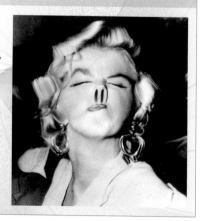

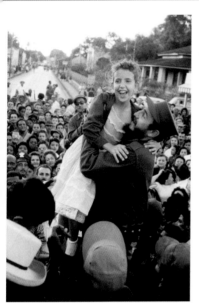

Fidel Castro
Burt Glinn's image of Castro being mobbed by crowds on his triumphant journey to Havana, Cuba in 1959, shows a perfect coordination of news event with the human moment.

magazines such as *Time*, *LIFE*, and *Paris Match*. At its height, *LIFE* had a circulation of 30 million.

By the 1950s, photojournalists were being sent around the world to cover news stories and events, and were increasingly seen as newsworthy in their own right. Their adventurous and seemingly glamorous lives were often the subject of news features and articles.

Magazine photographers such as Don McCullin (*see p.57*), Margaret Bourke-White (*see p.35*), and Irving Penn (1917–) were in great and constant demand. As the post-war depression set in, photographers sought to give impetus to the reconstruction of devastated towns and ravaged economies by laying injustices bare. This was also the period in which the picture essay reached an apogee, with photographers such as Henri Cartier-Bresson (*see pp.40–41*), William Eugene Smith (*see p.64*), Bruce Davidson (1933–), Robert Frank (1924–), and William Klein (1928–) producing eloquent series of pictures.

Reaching into the dark

The new breed of world-travelling photojournalist needed a source of lighting that was as mobile as the 35mm camera. The answer was to come from the work of American physicist Harold Edgerton (1903–90), who conducted investigations into making an exposure so brief that it would capture movements such as the flight of a bullet. One of his insights – that the exposure must last only as long as the accompanying flash of artificial light – formed the foundation for all flash photography. His investigations led to the invention of the stroboscope, which provided enormous amounts of light for just a fraction of a second. In the process, he created the basis for the portable electronic flash-gun. Edgerton's work during the 1950s and 1960s produced numerous classic photographs, from bullets tearing through playing cards to athletes frozen in motion. His images caught the public imagination, showing that a great scientist can produce great art.

Harold Edgerton's *Milkdrop Coronet*
This image, taken in 1957, captures the beauty of the moment in a way that the human eye could never appreciate. The flash exposure would have been 1/50,000 of a second or less.

Underwater lighting
Filmed with Harold Edgerton's underwater lighting, the undersea pioneer Jacques Cousteau explores the seabed in 1969.

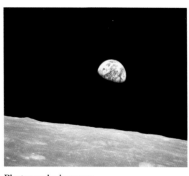

Photography in space
This is the view of the Earth-rise that greeted the Apollo 8 astronauts as they came from behind the moon in 1968.

New frontiers

Today it is taken for granted that major events are recorded on film for posterity. In the 1960s, deep-sea diver Jacques Cousteau (1910–97) revealed the astonishing variety of life beneath the waves, by working with Harold Edgerton to perfect the lighting systems that were required to film in a world previously unseen by a mass audience. But amazingly, when the race to be the first in space was won by the Soviet Union in 1961, photographing this momentous achievement was not deemed a priority. The first pictures from space were actually shot with a camera smuggled

on board the 1962 Mercury flight by astronaut John Glenn. The impact of these images persuaded NASA to commission specially modified cameras from Linhof, Nikon, and Hasselblad.

Fashion photography

Closer to home, photography was undergoing a revolution, as fashion photography became increasingly influential. London in the Swinging Sixties was a fashion hotspot, and as a result British photographers such as David Bailey (1938–) and Terence Donovan (1936–96) became household names, and their images made fashion photography both prestigious and

Fashion shoot
This image of the model Jean Shrimpton and photographer David Bailey was taken by an assistant in a studio in Paris in 1963.

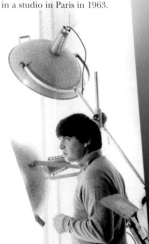

infamous. Newspapers and magazines reflected this trend, with clothes, fashion designers, and fashion photographers becoming newsworthy. The era's spirit of liberation was reflected in the work of Helmut Newton (1920–) and Guy Bourdin (*see p.34*), who used sexuality as a selling tool. Meanwhile, the burgeoning careers of high-society photographers Lord Snowdon (1930–) and Lord Lichfield showed that photography had reached across society, gaining establishment respectability while being embraced by counter-cultural, iconoclastic youth.

The Vietnam War

Far from the frivolities of fashion, the Vietnam War drew hundreds of photographers to document its death, destruction, and moral decrepitude. The US armed forces welcomed journalists and photographers, believing that the coverage would help the war effort. Numerous careers were made (and some sadly ended) by the war, including those of Britons Larry Burrows (1926–71) and Don McCullin (*see p.57*), and Americans Eddie Adams (1933–2004) and Catherine LeRoy (1945–).

Perhaps the most stunning proof of the power of photography as a documentary medium was the testimony of two rolls of film taken by amateur

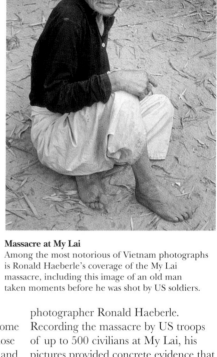

Massacre at My Lai
Among the most notorious of Vietnam photographs is Ronald Haeberle's coverage of the My Lai massacre, including this image of an old man taken moments before he was shot by US soldiers.

photographer Ronald Haeberle. Recording the massacre by US troops of up to 500 civilians at My Lai, his pictures provided concrete evidence that shocked the world. It is widely accepted that this, along with a handful of other key photographs that brought home the chaos of Vietnam, was instrumental in turning American and international opinion against the war, leading to the withdrawal of US troops.

Portrait of war
Larry Burrows's coverage of the Vietnam War is regarded as the most comprehensive and understanding. This image, taken in 1966, shows PFC Philip Wilson carrying a rocket launcher across a stream in the demilitarized zone. Twelve days later, he was killed in action.

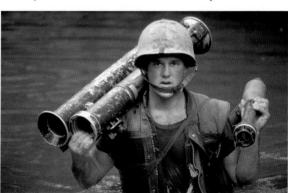

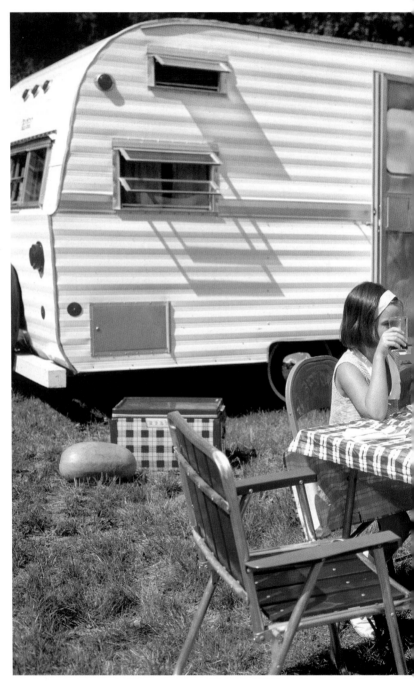

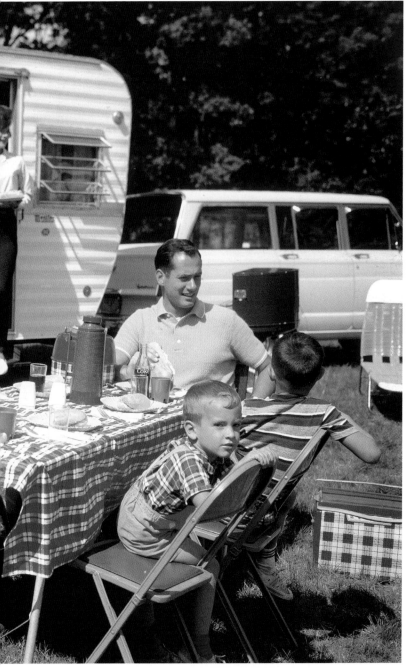

Family in the sun
While colour photography revealed the
horrors of war in Southeast Asia, back home in
the United States it was the essential tool for
advertising products and promoting lifestyles.

Divergences (1970–90)

As developments in technology broadened the scope of photography, photographers grew more confident in their own prowess. This led to more fluid methods of photography and a blurring of traditional categories, as snapshots became fine art, and fashion borrowed from documentary. Photographic technology increased our understanding of ourselves and our universe.

New colour photography

A new wave of topographical photography arose during the 1970s. In a reaction against the aesthetics of Ansel Adams, Edward Weston, and the rest of the Group f/64 (*see p.94*), it valued the ephemera and artefacts of everyday life but was driven, above all, by an obsession with colour. Chief amongst the innovators was American William Eggleston (1939–). His images monumentalized the trivial – a street-sign, a shoe, or a child's tricycle – and were widely imitated. Others such as Americans Stephen Shore (1947–), Richard Misrach (1949–), and Joel Sternfeld (1944–) used large-format cameras to take images that gloried in the grubby – street corners, empty swimming pools, and parking lots –

almost in deliberate mockery of the meticulous methods and natural subject-matter of the early visionaries.

The rise of imaging

Elsewhere, digital technology began to have an impact on how images were used. In 1970, Howard Sochurek, a photographer with *LIFE* and *National Geographic*, rescued a computer being thrown out by NASA and used it to digitally manipulate images. Coming some 20 years before the development of Adobe Photoshop, Sochurek's work was visionary but too far advanced for the

Awareness and vision
Joel Sternfeld combined acute observation with a fine sense of composition. Here, a fireman buys pumpkins while his colleagues tackle a fire.

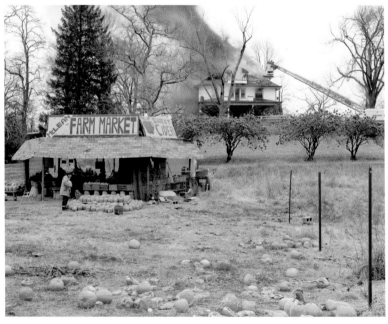

Medical breakthroughs
An example of a photographic tool extending the reaches of science, this image of a 3-month old human foetus was taken with an endoscope – a long tube with a lens at the end.

Early image manipulation
Howard Sochurek pioneered digital manipulation. He brought scientific images, such as this picture of a heart, to public notice through his use of colour.

technology available. He had to photograph the results of his manipulations on a television screen because it was not possible to print them out to sufficiently high quality. He showed the possibilities, but the world had to wait until 1990 for computing and software to catch up.

Our ability to see and record the world was extended by making visible the previously invisible processes of nature. For example, NASA's Landsat satellites revealed massive land forms, along with continental-scale patterns of weather. And in medicine, endoscopes allowed us to see inside the womb.

Landsat view
Images of the Earth taken by satellite remote-sensing were highly accurate yet artificial in their colours. They opened the way to an acceptance of the digitally enhanced image.

ELECTRONIC ADVANCES

The growing popularity of photography fuelled innovation from manufacturers. Electronic circuits were increasingly used for camera functions, enabling features such as auto-exposure to be added at low cost. Digital techniques also powered enormous advances in lens design – for the first time, it was possible for a zoom lens to match the performance of a single-focal length lens.

Canon AE1
Introduced in 1976, this mid-market camera was the first to use a micro-processor to control many of its functions. Its internal modular design greatly simplified assembly.

Time and Stern magazines
By the 1980s, pop groups could push current affairs off the covers of news magazines. The strongest growth in circulation was seen in celebrity publications.

The growth of celebrity

Television was gaining ground at the expense of current affairs magazines such as *LIFE*, *Stern*, and *Paris Match*. While the once-mighty titles dwindled, others developed to satisfy a growing preoccupation with celebrity. And to feed the hunger for pictures of film,

Celebrity photography
The subject of this photograph, Princess Diana, became the world's most photographed "celebrity". Her popularity as a subject for the paparazzi led indirectly to her death in 1997.

television, and pop stars came a new breed of photographer: the paparazzo.

Named after Paparazzo, the news photographer in Fellini's film *La Dolce Vita*, the paparazzo was immune to weather or insult, tirelessly tenacious, extremely mobile, and a photographer whose subject-matter was not the person, but celebrity itself. While hints of the paparazzi approach can be seen in the work of editorial photographers such as Alfred Eisenstaedt (*see p.44*), Dirck Halstead, and Harry Benson, they did work within a framework of consent. In contrast, the paparazzi disregarded both permission or privacy. And they were helped by very long focal-length lenses (600mm and larger) with high-quality fast film and rapid motor-drives that allowed dozens of shots to be taken in sequence.

Advertising sophistication

A high point in photographic history was the successful partnership of photography with a wave of creativity in the advertising world. Innovative campaigns that used clever visual puns and brilliant photography, such as those

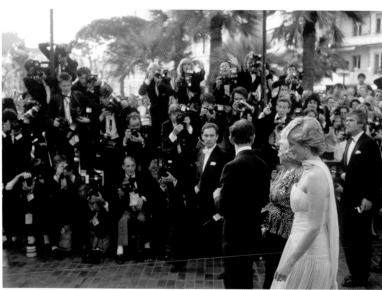

Bendy man advert
This 1987 advertisement for Ferguson by Steve Cavalier was achieved by combining three transparencies blended into a seamless and stunningly convincing image.

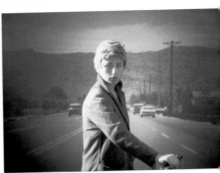

Video stills self-portrait
Cindy Sherman appropriates the visual characteristics of a video to create this self-portrait as a nameless character in an untitled video film, caught as a video stills grab.

for Dunhill, Smirnoff, and Ferguson, led the world in sophisticated art direction. These campaigns relied on the skill and input of versatile photographers such as John Claridge and Steve Cavalier, who, in their turn, relied on skilled technicians to painstakingly blend, colour, and manipulate images by hand.

Changing face of portraiture

The capture of the human likeness was one of the first trends in photography. The whole of photographic history can be written through portraiture – changes in portrait styles directly reflect the technological and artistic preferences of the time. In the 1980s and 1990s a loss of confidence at the heart of photography – symptomatic of cynicism at the heart of society – can be seen in portraiture's increasingly self-questioning style. This crisis of direction and identity is seen clearly in the work of Cindy Sherman (1954–), whose message is that portraits can tell you nothing about someone, since the appearance of the subject (in Sherman's case, herself) can vary considerably when photographed in different styles. At the same time, the growing use of image manipulation raised questions about photography's veracity.

Holography

The invention of the laser in 1960 had made it possible to create a fully three-dimensional image – the hologram. Early holograms were used to simulate precious artefacts for display. The images appeared solid and were dimensionally perfect representations of the objects. By the 1970s and early 1980s holograms were all the rage, with large-scale versions appearing as exhibits in art galleries and smaller versions being worn as jewellery. However, the technology for creating them was cumbersome, and live objects could be holographed only with the most sophisticated lasers. In-fighting among the pioneers inhibited its development. As an art-form it blossomed and died within ten years, but continues in more prosaic forms as rainbow holograms on credit cards and novelty toys.

Holographic image
The artist Edwina Orr created a hologram of herself in 1982 by using an extremely powerful and brief blast of laser light.

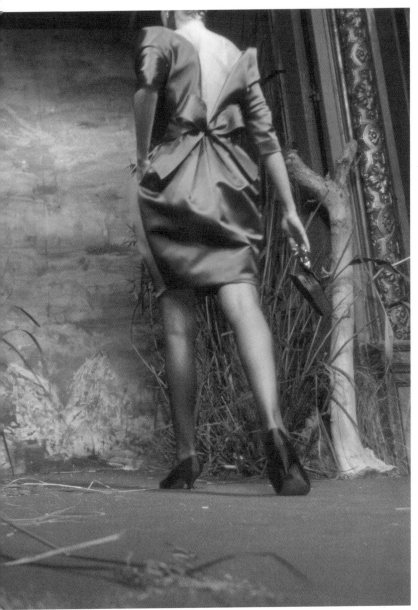

Model wearing Christian Lacroix
Hybrid styles of photography proliferated
in the 1980s. This fashion image taken in
Paris in 1987 by Abbas (1944–) reflects the
documentary roots of the photographer.

Dispersions & digital promises (1990–)

The launch in 1990 of the digital-imaging program Adobe Photoshop was a milestone in photographic technology, and sparked an explosion in image manipulation and digital photography. Meanwhile, the widespread availability of digital cameras, video, and the internet led to a challenge to film-based photography and a blurring of the line between professional and amateur.

The digital revolution

In 1990, Kodak launched the DCS-100 digital camera, the first professional model to come on the market. It featured a sensor of what was then a staggering 1.3 megapixels, housed in a Nikon F3 body, and had 200MB of memory. A separate unit with a black-and-white monitor and a hard disk could be connected for reviewing and storing images. The camera with accessories weighed a back-breaking 25kg (55lb) and cost £18,500 (US$30,000 at 1990 exchange rates). Four years later, Apple launched its first digital camera, the Quicktake 100. Its relatively low cost of £600 (US$999) meant that the convenience of digital photography began to outweigh reservations about low image quality. In 1994 Photoshop version 3 offered the ability to work in layers, which meant that images could be superimposed and individually adjusted. Such was the pace of development that by 2004 digital cameras were able to exceed 35mm film in image quality.

Apple Quicktake 100
This was one of the first consumer digital cameras costing under £600 (US$999) with a 640 x 480 pixel image.

Online access

The growth and accessibility of the world wide web revolutionized the way images were viewed, used, and sold, by enabling a single image to be seen by

millions of people simultaneously. The original resides on the owner's computer, and can be accessed by anyone visiting their website. For the first time, photography was wholly democratized. Not only did access become unlimited by distance, it was unrestricted by time zones, opening hours, or publication cycles. No longer did photographers need middle men to publish their images on a national – or even international – scale. The number of web pages containing photographs grew from some 30 million in 2000 to more than 100 million just four years later. Almost overnight, internet users became the largest producers and consumers of images.

New colour photojournalism

By the 1990s, black-and-white photography was a niche activity, practised by die-hard enthusiasts and a handful of photojournalists whose work

Creativity in news photography
The public's familiarity with sophisticated and imaginative images allowed news photographers greater creative freedom.

Colour photojournalism
Chris Steele-Perkins took this image in 2000 in Japan. It is characteristic of his pictorial style, which refers obliquely, rather than directly.

was seen on exhibition walls or sold as fine-art prints. The medium of photojournalism was colour – preferably lots of it and as violently bright as possible. Briton Chris Steele-Perkins (1947–), American Alex Webb (1952–), and Belgian Harry Gruyaert (1941–) were at the fore of this new style. Artistically, photographers exploited the limitations of slide film – particularly its tendency to turn shadows black – to project an emotional response onto the subject. Their photographs feature pure colours and solid blacks, and use colour for its expressive, emotive force rather than for its descriptive capacity.

Probing deepest space

The reach of colour photography achieved intergalactic proportions with the launch of the Hubble telescope in 1990. The first optical telescope to orbit the Earth above the atmospheric clutter that obscures the light of stars, the reflecting telescope could capture distant details with incredible clarity. However, the first images were disappointing due to miscalculations in the telescope's optics. In 1993 Hubble was repaired by astronauts while still in orbit, and by December of that year stunning images of stars thousands of light years away were beamed back to Earth. Its performance surpassed all expectations and reached the near-theoretical limits of what was possible.

Hubble image, 2004
A burst of light and cloud of circumstellar dust surround a star 20,000 light years away, captured by Hubble's Advanced Camera for Surveys.

Amateur news photograph
The sinking of the St Malo ferry off the coast of Jersey in 1995 was captured on film by holidaymakers. Most newspapers used amateur pictures in their coverage.

Amateur press photography

The availability of high-quality equipment to the general public has led to a subtle restructuring of professional practices. Some areas, such as travel photography for picture libraries, are actually dominated by hard-working amateur photographers. News pictures are also increasingly provided by non-professionals. Being more numerous, they are more likely to be on the spot when an incident occurs than the lone photojournalist, and are often carrying professional-standard equipment. Many of the images of the devastating tsunami disaster in southeast Asia in late 2004 that appeared in the media were taken by holidaymakers.

Freedom of the press

Professional photographers, especially those working in war zones, are battling against restrictions on their freedom to report. Ever since World War II, the armed forces and journalists have tried to find ways to work together. Politicians and army commanders encourage positive press and are extremely wary of negative coverage of operations that might lead to criticism from a public increasingly tired of war.

Recently, the practice of "embedding" journalists into a service unit was introduced, intended to prevent free-roaming reportage. However, it emerged that soldiers were allowing photographers access to events – both behind and at the battle-front – that they would never have seen had they been reporting on their own.

Yet, as photographers clamour to exercise their freedom, at times they also fail to act sensitively or responsibly towards those they report on. Tales of photographers waiting for the moment of death of a starving child or of

Press intrusion
A child laying a flower at a memorial of a subway disaster in Daegu, South Korea, 2003, is upset by a crowd of photographers.

MOBILE PHONE CAMERAS

In the process of fighting its corner in the competitive mobile phone market, Nokia, the Finnish phone company, accidentally became the world's largest supplier of cameras. With a world-market share of more than 37 per cent, Nokia sells some 10 million "cameras" a year. These phones – whose camera functions are contained in a thumbnail-sized unit – produce higher quality images than the first digital cameras. In the near future, the majority of images will be captured on camera phones.

Fred Pulling Branch
This image was taken on a camera phone by the photographer Harry Borden (1965–), for the Nokia Fonetography competition.

photojournalists instructing rioting youths to throw stones to order have damaged the public's trust of journalists.

Diversities of image

The breadth that photography now comprises has expanded to include a variety of technology and uses, from creating photo-etched templates for electronic micro-circuitry to speed-trap cameras and surveillance imaging. At the same time, artists such as Heather Barnett have explored the use of scientific imaging to expand the language of artistic vision.

Today, digital photography has put imaging into the hands of anyone with a computer, and their images can reach all round the world. As digital cameras and mobile phone cameras proliferate in hundreds of millions, the time has come when more images could be taken in a single year than in the rest of the history of photography put together.

Heather Barnett's Footprints
Ingeniously bridging science and art to uncover new ways of depiction, Heather Barnett has used culturing techniques to image her feet for this installation (*left*), representing them as organically growing footprints (*below*).

Uttar Pradesh, 1997
Showing a great understanding of the
visual language of photography, Sicilian
photographer, Ferdinando Scianna (1946–)
has used blur to great effect.

PHOTOGRAPHIC TOOLS

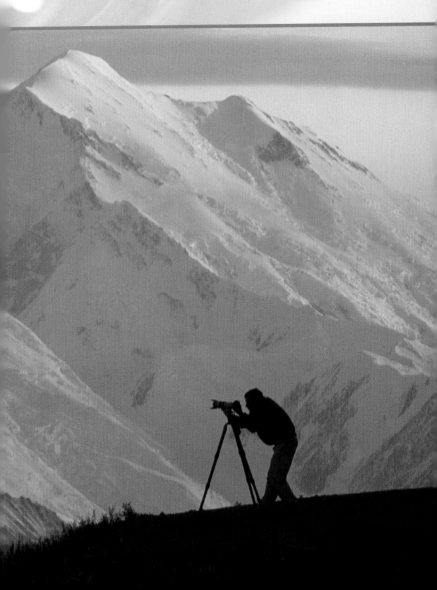

THE BASIC TOOL OF PHOTOGRAPHY – WHETHER DIGITAL OR FILM-BASED – REMAINS THE CAMERA. EVERY IMAGING SYSTEM DEPENDS ON PROTECTING A LIGHT-SENSITIVE ELEMENT FROM THE OUTSIDE. EXPOSURE THEN OPENS IT UP TO LIGHT, AND IT IS AT THAT MAGICAL, TRANSCENDENT MOMENT THAT THE PHOTOGRAPHIC PROCESS BEGINS.

While the principle of controlling the access of light to a recording medium has remained unchanged, today's cameras – all high-tech precision instruments – could not be more different from their early counterparts.

Controlling light
Cameras are primarily concerned with controlling and using light to create the desired image.

The first models were essentially large, empty, boxes. With a modicum of skill early enthusiasts could build their own. But a modern camera is not only small, it is incredibly densely packed. Just about every cubic millimetre is crammed with electronic circuitry, optical, mechanical, and power-management components. And while the first cameras simply allowed the operator to focus the lens, a modern camera has a profusion of buttons, dials, and displays on its back.

Most modern cameras require such high precision and delicacy in assembly that even the most skilled hands can no longer be relied on to assemble one.

Lenses
Modern lenses can record detail with great fidelity of colour and sharpness as well as freedom from distortion. There is something to suit every budget and requirement.

Many camera components are so delicate that only computer-controlled machinery can handle them without causing damage. The next time you hold even a modest modern camera, remember that it has been built with more finesse, and uses more intricate parts, than the most finely crafted Fabergé egg.

Cameras were formerly optical-mechanical devices – combining lenses and fine machinery – but now a great deal of the mechanics has been replaced by electronics or electrical parts. This is true of both film-using and digital cameras. The integration of three quite separate systems of optics, mechanical parts, and electronic controls is a technological triumph. Nonetheless, almost all of the famous images we know and love were created on film cameras, rather than digital. Indeed, many photographers still prefer to use mechanical cameras such as the Leica or Hasselblad, not only because of their reliability and simplicity of operation, but because they allow a more direct experience of the subject.

What has most radically changed in photography since the mid-1990s is, of course, the advent of digital imaging. This has inevitably affected camera design, but the impact on optical design has been no less revolutionary. The explosive growth of digital photography – around 100% per year for the early years of the 21st century – has given rise to today's most asked photographic question: should photographers abandon film, and if so, when? This chapter is designed to help you understand some of the technical issues, so that you can reach the right conclusion for you.

However, technology has not completely superceded traditional photography skills: darkroom film processing and making fine prints from an enlarger remain highly fulfilling creative activities. One of the joys of photography is that it really does have something for everyone, from compact digital and film-using cameras that will do all the work for you and still produce satisfactory, sometimes even astonishingly successful results, to large format cameras that, according to many photographers, still cannot be beaten for image quality.

As well as cameras, there is a wide range of attachments and accessories available to the modern photographer. This chapter will guide you through the myriad choices available, from lenses to camera bags, to software.

Panoramic shots
Views which take in more than the eye can see (*below*) are one of photography's contributions to how we see the world. The panorama is an artificiality created by a special camera or lens.

Photography on the move
Today's photographer relies on a sophisticated range of tools (*right*), but such modern, lightweight equipment would have been beyond the dreams of early photographers.

Wide-angle views
Wide-angle lenses allow the photographer to capture a greater depth of field, so are popular for photographing the natural world.

Close-up views
Formerly the province of well-equipped enthusiasts, close-up photography is now possible with almost any digital camera.

Film-using cameras

The photographic industry has toiled for over a century to master the entire photographic process, from designing increasingly sophisticated equipment to refining the stages of processing and printing. The great advantage of film-using over digital cameras is that there is no need for computers and software. You can just click the shutter and leave the rest to the experts. Furthermore, the cost-to-quality ratio is unbeatable. Film-using cameras are less expensive than ever and the quality of many amateur cameras now exceeds that of the professional models used to create the great images of photographic history.

Viewfinder camera

Small, easy-to-use, and portable, viewfinder cameras – such as the Pentax (*below*) – are the most popular type of film-using camera available. They are frequently chosen by professionals as their "off-duty"

camera. Unlike the SLR camera (*see p.124*), however, the viewfinder on this type of camera only gives an approximate representation of the shot being taken. Aperture and shutter setting options are also limited.

FEATURES OF A VIEWFINDER CAMERA

With increasingly sophisticated features, such as built-in zoom lenses and special effects, the majority of modern, film-using viewfinder cameras allow the photographer to exert a certain amount of creative control.

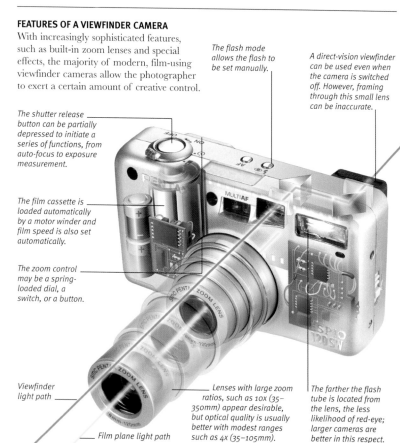

The flash mode allows the flash to be set manually.

A direct-vision viewfinder can be used even when the camera is switched off. However, framing through this small lens can be inaccurate.

The shutter release button can be partially depressed to initiate a series of functions, from auto-focus to exposure measurement.

The film cassette is loaded automatically by a motor winder and film speed is also set automatically.

The zoom control may be a spring-loaded dial, a switch, or a button.

Viewfinder light path

Film plane light path

Lenses with large zoom ratios, such as 10x (35–350mm) appear desirable, but optical quality is usually better with modest ranges such as 4x (35–105mm).

The farther the flash tube is located from the lens, the less likelihood of red-eye; larger cameras are better in this respect.

Types of viewfinder camera

The viewfinder camera has the greatest variety of designs and range of prices. At the budget end of the scale are disposable cameras: convenient, cheap, and capable of producing very good results in the right conditions. At the opposite end are superbly built models with metal bodies and excellent optics. Many are capable of the highest possible image quality. High-grade viewfinder cameras, for example, those made by Konica, Nikon, and Leica, are good value, rewarding, and satisfying to use.

Viewfinder *Flash*

DISPOSABLE CAMERA

Ridiculed when first released in 1990, the disposable or single-use camera was soon out-selling standard models. The entire camera is returned for processing – just like the early Kodak Brownies in 1900 (*see p.87*).

Agfa Le Box Flash
This single-use camera is easy to use and can give surprisingly good results, even in low light.

AUTO-FOCUS ZOOM CAMERA

A mid-range, 35mm auto-focus compact from a reputable manufacturer can deliver images far superior to those obtained by an equivalent digital camera. In addition, they retail at a fraction of the cost.

Fujifilm Zoom Date 90V
This auto-focus model, complete with zoom lens (38–90mm) and motorized film winding, offers extremely good image quality.

Viewfinder *Retractable zoom lens*

HIGH-QUALITY RANGEFINDER

Top rangefinder cameras, which use a type of manual focusing system, are beloved of photojournalists because of their reliable operation and superb images. The range of lenses is limited but the camera's ability to work in low light and focus wide-angle lenses is unsurpassed.

Leica MP
Stripped of all electronics, this camera performs efficiently in all conditions.

Large shutter dial *Interchangeable lens*

Single-lens reflex (SLR) cameras

The modern, auto-focus, auto-exposure SLR camera offers the best value available, being remarkably cheap for the quality it offers. The design – in which the lens that projects the image is also the lens through which you frame and focus – enables you to compose your photographs precisely.

With a 35mm SLR, easily controlled focusing and selective depth of field, as well as interchangeable lenses and lens accessories, give the photographer optimum creative control. The downside, however, is that SLRs are heavier and bulkier than auto-focus viewfinder cameras (see pp.122–23).

FEATURES OF AN SLR CAMERA

Advanced SLR cameras, such as the Minolta Dynax 7 (below), offer a host of features including multiple exposure controls, extensive shutter settings, auto-focus modes to suit different subjects, access to a wide range of interchangeable lenses, and built-in flash, as well as the option to make use of extra flash units and studio flash.

The viewfinder on a modern SLR provides a wealth of information, such as aperture, shutter time, exposure compensation, and flash settings.

The exposure compensation dial is used to fine-tune the exposure reading in order to obtain the desired result.

Built-in flash is a convenient way of adding light, but it should never be relied on as the main source of light.

DX code sensors automatically set the film speed. This helps to avoid errors if you frequently change between film speeds. However, it is useful to be able to override the setting, for example, to "push" films to a different speed.

The exposure mode dials on modern SLR cameras offer numerous settings. Using the manual setting allows you to experiment with exposure times.

A motor winder loads, winds on, and rewinds film. Using the serial or sequential mode, you can shoot several frames in quick succession just by holding down the shutter release button.

Light path

No matter what type of lens you attach, an SLR gives the same accuracy of framing. Auto-focus is less effective with wide-angle lenses and those with a small maximum aperture.

THE PRINCIPLES OF AN SLR

In an SLR camera, light enters through the lens, is reflected onto a focusing screen, and, by means of a prism or system of mirrors, is relayed from there to the eyepiece, allowing the photographer to see exactly what the film will record. For exposure, the mirror flips out of the way just before the shutter opens – momentarily obscuring the photographer's view of the subject – to allow the light to reach the film.

Types of single-lens reflex camera

For learning the basic elements of photography, there is still nothing to rival an SLR with its manual focusing and semi-automatic exposure (where you choose one setting, for example, the size of the lens aperture, and the camera sets the shutter time). You can obtain top-quality SLR camera bodies very cheaply and produce images far superior to those obtained with digital cameras, which can cost ten times as much. Any model of SLR produced by a major manufacturer – such as Nikon, Pentax, Leica, Olympus, Minolta, or Canon – can be relied on to produce excellent results.

STANDARD SLR CAMERA
Used proficiently, these rugged cameras with manual focus option, auto-exposure metering, and motor-winding features can give professional-quality images at a fraction of the cost of equivalent digital cameras.

Pentax MZ-M
Compact and relatively lightweight, this inexpensive camera is ideal for the beginner.

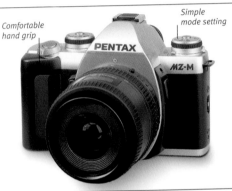

Comfortable hand grip

Simple mode setting

ADVANCED SLR CAMERA
Professional-quality SLR cameras are extremely good value and a joy to use. The additional expense buys a camera that will last a lifetime, survive harsh conditions, and work reliably, while producing pictures of superb quality.

Auto-focus and manual-focus lens

High-quality eyepiece

Canon EOS-1
Supremely hard-wearing and reliable, this SLR can withstand heavy professional usage.

AUTO-FOCUS MEDIUM FORMAT
Modern medium-format cameras that use roll film have an image area far larger than the usual 35mm format, ensuring that quality is close to the best possible with a portable camera. They also offer many automated features, including auto-focus and motor drive.

Pentax 645AF
This medium-format Pentax has lenses of outstanding quality and is comfortable to hold and use.

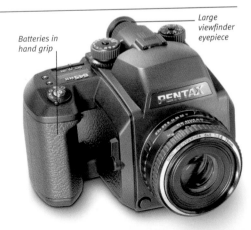

Batteries in hand grip

Large viewfinder eyepiece

Cameras for specialist photography

Often forgotten by advocates of digital photography, one of the advantages of working with film is that a range of film-using cameras have been designed specifically to tackle particular subjects and situations. For a price, such cameras can even be customized to suit your needs. Specialist cameras are usually, but not exclusively, the domain of professional photographers. They really come into their own when used in challenging conditions, when high-quality images together with maximum creative control are required.

PANORAMIC PHOTOGRAPHY

True panoramic cameras take in a view that is wider than a person's field of vision, that is, you would need to turn your head to see it all. However, the most popular type is the letterbox panorama, which simply crops off the top and bottom of a wide view. It enables large-format quality (*see p.127*) to be attained using medium-format film.

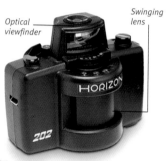

Optical viewfinder

Swinging lens

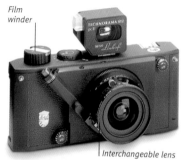

Film winder

Interchangeable lens

Horizon 202
This is a true panoramic camera. The lens swings around a rear optical node and captures wide angles of view of up to 120 degrees.

Linhof Technorama
A superb tool for landscape and architectural work, this letterbox panoramic camera produces a long, narrow image of the highest quality.

ARCHITECTURAL PHOTOGRAPHY

Architectural photography calls for cameras that allow extensive adjustments of lens and film to ensure that vertical and parallel lines still look vertical and parallel in the recorded image. Lens movements such as shift, swing, and tilt control how much foreground is in view, as well as maximizing the depth of field. The lenses, which are top quality, ensure that straight lines are not distorted into curves.

Linhof Technika
Beautifully crafted, with a near-perfect design, the Linhof Technika, also known as the flat-bed technical camera, has remained unchanged for 50 years. It has interchangeable lenses.

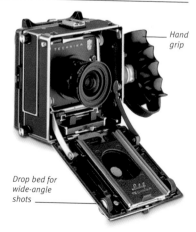

Hand grip

Drop bed for wide-angle shots

LANDSCAPE PHOTOGRAPHY

Large-format cameras with high-quality lenses capture the detail of every last twig and blade of grass, achieving a clarity that is unparalleled, and are the choice of most landscape photographers. Film sizes such as 5 x 4in, 10 x 8in, or even larger represent the ultimate in quality, and their use today reflects a longstanding photographic tradition. Medium format is accepted as a compromise for the sake of portability, providing the camera has exceptional optics and is handled with care when taking photographs. The quality of landscape images captured by large-format cameras is superior to that of the most expensive digital cameras.

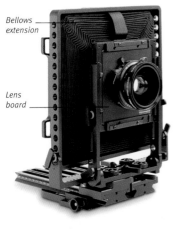

Bellows extension

Lens board

Accessory viewfinder

Canham MQC57

A combination of fine craftsmanship and precision engineering is characteristic of modern large-format cameras such as this 12 x 17cm (5 x 7in) model.

Hasselblad SWC

This is a popular camera for landscapes because of the extremely wide field of view for its 6 x 6cm ($2^1/_4$ x $2^1/_4$ in) format. Compact with a reliable body, above all, it has what is arguably the best available medium-format lens.

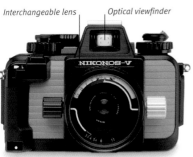

Interchangeable lens Optical viewfinder

NIKONOS-V

UNDERWATER PHOTOGRAPHY

By fitting watertight housings or plastic cases, many normal cameras can be adapted to work under water. However, it is generally best to use cameras that are specifically designed for the task, since they are more robust, reliable, and easy to use.

Nikonos IV

This classic underwater camera is the essential item for serious underwater photography. It is sturdy, easy to use, and accepts a wide range of lenses and accessories.

SPY PHOTOGRAPHY

In stark contrast with the unwieldy large-format camera, the inconspicuous spy camera can be held in the palm of your hand. High precision during the manufacturing process is needed to ensure that such a small camera can achieve good image quality. Spy cameras usually give some control over shutter time and the size of aperture, but there is no zoom facility and a flash unit needs to be purchased separately.

Minox spy camera

This classic Minox design has been in production and associated with espionage since the 1930s. It uses special format 8 x 11mm ($^1/_3$ x $^1/_2$ in) film cartridges.

Body extended for photography Lens

Film and formats

Modern colour photographic films are made up of as many as 20 individual layers: even black-and-white film can comprise four or more. Each layer is thinner than the width of a human hair and carries a precisely-controlled suspension containing minute crystals of light-sensitive silver salts – typically silver iodide and silver bromide – and light-absorbing dyes. These need to be carefully balanced with one another in order to record colours accurately. Modern films can consistently capture a wealth of tonal and spatial information using wonderfully rich and true-to-life colours.

The basics of film

All films respond to colours, but they are made to record in either black and white or colour. Fundamentally, all types of film record in negative but can be processed either to deliver a negative or a positive image. In both black-and-white and colour films, negatives are the end product. The transparency or slide, however, is delivered in positive.

HOW A NEGATIVE WORKS

The term "negative" means that the subject's tone values (bright and dark) – and colours (hues) – are reversed in the record. For example, where the subject looks bright, in the negative it appears dark due to the greater density of dyes (or silver, in the case of black-and-white film). When working in colour, the hue is also reversed. For example a red car will appear green on the negative, while a blue car will appear orange. When printed the colours revert back to the original.

FILM SPEED

The amount of light needed for a good-quality image is measured by the film's speed. Throughout the industry, this is measured against a standard processing and the result is given as the ISO number. A low ISO number, for example $100/21°$, indicates a film that needs more light (is slower) than one with a larger ISO number, say $400/27°$. A comparable standard has been established for digital cameras, also quoted as ISO.

COLOUR PALETTE

Different makes of film respond to light and colour in their own characteristic ways. A film such as Fuji Velvia is often chosen for its rich and vividly coloured palette. Softer, less brilliant colours can be obtained by using a film such as Kodak Elite. It is best to try out several films to see which one you prefer.

FILM FORMATS

Photographic film is trimmed to various sizes to suit different cameras and purposes. Smaller film formats are compact and more convenient but they do not offer the same potential for image quality as larger formats.

Types of film formats
This diagram shows the relative sizes of the most popular film formats.

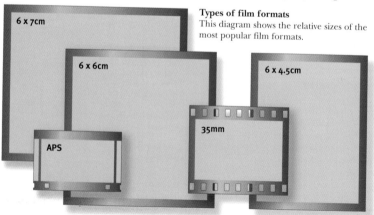

6 x 7cm

6 x 6cm

6 x 4.5cm

35mm

APS

TYPES OF FILM

There are two main types of colour film. Tungsten is used with indoor lighting while daylight film is suitable for natural light. There are also two types of black-and-white film. Panchromatic uses developed-out silver to disperse light to form the image. This can easily be developed at home (see p.132). The more modern chromogenic film uses clouds of neutral-coloured dye to absorb, rather than disperse, light in order to form the image and is developed in the same way as colour film.

COLOUR NEGATIVE

Colour negative film

Colour negative
A well-processed film looks low in contrast, with weak and reversed colours.

Colour print
When printed, colours are brilliant, with normal contrast and densities.

COLOUR SLIDE

Colour slide film

Colour slide
A slide (or transparency) should be perfect as further adjustments are difficult.

Mounted slide
For protection, the slide is usually mounted in a plastic or cardboard frame.

PANCHROMATIC

Panchromatic film

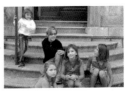

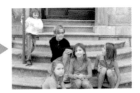

Panchromatic negative
Negative film can vary in appearance depending on how you process it.

Panchromatic print
The quality of print obtained depends on the appearance of the negative.

CHROMOGENIC

Chromogenic film

Chromogenic negative
These black-and-white films are low contrast like their colour negative counterparts.

Chromogenic print
Chromogenic negatives can be printed on normal black-and-white or colour paper.

Setting up a darkroom

With all the excitement over digital photography, it is easy to forget how satisfying it is to develop your own film, and have total control over the end product. Processing colour film at home is a specialist activity, but if you are working in black and white you can set up a darkroom for surprisingly little. Doing it yourself is one of the most gratifying of photographic experiences.

Equipping a darkroom

The illustrations show the basic set-ups for developing either films or prints (*below*) and for making black-and-white prints by enlargement (*opposite*). The equipment may look low-tech, but it can produce the very highest image quality. At the same time, the process is deeply rewarding, if rather time-consuming.

THE WET BENCH

The wet bench is an area of the darkroom exclusively used for any "wet processes", such as mixing up and preparing chemicals, developing films, and developing and washing enlarged prints. A safelight can be used for print development, but not for film processing (*see p.132*).

The safelight gives a "safe" red light.

A timer is vital for accurate results.

Chemicals should be stored in coded bottles.

The developing tank should be cleaned and dried after use.

Spirals should only be left out while drying.

One measuring cylinder is used for each chemical.

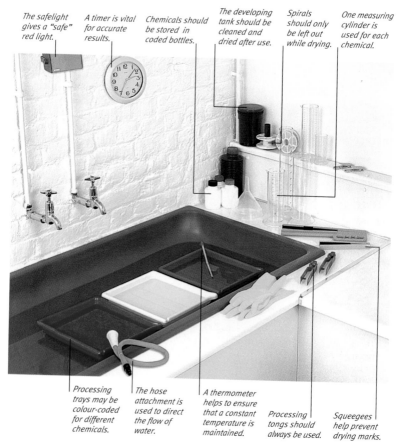

Processing trays may be colour-coded for different chemicals.

The hose attachment is used to direct the flow of water.

A thermometer helps to ensure that a constant temperature is maintained.

Processing tongs should always be used.

Squeegees help prevent drying marks.

THE DRY BENCH

The dry section of the darkroom is where negatives are prepared and print enlargements made. This area is also where any electrical equipment, such as the enlarger, is kept, so it is vital that the area is kept dry.

The enlarger column should be sturdy, keeping the enlarger steady during exposure.

The focus magnifier is used to check the sharpness of the enlarged image on the baseboard.

The enlarger head contains the lamp, and the negative and lens carriers.

The timer controls the length of the print's exposure.

The height control lifts or lowers the enlarger head to change the size of the enlargement.

The red filter, when swung into the path of light, allows you to adjust the printing easel's position with the paper in place, without exposing it.

The negative carrier opens up to allow the negative to be carefully positioned.

Photographic paper sits in the printing easel, which can be adjusted for different paper sizes.

Scissors are used to trim film strips into manageable lengths.

Photographic paper should be kept safely inside its envelope until you are ready to expose it.

WORKING IN THE DARKROOM

You only need to work systematically to produce exhibition-quality work in your darkroom. For the best results, time all processes carefully and consistently. Develop prints for the manufacturer's recommended time and not a second more or less and always develop film at 20°C (68°F). Similarly, time your enlargements with utmost precision and make a note of the timings and settings. This way, when you produce a satisfactory result, you can easily make another print equally as good by repeating the same steps. If you are disappointed with your results, you could try slightly different development times for your prints and films to see if they improve. If they do, you can adopt them as your standard. For example, you might decide that some prints need richer blacks or a greater contrast, and may benefit from an extra 30 seconds of development. Colour film and prints can also be processed at home, but costly equipment, which works at higher temperatures, is needed.

Black-and-white processing

One of the great attractions of working with black-and-white film is that you need just a few pieces of simple, low-tech equipment to process it. Furthermore, for developing black-and-white film you do not even need a dedicated darkroom or even running water (although both are an advantage); the chemicals are inexpensive; and careful work can deliver results of the highest quality.

How to process a film

The key to successful film development is meticulous preparation. Make up the three chemicals – developer, stop, and fix – following instructions to the letter, ensuring volumes and concentrations are as precise as possible. In particular, the developer should be at the correct temperature when it comes into contact with the film. If you are unused to working in the dark, especially when loading the film onto the spiral (step 2, *below*) it is a good idea to practise by using an old film in the light with your eyes closed until you are confident. For reliable results, it is vital that the timing of each step is consistent.

1. Organize the equipment
Assemble a light-tight developing tank with a spiral (some tanks hold two or more spirals), a pair of blunt-ended scissors, and a film canister opener. Everything, including your hands, must be bone dry. It will help if all equipment is at room temperature.

2. Load the film spiral
In total darkness, open the canister and use the scissors to trim the end of the roll of film and round the corners. Then feed the film into the entry slot and inch it in by twisting each side of the spiral alternately. If the film becomes jammed, do not force it; start again.

3. Check the developer
Pour all the developer into the tank but ensure that you do not completely fill the tank with developer. Recheck that the temperature of the developer is 20°C (68°F). If not, you will need to adjust development times by referring to the manufacturer's charts.

4. Load the tank
Drop the spiral into the tank and close tightly, ensuring that the lid fits securely. Start timing the development. Knock the tank sharply against the wet bench to dislodge any bubbles, then agitate for one minute. Continue agitation following the manufacturer's instructions.

5. End development and fix
When the development period is over, immediately pour out the developer. Pour in the stop bath. Agitate for 30 seconds, then pour the stop bath back into its bottle. Pour in the fix, agitate, and follow the manufacturer's instructions. At the end of the fix time, return the fix to its bottle.

6. Wash the film
Wash the fix off the film in clean water. If there's no running water, fill the tank with water, close it, invert it 10 times and dispose of the water. Repeat a further nine times. Add a drop of wetting agent to the final batch, agitate for 15 seconds, remove the film and hang it up to drip dry.

Working in the negative
Subjects such as this architectural scene taken in Auckland, New Zealand, work best in the negative. The reversal of tones accentuates the bones and structure of the image. This effect can be achieved either by photographing the negative against a bright light, or by using the positive print in the same way as you would use a negative.

Black-and-white printing

Making a black-and-white print mirrors the photographic process of creating the original negative. By projecting a negative image onto the printing paper, the resulting image is positive. The construction of the paper means that the more light that reaches it, the darker it becomes. Unlike a digital print, which is created line by line, the image emerges onto the paper as a whole during development.

How to print

You should always select the images beforehand, then visualize how you wish to print each image. Do you want a high, low, or average contrast? The printing process itself is reassuringly low-tech and easy. First, you need to prepare the chemicals; developer, stop, and fix. Always use fresh developer. Blow dust off the negative using a puffer or can of compressed air – never your breath. Turn off the room light, and turn on the safelight to begin.

1. Load the negative carrier
Make sure your film is cut into convenient lengths. Place the chosen frame emulsion- side down and upside down on the carrier.

2. Set height
Raise or lower the enlarger head to vary the enlargement size of the image.

3. Frame the image
Set the enlarger lens to full aperture (to give the brightest image possible), and keep the image roughly in focus while you readjust the height of the enlarger as necessary. Arrange the image neatly within the frame area that you wish to use, and square it up so that no unsightly edges are visible.

4. Focus the image
With the lens still set to full aperture to facilitate focusing, use a focus magnifier to examine the image's grain. This is critical not just for sharp detail, but for image quality too.

5. Stop down
To improve the sharpness of the image, set the lens to a smaller aperture, such as f/5.6.

6. Make a test strip
Incrementally increase the exposure to a strip of paper using a mask, then develop.

7. Expose the paper
Examine the test strip to choose the best exposure. Then place new printing paper in the easel, ensuring you do not accidentally change its position. Next, turn on the enlarger light and expose for the time determined by the test strip.

8. Develop the print
Slip the exposed sheet emulsion-side down into the developer and gently rock the tray. Use gloves or tongs to lift the paper by the corner to turn it over to check development.

9. Stop development
Following the manufacturer's instructions for development time, lift the paper from the developing dish by its corner, drain, and slip into the stop bath to stop development.

10. Fix the print
After just 30 seconds in the stop bath, lift the print by its corner, drain, and slip into the fix bath. Follow the instructions and do not exceed the recommended fix time.

11. Wash the print
When the print is fixed, rinse off the chemicals with copious amounts of running water. Again, follow manufacturer's instructions. Some papers are sufficiently washed in less than five minutes, others may need more time.

12. Dry the print
Modern PE (polyethylene) papers will dry flat by themselves, and need only to have excess water squeegeed off. Fibre-based papers tend to curl, so attach clip-on weights or pegs while drying.

TYPES OF PHOTOGRAPHIC PAPER

There are two main types of black-and-white printing paper. Fibre-based types use a paper core with a baryta (barium oxide) layer to carry the silver. These give the best results and deliver superior archival qualities, but they take longer to process. Polyethylene (PE) papers, also erroneously referred to as RC (resin-coated), have plastic layers over the paper core to reduce chemical absorption. This shortens processing. Modern papers are "variable contrast" and have a range of grades to match negatives of different contrasts built into the paper. The contrast is chosen by adjusting the printing light using filters, or through a setting on the enlarger head.

Analyzing a black-and-white print

When examining a scene your eyes continually adjust to the brightness. When looking at a dark area, your pupils open up to let in more light, and when looking at a bright area, they close down to shut out light. When making a print, you will need to make similar compensations to avoid dark parts of the picture becoming too black, and bright parts becoming burnt out. This is done by exposing different areas of the print paper to different amounts of light.

BURNING-IN AND DODGING

To correct the balance of tones in a print you can make over-bright areas darker by "burning in", and hold back shadow areas to stop them becoming too dark by "dodging". You can do this with your hands, but you can also buy or make tools for the task. A burning-in tool is simply a piece of card with a hole in the centre that allows light to pass through. By positioning this between the enlarger lens and the paper you can increase the exposure time for selected areas to make them darker. A dodging tool is a stiff wire with a piece of card attached. The principle for dodging is the same as for burning-in, but in reverse. You need to keep the tools moving to prevent obvious lines from appearing.

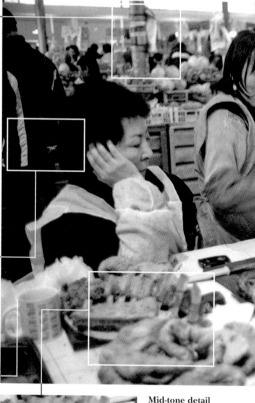

Background blur
As the background is blurred, it does not need to hold much detail, but it should be neither too dark nor too light.

Dodging the shadows
Without dodging, this area would have been uniformly black, losing the distinction between the woman's head and the jacket behind her.

The use of a moderate wide-angle lens (35mm on 35mm film) meant that objects at the edge of the frame, such as this mug, are slightly distorted. A little dodging blurs the outline to disguise the effect.

Mid-tone detail
The key to black-and-white images is the mid-tone detail. Here it was lightened a little with dodging tools to ensure that the shadows were not too dark.

THE ORIGINAL IMAGE

This image of women playing chess while selling tripe in a market in Bishkek, Kyrgyzstan, was taken using ISO 400/27° film. A few spots of light were provided by overhead lamps and the background was bright, but overall, the available light was very low.

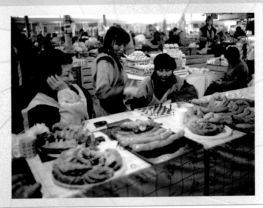

Assessing the image
The image is acceptable printed "straight" with no manipulation (*right*), but with a little burning-in and dodging it is far superior (*below*).

Avoiding overburn
Do not burn-in highlights next to mid-tones or you will make the mid-tones too dark.

The foreground was burned-in – although it was already dark – to help frame the main subject.

Burning-in highlights
The brightest parts of the foreground were the cups lit by an overhead lamp. It was necessary to burn-in to bring out shape in the mug. (Compare with the original image above.)

Dodging facial tones
In the unmanipulated shot, the lower part of this woman's face was in shadow. A dodging tool was used to limit the amount of light in order to lighten the face.

Digital cameras

Today, digital cameras easily outsell film-using cameras because even high-quality models are now relatively affordable. This change, combined with the convenience, flexibility, and opportunities for sheer fun that digital cameras offer the photographer, has led to an unprecedented explosion in the number of people taking up photography as a hobby.

The benefits

A great advantage of digital cameras is the fact that you can review your images instantly. Also, by using the LCD screen, you do not need to hold the camera to your eye to compose the shot. Each picture costs nothing to take so it makes no difference whether you take one or one hundred. Even entry-level digital cameras have many features designed to meet a range of needs.

FEATURES OF A DIGITAL CAMERA

Digital cameras, such as the Olympus E-20 (*below*), combine precise electronic engineering with highly evolved optics and mechanical parts, and produce outstanding results. The zoom lens is permanently attached to the camera.

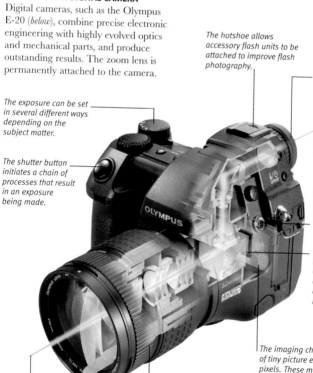

The hotshoe allows accessory flash units to be attached to improve flash photography.

The eyepiece can be used for viewing, as well as the LCD screen. On many cameras the dioptre correction can be adjusted to suit different eyesights.

The exposure can be set in several different ways depending on the subject matter.

The shutter button initiates a chain of processes that result in an exposure being made.

A traditional flash socket allows studio flash units to be used.

The sensor is the heart of the digital camera and it determines the camera's potential image quality.

The imaging chip is made up of tiny picture elements called pixels. These measure the intensity of light and create an electrical signal that in turn creates the image.

Light is shown here entering the lens and then being split into two parts. One is for viewing, the other for image capture.

Versatile, high-quality zoom optics are standard on virtually all modern digital cameras.

PERFORMANCE

In practice, what matters is not a camera's feature count, but its performance. Are colours recorded precisely? Does the camera set the exposure consistently and correctly? Is focus accurate? Is the image sharp enough without being overly so? That is, does the image preserve details without exaggerating edges (*see p.169*)? These are the most important questions to consider before buying a digital camera. Try to examine sample images to get a good idea of what is available. Check digital photography websites that allow you to download sample images, and refer to digital photography magazines for reviews. Some magazines give away free CDs containing test images, which can give you a good idea of camera performance.

THE DIGITAL SENSOR

If you use the LCD screen of a digital camera to frame a picture, you are effectively viewing the image through the same lens that takes the image (as with an SLR camera, *see pp.124–25*). The lens projects the image onto a sensor, which sends the image data to be viewed on an LCD screen. However, unlike film-using cameras, which employ a very limited range of film sizes, digital cameras use many different sizes of sensor. The vast majority are less than one quarter of the size of 35mm film. One effect of this is that depth of field increases, which can limit your creative control.

How a digital file is made
Creating a digital image is an entirely different process to capturing one on film.

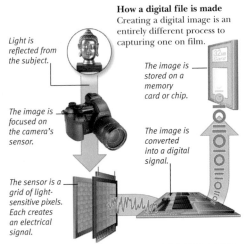

Light is reflected from the subject.

The image is focused on the camera's sensor.

The sensor is a grid of light-sensitive pixels. Each creates an electrical signal.

The image is stored on a memory card or chip.

The image is converted into a digital signal.

PIXEL COUNT AND IMAGE QUALITY

The pixel count is the number of picture elements on the imaging sensor that capture an image and set the upper limit of what a camera can achieve. Many digital cameras are 4 megapixels (4 million pixels or 4MP), which is more than adequate for most situations. This means that when choosing a camera, factors other than pixel count can be more important, such as how colour is processed, since some cameras accentuate colour and contrast more than others. The quality of the optics is also key. A good lens on a 3MP camera can give better results than a 7MP model with an inferior lens. A 3MP camera can make prints up to A4 in size. Professionals often work with 8MP cameras to produce large files, but these use a lot of memory.

MEMORY CARDS AND CAPACITY

Each camera uses a specific type of memory card, though some accept more than one kind of card. Each type has a range of capacities, with 256MB to 1GB offering the best value per unit of memory as a rule. Cards read and write at different speeds. More costly high-speed cards are best used in cameras with high pixel counts or when taking lots of pictures. The table below assumes the lowest level of compression, which gives the best quality using the camera's full pixel count.

CARD CAPACITY

Camera Type	File Size	32MB	64MB	128MB	256MB	512MB	1GB	2GB	4GB
2 Megapixel	900KB	34	79	149	289	565	1,130	2,270	4,540
3 Megapixel	1.2MB	25	55	103	210	420	850	1,700	3,400
4 Megapixel	2MB	15	31	62	124	250	500	1,010	2,030
5 Megapixel	2.5MB	11	23	50	100	200	400	800	1,620
6 Megapixel	3.2MB	9	18	37	75	150	310	620	1,250

Entry-level and mid-range digital cameras

Today's entry-level digital cameras easily out-perform professional-grade models of the late 1990s, some of which, at the time, cost more than the average family car. Not so long ago they were the ultimate dream for most amateur photographers, but now mid-range performance digital cameras are ubiquitous and almost taken for granted. Even newcomers to photography can expect to use refined, reliable technology, which is reasonably priced and able to give highly satisfactory results. The cameras shown here illustrate types of ranges, as well as a few individual models.

BASIC DIGITAL CAMERA

Even basic digital cameras will offer a zoom lens, built-in flash, and a range of automatic functions. These settings are designed to make photography easier. However, operation may be slower than on costlier cameras.

Konika Minolta DiMage G600
A compact, easy-to-use, and popular model, this camera has a pixel count of 6MP which gives good image quality.

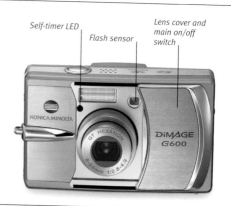

Self-timer LED

Flash sensor

Lens cover and main on/off switch

ULTRA-COMPACT DIGITAL CAMERA

The small size of sensor chips, and the fact that there is no need for film, means that digital cameras can be highly compact. The limit to miniaturization is the need to make controls large enough to use comfortably.

Ricoh Caplio RZ1
This camera, although by no means the slimmest on the market, is only 25mm wide with its zoom lens retracted.

Interchangeable faceplate

Wide-angle 28mm lens

Viewfinder

MULTI-MEGAPIXEL PHONE

It has taken mobile phones just a short time to graduate from using imaging chips with small pixel counts to offering 5MP models boasting good lenses and even zoom facility. Such a high pixel count means that photos taken with these phones can now match the quality of those taken with basic digital cameras. And, of course, you can still make phone calls.

Samsung camera phone lens

Samsung SCH-S250
South Korea's Samsung Electronics developed the world's first mobile phone to be equipped with a 5-megapixel camera.

Advanced digital cameras

Top-of-the-range digital cameras can offer over 100 different settings. These produce thousands of combinations, though you may only use a few on a regular basis. These cameras have many features invented more for marketing purposes than regular use. Digital technology has matured to the point that there is now little to be gained by waiting for next year's model.

COMPACT DIGITAL CAMERAS

These may look like other digital cameras, but hidden within the body is an advanced chip that captures images in such a way that they give significantly more detail than other chips.

Fujifilm FinePix F810 Zoom
This camera is popular for its quick response to commands and its compact styling.

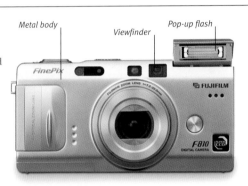

Metal body
Viewfinder
Pop-up flash

HIGH-RESOLUTION DIGITAL CAMERAS

Cameras with pixel counts of 7MP and more, together with higher-quality lenses, can produce image files good enough for publication or prints A4 plus in size.

Shutter button
Microphone for video mode

Olympus C70 Zoom
A high-specification sensor chip in this camera produces a resolution of more than 7 million pixels per image. The lens zooms between 38–190mm.

DIRECT-TO-CD CAMERA

All digital cameras must store recorded images in a memory of some kind. The majority of cameras use removeable solid-state flash memory, but there are some models that write data to CD. This may be slower than flash memory, but it is extremely reliable.

Sony MVC-CD500
Although it is bulky and relatively slow to use compared to other digital cameras, this model's ability to write direct to CD is much valued, where data needs to be secured and images must be kept safe.

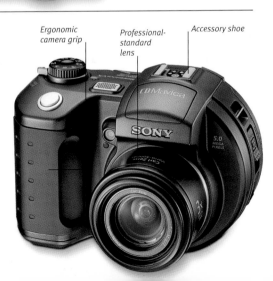

Ergonomic camera grip
Professional-standard lens
Accessory shoe

EVF and D-SLR cameras

When using an Electronic Viewfinder (EVF) camera you view your subject on a small LCD screen through the eyepiece. This design avoids the need for the traditional SLR's flapping mirror mechanics, but the camera must be turned on to view. Digital SLR (D-SLR) cameras, however, have the regular SLR's bulkier body and noisier operation, but allow continuous viewing.

EVF CAMERA

With the LCD screen viewed through an eyepiece, an EVF is easier to use in bright light than a normal digital camera, where the LCD is located on the camera back. The image is not as clear or stable as one seen through an optical viewfinder.

Leica Digilux 2
Designed to look like a film-using camera, this Leica is robust and offers more manual control than other digital cameras. It has a large LCD panel as well as a relatively high-resolution EVF.

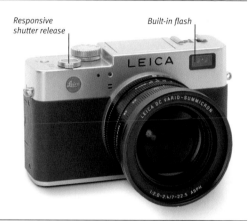

Responsive shutter release

Built-in flash

LEICA

High-magnification viewfinder

Mode dial

PENTAX

D-SLR CAMERA

The digital SLR is built like a film-using SLR camera, but it carries an imaging chip. It accepts lenses that fit traditional 35mm cameras, however if its sensor is smaller, the focal length is multiplied (*see p.144*).

Pentax ist DS
This 6-MP model is one of the smallest and lightest D-SLR cameras. By accepting SLR lenses, it opened the digital world to owners of Pentax K or equivalent lens mounts.

STILLS WITH DIGITAL VIDEO CAMERA

Many digital video cameras are also able to record still pictures, either onto the video tape or, and preferably, onto a separate removeable memory card. Pixel counts of 3 megapixels should be regarded as the minimum, since the imaging quality from video cameras (as a result of lens design and processing constraints) is not as good as that of digital cameras.

Sony DCR-PC330
This mini Digital Video Camcorder is capable of taking and storing still images on a memory stick. Unlike many camcorders, this model produces very good quality still images.

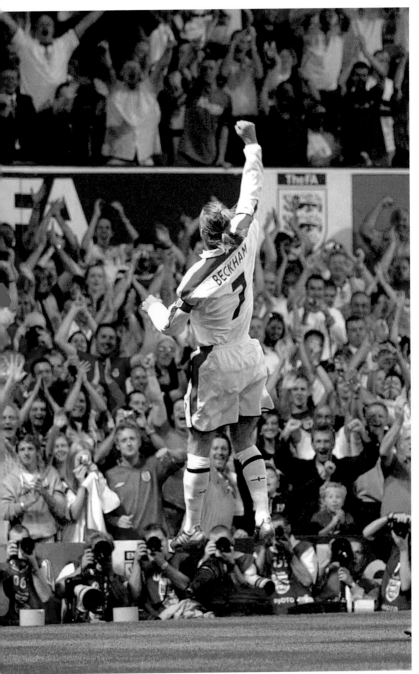

Sports photography
Apart from being a quintessential stock shot, this multi-layered image of a sporting hero playing to the crowd while photographers capture the moment also highlights the advantage of digital technology for sports photography. In this fast-moving world, the benefit is that digital images can be uploaded and sent to the picture desk without any delay or loss in quality.

Lenses

There are many different types of lens. If your camera does not accept interchangeable lenses, meaning the lens cannot be removed and replaced by another, it will not necessarily limit your photography. Some great photographers choose to work with just one focal length. However, being able to use the right lens for the job ensures the very best image quality.

Types of lens

The most common photographic lens is the zoom, which enables you to continuously vary focal length (*see pp.222–23*). It is used universally on auto-focus cameras with fixed lenses. With SLR cameras that accept different lenses, you can choose between a zoom and a fixed focal length lens. While the quality of top-of-the-range zoom lenses is high, it is always best to opt for a fixed focal length lens if you want quality at an affordable price. The inconvenience of having to swap between lenses is compensated for by image quality. Some D-SLRs can use normal lenses as well as specifically designed digital lenses.

ANATOMY OF A LENS

A lens comprises a number of different lenses and elements. These are arranged in groups. Groups are moved to adjust the focus or, on zoom lenses, to change the focal length. A bayonet mount fits the lens to the camera.

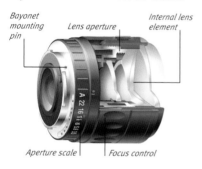

Bayonet mounting pin

Lens aperture

Internal lens element

Aperture scale

Focus control

Sensor size and field of view
35mm lenses can be used with sensors that are smaller than the film frame. This reduces the field of view and increases the effective focal length of the lens.

STANDARD LENS

Lenses with focal lengths of between 40 and 55mm give a natural, unforced view of the subject. They are the most versatile options for a wide range of photographic situations, from portraiture to landscapes.

Nikon 50mm
Standard lenses such as this give the very best combination of low cost, high speed (large maximum apertures of f/2 or greater), and very high image quality.

WIDE-ANGLE LENS

Prime lenses (those with a single focal length) for wide-angle views ensure superlative image quality with minimal distortion, even illumination across the image field, and high contrast.

Nikon 35mm
Wide-angle lenses like this produce superb images that are free of distortion. Very large maximum apertures result in particularly bright viewfinder images.

MACRO LENS

Macro lenses are designed for close-up work and produce life-size or magnified images of a subject. They are very highly corrected optics that give the highest resolution and contrast.

Tamron 90mm
This lens has extremely high performance optics and has long been considered one of the best macro lenses available.

WIDE-ANGLE ZOOM LENS

Ideal for landscape and travel photography, both of which often require wide-angle views, these powerful lenses combine versatility and convenience.

Canon 17–35mm
A lens such as this, which covers ultra-wide to moderate wide-angle views, is an invaluable tool for the modern photographer.

TELEPHOTO ZOOM LENS

Zoom lenses covering ranges from moderate telephoto (suitable for portraits) to ultra-long (suitable for wildlife or travel photography) can be heavy and need to be supported on a tripod to attain the best results.

Pentax 100–300mm
With its very useful zoom range, this lens can replace several single-focal-length lenses and still be capable of producing excellent images.

LENS FILTERS

Filters alter the quantity or quality of the light entering the camera lens. They may create a subtle correction of colour tints, or a dramatic shift of colour in addition to other special effects. The popular polarizing filter darkens blue skies and is an effect that cannot be replicated with any digital technique. Other filters provide special effects such as softening (which flatters skin textures) and more outlandish effects such as star-bursts and rainbows (*see pp.226–27*).

Round filter systems
The highest quality filters are made of glass, set into a threaded rim that fits specific-size lenses. They are used mainly for colour balancing or correction. A UV or clear glass filter should be fitted to every lens for optimum protection.

Square filter systems
Systems based on plastic filters use adaptors that enable one set of filters to be used on lenses of different sizes. The range of effects available is wide and varied. This system is best for gradient or graduated colour filters.

Gelatin filter systems
Filters made from gelatin are very thin and fragile but interfere minimally with image quality. Use of adaptors allows a set of filters to be used with many lenses. They are popular for colour correction or balancing tasks.

Camera accessories

With such a bewildering array of accessories on the market, making a selection can be a time-consuming exercise. Nonetheless, accessories can enable you to work to professional standards, or help ensure that your equipment survives adverse conditions. Unfortunately, accessories mean having more to carry, more to set up, and generally more to lose. A balance has to be found.

The essential accessories

The key photographic accessories are those that support, protect, and light. Using a tripod encourages careful composition and ensures that images are sharp. Indeed, tripods can be the single best way to improve the quality of your photographs. Camera bags or cases help protect your valuable equipment from water, dust, and shock ensuring it continues to work efficiently. Finally, since photography is all about working with light, the other essential accessories are for supplementing and controlling light.

TRIPODS

Tripods are vital when you are shooting in low light situations (under 1/60 second). Small tripods are useful for compact digital cameras when used on a stable surface, and are also invaluable when using the self-timer facility. Lightweight models are more versatile, suiting cameras up to 1kg (2.2lb) in weight. Heavier tripods give the best results as they are far more stable.

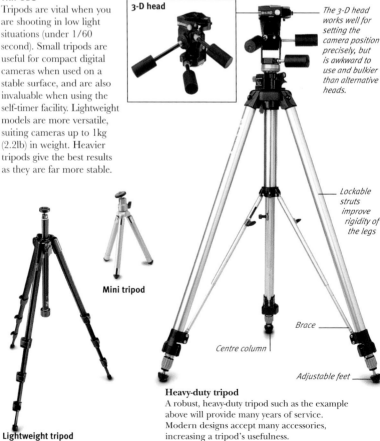

3-D head

The 3-D head works well for setting the camera position precisely, but is awkward to use and bulkier than alternative heads.

Lockable struts improve rigidity of the legs

Mini tripod

Brace

Centre column

Adjustable feet

Heavy-duty tripod
A robust, heavy-duty tripod such as the example above will provide many years of service. Modern designs accept many accessories, increasing a tripod's usefulness.

Lightweight tripod

CAMERA BAGS

Camera bags can be to the photographer what designer labels are to the fashion-conscious: an obsession. Many professionals have a dozen different types. Before buying a bag, it is important to think carefully about how much equipment you intend to carry and how far you intend to carry it.

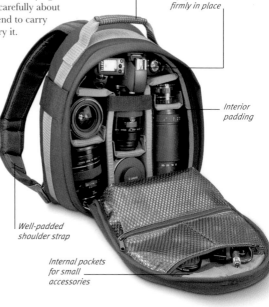

Carrying handle

Equipment held firmly in place

Interior padding

Well-padded shoulder strap

Internal pockets for small accessories

Ultra-compact bag

Small outfit bag

Backpack-style bag
Camera bags of this type are comfortable to carry long distances because the weight is evenly distributed over the shoulders. However, accessing items in the bag is less convenient than with over-the-shoulder bags.

FLASH ACCESSORIES

The key lighting accessory, and by far the most useful, is a separate, hotshoe-mounted flash unit. Modern units are amazingly powerful for their size and offer extremely efficient automatic-exposure functions. With these units you can fill shadows in full sunshine as well as work in complete darkness. Another great accessory is a compact reflector. These can have silver or gold finishes and are ideal for illuminating shadows with a touch of light.

Hotshoe-mount flash
The best flash units are those that swivel so the flash can be pointed upwards to control the direction of lighting.

Portaflash reflector
The simplicity of these metallic fabric reflectors stretched on a flexible frame belies the dramatic impact they can have on lighting.

WORKING WITH DIGITAL IMAGES

THE TECHNICAL DEMANDS OF IMAGE MANIPULATION ARE SUCH THAT IT WAS 1993 BEFORE THE FIRST TRULY PRACTICAL SOFTWARE APPLICATION, ADOBE PHOTOSHOP VERSION 2.5.1, WAS INTRODUCED. EVEN THEN, COMPUTERS COULD BARELY KEEP UP. WORKING WITH DIGITAL IMAGES COULD BE EXTREMELY TIME-CONSUMING AND FRUSTRATING.

Today's computers can cope easily with image manipulation. They are very fast and can make hundreds of millions of calculations each second, and they have tremendous processing power that can handle enormous amounts of data. By the turn of the millennium, the software controlling computers – the operating systems – had become very stable and reliable.

Art effects
Manipulation such as the colour-pencil texture in this image can take photography close to fine art practice.

If you are lucky enough to be learning image manipulation only now, you have been spared the agonies of those who worked at the cutting edge of digital photography development in the late 1990s. Back then, work was hindered by inexplicable crashes, illogical processes, incomplete features, and sluggish response – you really had to persevere to make any progress.

However, in the process of development and through competition, modern software has become loaded with numerous functions. Rather like modern cameras, which carry dozens of features in order to please as many people as possible, software developers aim to provide solutions for every user, from the amateur enthusiast to the busy professional.

The most frequently applied functions such as adjusting exposure, changing image size, correcting colour balance, and cropping the image will be offered by most entry-level software programs. More advanced programs allow you to perform more elaborate tasks, such as fine control of tone reproduction, special effects, removing image defects, and layering images on top of one another.

Learning to use even fairly elementary software can be a daunting task. It will be easier to find your way around the software and avoid frustration if you bear a few general strategies in mind. When you start to experiment with a new software application, open a small image – a maximum of 1MB in size. Using a small file ensures rapid response and

Double montage
The main effect – a double-exposure – was in fact done with film. But only digital image manipulation could have separated out some of the tonal details and enriched the colours which, in the original, were too dull.

feedback. A fundamental rule of image manipulation is "never touch the original", so always make a copy before you begin to make adjustments.

Work through the tools and menus systematically, making notes as you go. If you find a function that promises to be useful to you, make a note of it. Since the file is small, you can save it as a visual reference for the future, with the name of the command or filter attached.

While radical manipulations are possible, most of the time people use software to make minor adjustments to improve their pictures. The main changes, which should be executed roughly in this order, are as follows: control the size and proportions to ensure you have only as much data as you need, and to crop it to the required shape; adjust the exposure and tone to correct overall brightness and contrast; and make sure the colours are accurate. At this stage you can make further adjustments by applying filters or special effects. When preparing files for printing, you may need to improve the sharpness of the image as the final step.

Image manipulation has come a long way in a relatively short time. It is now so sophisticated that it is often impossible to tell whether an image is original or not. Some may view this as a negative, even a dangerous, development. But most see it as an exciting leap forwards for photographic creativity.

Panoramic composite
By creating a false panorama and overlaying images, a few shots of bare branches (*right*) are transformed into a pleasing abstract image.

Original image
The original image, of a sunset over Auckland, New Zealand, shows shadows that are too dark, contrasting strongly with the distant sun.

Shadows and highlight adjusted
By adjusting the shadows to increase detail, and the highlights to correct the colour the image is closer to the view as seen.

Sepia tone
The adjusted image has been sepia-tinted by turning all the colours to brown tones. This creates a romantic, mellow effect.

Extreme effect
A dramatic digital effect such as this can not only reverse the tones but also the colours. The effect is almost psychedelic.

Setting up a digital workroom

The main advantage of the digital photography workroom over the darkroom is that any room in an average home or office can lend itself to the purpose, and no extra expense need be incurred in preparing the room. The key requirement of a workroom is comfort, since you are likely to spend a lot of time at your desk. However, it is also important to avoid working for long periods without a break as this can cause health problems.

The environment

Computers, monitors, and other electrical equipment can get extremely warm when left running for hours at a time, so your chosen workroom should always be well ventilated to dissipate the heat. Windows need to have heavy, lined curtains or blinds so that you can shut the daylight out when necessary. Given all the expensive equipment required for a digital workroom, it is also a good idea to make your room secure, even within your own home.

SETTING UP THE WORKSPACE

The desk you work at should be stable and capable of supporting the weight of your equipment. It is also important that the desk is at the correct height. When you are seated at the keyboard, your forearms should be horizontal or slightly inclined down, and there should be ample space for your legs. Position the monitor so that the top of the screen is approximately at eye level. Ensure that your chair allows you to place your feet flat on the floor (or use a footrest) and that it supports your back. It may seem obvious, but make sure your desk is large enough, not just for the equipment, but so that you can use additional items such as books and notepads comfortably while you work.

LIGHTING

To avoid glare and reflections, arrange desk-lamps so that they do not shine directly onto the monitor screen. Some lamps are specially designed to prevent this. Position the screen so that it does not face a light source such as a window or lamp. If lighting is problematic, you can buy a hood, or make one from black card, to block out light.

STORAGE

Make sure you have safe storage for all your data files. Any magnetic-based media such as hard disks and zip disks should be stored at least 30cm (12in) from strong magnetic fields. These are produced, for example, by monitors and speakers.

Basic equipment
This diagram shows most of the items that you need in a digital-photography workspace. Some of these are essential if you work with prints and transparencies.

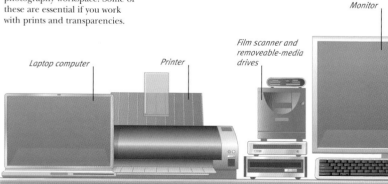

Laptop computer

Printer

Film scanner and removeable-media drives

Monitor

AVOIDING INJURY

It is unlikely you will work the long hours that can lead to repetitive strain injury (RSI) from excessive typing or use of the mouse, but you should still be careful. Many computer users do, however, suffer from eyestrain and back pain so it is worth taking precautions. Monitor and listen to your body. If something starts to ache or feel uncomfortable while you are working, it is time to make adjustments or stop what you are doing.

• To avoid backache, do not work at the monitor for more than one hour at a time. Take a break, get up and walk around. After two hours' work, get up, stretch, and take a longer break.

• To avoid eyestrain, look out of the window at distant objects every hour or so. Do not take a break by watching television as this exacerbates eyestrain problems.

• Keep your equipment clean and well-maintained. Sticky mice and dirty monitor screens or keyboards can all add to stress and strain in a subtle way.

Correct posture
When working at a computer for long periods, posture is very important. Make sure your chair and desk are set at the correct heights and the screen and keyboard correctly positioned, as shown in this diagram.

ELECTRICAL ARRANGEMENTS

Most computer peripherals draw a relatively low current at low voltages compared to domestic appliances. This is fortunate as the peripherals for a modest workroom easily sprout a dozen power leads all needing electrical outlets to plug into. If in any doubt about electrical issues, seek advice from a qualified electrician. Do not be tempted to undertake electrical rewiring yourself. Avoid wiring more than one appliance into a single plug or replacing a blown fuse with one of a higher rating. To avoid a loss of data or a computer crash, do not plug a device into a computer or other peripheral that is half-way through an operation. This is usually indicated by a flashing or lit light, or by noises indicating that it is running. To help protect your computers from electrical damage, use plug adaptors fitted with either surge protectors, which stop large rises in current, or spike suppressors, which stop sudden rises in voltage.

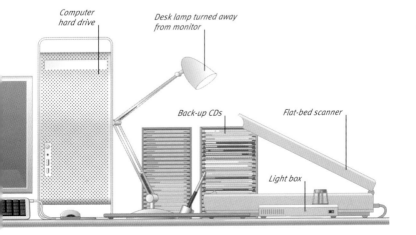

Computer hard drive

Desk lamp turned away from monitor

Back-up CDs

Flat-bed scanner

Light box

Transferring and storing digital images

One of the most radical effects of digital technology is the way in which it has unfolded space and time for the photographer. Whereas a strip of film or a print can be in only one place at any one time, the digital image can be stored in a million places at once and can be accessed at any time. The process of digital transfer and storage is central to modern digital photography.

Digital transfer technology

There are a variety of ways to transfer digital files from camera to computer. There are two industry standards based on cabled connectors: USB (Universal Serial Bus) and FireWire (IEEE 1394 or iLink). In addition, there are increasingly popular wireless methods based either on infra-red communications, which require both items of equipment to be in line of sight, or radio-based methods such as Bluetooth. One of the main issues regarding connections is compatibility, in other words, whether the camera or other equipment can communicate with the computer or another device such as a printer. This is ensured by using equipment that complies with internationally agreed standards. The other key issue is the transmission rate, or speed of communications. Maximum transmission rates are not always reached and do not always mean that less time is needed for a task to be completed. Most modern systems will handle data at rates that are adequate for the majority of purposes.

CONNECTIONS AND PORTS

The two main types of connections are USB and FireWire. USB has become the standard connection for both PC and Apple Mac users. FireWire is the connector of choice for high-speed downloading. Modern cables, such as USB, USB 2.0, and FireWire, can be connected and disconnected while devices are switched on (usually shown by a warning light), but you should never disconnect a device while it is actively working, for example copying data.

Different endings
The industry standards, such as USB, can make use of four or more different endings, depending on whether strength, size, or convenience is the priority. Ensure that you use the correct ending for the socket on your device.

SCSI USB USB Parallel port

FireWire adaptors
A kit of different connectors for the FireWire or IEEE 1394 system is a useful stand-by.

USB hub
A USB hub enables you to connect more than one device into a single USB port.

High-quality connector
Gold-plated connectors such as these are more reliable than standard types.

PICTURE STORING ON THE WEB

One important innovation introduced by the Internet is remote data storage. This means that your valuable images do not have to reside on a hard disk on your premises; they can instead be stored in systems which are secured against loss.

Storing images on a website, such as those run by Apple or Kodak, keeps them safe and releases space on your computer. Perhaps the most revolutionary aspect of this facility is that you can store new images or access old ones from anywhere in the world.

MEMORY CARD READER

A simple way of transferring images to a computer is by using a memory card reader. Many are specific to particular card types, while others will read different kinds of card. With these readers, the memory card can assist in transferring files between computers.

Lexar memory card reader

Card readers such as this model have several slots to enable them to read different card formats from different manufacturers.

Multiple card slots

Colour LCD screen

Control buttons

PICTURE DRIVE

Picture drives are portable hard disk drives used for backing up images from memory cards. They are very useful for storing images and are particularly practical if you are on a long trip, taking lots of pictures.

Elio personal media player

Media players like this one can store music as well as images and even video, and play them all back on a small screen.

PORTABLE HARD-DISK DRIVE

The most convenient portable hard-disk drives are those that are bus-powered (so they receive power via the same cable that sends the data).

Lacie Databank

Smaller than a pack of playing cards, hard-disk drive models such as this can hold between 20GB and 40GB of data.

Single cable carries power and data

Status light

Stackable or rack-mountable casing

DESKTOP HARD DISK DRIVE

Desktop hard disks can hold an enormous amount of data. They can run faster than more portable models and offer much greater capacities – 200GB and more are now commonplace and surprisingly affordable. It is always wise to have a second hard disk to back up the first.

Lacie D2

The elegant, streamlined design of this model makes it a style statement as well as a highly functional device.

Converting film to digital

Digital technology has opened up new pathways through the creative process, bringing exciting new opportunities to photographers. It is now possible to start with film and convert to digital by scanning the image, make changes, and then create a print. Scanning is essentially capturing an image, so it calls for the same care as the original photographic process.

Scanning images

Scanning is central to the conversion process. The original image is systematically "examined" by the scanner so that the colour values can be recorded. This turns a physical object, the print for example, into a virtual object, the digital file. Once in this form, a computer can display the data as a digital image, which is made up of pixels. Image manipulation involves changing these pixels, making any single one or group of them lighter, darker, more blue, less green, and so on. Before scanning, always ensure that you dust the originals with special brushes or blow them with air. (Never blow on them as your breath contains moisture.) Align the original images carefully to avoid having to rotate them digitally and remember to crop off any unwanted margins before undertaking image manipulation.

TYPES OF SCANNER

There are two types of scanner. A modern flat-bed scanner shines light onto the original and reads the reflected light, while a film scanner shines light through the original and reads the light transmitted through it. The flat-bed scanner is most widely used, being suitable for prints, printed matter, and even flat solid objects. It looks much like a photocopier and works in a similar way. The original is placed face down to scan. The film scanner, sometimes called a transmission scanner, is more specialized as it is only used for scanning film, either in negative or transparency form. It gives the best results for 120mm format roll and 35mm film or smaller, and is the ideal way to convert a collection of film originals to digital form. Some flat-bed scanners can also scan transparencies or film using accessories or a light-panel built into the lid. These are best used with larger film formats. Be aware that the conversion of analogue to digital is susceptible to electrical interference and the scanning process itself is sensitive to vibration and noise, all of which reduce scan quality.

Flat-bed scanner
The first scanners were huge industrial machines that gave poorer results than small modern versions. Typical of modern designs, this model can scan originals up to A4 in size to resolutions greater than 3,000 ppi (points per inch), yet it is no larger than a telephone directory.

Film scanner
Modern film scanners accept mounted and unmounted transparencies or individual strips of film and offer resolutions of 4,000 ppi (points per inch) or more. Additionally, these scanners produce much better results than any type of flat-bed scanner.

HOW A FLAT-BED SCANNER WORKS

A flat-bed scanner can reproduce an original photograph by reflection scanning, or a transparency or film by transmission scanning when using a transparency adapter. The basic principle of scanning is that sensors measure the changes or variations in light intensity in the original against a standard light source. The changes are caused by the details in the original image, so they accurately represent those details. The variations in intensity are converted first into electrical data, then changed into digital data, which is used by the scanner software to create a "map" or true representation of the original.

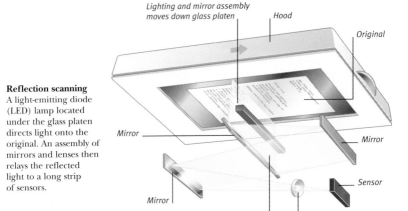

Lighting and mirror assembly moves down glass platen

Hood

Original

Reflection scanning
A light-emitting diode (LED) lamp located under the glass platen directs light onto the original. An assembly of mirrors and lenses then relays the reflected light to a long strip of sensors.

Mirror

Mirror

Mirror

Sensor

Light path Lens

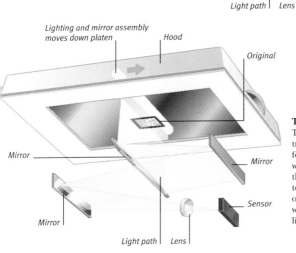

Lighting and mirror assembly moves down platen

Hood

Original

Transparency scanning
This diagram shows a transparency adapter for a flat-bed scanner, where light is shone through the original towards an assembly of mirrors and lenses, which then relay the light to the sensors.

Mirror

Mirror

Mirror

Sensor

Light path Lens

CHECKING FILE SIZE

Once scanned, the image can be saved as different file sizes, depending on the print size needed. This table shows the preferred size of an open, uncompressed RGB file to be suitable for various sizes of print reproduction. These file sizes are generous for inkjet printers so it is worth making a trial print to check quality.

Size	mm	Approx inches	MB
A0	841 x 1,189	33 1/8 x 46 3/4	150
A1	594 x 841	23 3/8 x 33 1/8	100
A2	420 x 594	16 1/2 x 23 3/8	75
A3	420 x 297	16 1/2 x 11 3/4	50
A4	297 x 210	8 1/4 x 11 3/4	25
A5	210 x 148	5 7/8 x 8 1/4	13
A6	105 x 148	4 1/8 x 5 7/8	6

Image manipulation software

Central to digital photography, image manipulation software gives you almost total control over your images. However, before you can benefit from these programs, you need to master them. Start with a simple software package that covers the basics including exposure, colour, and size adjustments, and a few special effects, before tackling more advanced programs.

Choosing software

The majority of digital cameras and scanners, and many computers, are sold with entry-level image manipulation packages, so it is unlikely that you will need to buy any software to begin improving and adjusting your images. However, as your skill and interest develop you may require more features than such basic software will provide.

When choosing a program, make sure both you and your computer can cope with its technical demands. Remember, less powerful software requires less memory and can therefore run more quickly, and is easier to master. Older versions of a software program can be a lot cheaper than the latest editions and still give satisfactory results.

SCRAPBOOKING

Creating a digital scrapbook is a fun and easy way to preserve your memories of a special occasion or event. A specialist software package such as Photomix (and, increasingly, standard image manipulation software), allows you to combine your photographs with other pieces of ephemera such as theatre tickets and greetings cards. It also helps you to lay out pages quickly and generates decorative elements such as textures and wallpapers.

Scrapbook page
A typical page is created on 30cm x 30cm (12 x 12in) sheets: it can be digital or a collage. This is a title page for a scrapbook on a trip to Morocco.

MID-LEVEL SOFTWARE

Today's mid-level software can offer features that were until recently only available at a professional level. In addition to the basic features, which carry out adjustments to exposure, contrast, colour, and size, as well as manipulations such as cloning and painting, this type of package will give the option to work with layers (*see pp.176–77*) and an extensive choice of filter effects (*see pp.170–71*). In addition, it will be capable of creating panoramas, versatile print options, and web pages, as well as offering ways in which to manage your collection of images.

Adobe Photoshop Elements
This is a powerful application that is capable of all but the most sophisticated image manipulations.

Roxio Photosuite
A popular picture-editing program, it offers automatic features, such as project templates and slide-shows.

Arcsoft PhotoStudio
This package provides a range of image correction tools, as well as many special effects such as 3D lettering.

ADVANCED SOFTWARE

More costly to purchase and requiring more time and effort to master, advanced software packages are designed to meet the needs of the professional user, giving full control over colour management, advanced cloning, and painting tools. The software programs shown below give you a greater ability to manage the way you work as well as accepting a much wider range of file types.

Adobe Photoshop
A fast-working and highly customizable image manipulation software package, this program is widely supported with handbooks.

Corel Paint Shop Pro
This program has filters for correcting problems common in digital camera images, RAW image conversion, and more advanced artistic effects.

CorelDRAW Graphics
A package of illustration, page layout, animation and image manipulation software, this program incorporates many extras such as clip-art.

SPECIALIST SOFTWARE

As your skills and needs develop, you may wish to progress to more specialist software. It may be important to you to have an efficient and speedy way to review and manage your images. Alternatively, extending your artistry or archiving your images may be priorities. Whatever your needs, using the right software for the job can make the creative process easier and more manageable.

Adobe Photoshop Album
If you have a lot of images, this type of asset management software is an essential aid to managing, naming, and annotating your photographs.

Extensis Portfolio
A powerful application suitable for web-based operations: this software is a useful image database with many search options.

Roxio Toast
For archiving images it is best to use software designed for making CDs or DVDs. Toast is the easiest software to use for burning discs.

ACDSee
This fast-working image management program allows you to browse and organize large quantities of digital images.

Corel Painter
The Painter application provides powerful digital tools for producing graphic effects that mimic art materials.

Frozen lake and herd
For this image, a winter landscape was reflected
on itself and superimposed over an image of a
building, then a herd of goats was added.

Controlling size, shape, and brightness

The image file size sets a limit on the quality of the print you can produce. Since large files tend to be slower to work with, it may be best to reduce the file size. Cropping the image removes unwanted margins of the picture and can also change its shape and alter the composition. Brightness may also need to be worked on after these adjustments have been made.

Selecting image size

The size of a digital image sets the limit of the reproduction size. The bigger the image, the more data it holds, so the larger it can be printed. When prints reach poster size (A2 and larger) there is a tendency to view the image from farther away. As a result, large prints may need less data than their size suggests.

IMAGE SIZE

The Image Size dialogue is where changes to image size, output size, and resolution are made. The example below (from Photoshop) is typical. Avoid using this control to increase image size to more than double the original, as quality may disappoint (*see Checking File Size p.159*).

This shows the uncompressed file size.

The Output Size is set to give the size of print you need.

If this box is ticked, the ratio of length to width of the image is automatically maintained.

If this box is ticked, the file is interpolated to produce a different number of pixels.

This button is clicked to accept the changes. The process may be slow if the file is large.

The original image size is measured either in pixels or as a percentage.

Output Resolution determines the number of pixels required for printing (300 ppi is usually ample).

The Interpolation Method is used to suit the image. Bicubic is best for photos.

CROPPING IMAGES

If you want to change the shape or improve the composition of your image, cropping can remove unwanted areas. A crop can be a modest tidying or can create a radical change in composition. If you make a substantial crop, check that the image still has sufficient data for the size and type of print that you wish to produce.

Original shot
The photograph of cattle in the late afternoon sun is full of strong horizontal lines. It is easy to miss the figure of the lone cattle-herder. A crop may show less but tell more.

Letter-box crop
A severe crop of the original image helps to emphasize the lines of the hillside as the gradient changes. It also draws attention to the tiny figure of the cattle-herder in the top right.

Adjusting brightness

One of the major technical problems in traditional photography was adjusting exposure after image capture. In image manipulation, there are now a number of methods to compensate for errors in brightness. The Brightness/Contrast control is easy to use but can adversely affect image quality by losing image data. The Levels control (*below*) offers the best balance between ease of use and quality preservation. Automatic adjustments can give good results on an almost perfectly exposed image but can do little to improve poor quality ones.

IMAGE BRIGHTNESS CONTROL

Altering brightness in a captured image changes the overall shade of the image and qualities such as colour and contrast. Images obtained by increasing or decreasing exposure when making the shot will look subtly different to alterations made using the Brightness Control. Choosing to change image brightness at the time of exposure or after depends on the visual effect you wish to obtain.

Original image
With correct exposure parts of the subject can be too dark and some too light.

Brighter image
Increasing brightness overall renders shadows full of detail and makes highlights too light.

Darker image
Reducing brightness intensifies mid-tone colours but shadow details are lost.

LEVELS CONTROL

This control is centred around a display that shows how many pixels of a certain brightness are in the actual image. It monitors the levels of pixels, measuring their relative brightness. A peak to the left indicates a dark image, while a peak to the right indicates a bright image.

If the Mid-tone input level shows a figure less than 1, the image is darkened. If higher, it becomes brighter.

Colours can be adjusted separately or at the same time.

This pointer slides to the right to make pixels darker.

The Output Black is used to prevent pure blacks from being printed.

The Mid-tone Slider is the safest way to change the brightness of your image.

This pointer slides to the left to make pixels brighter by turning already bright pixels into pure white.

This button saves time by allowing you to re-use a previously saved setting.

This button is clicked to save the settings; give them a name that reflects the change.

Auto is used for quick corrections. A big change in brightness usually means more sophisticated manipulation is needed.

When this option is ticked, you can see the effects of the image manipulation.

The Output White control is used to prevent pure whites from being printed. For most purposes it should be set between 245–250.

Levels

Channel: RGB
Input Levels: 0 0.74 255

OK
Cancel
Load...
Save...
Auto
Options...

Output Levels: 0 255

Preview

Controlling colour

Accurate rendering of colour could once only be achieved by highly skilled technicians using precise chemical processes. Now, in the digital era, colour processing is built into the circuitry of cameras, enabling them to work in varied conditions and still reproduce colours accurately. Any further colour modifications are then easy to make with image manipulation.

Adjusting colour

The Color Balance control provides the easiest method of ensuring that colours are reproduced accurately. Digital cameras render whites untinted or pure, which, in turn, renders all colours accurately. This process is known as "adjusting the white balance". Some digital cameras allow you to use pre-set values but it is useful to be able to refine colour balance with software.

COLOR BALANCE

The best-known Color Balance control is that of Photoshop, which is most effective for small adjustments. You must first assess the image carefully: does it have an unnatural colour cast, say green or cyan? One small movement of the slider can give an instant correction.

Colour adjustments can be set by numerical value, which is most useful for correcting a sequence of images taken under the same conditions.

The preview option should be ticked or you will not see adjustments until you click OK.

The colour adjustment slider moves between red, green, and blue and their complementary colours cyan, magenta, and yellow.

Clicking OK saves the image when you have finished.

Primary hue bands have broad ranges, which are sufficient for most purposes.

Shadows restricts changes to the important shadow tones. As these carry density, small changes can have a large effect.

Highlights restricts colour adjustments to the three-quarter or highlight tones. Light colours will not show much change in Color Balance.

The Preserve Luminosity option maintains overall brightness.

Midtones is selected by default, and restricts colour adjustments to the tones lying between highlights and shadows.

Color Balance

Color Balance
Color Levels: -16 0 0
Cyan ——————————— Red
Magenta ——————————— Green
Yellow ——————————— Blue

OK
Cancel
☑ Preview

Tone Balance
○ Shadows ● Midtones ○ Highlights
☑ Preserve Luminosity

Ambient light
Correction is often needed for a shot taken with indoor lighting. This image is almost acceptable but highlights are slightly yellow.

Ambient light corrected
By increasing the blue using Color Balance and correcting brightness levels (*see p.165*), the yellow cast is largely removed.

CHANGES IN COLOR BALANCE

Images with an overall tint or pale colour cast of any hue (but most commonly yellow or blue) may be made neutral though a correction of the colour balance. This is commonly achieved by ensuring that white, grey, or black areas are devoid of colour.

Removing a tint from a grey patch, for instance in the metal utensils in the images below, automatically corrects the overall colour balance. Alternatively, you can change the colour balance in order to give your images a specific mood or feel. A red cast, for example, will add warmth.

Mixed light original
This interior is mainly lit by sunlight streaming through the window but there is also some additional light from indoor lamps.

Crossed correction
This image results from forcing the highlights to maximum blue, the shadows to maximum yellow, and mid-tones to slightly magenta.

Red cast
A slight red cast may make the image appear warm, but highlights will be pinkish while blue skies or leaves may appear a little dull.

Magenta cast
A common white-balance error leads to a magenta cast, which combines blue and red. This may dull a wide range of colours.

Green cast
Even if only very subtle, a green cast is easily spotted. It is particularly unwanted with skin tones, tending to make them muddy.

Yellow cast
A heavy yellow cast may look slightly unnatural but can still be attractive. Removing yellow may make the image look more dull.

Blue cast
A blue cast, while sometimes desirable, can make the image too cold. Removing a blue cast can also brighten the image.

Cyan cast
A slight cyan cast results in a dulling of warm colours. Just a small adjustment can make a significant improvement.

Adjusting sharpness

Until the advent of digital photography, each step of the photographic process tended to reduce the sharpness of detail in an image. In fact, a great deal of photographic practice was directed at minimizing this loss of detail. The arrival of image manipulation software has initiated significant advances, including the power to adjust an image to make it look sharper than it really is.

Sharpness and resolution

Photographic sharpness is dependent on the ability of a photographic system such as a camera, scanner, or enlarger to separate out detail so that it becomes visible. This ability is known as "resolving power" and there are defined methods for measuring it. The term "resolution", when used in connection with digital photography, is different to resolving power: it refers instead to the capacity of a camera or image to hold information or retain data. Resolving power and resolution are linked, in that more data is needed to record more detail. So, higher resolution cameras or files are needed to attain high resolving power.

INCREASING SHARPNESS

If a boundary is more defined, it appears sharper. The main control for increasing sharpness in image manipulation is the Unsharp Mask (USM) command. This works by searching for boundaries or edges and then slightly exaggerating the differences.

Clicking OK applies the changes. On large files, the change will take several seconds to complete.

If the Preview option is ticked, it allows you to view the change to the image. This can slow down operations and is not strictly needed, so it can be turned off to speed up work.

The preview window shows the result of applying the change. On some software, such as Photoshop, clicking on the window shows the unchanged state.

Unsharp Mask

OK

Reset

☑ Preview

50%

Amount: 142 %

Radius: 2.8 pixels

Threshold: 13 levels

View the image at 100% for the best results. At other magnifications, the monitor image does not give such an accurate representation of the pixel structure.

Start with an Amount setting of between 50 and 150. A setting of 111 is simple to make, or use the slider to adjust.

Set a small Radius (see opposite) if there is fine detail. Set a larger Radius if there are large areas of uniform tone. This parameter has a significant effect, so use it carefully. A very small Radius with a large Amount setting is often used to tidy up artefacts in digital camera images.

The slider is pulled to the left or right to set different amounts of change in each of the settings. Avoid using this to adjust Threshold as small changes can have large effects.

The Threshold sets the difference in brightness between two pixels before the Unsharp Mask is applied. Increase this if the image is noisy (that is, has many specks or unwanted dots).

SHARPNESS EFFECTS

Unsharp Mask should be used sparingly. Applying excessive sharpening to an image causes the edge contrast to be exaggerated into haloes, and defects or small details to become too prominent. When applied, sharpening should be only just sufficient to improve details. Some digital cameras apply their own automatic sharpening: turn this off if possible. For images with fine details set an average Amount and a small Radius. For images with hardly any fine detail set a low Amount and a larger Radius. Images used on the web may need a little more sharpening than those used in print.

Original image

USM normal setting
With an Amount of 111, Radius of 1, and Threshold of 11, the Unsharp Mask command lifts the sharpness of the majority of scans and digital images. The Threshold setting can be lowered to increase the effect. This shows the image at 300 per cent enlargement.

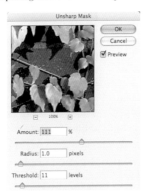

USM large Radius setting
With a large Radius setting of 22, the sharpening effect has extended beyond the boundaries of the selection to include larger areas. This has the effect of increasing contrast overall and can be a way of improving the "sparkle" of an image.

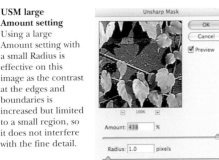

USM large Amount setting
Using a large Amount setting with a small Radius is effective on this image as the contrast at the edges and boundaries is increased but limited to a small region, so it does not interfere with the fine detail.

Filter effects

Digital image manipulation is most dramatically demonstrated with the use of filters that can instantly transform any ordinary picture using fantastic colours and a plethora of distortions and textures. The best use of filter effects is, however, an exercise in balance. While some effects produce subtle changes, others can completely destroy the integrity of the original image.

Controlling filters

Have fun experimenting with the hundreds of variations of filter effects by first trying them out on small files to see the results. Subjects with very simple, clear shapes are the easiest to work with and the most likely to be successful. Filters are less effective with busy images, or those featuring people, since the results can be hard to read.

Original image of a bridge over a river

DISTORTING EFFECTS

Distortions do not change the colour or brightness of pixels. Instead, they change the shape and size of the image by effectively redistributing those pixels. Effects range from the wildly dramatic and complex to the subtle. They are particularly useful for correcting lens defects.

Spherize
Pixels are arranged as if they are wrapped around part of a sphere. This filter is used to adjust slight distortions. Here the bridge is straightened.

Polar Coordinates
When this filter is applied, the coordinates of pixels are rearranged to fit around a globe. It is fun to use because results are unpredictable.

ART MATERIALS

Mimicking the effect of crayons or oil paints, and the textures of different types of art paper, this filter is most useful when used in combination with other effects. It often requires correction of brightness and contrast.

Colored Pencil
Given a contrasty image with strong colours, the Colored Pencil filter can produce passable imitations of pencil work. For even better results, use Corel Painter (see p.161).

STYLIZING EFFECTS

These techniques produce a miscellany of effects, which result in images that are only loosely based on the original. Shapes, colours, structures, and textures can all be manipulated and distorted beyond recognition. Stylizing effects are most commonly used to create abstract images.

Extrude
Using this effect the photographer can quickly create graphic landscapes which are made up of extruded blocks or pyramids.

Difference Clouds
An unpredictable filter, Difference Clouds overlays the image with a random pattern, then applies a Blend Mode (*see p.176*).

TEXTURIZING AND PIXELLATION EFFECTS

By taking a group of pixels and treating them as one, pixellating or texturizing filters change the distribution of colours within the group, while retaining the broad outlines of the subject in the image. The main control is over the size of the group of pixels. Larger groups conceal more of the image's detail.

Stained glass
Suited to colourful, graphic images, this effect is achieved by creating irregular patches of colour surrounded by a neutral border.

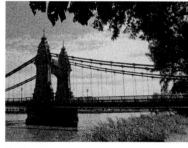

Grain
This effect mimics film-based images of high sensitivity. It is useful for improving the results of lower-quality printers.

Color Halftone
This filter renders the image as it would appear if it were printed using half-tone dots that are varied in size but not in strength.

Mosaic
Imitating and exaggerating the pixellation of an image, this filter is widely used in the media when someone's identity needs to be disguised.

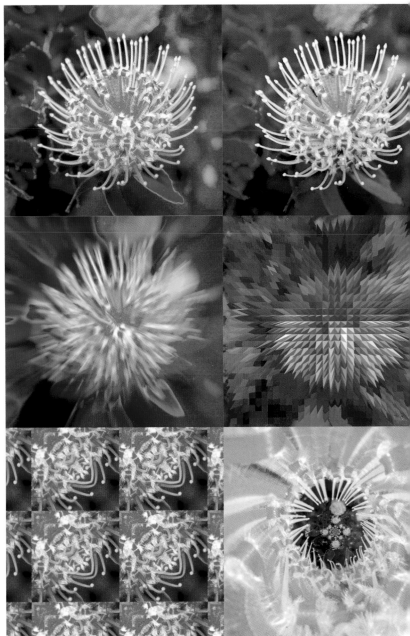

Gallery of effects
Starting with the original in the top left corner, this image was subjected to increasingly wild effects, including distortions, extrusions, tesselation, hue changes, and fractalization.

Selections and masks

Photographers have always sought to manipulate the photographic process in order to improve the captured image. The fundamentals of this procedure have not changed with digital photography, but the ease and accuracy of selecting parts of images in order to copy, cut, or manipulate or combine them with other images has taken a huge leap forward.

Making selections and masks

When parts of an image are selected, any subsequent digital effects or manipulations are confined to the pixels that are included in the selection. The most popular and widely used tool for making a selection is the Lasso, so-called because it "ropes in" an area of pixels. By making a selection in this way, you are also creating a mask, which restricts the area that the manipulation will affect. Masks and selections have, essentially, the same effect, but technically a mask is said to be a greyscale representation of a selection.

DEGREES OF SELECTION

A pixel may be fully selected, partially selected, or not selected at all. The degree of selection at the periphery of a chosen area can be graded, or feathered, between full and partial selection. The practical effect of feathering is seen as a partial application of a change. A selection can accurately follow an outline with sharp angles only if feathering is set to a low or zero figure (measured in pixels). A large feathering value leads to loose selections, with rounded corners. This is shown in the selections on the right, made with the Lasso tool.

Narrow feather
With a narrow area of feathering, the selection tends to be precise, accurately following even small details of the subject's outline.

Wide feather
With a wide area of feathering, the selection cannot be precise, so it may miss, or not fully select, areas with small, sharp boundaries.

MAGIC WAND

A Lasso tool gathers the parts of an image that you indicate, irrespective of the values of the pixels. The Magic Wand is an alternative selection tool. It searches for pixels that are similar to a sampled point on the image, that is, the pixel on which the tool is clicked. This tool is particularly useful for selecting large areas of the same colour, as in the black clothing in the image below.

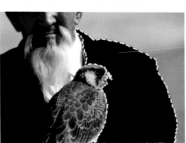

Contiguous selection
When the Magic Wand is used with contiguous selection, similar pixels are selected only if they are neighbouring those sampled.

Non-contiguous selection
With this option, the Magic Wand seeks out all pixels similar to those sampled, so any similar pixel in the image is selected.

EXTRACT

One of the most common image manipulation tasks is the separation of a subject, typically a portrait sitter, from a distracting or unwanted background. The various specialist software programs all work on similar principles. The transitional edge or boundary of the subject must be defined by an outer margin and an inner margin before extraction can take place. The task is technically much more difficult if the subject has fine, blurred margins such as hair or fur. Semi-transparent objects such as glass bottles are also challenging photographic subjects.

Portrait before extraction
You may want to remove the person in the background of this portrait since they draw the eye away from the main subject.

Defining the edge
The broad green line is the first stage in masking out the distracting background behind the main subject.

Defining the area to be kept
By filling in a contiguous area, you tell the software which area to keep, and which area to mask off.

Extraction
When the subject is extracted, as above, it can then be placed on a different background (*see pp.176–77*).

COLOR RANGE

A close relative of the Magic Wand command is Color Range, a quick, efficient, and powerful tool for making selections. It selects colours right across the image according either to a sampled colour (it then works in exactly the same way as Magic Wand) or a band of colour (which is chosen from a drop-down menu). The Fuzziness slider enables you to adjust how precisely similar the selected colours are to the sampled or chosen range.

Original image
Assume we wish to extract these pink flamingoes from the background.

Color Range masked
After applying the Color Range control, you can mask the background (in blue).

Separating the elements
With the image separated into two parts, you can apply different effects to each.

Layers and blends

One of the most creative techniques digital technology has given the photographer is the ability to work with layers of images blended in different ways. The number of image layers is limited only by your computer's memory and your artistic needs. The interactions between layers can be highly complex, visually intriguing, and artistically challenging.

The depth of an image

Before digital manipulation became commonplace, the depth of an image was rarely considered except in a metaphorical sense. Now, an image can have "depth" by virtue of layers. Images can be combined and laid over one another, and image manipulation can control how much of each image is allowed to show through. A high opacity shows little through from below, while low opacity reveals more. (The opposite measure – transparency – is also used sometimes.) Even combining just two layers can produce unexpected and interesting results, and contrasts, colours, and composition can be altered. Furthermore, a different blend mode can be applied to each layer.

LAYERS PALETTE

The various layers of a photograph can be managed in the Layers Palette of an image manipulation application (the illustration below shows a number of the basic features). It should normally be possible to rearrange the order of layers by clicking on them and dragging them to a new position.

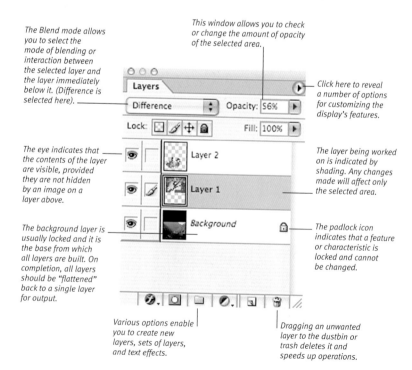

The Blend mode allows you to select the mode of blending or interaction between the selected layer and the layer immediately below it. (Difference is selected here).

This window allows you to check or change the amount of opacity of the selected area.

Click here to reveal a number of options for customizing the display's features.

The eye indicates that the contents of the layer are visible, provided they are not hidden by an image on a layer above.

The layer being worked on is indicated by shading. Any changes made will affect only the selected area.

The background layer is usually locked and it is the base from which all layers are built. On completion, all layers should be "flattened" back to a single layer for output.

The padlock icon indicates that a feature or characteristic is locked and cannot be changed.

Various options enable you to create new layers, sets of layers, and text effects.

Dragging an unwanted layer to the dustbin or trash deletes it and speeds up operations.

BLENDS

Control of the blending modes is invaluable for combining images because it gives you almost unlimited versatility with tonal effects. Choosing a blend mode can reveal details and visual interactions that would otherwise remain hidden.

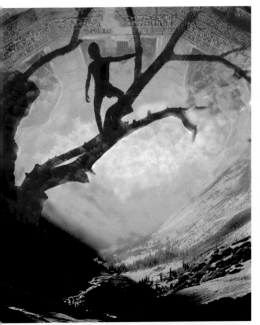

Composite with blends
The main image (*left*) was created by combining the top two images (*above*) in Exclusion mode, then merging the result with the bottom image.

Blend normal
A normal blend (100 per cent opacity) reveals nothing. Here, the opacity is set at 50 per cent, so that both layers can be seen.

Blend darken
Choosing this mode ensures that only the parts of the upper layer that are darker than the lower layer show through.

Blend lighten
Here, only those parts of the upper layer that are brighter or lighter than the lower layer show through.

Blend color
Subtle colouring is possible when colour values for the top image are added to the grey-scale values of the lower layer.

Blend soft light
The effect here is similar to projecting two images onto each other. It imitates a traditional double exposure.

Blend vivid light
With overlapping dark areas made darker and bright areas made brighter, the effect is an overall increase in contrast.

Printers

One of the best-buy products of the digital era is the modern inkjet printer. Its relatively low price belies the fact that, in effect, an entire print factory is contained in a compact box that can sit on your desk. With just a small investment, you can replace a colour darkroom or printing press. All you have to do after that is buy ink cartridges and paper.

How printers work

The best, and most costly, method of printing images is with dye sublimation: a solid dye is heated up until it turns into a tiny cloud of gas. This gas travels to the special receiving paper where it solidifies as a small, diffused dot. This diffusion is the key to dye sublimation's close resemblance to a photographic print. Laser printers use a laser beam to write a pattern of electrostatically charged dots that are transferred to paper through heat and pressure. They are faster and neater for printing text but give inferior results when printing pictures. The most popular and versatile printers are the inkjet printers. An inkjet is any printer that squirts ink from tiny nozzles onto paper. One of the most popular printers using this technique is the bubble-jet printer (*see below*).

BUBBLE-JET PRINCIPLES

Instruction from the software turns on a heating element to vapourize the ink behind the nozzle. The heated ink bubbles up and is forced out of the nozzle. When the heat is turned off, the bubble collapses and the ink separates and drops. When this happens, fresh ink fills the reservoir.

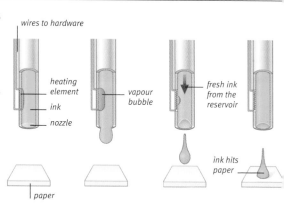

PRINTING IN BLACK AND WHITE

It may seem perverse to use colour technology to produce black-and-white prints but, thanks to the use of dark inks, inkjet printers can give superb results that easily rival silver-based prints. In fact, inkjet printers gave the photographer the first true blacks in prints, which were previously only obtainable with industrial-scale printing.

In colour
While the colours in the original image are acceptable and accurate to the scene, they may romanticize the heat, dust, and hard life. Colour may be removed in different ways, including changing the image to greyscale, and desaturating the colours.

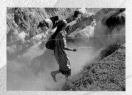

In black and white
Turned into a black-and-white image, the picture is transformed from a pretty travel shot into a harsher, grittier image. A black-and-white image may print best when left as greyscale, but if you want to tint the image, its mode should be changed to colour.

Choosing a printer

A range of printers is available to satisfy the requirements of both the amateur in need of the occasional colour print and the serious photographer printing for sale or exhibition. Some machines also combine other functions, such as scanning and faxing. The first consideration when choosing a printer is how large you want to print. The majority print to a maximum of A4. Some print A4 without a border with the image going right up to the edge of the paper, others leave a small white margin. If you intend to make many prints, choose a printer with separate colour cartridges rather than one that combines several in one cartridge. For optimum results, use papers of the best quality possible. There is a very wide range of types and surfaces available, from hard metallic gloss through semi-matt to canvas-patterned.

MID-RANGE PRINTER

A mid-range printer can produce photo-quality prints to modest sizes and is capable of giving a very satisfactory service. Some models can print directly onto CDs and DVD discs and others can take a roll feeder to produce banner-sized prints.

Paper support

Borderless print

Epson R200
This model has six colour photo inks, a resolution of up to 5,760 x 1,440 dpi, and prints borderless photos in three standard sizes.

MULTIFUNCTION PRINTERS

Multifunction machines are useful when you need to save desktop space as they can combine scanning, copying, and printing.

PORTABLE PRINTERS

These are very useful if you need to work away from home or the office. Some models can be powered with a battery.

DYE-SUBLIMATION PRINTER

Such printers make small but realistic photographic prints. Many read SmartMedia and CompactFlash cards without the need for a computer.

Epson CX6600
The printer, scanner, and copier flexibility of this inkjet unit makes it a popular choice. It gives excellent print quality.

Canon i80
The print speeds are adequate, with quality (4,800 x 1,200 dpi) that is above average for a portable inkjet machine.

Olympus P400
Although the output resolution of 314 dpi seems low, this printer gives very good results.

Creating the perfect print

A perfect print is one that conveys your own particular artistic message with
good detail and accurate colour, and without any unwanted effects. If you insist
that a final print bears an absolute likeness to your original subject, or even
what appears on your monitor, you are likely to be disappointed. The key
to making perfect prints lies in managing your expectations.

Modern systems

Images obtained from a modern
digital camera or scanner will print
with satisfactory results on a modern
printer, without modification. Results of
greater depth and quality are possible,
but only by using image manipulation
software, and assessing the image on
your own monitor. This bypasses
standards built into cameras and
printers. This means you have to
control and manage colour settings
yourself, which can be quite complex.

COLOUR MANAGEMENT

Colour information can be translated from
one device, such as a computer monitor, to
another, such as a printer, to ensure
that colour is output in a consistent way.
Colour management is based on a common
set of colours known as the "profile
connection space". The way in which any
particular device handles colour is defined
by the differences between its own set of
colours, which is called the colour space,
and that of the profile connection space.

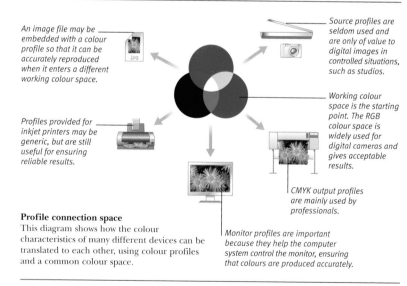

An image file may be
embedded with a colour
profile so that it can be
accurately reproduced
when it enters a different
working colour space.

Source profiles are
seldom used and
are only of value to
digital images in
controlled situations,
such as studios.

Working colour
space is the starting
point. The RGB
colour space is
widely used for
digital cameras and
gives acceptable
results.

Profiles provided for
inkjet printers may be
generic, but are still
useful for ensuring
reliable results.

CMYK output profiles
are mainly used by
professionals.

Profile connection space
This diagram shows how the colour
characteristics of many different devices can be
translated to each other, using colour profiles
and a common colour space.

Monitor profiles are important
because they help the computer
system control the monitor, ensuring
that colours are produced accurately.

CALIBRATING THE MONITOR

It is essential that your monitor is set up to
meet industry standards so that it is correctly
calibrated. Your computer's standard
software will give you a way, through control
panel or system preferences, to calibrate the
screen using simple visual controls. Look up
the Help sections of the operating system
software for instructions. You may encounter
conflicting advice or be given choices. The
correct settings are those that give you
reliable results when using your printer. If
it is set up correctly, you will avoid errors
and save on ink cartridges and paper.

MONITOR SETTINGS

You assess your images by viewing them on your computer's monitor, so it is vital that you monitor displays your images with accurate colours, at the correct brightness and contrast. If, for example, your monitor image is too dark, you will tend to make your image brighter to compensate. This could result in your prints being too light. Common standard settings are shown below.

D50 white point
The D50 or 5,000K white point is a paper-white as seen under light from a bright tungsten-halogen lamp. This standard is used in the printing industry.

9,300K white point
The 9,300K white point is used in TV sets and produces good colours but is a poor white point for checking colour accuracy.

Gamma 2.2
The gamma of a screen measures the way the image is projected: the standard is 1.8 but a 2.2 gamma setting gives richer mid-tone colours.

CHOOSING PAPER

For good results with printing use the best paper you can afford. Those with weights greater than 180gsm (grams per square metre) are generally the best, although thinner papers with high-quality surfaces can give good results. Papers with glossy surfaces produce the greatest contrast between whites and blacks, and the most brilliant colours. Matt-surfaced papers give more subtle contrasts and colours.

PRINTING HINTS

Check the document or print set-up before you print to ensure the image is at the output size required. Use the printer's highest quality or highest resolution and lowest printing speed settings for optimum results. It is also advisable to test the paper in your printer, even if it is from the same manufacturer, to ensure they are compatible.

Printing even skies
If your printer cannot print large areas of even colour, such as the sky in this scene, try applying a little noise to the image by using a filter effect. This scatters ink-dots randomly, disguising unevenness in printing.

Printing a night scene
Printing dark images can consume large amounts of ink. By reducing the black output level, you not only reduce the amount of ink needed but also avoid the problem of ink "pooling" on the paper.

ELEMENTS OF
PHOTOGRAPHY

THE FOUNDATION OF ANY IMAGE IS ITS TECHNICAL QUALITY. WHILE THE LEGENDARY PHOTOJOURNALIST EUGENE SMITH CAUTIONED "WHAT IS THE USE OF ADEQUATE DEPTH OF FIELD IF THERE IS NOT ADEQUATE DEPTH OF FEELING?" IT IS EQUALLY TRUE THAT A PICTURE OF POOR QUALITY HAS TO WORK HARDER TO COMMUNICATE.

Technical quality is a complex of several elements – composition, focus, exposure, and tone. Composition determines the way in which different parts of the image are arranged in relation to each other. Focus can be pin-sharp or blurred to give different artistic effects. Exposure sets the overall brightness of the image. Tone defines the way in which light from different sources interplays with the subject and is rendered in the image. A further dimension to technical quality is the level of "noise" or unwanted information, such as the grain of film or the artefacts on a digital image.

No single element is more important than any other, but the most successful images are those in which perfect or intriguing composition is allied with precise focus and appropriate depth of field, pin-point exposure, and accurate tones supported by clean, clear reproduction. If one of these elements is

Sharp focus
Accurate focusing was important for this image, making it sharp throughout.

seriously defective, or causes the image to be unbalanced, the image could be ruined. Perhaps the single element that can do the most damage is exposure. It can wreck perfect composition and focusing, and reduce the overall brightness and accuracy of tones. Similarly, every other element could be in perfect balance, but if the noise or grain is excessive, details may be obscured and subtlety in tonal values destroyed.

This chapter contains simple techniques for improving your command of these four basic elements. But if you try to remember every technique, you may lose the ability to take in your surroundings, or worse, suffer from shutter-finger paralysis. To help you, follow the "Three Ps" of Photography – Practice, Pre-visualize, and Project.

Practise using your camera and equipment regularly, as you would if you were learning a musical instrument or sport. Use the dials and controls until it becomes second nature. Learn which way to turn controls to set the options or modes you use most often.

Perfect composition
The bridge and its reflection in the canal are used to frame the image. This draws the eye into the centre of the scene.

Pre-visualize the result. Imagine the picture you want to make, such as a tonally rich print or a luminously coloured portrait. At first you may find it almost impossible to capture the image exactly as you imagine it, but each time you try again, you will get closer to your vision. Having a vision will help you to coordinate your actions with your thoughts, which will help you to master the photographic process.

Finally, choose a photographic project or idea to help shape the way you go about your photography. It could be as simple as showing off your garden, or exploring local history. Whatever your project, you will find it useful to have a target at which to direct your efforts.

Reflected view
Photography encourages experimentation with viewpoint – this shopping arcade (*right*) is revealed through a reflection.

Time exposure
An understanding of the photographic process will enable you to create images not available to any other visual art form. For this picture, Ernst Haas (*see pp.46–47*) set a long exposure that allows the moving cars to be "smeared" across the film, while static elements remain sharp.

Subtle tones
This image shows a good eye for colour and composition. The blues and greys complement each other and the tones are well balanced.

Visual tricks
It is fun to experiment with compositions – here Raghubir Singh (1942–99) creates an interesting image by framing through a car windscreen.

The art of composition

It is easy to let concerns about composition inhibit your photography rather than improve it. The problem is that the art of composition is too often presented as a set of rules, which implies that unless you follow them your photographs are doomed to failure. The truth is, in fact, the opposite. Slavish adherence to rules can suppress your personal and creative response to what you see and experience.

Understanding structure

If you analyze the structure of a photograph or painting that you find appealing, you will usually discover that it conforms to one of a number of basic, simple patterns. These help organize the picture into static elements, which have a stabilizing effect, and active elements, which suggest movement or tension. A successful composition often arises from the interplay between the static and active elements in the picture. There are, however, no hard-and-fast rules to the art of composition, only guidelines.

BALANCING THE ELEMENTS

Successful compositional patterns balance all the elements within a picture. One example of compositional structure is the rule of thirds, in which the key elements lie on dividing lines, either horizontal, vertical, or both. Other successful patterns use symmetrical, diagonal, or radial lines to lead and hold the eye (*see opposite*). Radial patterns can be simple, like a cross, or more complicated, with many lines of composition running through the image and converging. The point of convergence may be off-centre, which usually adds dynamism, or it may be closer to the centre, where it tends to ground or stabilize the picture.

Horizontal thirds
This Tuscan landscape (*above and below*) falls naturally into thirds of skyline, background, and foreground. The colours, ranging from soft blue to vibrant green, emphasize the composition.

Diagonals

The diagonal line running from the lower left corner to the upper right forms the basic structure of this dawn image (*below and right*). Underlying the diagonal structure is a composition based on horizontal thirds.

Symmetrical

A symmetrical subject such as this bird of prey (*left*) provides a simple but extremely powerful image. Compositions such as this usually work better when the subject is centred in the frame so that the negative space around it is also symmetrical.

Radial

This shot of a friendly Kyrgyz shepherd posing against the setting sun (*below*) offers an excellent example of a radial composition. All the lines in the picture – of hillside, tree-line, ground, and shadows – neatly converge on a single point, giving the photograph structure and movement at the same time.

HOW THE MASTERS WORK

Subtlety, depth, and visual surprise are the defining qualities of many great photographs and the hallmarks of superb photographers such as Marc Riboud (1923–). The way in which a picture is composed is an important contributing factor to the success of an image and Riboud has proved himself to be a master of photojournalistic composition.

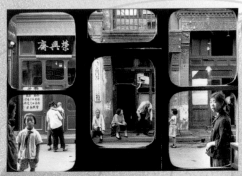

Marc Riboud
French photographer, Marc Riboud frames what he finds into almost-too-perfectly positioned graphic elements. You know, however, that nothing has been altered; everything has been quietly and patiently waited for. This image, titled *Window* (1965), was taken from inside an antique dealer's shop in Beijing. It is breathtakingly simple in composition, taking the regular grid of the window as its structure. Yet it remains matchless in its perfection of timing, capturing the perfect disposition of every element. Even the empty spaces feel right.

Composition in practice

Henri Cartier-Bresson (*see pp.40–41*) prescribed a demanding regime, saying that "Composition should be a constant preoccupation, being a simultaneous coalition – an organic coordination of visual elements." By allowing pictorial composition to be a "constant preoccupation", you will soon discover that it becomes an integral part of your visual experience. Then, you can make the transition from taking snapshots to capturing great photographs.

ANALYZING A COMPOSITION

After a little practice, good composition will become second nature. While travelling on the road to Essaouira, in Morocco, my eye was drawn to a stray dog. It disappeared for a while but when it emerged on the roof of a shop, it became clear that there was a picture in the making. Just as I was framing up the photograph, a boy on a donkey came round the corner and it was obvious that a better picture was going to walk into the frame. The exposure was already correct so it was then just a case of ensuring the image was in focus and judging just the right moment to release the shutter.

Diagonal lines
The diagonal line is a popular compositional device, and is often considered more dynamic than horizontal or vertical lines. Here the converging pair of diagonals lead the eye across the picture.

Empty space can help to hold the main subject, like the earth and walls in this image.

Distant subjects
Features that are visible but not the main focus of the image, such as this wall, help to define space and distance. They form what is known as the active padding of a composition.

Colour contrast
The red gas cyclinder provides a strong colour contrast with the blue door. This works well because it is balanced by the muted red earth colours.

COMPOSITION AS ARTICULATION

On his approach to composition, Don McCullin (*see p.57*) tells us "I try to compose my pictures – even in the moment of battle and the moment of crisis – not so much in an artistic way, but to make them seem right, to make them come across structurally." It is the "coming across" that is important. Pictures, like words, are all about communication. In much the same way, they can be composed, or articulated, either well or badly. It is worth taking the time to make sure the image in your viewfinder is composed well. As with language, it is enough at first simply to be clear. With practice, you can aim for the poetic.

Drawing the eye
While the central action in this shot taken on a tram in Hong Kong is the father taking a picture of his daughter, the near figure demands attention, especially her hand. The poster in the window then draws the eye. Although one's eye is pulled in many directions, the strong lines and repetitive shapes of the tram's interior hold all the elements together.

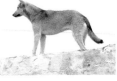

Counter-subject
The dog enlivens an otherwise empty sky. He was the original focus of the picture, but the arrival of the donkey turned him into the counter-subject – one that balances the main subject.

Three strong rectangles here create a composition within a composition.

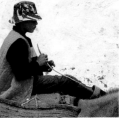

Clear shapes
The profiles of rider and donkey are cleanly presented, without distractions. A shot that was taken one-third of a second later, with the donkey's face in the door frame, was clearly inferior.

Timing
Even the most tranquil composition can depend on perfect timing. Here, the position of the donkey's foot gives the viewer a sense of a leisurely pace of life.

Experimenting with viewpoints

The image you see through the lens is not just affected by your position, where you look, and your choice of focal length. These factors all play their part, but viewpoint is also about your outlook, your frame of mind at a specific moment, and what your eye picks out from the scene in front of you. Vision and understanding – and sometimes a little luck – will guide your eye as well as your feet. Keep your wits about you, be attentive, and keep looking.

USING YOUR FEET

What you see depends on where you are located. This may seem obvious, yet it is often forgotten. While some photographers rely on lenses with "perspective control" features, many more mistakenly believe that altering zoom settings changes the perspective of a scene. As Ernst Haas (*see p.46*) put it, "the best zoom lens is your feet", advocating changing position to improve the composition of a photograph, in preference to simply changing the zoom setting.

EXPLORING PERSPECTIVES

There is a historical reason why the perspective in most photographs is at eye level. Early cameras were so large and unwieldy, with exposure times so long, that they had to be fixed onto a stand (later a tripod). It was only with the introduction of what were then called "ultra-miniature" cameras such as the Leica, and compact roll-film cameras such as the Rolleiflex (which did not require the use of a stand) that photographers began to fully explore perspectives deviating from the standard position. The first master of the "unconventional" perspective was Alexandr Rodchenko (*see p.63*), although his work had perhaps its most immediate effect not on photographers, but on cinematographers such as Sergei Eisenstein.

These days, with ultra-compact cameras – not to mention high-quality mobile phone cameras – there is no reason for remaining stationary while you photograph. In addition, modern digital cameras with swivelling LCD screens give even greater freedom. Even at arm's length it is easy to monitor the framing of the shot. With these technological advances, there are no excuses for not fully exploring perspective.

Reflections
Perspective is given another dimension by reflections, because you view not only the scene that is reflected, but also the reflective surface. Here, the red car body helps to frame the photograph.

Shadows
The obvious framing here would be of the tree, with the sun behind it. Instead this view engages with the tree's shadows, which contrast with the road markings and texture of tarmac, creating an intriguing perspective on an obvious subject.

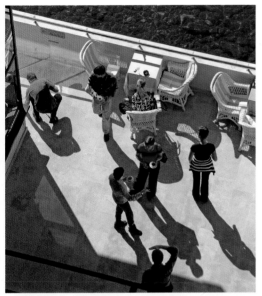

Overhead perspective

This viewpoint disorientates by changing familiar objects into more abstract shapes, with the effect of making the ordinary extraordinary. At coffee-cup level, this scene would be prosaic. However, viewed from above, it turns into a ballet of shadows, which perform parallel to, yet somehow independent of, the movements of the people.

Keep shooting

In a complex scene made up of moving elements (*below*), you cannot always capture the image perfectly first time. Do what the professionals do: keep waiting, keep looking, and keep shooting.

HOW THE MASTERS WORKED

One of India's greatest photographers, Raghubir Singh (1942–99) was a guru of photographic composition. Like his fellow countryman, Raghu Rai (*see pp.60–61*), he concentrated his work on India, publishing numerous celebrated collections of picture essays. One of his best-known projects was based on the simple idea of photographing his country from an "Ambassador", a car that is ubiquitous in India. He used all his photographic skill to fully exploit the possibilities offered by the curves of his car, and the changes in shape obtained, for example, by opening the door to different extents. Using the doors, windows, and mirrors of the car as framing devices, Singh delivered a virtuoso exercise in unconventional viewpoints and photographic framing. A testament to his love of India, this project was, sadly, to be his last major work before he died.

Raghubir Singh
A Way into India (*below*), taken in Rameshwaram, Tamil Nadu, is essentially a straightforward beach scene, which anyone could have photographed. It is, however, transformed into a formalist play of line, colour, and shape by the imaginative step of taking the picture from within the car.

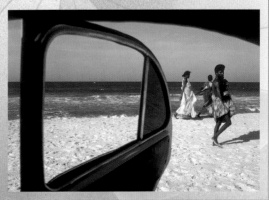

Taveuni, Fiji
The usual view of this scene would take in the
whole of the girl, but the best picture was really
at her feet, with the texture of the rocks and
contrast between the yellow leaf and blue water.

Using colour

"Colour is joy... One does not think joy. One is carried by it", wrote Ernst Haas (*see p.46*). As such, colour is integral to the way in which we experience a subject, it evokes the mood and atmosphere of a scene and can dramatically affect our emotional responses to it. Success in colour photography requires a certain degree of sensitivity and intuition. Vibrant, brilliant colours can create drama and excitement; while muted pastels are more likely to instil a sense of harmony and calm.

Colour and photography

Three independent factors come into play with colour photography. The first is the true colour of the subject. The second is the illuminating light, which may contribute its own colour. And finally there is the viewer, who either perceives the colour (if a human), or records the colour (if a sensory device). As a result, the colour we capture in a photograph may not be the same as the subject's actual colours, and what we see with our eyes may be different again.

KNOWING YOUR MATERIALS

Whatever medium you use – colour negative, positive (transparency) film, or photo-sensor – the end results will be mediated by technical processes. The final product invariably involves compromises between what is technically feasible, what is affordable, and to some extent, what is acceptable.

If you recognize both the good and the bad points of the tools of your trade, you can learn how best to use their strengths and avoid their weaknesses. For example, certain films reproduce red colours very vividly, but are poor at distinguishing green hues, so choosing them to record the autumn colours of Vermont, USA, or a Chinese New Year parade, for example, would work well. However using them to capture a garden in springtime would disappoint. Similarly, digital cameras separate luminous colours well, but dark subjects and anything in the shadows will be indistinct. Consequently, they will be successful in recording a summer party with guests in pale clothing, but they are likely to produce disappointing results when applied, for example, to animals in a shady zoo enclosure.

HOW THE MASTERS WORK

A poet among nature photographers, Minnesota-based Jim Brandenburg has done more than anyone to help give us an understanding and appreciation of the wolf. He has spent countless days in freezing conditions photographing these enigmatic animals. Using both ultra-wide-angle lenses and the longest of telephoto lenses, Brandenburg eschews elaborate apparatus and allows nature's beauty to reach out through the medium of his work.

Jim Brandenburg
In *White Wolf* (*left*), the multiple symmetries of reflections and the strong diagonal line of the cloud formation superbly frame the leap of the white wolf, which is placed almost exactly in the centre of the picture. Here, Brandenburg skilfully weaves together the few colours of this austere Arctic landscape by relying on tonal differences to shape the image.

BALANCING COLOURS

The colour wheel is a common way to represent the relationships between different colours. Colours that offer the greatest visual contrast are located opposite each other on the wheel, while colours perceived to be more similar are closer together. However, it is not a wholly accurate model of colour perception, as it gives equal weight to colours that may not be seen in the same way. Blues, for example, would usually appear much darker and stronger than yellows.

The most harmonious, and often the most effective, colour schemes use colours adjacent to each other on the wheel, thus using a limited range of colours. Desert landscapes are effective because of the serene blend of sandy, yellow, and rusty colours. Strong contrasts such as blues against reds or purples against greens are less pleasing

because there can be too many distractions for the eye to find a focal point. When photographing contrasting colours, ensure the image is not too busy. Aim instead for a graphic shot – a detail of some flowers, for example, rather than an entire flower bed.

The colour wheel
The wheel diagram (*right*) is probably the earliest model of colour perception – its precursors appeared in China in the 6th century – and it is certainly the most intuitive. It is the basis for all subsequent colour models.

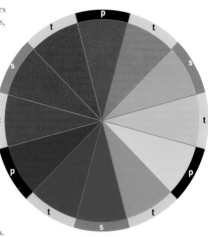

p = primary s = secondary t = tertiary

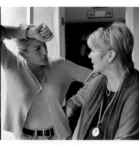

Adjacent colours
In this snapshot of friends chatting (*left*), the emotional warmth of the scene is matched by the warm, earthy tones that dominate the colour palette, accented by the red New Mexican chillies. There is just enough contrast from the blue jeans and purple top to balance the picture

Contrasting colours
The contrasts, not only of colour, but also of shape and distribution, as well as the reflections on the water's surface could make this seem an unpromising subject (*right*). However, increasing the contrast and deepening colour saturation can help to bring out out all the elements, which are offset against a neutral background.

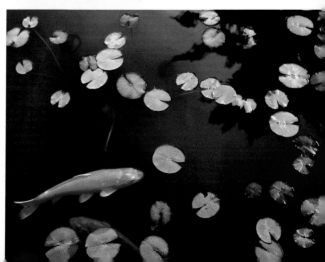

Working with colours

The basic discrimination in colours is that of hue, which is the name we associate with a particular range of wavelengths of light, such as magenta, purple, and so on. Within a hue, there are different shades. For example, the same red can be described as light, brownish, or deep. This is a result of variations in qualities such as colour richness or saturation. In photography and printing the range of colours that can be recorded is greatly restricted. A key skill when working with colour is to look at the scene with the photographic process in mind, so that you can visualize how it will render the colours you see.

EXPOSING FOR COLOUR

The myriad colours and broad range of scene luminance deliver a dazzlingly rich array of colours in this shot, taken from a herb shop in Marrakech, Morocco. The main problem is that the only colours in the image that will be reproduced accurately (where the brightness of the recorded image directly relates or is proportional to the brightness of the scene as you see it) are those that fall within the exposure latitude of the film or sensor.

Underexposed areas may create silhouettes whose dark colours help to frame active areas.

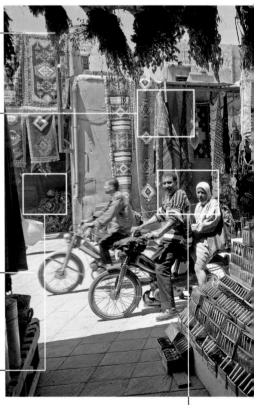

Mid-tone colours
Colours that fall in the middle of the brightness range are likely to be the most accurately recorded, as well as being the most saturated.

Areas in the full sun are overexposed and drained of nearly all colour.

Out of gamut
Colours that can be seen but that do not print accurately, such as deep purples and blues, are said to be out of gamut for the printer's colour space.

Skin tones
In general, it is best to set skin tones to the mid-point. In this image, skin tones were a shade over-exposed in an attempt to get enough exposure to show some detail inside the shop.

DESCRIBING COLOUR DIGITALLY

Before digital photography, colour was described in terms of hue, saturation, and brightness. Now, colours are usually separated into sets, for example, red, green, and blue, and then defined by measuring the proportions of each. In digital photography, colours are defined by the separation primaries of red, green, and blue. These "pure" colours are good for describing sources that emit colour, with 0 representing the weakest colour, and 255 the strongest. So, pure blue would be notated as 0:0:255 (zero red and green, maximum blue). When printing images, it is common to employ the set of three subtractive primaries: cyan (blue-green), magenta (blue-red), and yellow, plus black.

Primary colour mixing
Colour perception is based on mixing light of red, green, and blue in different strengths to give the entire visual spectrum, from pure colours to white and, in the absence of any light, black.

Dark colours
In shadow areas containing detail, there is little colour discrimination, only hints of the hue, but that is all that is needed to provide structure and some visual interest.

Contrasting colours
Where the scene presents us with lively lighting contrasts and colours in small areas, colour accuracy becomes less important. With digital photography, colour accuracy will be compromised by the difficulties in extracting accurate data from tiny areas.

Maximum darkness
In very dark areas, no colour is recorded, although it may be visible to the eye. This means that trying to make the area lighter digitally will only produce greys.

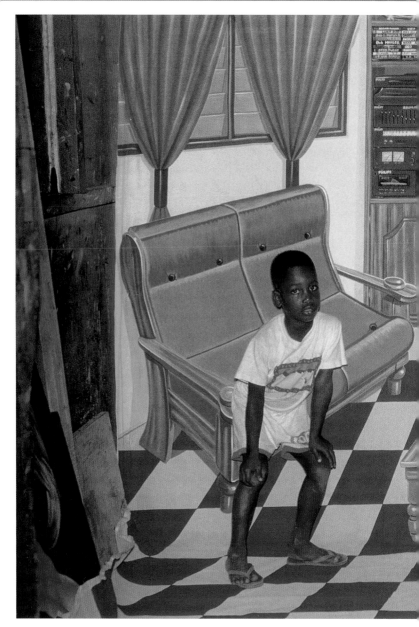

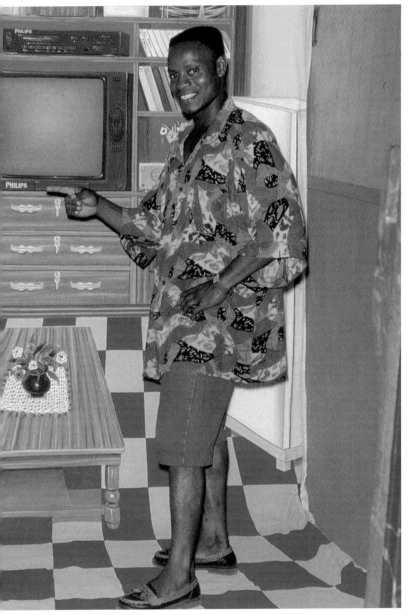

Portrait, 1996
Philip Kwame Apagya was born in Ghana in 1958. His portrait series, made in front of specially painted backgrounds including the image above, has become immensely popular.

Working in black and white

Black and white is photography's basic working mode or way of recording an image. It creates a greyscale map of the brightness distribution of the subject, losing colour information in the process. This gives us a step of abstraction that brings the shapes of the subject to the fore. Composition then becomes paramount as an exploration of tonal differences and spatial relationships.

The power of black and white

Some photographers still choose to work in black and white because they appreciate its abstract qualities and the way in which it removes the distractions of colour. In addition, working professionally with black-and-white film can be cheaper. Bought in bulk, black-and-white film is a fraction of the cost of colour film. Technically, too, there are advantages. Black-and-white film will tolerate more exposure error than colour, which means that you can create successful black-and-white images in a wide range of lighting conditions. Furthermore, whether you are working with film or digitally, black-and-white prints are longer lasting than colour.

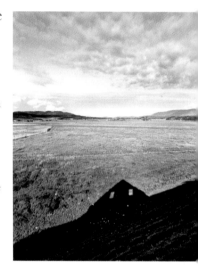

Misty morning
This woodland scene (*below*) was full of pale greens and browns, but in black and white the quality of light becomes the main focus.

Shadowed landscape
A colour image of this ruin (*above*) would be dominated by the green grass and blue skies, but the greyscale image accentuates the shadow

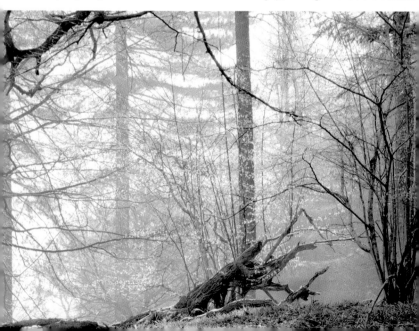

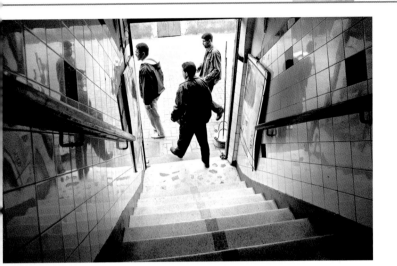

BRIGHTNESS

In colour photography the image is sensitive both to wavelength (hue) and to intensity (brightness). When working in black and white, however, brightness may vary with colour or remain the same even though the colours in the image are different. There are three key terms that refer to brightness in black-and-white photography. Monochrome is a single colour. Greyscale is a range of greys or "ramp". Black and white is a range of greys between black and white.

CHARACTERISTICS OF BLACK AND WHITE

The most common black-and-white film is the panchromatic type (see p.129), which is sensitive to all visible wavelengths of light. However, the speed or sensitivity of the film will vary slightly with hue. Black-and-white films are usually less sensitive to greens than to blues, and more sensitive to blues than to

Composition in black and white
If the composition of a photograph is simple and strong, as in this image of a restaurant entrance in Morocco (*above*), colour can be irrelevant at best, and a distraction at worst.

reds. That is why verdant landscapes often come out disappointingly dark in black and white. It also explains why deep blue skies may turn out brighter than expected.

Black-and-white film, particularly the more modern chromogenic type (see p.129), can cope much better than digital cameras in dark, shadowy, or very bright conditions.

The grain of black-and-white film is a great attraction for some. The heavy grain of Kodak Tri-X film has been key in the history of photography from the images of Robert Capa (see pp.38–39) through to the elegant portraits of Irving Penn and the passionate compositions of Sebastião Salgado (see p.63).

ASSESSING FILM SPEED FOR DOMESTIC LIGHTING SET-UPS

Domestic tungsten light affects black-and-white film by reducing its effective speed or sensitivity. Indoor lighting is generally dimmer than daylight and lacks blue and green, which is why it looks orange in colour images. Generally, you will need to set a lower film speed than that of the film you are using, or correct the exposure so that the metering system gives around two-thirds to one stop more exposure. The more red the light, the greater the compensation that is needed. For example, when using ISO 400/21° film, try setting 250/19° when working with bright lights, or 200/18° with dim lights.

Tungsten lighting
The low, yellow-red light in this bakery in Marrakech, Morocco is a typical situation in which you would need to give extra exposure to black-and-white film to attain the best results.

Digital toning

A partial solution to the lack of colour in the early years of photography was to tone a black-and-white print to give it an overall hue. The most popular colour in the late 19th century was a dark reddish-brown, known as sepia. Sepia toning lays claim to being the longest-lived photographic process. Even today a number of digital cameras offer a "sepia" mode.

CHANGING COLOUR DATA

Traditional toning involves bleaching the image silver so that it becomes clear or pale, at which point it is chemically active and can be replaced by other metals or compounds that are coloured. This principle – bleach then colour – is also a key step in colour photography. With digital photography, it is easier than ever to tone prints.

One digital technique is to desaturate all colours. This reduces the strength of the colours, turning the image grey. Then, using the Color Balance control (see p.166), you can add an overall coloured tone to the image by adjusting the colour levels. Another digital method is to use the Duotone mode, which is available in more advanced software.

Basic black-and-white image
This pastoral scene in Samarkand, Uzbekistan, was photographed on black-and-white film and then scanned.

Sepia image
Many image manipulation applications offer a quick way of adding sepia tone to the image. Here it has been done using Photoshop.

Blue duotone image
By printing the image using black and blue ink, the image is tinted overall in blue. Using software, you can control the relative weights of ink so that one is more intense in the shadows, while the other is heavier in the highlights.

Tritone image
The tritone printing process uses three inks. Here, a blue ink was liberally applied to the highlights, tinting them heavily. A yellow ink was applied to the shadows, warming them. Black was added to provide weight to the tones.

CONTROLLING GREYS

A colour image can be digitally converted to black and white in a number of ways. Desaturation mimics the principles of black-and-white film, whereby colours are treated equally and their brightness is translated directly into grey tones. With this method, a green, red, or bright blue might all translate into exactly the same grey tone. A more controlled method is to use the Channel Mixer found in advanced image manipulation software (*see p.160–61*), which creates a greyscale image by mimicking the effect of coloured filters. This is achieved by forcing one colour to be brighter than another. In this way, blue skies can be made to come out nearly black (imitating the effect of a red filter used with black-and-white film) or greens can be made to appear brighter than usual (which is what a yellow-green filter does for film).

Original image
This graceful landscape in northeastern Turkey is full of rich pastoral colours. The strong lines of the trees and the road suggest that it would work well in black and white.

DIGITAL BLACK AND WHITE

Producing digital images in black and white is not the contradiction it may seem and there are certain advantages in saving an image as a greyscale. First, a black-and-white or greyscale image is one-third of the size of an equivalent colour image. This inevitably saves on memory card space and speeds up operations on a digital camera. It makes sense then, to capture in mono from the outset if you need only black-and-white images, for a newsletter, for example. Also, printing greyscale images gives generally much better quality than printing in colour.

Simple black-and-white conversion
A simple desaturation of the colours to neutralize their colour values produces a very grey image. A conversion to greyscale preserves more differences in brightness but still results in a relatively flat image.

Channel mixer conversion
Using the channel mixer, the red was strongly boosted, and extra green added but the blue was reduced. The result is a very sharply contrasted landscape whose greyscale values closely mimic the original colour image.

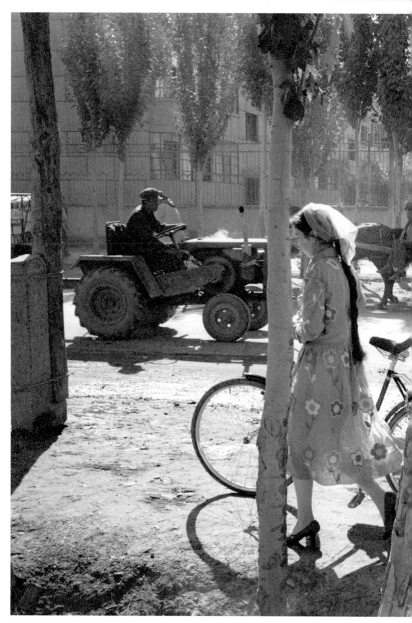

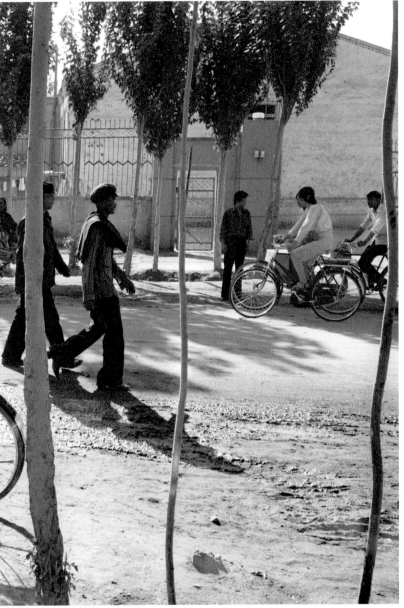

Kashgar, Xingiang, China
Black-and-white photographs, such as this busy
street scene, most effectively demonstrate the
photographic concepts of highlights and
shadow, detail, contrast, and tonal range.

Working with light

"Wherever there is light, one can photograph", declared Alfred Stieglitz (*see p.65*). To which Ernst Haas (*see pp.46–47*) later added "All light is good light." If you consider these two statements together, they indicate that for the purpose of taking a photograph any light situation can be exploited and that there is no such thing as ideal light. The quality of light essentially adds another dimension to the spatial qualities of an image. Light's ability to shape and texture the subject in an image creates emotional depth.

Types of light

Operationally, the issue is not what kind of light is good. We know from the masters that good photographs can be taken in all light conditions. But which type is easier to work with? Generally, lighting with an extremely wide range between the darkest parts and the brightest parts – often called "contrasty" lighting – is harder to work with than flatter lighting. However, lighting that is very flat, where the brightest parts are nearly the same luminance as the darkest parts, is equally challenging to work with, for different reasons.

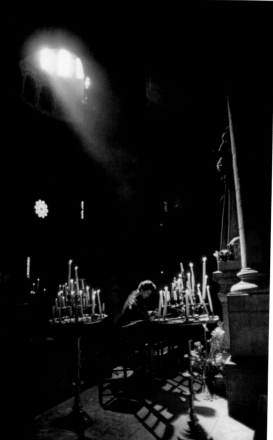

CONTRASTY LIGHT
With an image that has strong contrasts between light and dark, solid shadow areas can work if the visually important parts of the image are correctly exposed. With transparency film, one effective strategy is to expose for the highlights, making compositional use of the shadows, which remain dark. With digital and colour print film, it is best to expose to obtain the required shadow detail and then process the image to show up the highlights.

BRILLIANT LIGHT
Sunny days often inspire photographers to reach for their cameras, but the results often disappoint. Bright areas look washed out, while shadows appear too dark. This is because the range of luminance in the scene is too wide for a photographic sensor or film to cope with.

Extreme lighting
This atmospheric shot of the Sacre Coeur, Paris, was exposed for the portions of the scene lit directly by the sun, allowing the unlit spaces to remain dark.

HOW THE MASTERS WORK

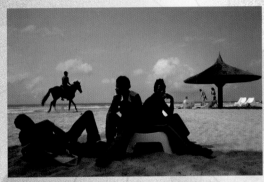

Alex Webb
Capturing a successful image of a tropical beach in full sun with dark-skinned subjects ought to be a photographic impossibility. In *Ivory Coast* (*above*) Webb shows how, if you work with what you have, you can create arresting images with rich gestures of light, colour, and form.

The signature work of Alex Webb (1952–) glories in the extreme light contrasts of the tropical regions, which many photographers struggle to work with. By pitching his exposure at the highlights, Webb saturates the colours of people and objects in full light. This sends the unlit areas into the highest density, with barely any details. Webb's skill is in composing with the near-silhouettes of whatever lies in shadow.

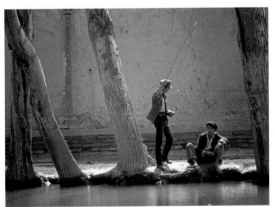

Low contrast
Outside, in flat lighting conditions, the entire sky illuminates the scene. As a result, contrast is soft and shadows are almost eliminated. Here, in Kashgar, China, the flat, soft lighting has erased nearly all moulding of forms and textures, so the image must rely on structure and composition for visual interest.

FLAT LIGHT

On dull, flatly lit days, the cloud cover interposes between the sun and the subject, acting as a giant diffuser, so that the entire sky becomes the light source. This seemingly uninspiring weather can in fact be a gift to photographers and filmmakers. They often welcome such lighting because its narrow luminance range reduces exposure and lighting problems, and frequently helps to increase colour saturation. This flat light, with its broad range of mid-tones, illuminates the scene without becoming part of the subject of the picture itself, giving the photographer more control over pictorial composition.

Soft and hard lighting
Under normal conditions, soft lighting effects (*right*) are associated with low contrast: light comes from many angles, reducing shadows. With high contrast lighting (*far right*), light shines from one angle, so lit areas appear glaringly bright while shadows remain dark.

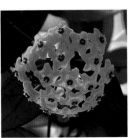

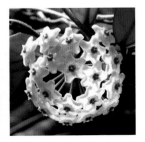

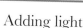
Adding light

Substantial advances in photography were made when artificial lighting systems became readily available. There are three options for artificial lighting. A flash built into a camera is the most portable and convenient, but gives unsatisfactory results. A flash attached to, but held away from, the camera combines practicality with greatly improved results. Portable lighting units, producing either a flash or continuous light, give the utmost quality and control but the drawback here is cost and inconvenience.

ELECTRONIC FLASH

A built-in flash creates a small light source. Its position – situated right next to the lens – and its size produce a contrast-creating light that cannot sculpt the form of the subject, resulting in hard shadows. A flash either mounted on the camera, or held out to one side, can illuminate the form of a subject more clearly. Diffusers can be added to flash units to soften the lighting and improve results even further.

FILL-IN FLASH

Paradoxically, flash is used most effectively in daylight and it is often most useful when there is too much light. Using flash is akin to shining a torch into the darker areas of an image, supplementing the available light. You can use flash in very sunny conditions where there is likely to be deep shadow, or to bring light to an unlit part of the subject. This can work very well in sunset or dawn views where the foreground is often black.

Balanced flash
Flash used indoors often results in bleached-out faces against a dark background. In this shot (*left*), colour and detail are retained by setting a wide aperture to capture maximum ambient light, while the flash adds to the available light.

Lighting dark areas
Using too much flash here, in the poorly lit undergrowth of the Fijian rainforest (*below*), would have spoilt the photograph's dark, dank mood. Instead, a single beam of light aimed at the fern in the foreground lifts the image, without making it look unnatural.

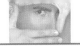

RED-EYE

When the pupils of the subject's eyes are wide open and the flash is positioned close to, and pointing directly into, the eyes, red-eye is likely to occur. The flash lights the retina, which shows as a spot of red in the eye. The effect is especially marked in low light (when a subject's pupils are at their most dilated). The best way to avoid this problem is to locate the flash well away from the camera. Another method is to fire small flashes close to the subject's pupils just before the main exposure, but this delays exposure so you may miss the moment. Image manipulation software is also very effective for removing red-eye.

Flash on camera **Flash off camera**

Distance of the flash
The further the flash is positioned from the lens, the less the risk of red-eye. Using an off-camera flash, held as little as 15cm (6in) away, will usually solve the problem.

INTERIOR LIGHTING

Portable lighting units, such as focusable Dedo lights, lamps, light stands, and light shapers (for example, barn doors), can be used to illuminate shots of interiors. They are invaluable for bringing light into dark corners and for balancing light and shade to produce the best effect.

Lifting Shadows
Three Dedo lights were used to supplement the existing light in this modern spa reception area (*left*).

HOW THE MASTERS WORKED

Born in Albania and trained in the USA, Gjon Mili (1904–84) graduated from the Massachusetts Institute of Technology in 1927. Mili saw the artistic potential in the work of his classmate Harold Edgerton (*see p.99*) who invented the stroboscope, a device that gave out brief flashes of light rapidly repeated at short, regular intervals. Mili's brilliant innovation was to use the stroboscope to dissect the movements of a rapidly moving subject. With this, a golfer's swing or the rotation of helicopter blades could be examined at leisure and in detail.

Gjon Mili
This celebrated picture of the ballerina Alicia Alonso performing a *pas de bourrée couru* (a gliding, running movement on pointes made with many small steps) is typical of Mili's work, combining physical grace, artistic vision, and scientific analysis into a seamless whole.

Blinds
Lucien Clergue, born in Arles, France in 1934,
is the most celebrated of all photographers
of the nude. This image is from a series that
projected shadows on to the nude body.

Controlling exposure

Exposure control is one of the foundations of image quality and setting the correct exposure can make or break an image. There is, however, no single rule that guarantees the correct exposure in all circumstances. Different situations require different approaches. Obvious factors such as light levels and film speed need to be considered, but setting the right exposure depends fundamentally on the kind of picture you wish to create.

Correct exposure

The definition of "correct exposure" is the level of exposure that gives you the desired result. This is usually the same as an average exposure, which is one that places the mid-tones in your subject (for example, grass on a cloudy day) in the mid-grey of your image. Mid-grey means that the tone lies halfway between full black and full white. As a result, dark and light fall equally on either side of the subject's mid-tone.

Exposure for highlights and shadows
With strong lighting on the model, an exposure for the highlights (*above left*) throws the unlit areas into shadow. Exposing for the unlit part of the face (*above right*) gives a more natural result.

SETTING THE MID-TONES

In order to reveal detail in highlights or brighter areas, you will need to underexpose by setting the mid-tones darker than mid-grey. This will give a darker image overall with a loss of fine detail in the shadows. Conversely, if you wish to release more detail in the shadows, you will need to overexpose by setting the mid-tones to be lighter than mid-grey. This will give a brighter image in which fine detail in the highlights is lost.

Low-key exposure
As this image is essentially all about hints of exposed body, an underexposure of two stops brings out the sensuous lines of the model.

EXAGGERATED EXPOSURE

The technique of deliberately setting a non-standard exposure can be used creatively to vary the emphasis on colours or the composition of the scene. Try experimenting with extreme underexposure to produce low-key images, which give a sombre or moody effect. Low-key results are overall very dark, with no tones lighter than mid-tone and colours, if present, that appear more intense. Alternatively, try overexposing by a few stops to produce high-key results, which appear bright and full of light. In a high-key image no tone is darker than mid-grey and colours, if present, appear light and delicate.

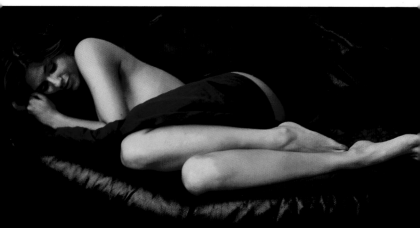

HOW EXPOSURE WORKS

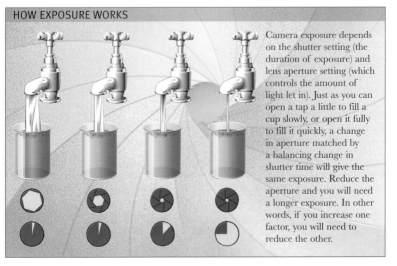

Camera exposure depends on the shutter setting (the duration of exposure) and lens aperture setting (which controls the amount of light let in). Just as you can open a tap a little to fill a cup slowly, or open it fully to fill it quickly, a change in aperture matched by a balancing change in shutter time will give the same exposure. Reduce the aperture and you will need a longer exposure. In other words, if you increase one factor, you will need to reduce the other.

CHOOSING EXPOSURE

Bracketing exposures – a standard technique among professionals – is the best way to learn about exposure. Bracketing means that in addition to the camera-correct shot, one with slightly less and another with slightly more exposure is taken. Generally, there should be a difference of at least half a stop, but for learning purposes it is best to work with one stop or more. On reviewing your results, you will find that the camera's choice is not always the best. In contrasty light, the under-exposed image will often look more dramatic, with richer colours. In diffused lighting, or with pale-toned subjects, the correct or overexposed image may be preferable.

High-key exposure
With a forced overexposure of four extra stops, this portrait (*right*) is given a modern, bright look and the colours in the shadows are revealed.

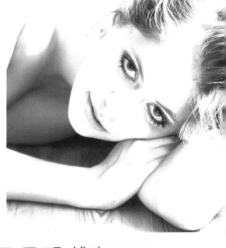

Adjusting exposure
A shot made using automatic settings (*far left*) is too dark. The whites appear murky and grey, so the skin tones look muddy. The yellow cast, typical of tungsten lighting, also reduces brilliance. Increased exposure (*left*) gives a livelier result. The whites are white and the skin tones glow. The Color Balance was also adjusted here using image manipulation software (*see p.166*), to make the whites almost neutral without losing warmth and to eliminate the yellow cast.

Exposure measurement

Modern automatic exposure metering systems analyze large amounts of data against stored scenarios to work out a shutter time and aperture. These "intelligent" or "evaluative" systems get it right most of the time. However, the problem with relying on them is that you will never learn how to improve results or how to exert more creative control over your exposures.

SHOOTING AGAINST THE SUN

When the sun starts to set on the main square in Marrakech, Morocco, crowds gather to watch the street performers. Here, the best views of the performance are *contre-jour* – with the sun behind the subject and the long shadows in the foreground. For a scene like this, a camera's evaluation system might get the exposure right, but it is more likely to get it wrong because of the extreme range of lighting contrasts. The safest course here is to locate the mid-tone and then – using a metering pattern that reads from the central portion of the frame – aim the camera's metering at that area. Hold that reading and then use it as the exposure setting for the whole scene.

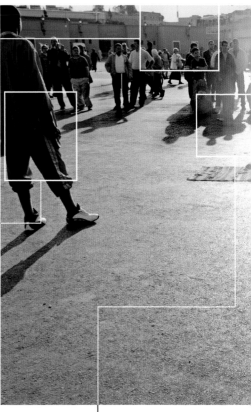

Burnt-out highlights
The sky next to the sun will always be virtually white, no matter what the exposure setting.

Shadows with detail
Important areas of colour should retain an indication of their hue. If not, the overall image will look too dark even if the exposure is technically correct. In difficult cases, you may have to introduce additional lighting or add colour with image manipulation software (*see pp.160–61*).

Veiling flare
In this part of the image, the crowd looks bright because of veiling flare – unwanted light on the image that is caused by internal reflections within the lens, reaching the sensor as non-image-forming light.

EXPOSURE VARIATIONS

An ideal way to learn about camera exposure is to analyze a scene into its luminance (or brightness) values. If you have a spot-meter mode in your camera (it measures from just a central three to five per cent of the image area) you can point it at different parts of your subject to get the correct exposure for each section. You will learn how just a small difference in exposure significantly affects the detail attained. This scene shows a difficult situation for exposure measurement because the low, bright sun can upset the reading to cause a heavy underexposure.

Analyzing the scene below
The "o" here denotes the luminance in the scene which gives the mid-tone after normal processing (film or digital). Numbers indicate tones that are darker or lighter, in steps of one camera stop, according to the plus or minus signs.

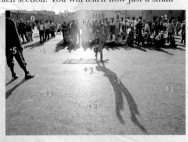

Dark areas
It is tempting to take the exposure reading from the crowd, as usually the skin-tones and clothes would represent mid-tones. But since it is in shadow, readings from this area will mean the image is overexposed, making it too bright overall.

Reduced shadows
One of the effects of veiling flare (*see left*) is to reduce contrast by introducing light into shadows. Here, the shadow of the boy acrobat is a crucial part of the picture but was originally too light because of the flare. A slight burning-in using image manipulation software has given it more depth.

In tricky lighting situations, locate a mid-tone grey, such as the ground here, and set your exposure to that area.

The corner areas of this extreme wide-angle view are darker than those in the centre. This is called "light fall-off" and is caused by peripheral rays lighting the image at an angle.

Using exposure time

If photography depicts a slice of life, then the shutter time determines the thickness of that slice. In the majority of situations, the main concern is that the combination of shutter time and aperture produces a well-exposed, focused image. Shutter setting, however, determines more than just the amount of light captured. It also controls the way in which we record motion and gives us the option to either freeze a moving subject or allow it to blur over the frame.

CAPTURING MOVEMENT

Long exposures capture movement, allowing a subject to blur. The faster the movement, or the longer the exposure, the more pronounced the blur. The effect is one of the medium's great contributions to visual language and, since our eyes can see motion blur, it imparts realism to an image. Short exposures, on the other hand, freeze the moment, giving sharply defined details. In an image of a moving subject, the amount of blur determines the sharpness of the picture. If you want a lot of blur, set a longer exposure, such as 1/15 second. For minimal blur, set a shorter exposure, such as 1/1000 second.

Long exposure: in the rain
The camera was still unintentionally set to a long exposure when these women rushed past in a heavy storm in Tajikistan (*below*). The effect successfully conveys the hurried atmosphere of people trying to get out of the rain.

Short exposure: road blur
Even the shortest shutter settings will not prevent motion blur in very fast-moving situations. In this image (*above*), taken from a moving car, a certain amount of blur is exploited to create ambience and interest.

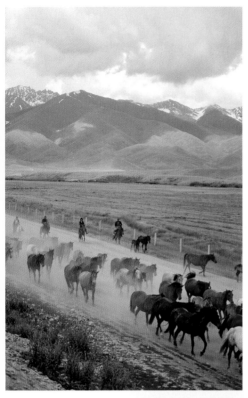

SETTING PRIORITIES

All exposure calculations must balance the need for brief shutter times – to freeze movement and minimize camera shake and subject blur – with the need for an aperture setting that gives sufficient depth of field and optical correction. From this comes the notion of shutter priority and aperture priority. Shutter priority is generally chosen when short shutter times are needed to freeze action and the aperture can be as wide as necessary to give the correct exposure. Aperture priority is selected when greater depth of field is required and the shutter setting is not so critical.

Long exposure time
While I was preparing for a landscape shot in Kyrgyzstan (*left*), these horses suddenly came thundering down the road towards the camera. A longish exposure was chosen to maintain maximum depth of field.

Freezing motion
If the photographic subject is moving fast, is near to you, and travelling across the field of view, you need to select the shortest shutter times – 1/2,000 second or shorter – to freeze motion. If the object is slower, further away, and travelling towards you, you should select longer shutter times of 1/125 second or longer. This table gives some indicative settings that you can experiment with.

SUBJECT	DIRECTION OF SUBJECT MOVEMENT		
	Towards camera	Across frame (90° to camera)	Diagonally (45° to camera)
Pedestrian	1/30 sec	1/125 sec	1/60 sec
Jogger	1/60 sec	1/250 sec	1/125 sec
Cyclist	1/250 sec	1/1,000 sec	1/500 sec
Horse at gallop	1/500 sec	1/2,000 sec	1/1,000 sec
Car at 50km/h (30mph)	1/250 sec	1/1,000 sec	1/500 sec
Car at 160km/h (100mph)	1/1,000 sec	1/4,000 sec	1/2,000 sec

Shutter time and distance
This diagram shows a train travelling at 161km/h (100mph). At a distance of 15m (50ft), a shutter time of 1/4,000 second or shorter is required to freeze its motion on film. At distances over 100m (300ft), the requirement drops to 1/500 second or shorter. If sharpness is critical, even shorter times should be set.

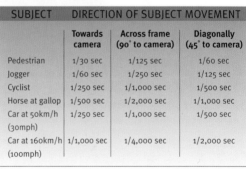

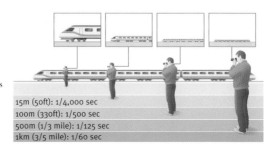

15m (50ft): 1/4,000 sec
100m (330ft): 1/500 sec
500m (1/3 mile): 1/125 sec
1km (3/5 mile): 1/60 sec

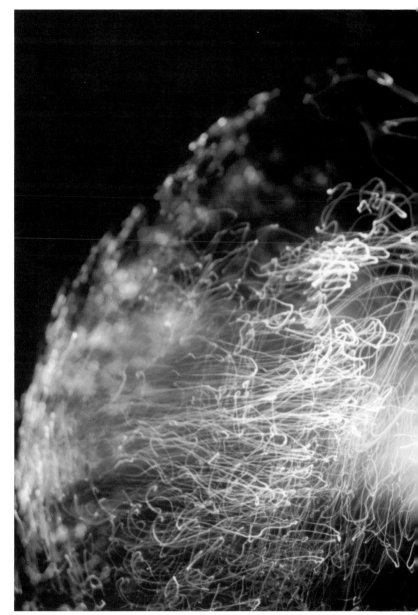

Time exposure
Photography can capture motion over time
in a way that is unique to the medium. The
random movements of fibre-optic lights are
faithfully recorded in this long exposure.

Using lenses

The lens is the eye of the camera. It translates what we see into a photograph and it is vital to the image in every way. The lens impacts on our vision, controlling what is in focus, as well as how much of a scene is captured. Different focal lengths give us different views of the world and can limit, match, or expand our photographic intentions.

Understanding focal length

The focal length of a lens is the distance between the point from which the image is projected, to the image itself, where the subject is at infinity. It is important to understand why a long focal-length lens magnifies the image, and why a short one shows more of the view. Imagine that you are looking through a hole in a fence. If the hole is close to your eye you can see most of the view on the other side – as in a wide-angle image. If you move further away from the hole, you see much less of the view and the image becomes smaller. If you then enlarge that image in your mind's eye so that it is the same size as the wide-angle image, the detail inside the hole becomes bigger, as in a long focal-length image.

STANDARD FOCAL LENGTH

The standard lens for any format gives a neutral effect that is neither telephoto nor wide-angle. There was a time when all 35mm film cameras were sold with a standard 50mm lens. Now that zoom lenses, which have variable focal lengths, are the norm, the benefits of the 50mm have been forgotten. Using the 50mm lens is excellent training. It concentrates the mind on composition, forcing you to look harder and move around rather than simply zooming in or out.

COMPARISON OF VIEWS

A wide-angle lens has a radically different view of the world to that of a telephoto lens. The difference is best demonstrated by comparing views in which the main subject is kept at the same size. Set your lens to its widest setting and frame a subject so that it fits the height of the frame. Then set the longest setting and try the exact same framing: you will find you have to move a considerable distance from the subject to compose the second shot, which results in the two perspectives being very different. This dramatic change in perspective, forced by using different focal lengths, is the reason why choice of lens is such an important consideration.

Using a telephoto lens
A long focal length or telephoto lens brings distant objects into the same picture plane as relatively close ones. This 200mm lens for 35mm format makes the distant building (Fontainbleau, in France) appear close to the sculpture. The building is out of focus, because it falls outside the narrow depth of field.

Using a wide-angle lens
With a short focal length (21mm lens for 35mm format) the wide-angle lens makes the palace appear far away. The great depth of field of the wide-angle view is also evident in the relative sharpness of the building.

FIELD OF VIEW

The diagram below shows how fields of view alter with a change of focal length: as focal lengths increase, fields of view narrow.

Note that the field of view is measured across the diagonal of the format and not the width, as you might expect. If you use single focal-length (or prime) lenses such as 24mm, 50mm, or 180mm, then there are gaps or jumps in the changes in view. One advantage of using zoom lenses is that the changes in focal length are continuous, helping you with composition. However, zoom lenses on many compact cameras still change focal length in steps, rather than continuously.

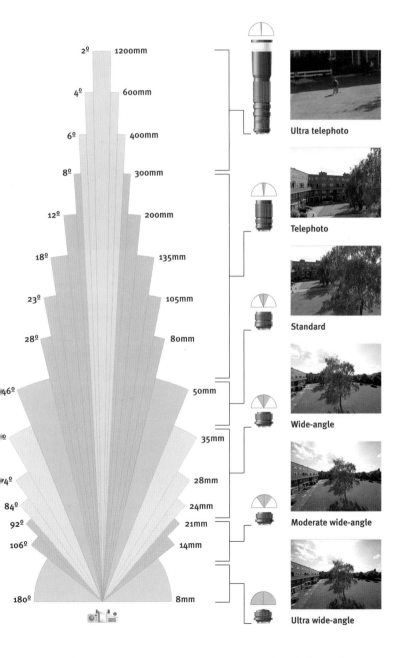

Focusing and depth of field

The best automatic focusing (AF) systems can focus far more rapidly and accurately than a photographer working manually. However, even the most advanced cameras cannot control depth of field. Since depth of field has a fundamental effect on how a subject is reproduced in a photograph, this requires creative input from the photographer as well as a technical understanding of lens aperture, focal length, and working distance.

FOCUSING STRATEGY

Modern auto-focusing systems work even in dim light but they may select the wrong part of the scene to focus on. Manual focusing allows more creative control, but can be too slow in some situations, and is also dependent on good eyesight. One strategy that overcomes the drawbacks of autofocus is to point the central focusing area at the key element that needs to be sharp, press the control that initiates auto-focus, then hold it in order to re-frame the image before shooting.

As focal length increases, so does the need for accuracy. With telephoto lenses it is worth giving the system a little more time to focus accurately because depth of field is sharply reduced and technical limitations reduce the efficiency of auto-focus systems.

CAMERA SHAKE

However perfectly focused your image may be, any movement of the lens during exposure will reduce sharpness. If you are using a zoom lens set to its maximum extent, you will either need to use a tripod or set a shutter time of 1/250 second or shorter for a focal length of 200mm.

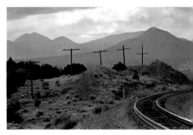

Distant depth of field
In images of distant subjects, the depth of field appears infinite, even with a long focal length. In this picture (*above*), taken with a 400mm lens, the hills are as sharp as the telegraph poles. These objects are said to be at infinity: changes in distance do not affect sharpness.

Shallow depth of field
Using a full aperture and a long focal length throws the flowers in the foreground out of focus (*below*). This transforms them into a brilliant abstract blur of colour, which helps to frame the main subject of the photograph, a young bride in Uzbekistan.

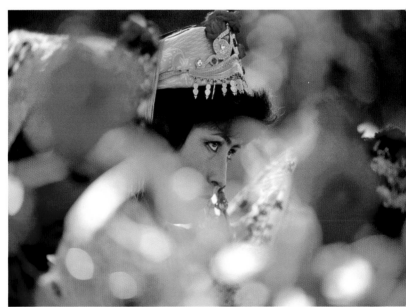

UNDERSTANDING DEPTH OF FIELD

Suppose you point your camera at a man approaching from a distance, with the lens focused on a point 3m (10ft) in front of you. The man will start off out of focus and become progressively sharp as he moves towards the camera. There is a point at which he will become perfectly sharp, but as he comes even closer, he will then slip out of focus again. Having a shallow depth of field means that the zone in which the man appears sharp is narrow. He walks only a short distance before he loses his

sharpness. Conversely, an extensive depth of field means that, once sharp, the man remains in focus for a great distance. "Unsharpness" is, of course, subjective, depending as it does on how the image is viewed, how critical the viewer chooses to be, and the effect that the photographer intends to create.

Varying depth of field
The three diagrams below illustrate how depth of field varies with aperture, how it changes with focused distance, and how it alters with focal length.

Changing the aperture (with 70mm lens focused at 10m)

depth of field ●

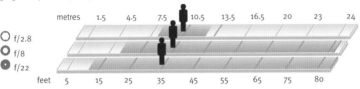

Changing the focused distance (with 70mm lens set at f/8)

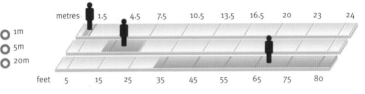

Changing the focal length (with aperture set at f/8 and focused at 10m)

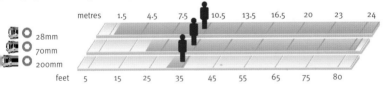

CONTROLLING DEPTH OF FIELD

The primary control of depth of field is the lens aperture. A smaller aperture gives greater depth of field, while a larger aperture reduces depth of field. Depth of field is also controlled by other factors and it can be maximized by increasing the focused distance (the space between focal plane and subject), shortening the focal length, and decreasing the format or sensor size. In short, to get more of a scene in focus, use a smaller aperture and distance yourself from the subject, or use a wide-angle lens. For less depth of field, use a wide aperture and get closer to the subject, or use a telephoto lens.

Extensive depth of field
With a wide-angle lens focused to medium distances and an average aperture, everything from blades of grass to distant peaks is sharp.

Filters and in-camera effects

Now that digital image manipulation effects have become so easy to use, filters that attach to the front of the camera lens may seem to be obsolete. In practice however, filters are still the easiest way to create special photographic effects. There is no need for software or even a computer, and if you work digitally, you have the advantage of being able to check your results while you work.

Development of special effects

During the 1960s, a decade synonymous with adventurous artistic expression, photographers began to look for new ways to diversify. The search for photo-graphs with a difference, using special effects or tricks to give visual impact, began in earnest. The SLR camera, which enables effects to be judged accurately before they are committed to film, was a key tool in that quest. Plastic filters were invented to fit any SLR and lens combination offering numerous wild effects, such as multi-coloured prisms that fracture the image and rainbow-coloured highlights. Even now, many effects, such as double exposure, star-bursts, and distortions, are easier to create in-camera or with filters than with image manipulation software.

Coloured prisms
A flat prism filter and a rainbow filter were used to create this image of the Eiffel Tower. The prism splits the image into several parts, which are each coloured by the filter.

USING FILTERS

The effect of a filter usually depends on the aperture and focal length of the lens. Broadly speaking, filter effects increase in strength with smaller apertures and shorter focal lengths (wide-angle settings). Softening filters, however, are strongest on full aperture. While you normally view a subject with the working focal length, the lens aperture is generally wide open. In order to assess fully the effect of the filter, you need to stop down the lens to the working aperture (not all cameras allow this). The image may become very dark, which is correct, but your eyes need time to adjust before you can judge the image accurately.

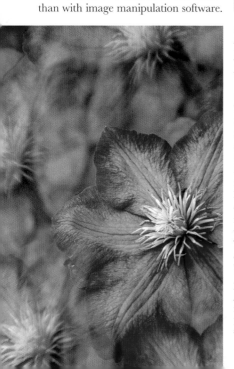

Multiple images
A multi-faceted prism filter breaks up an image into many repetitions. This effect works particularly well for subjects with strong graphic shapes, such as these clematis flowers.

IN-CAMERA EFFECTS

Some special effects can be created without using filters and there are a number of techniques that produce dramatic and unusual pictures. SLR cameras allow you to change the zoom setting during a long exposure, which causes the image to spread into converging streaks. A variant on this effect, possible with even very basic cameras, is to

Using zoom and a long exposure

Setting a long exposure time and zooming during the exposure causes an unpredictable streaking effect, as in this image of a tree.

use long exposures to allow moving lights to "write" over the film (*see pp. 220-21*). Yet another effect is created when you make more than one exposure on the same piece of film.

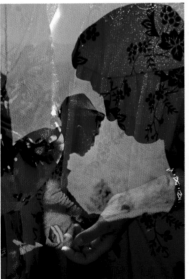

Double exposure
This image was made by photographing one print (of silhouettes in profile) then photographing the print of a colourful Tajik woman's dress on top of it.

Long exposure
During this night-time parade, an exposure of several seconds gives the procession of lights time to spread a trail over the film while the flash freezes other elements of the picture.

TAKING
SUCCESSFUL
PHOTOGRAPHS

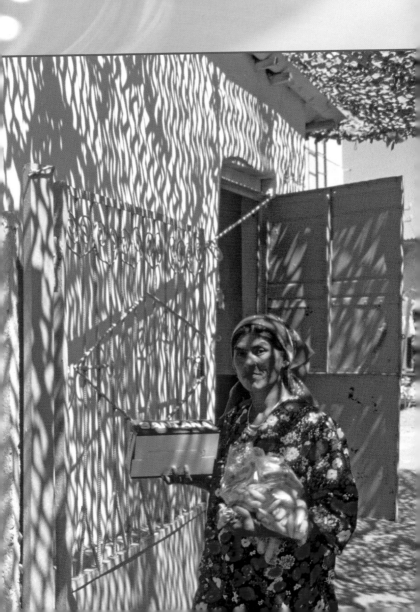

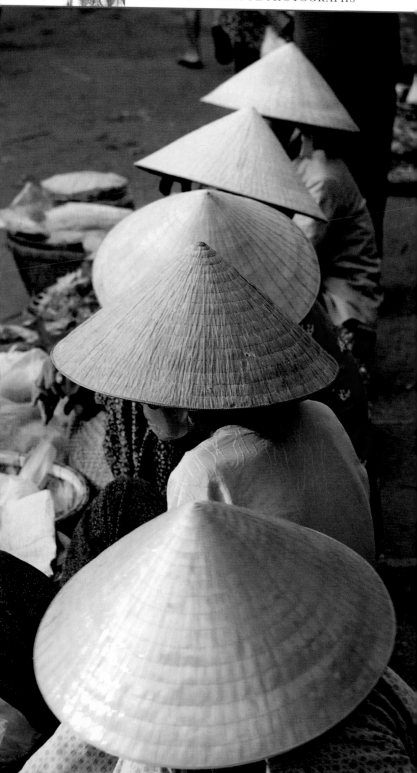

IF THERE IS A MAGIC FORMULA FOR APPLYING PHOTO-TECHNIQUES SUCCESSFULLY, IT IS ONE SHARED BY ALL OF THE WORLD'S GREAT PHOTOGRAPHERS, AND IT IS DELIGHTFULLY SIMPLE. WHETHER TRAVELLING THE WORLD OR STAYING CLOSE TO HOME, WORKING IN UNPLEASANT CONDITIONS OR IN THE SAFETY OF THE STUDIO, GREAT PHOTOGRAPHERS WORK HARD.

That observant and witty photographer Robert Doisneau (1912–94) once pointed out: "If I knew how to take a good photograph, I'd do it every time." But great photographers do share a special mindset that ensures they are led – almost obsessed – by a vision, that of a visual truth which communicates with perfect, inconvertible clarity. They know what they want and will not rest until they have seen it realized, and recorded it. The writer Mark Twain put it well: "You can't depend on your eyes if your imagination is out of focus."

Combining shapes
The asymmetrical plant works with the geometric lines of the hotel lobby.

To realize that vision in the form of a captured image, photographers are constantly observing and responding to the world around them. If there is one secret of successful photography it is to delight in our world in all its beauty and even its sadness in the search for visual truth. We can see the world through the gift of light, and great photographers know how to use that gift.

Creative viewpoint
Instead of the usual view of a market showing produce being sold, this photograph uses the straw hats to create an almost abstract pattern.

Modern technology makes much of the mechanics of the photographic process straightforward: fast, accurate focusing can be carried out automatically, as can exposure-setting. Some digital cameras will even run off a series of pictures, and then automatically select the best shot. What you are left with are the obviously creative options – but even focusing and exposure can be controlled and used creatively. Once you have learnt and are confident with the right technique, you can deliberately use the "wrong" settings to create a particular effect.

There are still opportunities to discover new techniques, none of which need cost anything to try. For example, you could take an accepted rule of composition and deliberately set out to break it. You could find a new look at standard subjects: for example, instead of flowers in perfect bloom, conduct a photographic study of wilting blossoms. Instead of treating photographs as the final product, use them as intermediates by photographing prints placed on top of prints, or three-

Colour splash
The bright yellow tulips are echoed in the passing taxis, emphasizing the juxtaposition between the natural and man-made world.

dimensional objects placed on prints. As a photographer, your aim should be to find your own way forward. There is no inherent need for you to innovate in photography when the world is continually offering you new subjects, new debates, and new and exciting photographic opportunities.

Nonetheless, whatever you choose to photograph there are steps you can take to make your images more your own. To do this, you will need some command over the basic techniques – just as musicians must know their instruments, be familiar with different styles of music and interpretations, and understand their music theory.

In photography, mastery of a technique, such as exploiting the effects of depth of field, is just as valuable whether you are taking travel shots or portraits. Similarly, many of the skills (not all photographic) that are required for successful child photography are, perhaps surprisingly, the same as those

that you would use for photojournalism, and if you are covering a wedding or a birthday celebration, you will find that you will employ the same skills and techniques as you would for a major event such as a street carnival or a demonstration.

This section looks at a variety of photographic genres, and concentrates on ideas: what you can do to get more out of the picture-making experience. Most importantly, these ideas don't involve additional equipment or costs, just simple things like getting up early, getting in to look more closely, waiting a little longer, or walking not even the extra mile but just a few extra paces.

Matemwe, Zanzibar
Cows taking a rest on a sunlit beach disrupt the accepted view of a tropical paradise, and create an amusing composition.

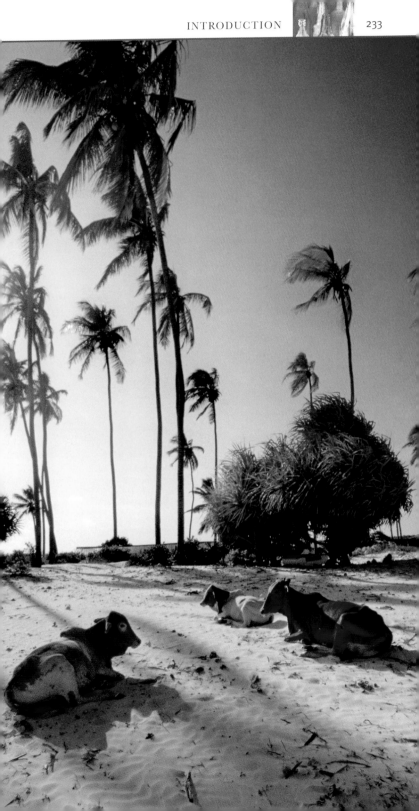

Portraits

The portrait is seldom a neutral record of a person. It almost always aims to communicate a personal response, or attempts to say something about someone. As a result, the portrait photograph usually has to strike a balance between truthful representation and subjective expression. Very often the skills needed to get the best out of a sometimes reluctant subject are more interpersonal and psychological than photographic.

Setting up the shot

Portraits do not have to be set up in a formal way. And a model need not be conventionally beautiful. You may be inspired by a characterful face in crowd. Then all you can do is approach the person and explain why you want to take their picture and what you will use it for. It helps if you have examples of previous work. Once you have their co-operation, the key elements of portraiture are background, lighting, and perspective, which will determine the lens you use.

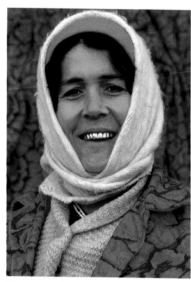

Matching background
Here the woman's patterned coat matches the background. The effect would be overpowering without the scarf that encircles her face. The vivid pink headband enlivens the whole image.

BACKGROUND

Generally the most versatile backgrounds for portraiture are those with some texture but without distracting details. For example, a rough stone wall is better than a brick wall with its hard straight lines. If an unattractive background is unavoidable, you can keep your subject in focus and blur the background by setting a large aperture to narrow the depth of field. Alternatively, you can adjust the image later using manipulation software.

HOW THE MASTERS WORKED

The works of the great portrait photographers encompass a variety of styles and approaches. Madame Yevonde (1893–1975) was a pioneer of colour photography in England in the inter-war years. Working on advertisements for high-profile companies, she was also sought after by members of London's high society, who she satirized in her *Goddesses* series.

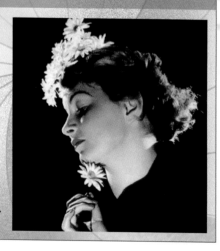

Madame Yevonde
Yevonde often used the Vivex tri-colour process. This gave her pictures a memorable artificiality, as in "Miss Susan Bligh as Calypso" (right), taken in 1935. She once famously remarked, "If we are going to have colour photographs, for heaven's sake, lets have a riot of colour, none of your wishy-washy hand-tinted effects."

Off-centre framing
Your subject need not always occupy the centre of the picture, and does not have to be looking straight ahead. Placing your subject off centre can bring an otherwise inactive composition to life. The eyes cast down towards the camera add character.

Using leading lines
A composition that makes use of converging parallel lines creates depth and stability and draws the eye to the subject.

LIGHTING
While soft lighting flatters skin tones, it is not the only way to light a portrait. In fact many types of lighting can be effective, so it is worth experimenting. A hard spotlight from behind the subject produces a rim or halo of brightness, creating an ethereal effect. A softer but still hard light can bleach out shadows reducing the face to an expanse of even tone. Lighting from the sides or above usually works well, but lighting from below is more difficult. If you are not very careful your portrait will look like a still from a horror movie. The only light guaranteed to give unattractive results is that from a flash mounted on a camera. This produces a hard light with hard shadows that seldom, if ever, flatters the subject.

Digital manipulation
Skin tones and hair colour do not have to be naturalistic. Subtle use of image manipulation software can turn an average portrait into a visually striking, sophisticated image.

PERSPECTIVES
Portraits can be taken from any perspective, from close-up to distant, depending on the effect you wish to create. However, most people tend to opt for standard head and shoulders shots. For these, focal lengths longer than normal (70mm–105mm for 35mm format or equivalent) give the best results.

Focusing on the eyes
A most striking way of depicting a face is to zoom in on the eyes by framing tightly. By losing some of the face, you concentrate attention on the face's most arresting feature.

Analyzing a portrait

The most successful portraits are those that combine an accurate portrayal of the person being photographed with an interesting composition, attractive and appropriate lighting, and sharp focus. But your subject can also be your biggest problem. Many portrait sitters are either too willing to be photographed, with their own very definite ideas of how they want to look, or they are too unwilling, and may even refuse to sit still or show their face. This is where having highly developed people skills comes into play.

BUILDING THE RELATIONSHIP

When covering a national celebration in Kyrgyzstan, I approached this falconer with deference and was rewarded with his full co-operation. I was able to walk around him, asking him to turn this way and that until the harsh light fell in an attractive way. By taking care with the photography, I won the subject's trust and as he relaxed, his character was revealed. An unexpected bonus was the eagle stretching its wing to rest it in total confidence on the falconer's head. This touching gesture lasted only a few seconds. But by then, I was fully prepared to record this revealing moment.

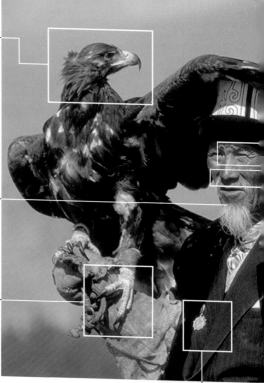

Working with animals
If portraits are tricky, working with animals is notoriously difficult. Here, a fetching turn of the head from the Golden Eagle, revealing a perfect beaked profile, lifts the portrait to a higher level.

A neutral expression is best for portraits. It is easy for the subject to hold, natural, and unlikely to be exaggerated.

Retaining sharp details
Although the main subject is the face, ensure that interesting details, such as the gloved hand and eagle's claw, are retained. This supports the image, showing the viewer more about the person.

Including visual accents
Small details can be very revealing. Here, a military service medal catches a glint of sunlight, rewarding the viewer with a hint at the background of the subject. It is worth waiting to catch a glimpse of visual accents such as this, as they add extra interest to the image.

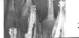

CHOOSING THE RIGHT ENVIRONMENT

To take a great portrait, your sitter must be relaxed, so they need to feel that the setting is appropriate for them. Let your sitter choose the first location. Here a shopkeeper relaxes in his herb shop in Marrakech, Morocco. Do not be too preoccupied with lighting – great portraits have been made with a single bare bulb. By giving your sitter priority, you can work in tandem with them and share the portrait-making experience.

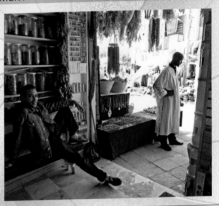

Double portrait
Portraits can include more than one person, and can also show the daily environment in which they live or work.

A surprising wing gesture from the Golden Eagle creates an unusual composition.

Avoiding overshadow
Shadows on the face are generally to be avoided, especially if the subject is in full sun. If you cannot avoid them, ensure they do not overshadow the eyes. here, unfortunately, the bright sun made the subject half-close his eyes.

There is a little too much space to the right of the subject, but a large aperture and a long focal length on the zoom lens have put the background nicely out of focus so it offers no distraction.

Enhancing shadow detail
Ensure that any large, dark areas retain some detail – enhance them through image manipulation if necessary. The amount of detail in dark areas will depend initially on the exposure that you set, which must be focused on the face.

Classic nose shadow
The shadow of the nose helps to give shape to the nose without confusing the shape of the lips. Here, by careful observation, the face was photographed with just the right nose shadow – not quite touching the lips.

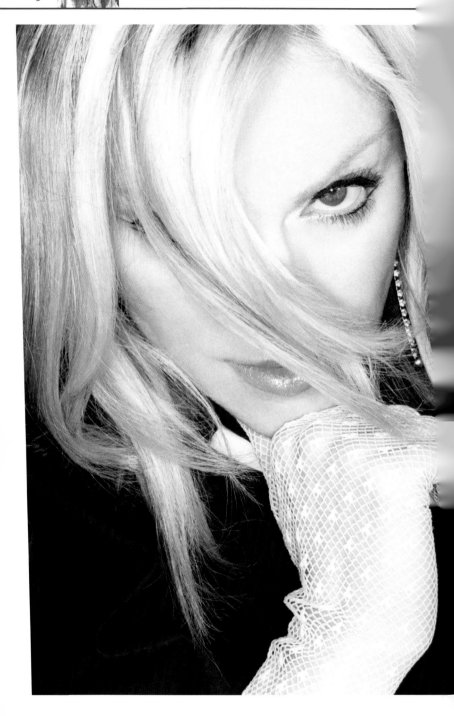

Dynamic portrait
A sweep of blonde hair, a piercing gaze, and a
flailing necktie dramatically compose this image
of Madonna, by Regan Cameron.

Animals

Wildlife photography is notoriously difficult because animals are constantly on the move, often shy, and can be easily panicked. But it can be immensely rewarding. The best wildlife photographers spend much of their lives following the movements of their chosen animals, but such dedication is not a prerequisite. You can take great images without venturing far from home.

Creatures close to home

Domestic animals are good subjects for photography, since you can draw close without startling them. If you have no pets, visit parks and zoos or seek out the wild animals that share your neighbourhood. You can find animals in most environments if you know where to look. Many cities have nature reserves, woods, and lakes. Areas such as cemeteries and playing fields often provide shelter for small animals as well.

The most visible urban creatures are birds, but mammals can also be found. A city fox or possum is easier to spot than its countryside cousin, as it is less afraid of human beings. Learn about the habits of the animal. At dusk, most birds congregate prior to roosting, and mammals pass along favoured runs that can be identified by small gaps in hedges and fur caught in branches.

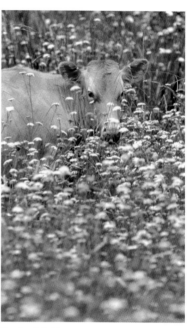

Depth of field
A narrow depth of field leads the eye from the out-of-focus flowers in the foreground towards the sharply focused face of the cow and beyond, where the flowers again become out of focus.

Close-up photography
SLRs and digital cameras make it easy to approach very close to even minute creatures and insects. Depth of field is very limited, so you will need to focus with great care.

Waiting for the pose
To obtain a photograph of a bird busy at work, well posed and with good lighting, takes many attempts and much observation. This image was the best of over a dozen exposures.

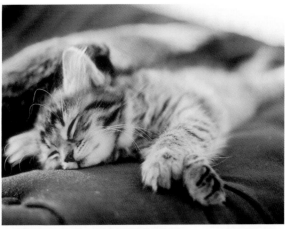

Sleepy kitten
A sleeping pet is an easy target for animal photography. If you set up your camera and tripod at its favourite sleeping spot you will be able to make the most of the available light. The same principle applies if you are stalking wild animals. The more you know about them, the easier it is to catch them behaving naturally.

Showing character
A glimpse of an animal can reveal as much as a full view. Here (*above*) a wolf appears wary even within its enclosure. By zooming close – 600mm efl – I eliminated the surrounding wire fence.

Different viewpoints
Use the close-up abilities of your camera to gain new insight into your subject by looking for unusual views and telling details, such as the feet of this macaw (*right*).

VISITING ZOOS AND NATURE RESERVES
Many modern zoos and nature reserves are centres for research that help to save rare species from extinction. While it is no joy to watch a large mammal in confinement, your visit will support an important conservation effort.

Your photographs will be more effective if you compose your shots to minimize evidence of the artificial surroundings. As with photography in the wild, you may have to wait and watch for the animal to appear. Avoid visiting during school holidays as the animals can be disturbed by the increased number of visitors and may retreat into the depths of their enclosures.

CHOOSING THE MOMENT
Whether you are photographing your pet, an animal in the wild, or a creature at the zoo, you will need patience and perseverance to capture successful images. The best animal pictures show some of the character of the animal, in much the same way as a portrait of a person reflects their mood and personality. For this reason, it helps to have some empathy with the animal and a knowledge of its behaviour, so you can predict its movements and anticipate when you are likely to get the best shot. Unlike a human, an animal will not wait patiently while you set up the shot, so the trick is to follow its actions and take as many pictures as you can.

On safari

One of the best ways to photograph animals is to take a wildlife safari. The game parks and nature reserves of Africa, North America, and elsewhere need and deserve the support of tourism. In return, they offer innumerable, unforgettable opportunities for photography. To make the most of the trip, it is worth making thorough preparations, such as ensuring you have the longest focal-length lens that you can afford, carry, and handle.

CHOOSING A CAMERA

Film-using cameras are superior to digital SLR (D-SLR) cameras for photographing animals in the wild. Often the air is full of dust or moisture that will settle on the sensors of a D-SLR if you remove a lens to change it. Dust can also cause electrical connectors and back-up devices, such as picture drives, to be unreliable, and you may be far from electricity to recharge your batteries. Provided you can manage without the instant review facility of digital cameras, film cameras offer the highest quality and reliability for the lowest cost. Colour negative film copes better with the bright conditions found in many safari parks. Furthermore, the benefits of fast download and ease of emailing of digital images are useless when operating far from a power supply or internet access.

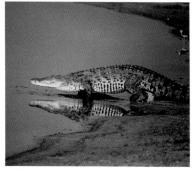

Reflected image
The mirror-like reflection of the crocodile makes it clear that the water is still, reinforcing the stealthy nature of its movements.

CHOOSING A LENS

Most of the time on safari you will be seeing animals from a distance, so it is essential to use a long focal-length lens to bridge the gap between you and your subject. If you are photographing large animals, such as elephants or giraffes, a lens of 200mm will be satisfactory. But for smaller animals a lens with a focal length of at least 400mm is necessary. If you wish to take extreme close-ups, you will need a 600mm lens, but bear in mind that lenses of this size are heavy and cumbersome. Assess what lens to take by deciding the type of images you want to take and the animals you wish to photograph.

Large lenses are also expensive, so for a once-in-a-lifetime trip it may be worth renting one. Alternatively, a long zoom lens such as the Canon 100–400mm or Sigma 50–500mm is cheaper.

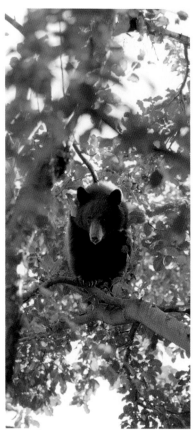

Selective cropping
This bear was too far away to fill the frame. A tall, narrow crop that places the animal centrally in the frame makes the best of the image.

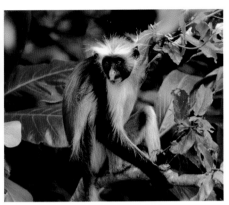

Approaching closely
Special reserves, such as the Jozani Nature Reserve for the Red Colobus Monkey in Zanzibar, are ideal for getting close to animals that are normally too wary to be reached.

Unusual views
Photographing from unconventional viewpoints or finding unfamiliar views of familiar subjects is an effective way to create eye-catching, even amusing, images.

Capturing details
It is not necessary to show the whole animal. Try concentrating on striking features, such as these zebra stripes.

COMPENSATING FOR CAMERA-SHAKE

Camera-shake increases in proportion to the effective focal length (efl) of the lens, and is a particular problem when shooting from a moving vehicle (common when on safari). A few specialist lenses are designed to counteract it, by either shifting optical cells within the lens, or moving the sensor itself.

Image stabilized from boat
While not perfect, this image would not have been possible with an unstabilized lens. It was taken from a canoe bobbing up and down on a choppy river.

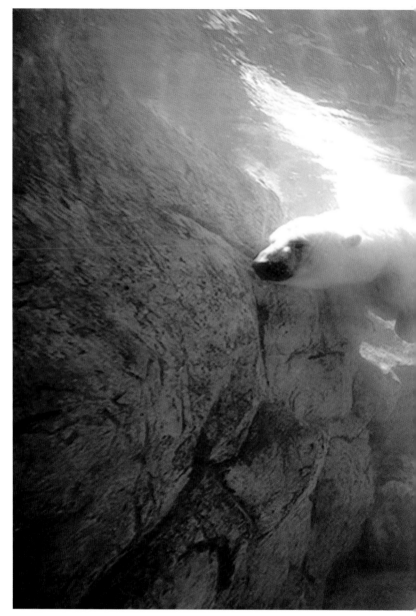

Polar bear
You need not dive into freezing Arctic waters
to catch a polar bear in a natural-looking
environment. Visit a zoo instead. A wide-angle
view takes in the colours of the water and
rocks, and also eases the demands of focusing –
here the bear was swimming quickly.

Events

Our lives are full of events, some of which we may wish to remember, and others we may prefer to forget. One of the greatest claims of photography is that it preserves our memories, but it is rare to find an image that reflects how we truly felt at the time. The challenge in photographing an event is to capture the action and the atmosphere through still images.

Choosing an approach

Your objective for photographing an event will shape the approach you take on the day. For example, if you wish to remember the people who played a special role at your birthday party, you will concentrate on taking portraits. Alternatively, if you wish to provide an objective record that is as complete as possible, you will photograph everything you can from every possible angle.

DECIDING WHAT TO RECORD

Start by deciding the purpose of your photographs. If you simply wish to capture interesting moments throughout the day, take some before-and-after shots, as well as the main event. If you want to tell a story, with a beginning, middle, and end, make sure your pictures include everyone involved, as people are usually central to a story. If you are using a digital camera, do not delete any of your pictures. Even those that seem to be less than perfect at the time may have unexpected potential when reviewed later.

SELECTING EQUIPMENT

A zoom lens that ranges from moderate wide-angle to moderate telephoto (i.e. from 35mm to 80mm) is ideal for photographing events.

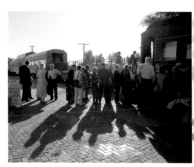

Starting the narrative
The first image shows guests queueing for a ride on a historical train. Long shadows draw the eye to the figures in the centre, balancing the shot.

Use very wide-angle lenses (focal lengths of shorter than 24mm for 35mm format) sparingly, as objects at the edge of the image appear distorted. This effect is particularly unwelcome when photographing people.

One of the most useful accessories for photographing an indoor event is a flash unit with a swivelling head, which can be attached to a camera hotshoe (a bracket with electrical contacts found on the top of most cameras). By swivelling the head, you can aim the flash at a nearby surface to bounce the light off and illuminate your subject. This provides a wider lighting coverage and softer light than flashing directly.

Setting the scene
The late-afternoon train ride carries guests through the countryside, so a picture is needed to represent the journey. By waiting for the right combination of the train's orientation to the sun and terrain, I was able to capture this image, with its attractive combination of light, shadow, and colours.

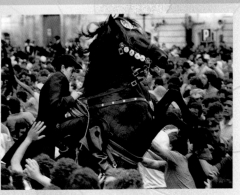

Depicting the main event
Once the train had reached its destination, the guests disembarked for a birthday party. To obtain the best shot, I set the camera to its widest angle setting (shortest focal length) and held it above my head to include as many people as possible.

Showing the preparations
Others may while away the time as they wait for the event to get underway, but you have to watch and work. An extreme wide-angle view such as this distorts faces at the periphery, so frame your shot carefully.

The end of the day
Sometimes you may feel you need to be in two places at once. At the end of the return journey, I had to choose between showing the guests descending from or leaving the train. I opted for the latter to obtain a high viewpoint.

HOW THE MASTERS WORK

Spaniard Cristina Garcia Rodero (1949–) documents the fiestas and religious festivals of her native country. Thanks to her detailed knowledge of the rituals and events, as well as repeated visits to major festivals, her work is unrivalled for its depth, extent, and humanity.

Cristina Garcia Rodero
Rodero works mainly in black and white, which is superb for cutting out the many distractions provided by colourful festivals.

Analyzing an event photograph

Family albums are full of photographs that record important events and milestones in life, such as birthdays, weddings, graduations, and other celebrations. A skilled photographer will ensure that, as well as compiling a collection of pictures that record each aspect of the event, there are also shots that encapsulate the event as a whole. It is essential to know when and where the key moments of the event will occur. Find out the running order of the day and plan where to be at what time, in order to get the best shots.

FINDING THE KEY SHOT

The secret to catching the key moment of an event is to keep working – never stop, never rest. If you wish to record an event in a professional way, you can forget about participating in it. You are there for the photography, not the fun. When reviewing the images that I took at a Hindu wedding, the picture below stood out. It contains all the vital elements of a key shot; it is colourful, vibrant, and dynamic, and has the smiling bride at the centre surrounded by well-wishers. It perfectly encapsulates the spirit of the event – a joyful celebration involving family and friends.

Tracking the subject
By tracking the bride with the camera during exposure, I ensured that she is nearly perfectly sharp, while others are blurred. This makes her the main focus of the image.

Capturing visual accents
Vivid spots of colour, such as the red rose buttonholes, help to enliven and structure the image. Here, the roses are repeated in an arc across the picture from left to far right.

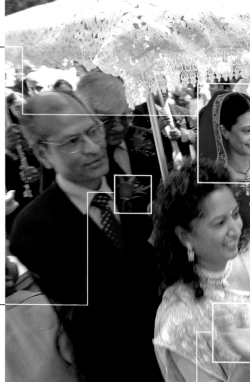

Choosing depth of field
Camera exposure was set to maximize the depth of field, at the expense of a short shutter time. This resulted in blurring, such as the applauding hands. This is acceptable as long as the crucial details are sharp, and can add a sense of movement to the image.

GROUP PHOTOGRAPHS

The group photograph is an obligatory part of recording major events such as weddings. But they do not need to be stiff, static, set pieces. Once you assemble the group, encourage frivolity such as jumping in the air, or tell a joke. Work quickly as the moment is easily lost.

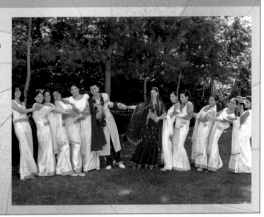

Tug of war
Rival "factions" try to pull the bride and groom apart, transforming a standard shot into a warm, amusing picture.

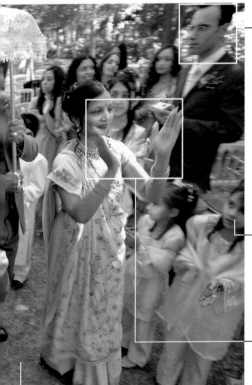

Using a wide-angle lens
With wide-angle lenses, subjects at the periphery of the frame can be distorted. Here, a face has become egg-shaped. Where possible, place subjects away from the edges of the image.

Avoid cutting off a face at the edge of the frame unless there is a good reason. Here the crop was unfortunate and unplanned.

Quiet areas of an in image are important for structure, but ensure they are not too large. If they are too dominant, you can reduce their impact by image manipulation, such as burning-in the corners to darken them.

Synchronizing your shot
Perfect timing is needed to catch rapid hand movements in their best position. Until you are experienced with your camera, estimate the length of the shutter lag before pressing the shutter release.

Children playing in bubbles
This classic image, taken in Barcelona in 1997
by David Alan Harvey, shows event photography
at its best. It is full of fun, chaotic action, and
bright colours captured in glorious light.

Documentary

Despite being central to photography's ideological and historical development, the genre of documentary photography is still hard to define. It includes many modes of working and has many different uses, from corporate photography, to hard-hitting investigative journalism, to plain old-fashioned storytelling. However, what all the greatest documentary photographs have in common is that they provide a true record of real situations, real events, and real people.

Defining documentary photography

There are a number of factors that set documentary photography apart from other genres. A common, but not necessarily mandatory, requirement for a body of work to qualify as documentary is that it must be ideologically motivated. This distinguishes it from, say, travel photography. In addition, unlike on-the-spot news gathering, documentary work usually takes some time to complete. Crucially, with the exception of corporate or artistic documentary work, images should not be controlled, set up, or otherwise manipulated.

CHOOSING A PROJECT

Inspiration is all around you. You do not need to travel far to find fascinating subjects. The key is not in uncovering an unknown, or even unusual, subject, but in interpreting any subject in an unusual or revealing way.

Some of the best documentary works cast a fresh eye on everyday subjects, for example, the construction workers on this page. Others, such as the images opposite, look behind the scenes to shed light on unfamiliar subjects.

Ambiguous scale
Positioning himself so that all elements are separate but sharp (*below*), the photographer creates a composition of uncertain perspective.

Creating tension
The tiny figures and implied movement from the lack of verticals (*above*) induces a sense of vertigo in the viewer.

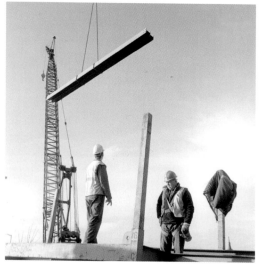

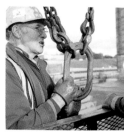

Juxtaposition
Direct contrasts, such as the man and the heavy steel that he works with (*above*) can make a powerful statement.

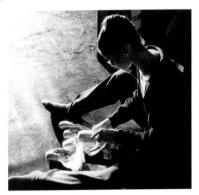

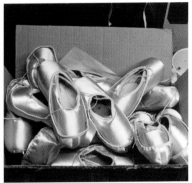

Chiaroscuro lighting
The advantages of black and white can be clearly seen in this striking backstage study of a ballerina. Combined with dramatic lighting, it reduces the image to shapes of light and dark.

Telling details
At its best, documentary work does not need titles to identify its subject. This image says "ballet" more clearly than any words, and it does so in any language.

THE TOOLS

Technologically, much documentary photography has remained in the 20th century. While a few documentarists have adopted digital photography, the majority of work continues to be created on film. One key reason is because the camera most favoured by the profession, since it was launched in 1954, is the Leica M series of rangefinder cameras. It is the camera best suited to working inconspicuously, in low light, and with a wide-angle lens. In documentary work, the majority of images are made within the 24–50mm range of focal lengths and a rangefinder is by far the best way to focus these lenses.

The preferred medium for documentary photography is overwhelmingly black and white, due in part to its newspaper heritage, but also because of black and white's ability to simplify the image and tell the story directly.

Being discreet
A prerequisite for documentary photography is the ability to work silently and inconspicuously. To capture the shot below the photographer had to take care not to distract the dancers.

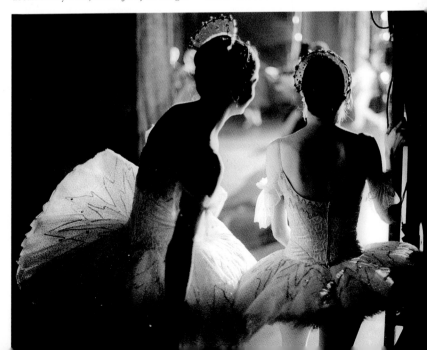

Developing a narrative

The central premise of documentary photojournalism is that you are telling a story that few, if any, have considered, or that you are revealing a new aspect of something familiar. The aim is to surprise and intrigue, perhaps even to shock. To achieve this you must compose your pictures in an interesting way, with hardworking images that offer a coherent logic and narrative thrust.

FINDING A STORY

Once you have decided on a subject area, you need to narrow down the choice of potential subjects until you have a specific theme. During a trip to Central Asia, I wanted to photograph the food of the region. I first chose to investigate the importance of meat in the area, and then sought "hooks" or stories beyond the mere act of meat-eating. A little research uncovered three potential hooks: the consumption of meat is a central part of festivities; working with animals is a substantial part of people's lives in the area; and the region may be consuming more meat than it can produce, which could cause a crisis that impacts rights across society. This final hook gave the best story as it brings together the role of meat in people's lives, which opens up the debate about how much is being consumed.

COVERING THE STORY

When you cover a story, ensure that you have photographed every aspect of it from every angle. For my coverage of food in Central Asia, this included people, animals, and the preparation and consumption of food.

Ensure that what you photograph is found, not constructed. Interfere with the subject as little as possible, but enter into people's lives without obstructing their work. Leave no footprint. No-one should realize you have been at work until they see your pictures.

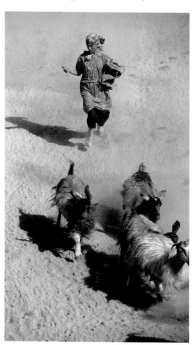

Young shepherdess
The opening picture of the series should choose itself. It needs to sum up what the story is about – here, the relationship between the young population and its growing need for a diminishing food supply.

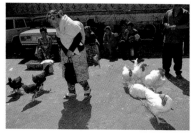

At the market
The first place I visited was a grand bazaar used for trading chickens. The resulting image has interesting elements but its contribution to the story is not clear. It was placed on reserve.

Animal fair
More directly related to the story was an animal fair. I framed the shot in an unusual, visually arresting way, contrasting the woman selling the young cattle with the buyers, who literally appear as shadowy figures.

Food preparation
Although gruesome to Western eyes, the slaughter of animals is a part of everyday life here. The picture is completed by the dog who is struggling to maintain discipline.

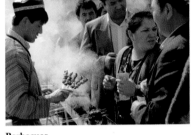

Barbecues
Smoke from "shashlik" barbecues is an attractive backdrop for photography. This shot was timed to show food being offered, but tension is evident in the subjects. It was left on reserve.

Wedding banquet
Eating is an important part of ceremonies in Central Asia. Here the village elders gave thanks for their food before settling down to a banquet at a traditional Islamic wedding.

Simple meal
At this simple meal the food was served first and tea, an essential accompaniment, was poured. Show details that are relevant to the story in an interesting, contextualized way.

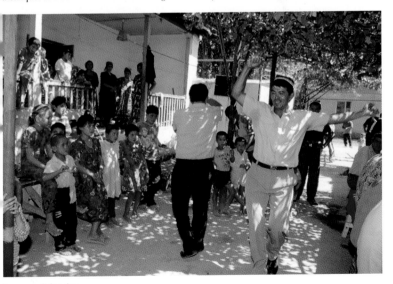

Songs and dancing
This shot sums up the jubilation and celebration at the end of the wedding festivities. In the process of covering a story you will take pictures that remind you vividly of the people you met. This was taken with flash to supplement the main exposure, ensuring that shadows were filled in despite the very bright sunshine.

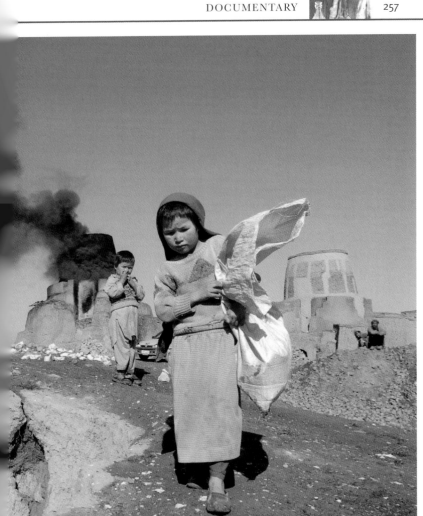

Innocence lost
Children search for scraps of wood in Kabul, Afghanistan. This image was taken by Chinese photographer Chien-Min Chung, who won the Award of Excellence from Pictures of the Year International for his documentary series "Afghan Child Labor".

Children

In the early days, photographing children was extremely difficult. It was almost impossible to get a child to sit still for the long exposures that were needed. Today, children are one of the most popular and perennial subjects for photography. Fast films and manageable cameras have made the photographer's job easier. However, as a subject children still present a number of challenges.

Essential skills

Child photography is superb training for photojournalism. Trying to persuade an unwilling child to pose for a picture can be as difficult and stressful as trying to get past a police cordon. Children are easily distracted, and are often either too tired or too excitable to co-operate. The very qualities of a photojournalist – patience, understanding, quick reflexes, and great technique – are needed.

SETTLING YOUR SUBJECT

A key technique of child photography is to exploit the subject's boredom threshold. After the child becomes used to the camera he or she will relax and behave naturally.

When you first bring out the camera the child may play up to you, in which case you should start taking pictures straight away. However, if the child is being shy or difficult you will need to win them over. Allow the child to look through the viewfinder and press a few buttons, even ask them to take a picture of you. All these things help put children at ease and get them on your side.

With a digital camera you can take pictures freely. If you are using a film camera, you can avoid wasting shots by starting with an empty camera to allow the child to get used to the sound of the shutter run and film wind.

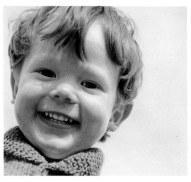

Child's eye view
We are used to seeing children from above, so a low perspective makes a refreshing change. Children love it when you get down to their level, so you should be rewarded with a big grin.

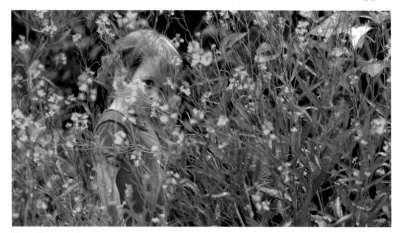

Capturing moods
A winning smile and a sunny mood are not pre-requisites for a great child photograph. Here, a sulk in the garden is captured perfectly in the tilt of the head and the accusing glance. The key to success of the image is the exact focus on the child's eye.

CAPTURING CHARACTER

While studio photographs capture the likeness of a child, they rarely capture a child's true character. Spontaneity is the key to obtaining shots that show personality and individuality.

Children are the sternest test of auto-focus systems. One technique that works well is to set the lens manually and stay in focus by keeping at a constant distance by moving as if you are attached to the child by an invisible thread. If you wish to fill the frame, a long focal length (135mm or longer) works best. If you are using a digital camera, remember that using the full zoom may give a smaller maximum aperture, which results in longer exposure times and blurred images, and reduced auto-focus speeds.

Catching them still
One of the most beautiful sights a family can enjoy is a child sleeping peacefully. It is usually best to set the longest focal length possible, then approach as close as you can.

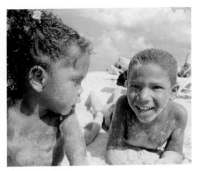

Resting after play
If the children are too busy running about enjoying themselves for you to keep up with them, let them wear themselves out and catch them when they flop down for a rest.

Photographing shy children
Some children are unnerved by large cameras. Compact models are less likely to intimidate them. Here the child's uncertain expression and gestures add to the charm of the image.

HOW THE MASTERS WORKED

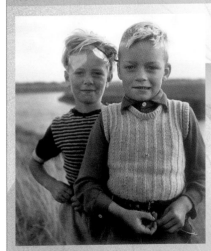

An influential figure in European photography, the Dutch photographer Emmy Andriesse (1914–53) studied photography between 1935 and 1937 at the Academy of Arts in The Hague. She went on to build a successful career working in child portraiture, fashion, advertising, and photojournalism. Being of Jewish descent, she went underground during the Nazi occupation, but recorded the Dutch famine of 1944, known as the "Hunger Winter", and the liberation of the Netherlands in 1945. Andriesse died of cancer when she was just 39 years old.

Emmy Andriesse
Best known for her extensive photography of children, which owes much to the traditions of August Sander, Andriesse's approach to photography was greatly changed by the events of World War II.

Analyzing a child photograph

The perfect child photograph need not be an image that must appeal to people across the world. Rather, it can be an intimate study that holds meaning for just the subject and the photographer. It may be a private moment frozen in time; a flashback to the past that evokes everything loved about the child; it may bring together many elements whose totality references the spirit of childhood and happy memories; or it may simply bring out a feeling of tenderness.

FINDING THE PICTURE

As with so much of photography, the key to taking great shots of children is to be constantly vigilant and have your camera with you at all times. When the moment arrives, all your photographic skills must come together to frame the image (give yourself plenty of room); to focus the lens (ensure the nearest eye is sharp); and to expose the shot correctly. In this picture a child waits for his turn during a parade in Bishkek, Kyrgyzstan. The obvious image is his portrait, taken close up. But the interplay of pinks between the balloon and his jacket, as well as the rose garden, suggest a wider view.

Centring the composition
The balloon was swaying slightly in the wind, so it was important for me to press the shutter when it was directly over the boy's head.

Including focus blurs
Use a long focal length lens to throw background details out of focus, which accentuates the main subject.

Try to include areas of low contrast and dark colour in your image, to give balance to a busy photograph.

Adding visible details
Details that become progressively sharper as they near the main subject help to draw attention to the face. Echoes of pink with the jacket also help the composition.

UNCONVENTIONAL FRAMING

It is all too tempting – and entirely natural – to try to compose all pictures of children so that they occupy the centre of the frame. But other framings can be equally, if not more, arresting and can capture the character of a child by reflecting their unpredictable pattern of movements.

Swinging shot
A slight delay in the shutter run means that the child is almost out of frame, but it makes for a dynamic and fun image.

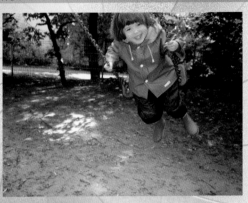

Correcting brightness
Exposing for the face renders the hat too white. Here it has been darkened digitally.

Achieving sharp eyes
Central to portraiture of any kind are the eyes. They should be focused as sharply as possible, unless you wish to produce a very specific effect.

Be careful not to allow light reflected from leaves to give the skin an unpleasant green cast.

Using quiet areas
Exposure should be sufficient to deliver shadow detail, but the lack of detail in this small part of the image is not a problem. It is a quiet area in an otherwise busy image. We are only interested in the boy's face and clothes, and the roses.

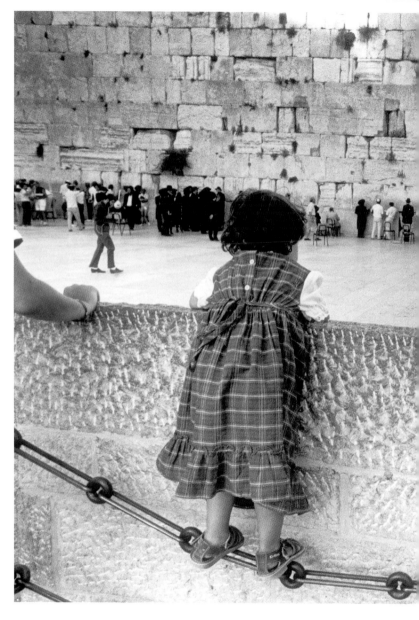

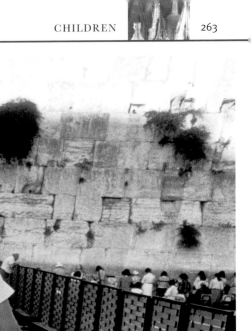

The Wailing Wall, Jerusalem
Two girls watch male worshippers at the
Western Wall in Jerusalem from a vantage
point only open to them because of their
youth – a fence on the right separates men
from women. Taken by Micha Bar-Am in 1985.

Travel

One area of photography in which amateur photographers dominate is travel. It is easy to see why – more people are going to more places and taking more photographs than ever before. But successful travel photography requires more than merely watching a sunset with a camera in one hand and a dry martini in the other. Hard work is necessary to be in the right place at the right time to capture distinctive images.

Taking travel photographs

There are few places in the world that have not been photographed several times over, and many more that have been photographed millions of times. The challenge of travel photography is to create imaginative, original images, while coping with the extreme conditions often encountered when travelling.

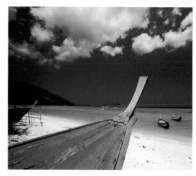

Foreground interest
By placing a colourful prow of a boat in the foreground instead of the stretch of beach, this image gives a greater sense of space and an involvement in the place.

CREATING ORIGINAL IMAGES

To take outstanding images, try to photograph not the place itself but an idea of the place, or your enjoyment of it. In summary, your goal is to encapsulate the whole world of travel. You do this primarily in the third person, perhaps by showing

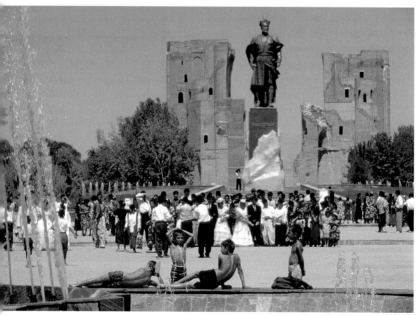

Using scale
This image taken in Uzbekistan has everything – a Timurid monument in the background; the social documentary of the weddings in the near background; and the boys in graceful poses in the foreground. All are dominated by the huge statue that disturbs the sense of scale.

families enjoying a beach party, a couple sharing a sunset, or a traveller shopping in an exotic bazaar. The spirit of travel, a sense of adventure, the joy of experiencing new destinations – these are the key elements of travel photography. Even if you do not wish to offer your photographs commercially, you will find that your travel photography will improve. As a result you will enjoy both working to take the images, and also the images themselves.

CARING FOR EQUIPMENT

Check your equipment – especially lenses – at every opportunity, and clean each item if necessary. This is particularly important if you use a D-SLR camera and regularly change lenses, since particles of dust or dirt can easily penetrate. Ideally you should clean the sensor every day. To guard against loss of images, use a back-up picture drive if you are using a digital camera, or keep film canisters in the hotel refrigerator to preserve quality.

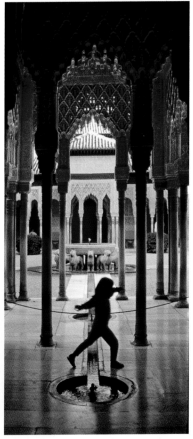

Careful composition
At this pilgrimage destination in Uzbekistan, almost any picture would be beautiful. But a patient wait for an elegant grouping of people has paid off. This composition could hardly be improved if it had been directed.

Waiting for the moment
The Alhambra Palace in Spain is a world-famous, much-photographed architectural masterpiece. Here, a classic viewpoint is enlivened by a child enjoying the space. If you bide your time you will often be rewarded.

MODEL RELEASES

If you want to publish your images, you have a duty to any people depicted to be accurate and fair to them. If the pictures are used commercially, you must obtain model releases from each person (see p. 309).

Showing faces
This image could be used in a magazine article on life in Fiji, but because the people are recognizable it cannot be sold or used for advertising without signed model release forms.

Analyzing a travel picture

Some travel pictures are simply stunning shots of a beautiful place, while others manage to inform, teach, or show the viewer something about life in another country. But since travel photography is one of the most oversubscribed forms of photography, a travel picture needs to stand out in order to create an impact. Merely being informative is not enough. Successful travel pictures are colourful and characterful, well timed, and, importantly, technically perfect.

WAITING FOR THE MOMENT

This photograph could easily be used to convey information about a way of life, or about what a visitor to Marrakech, Morocco, might expect to see. But the shot was also timed to capture an atmospheric light, and to show people going about their business and interacting with each other, which creates a more arresting image and a lasting impression. The zoom lens was set to a moderately wide angle so as not to distort figures on the periphery of the frame. Then it was a matter of waiting and watching people, until their positions and actions fell into a compositionally coherent pattern – the decisive moment in which independent elements add up to a meaningful whole.

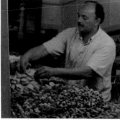

Capturing activity
The photograph shows activities typical of a Moroccan market – selling and buying.

Warm colours of the wall are adjacent to one another in the colour palette

Delicious colours
The many colours of a Moroccan market are central to its appeal. Here the wide range of hues from reds through to greens provide an exotic visual feast.

Sense of depth
The strong diagonal lines of light and shade lead the eye across the image and into the depths of the scene, creating a sense of a living space. The lively lighting also transforms the otherwise empty floor into something that contributes to the visual interest.

EYE CONTACT

Photographs of people you meet on your travels are more interesting if the photograph gives you eye contact with the subject. Direct eye contact will show that you have succeeded in creating a relationship with the person in the picture, rather than being merely an observer or, worse, an unwelcome interruption in their lives. This in turn helps make the viewer feel more comfortable about examining the image and creates a sense of involvement.

No eye contact
Although he is smiling, the lack of eye contact shows that the man is shy or uncomfortable about being photographed.

Direct eye contact
He may not be smiling, but the direct eye contact shows that he is aware of the photographer. He next broke into a broad grin.

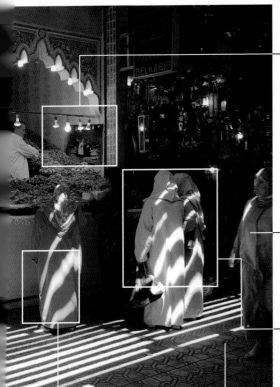

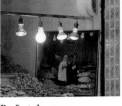

Perfect sharpness
As a measure of quality, sharpness is the first judgment made by any viewer, professional or not. If the image is not sharp it will be rejected, unless there is a very good reason to reconsider it.

Captured movement leads the viewer's eye into the scene

Tonal gradation
Smooth tonal transitions or gradations are a sure sign of correct exposure. Here the subtle changes in the pink tones are captured perfectly.

Precise exposure retains detail in the shadows

White balance
The standard bearers of accurate colour are the neutral tones. Here the whites and greys contain little other colour, which leads the eye to read all colours correctly.

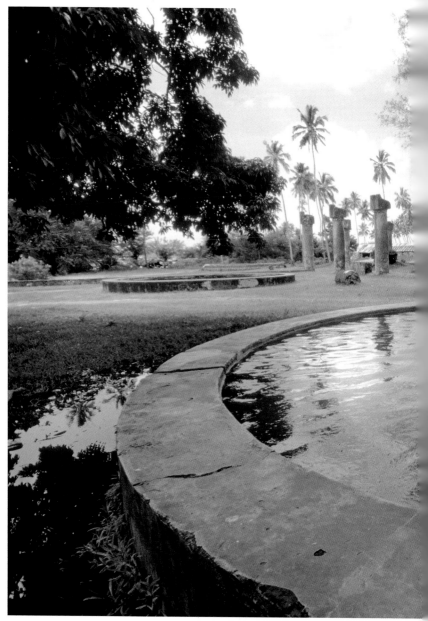

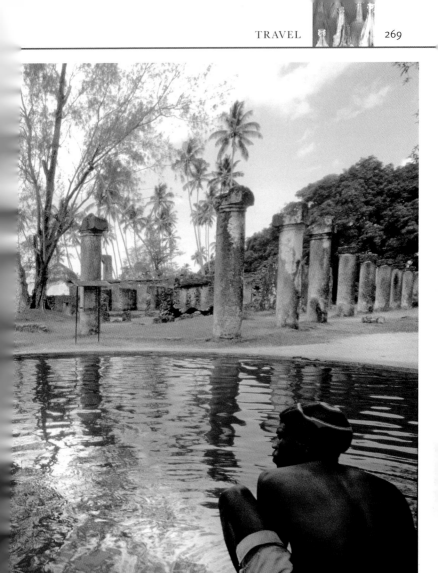

Zanzibar Island
A wide-angle lens was used for this view,
with the lens pointing horizontally so that the
ruined columns in the background stay vertical.
The original, which was shot on film, was
scanned so that the surface of the pool could
be lightened to balance tones with the sky.

Landscapes

Landscapes are a perennial subject for photography. While they may appear to be passive, spread out before you, awaiting your attention, in truth they are capricious, challenging subjects. You may arrive at a viewpoint and find yourself prevented from reaching another by a combination of terrain, light, and weather. Landscape photography can be opportunistic, a snapshot of the view that is offered, or the deliberate, precise result of preparation and observation.

Working with light

Landscape photographers may seem to be at the mercy of the weather. Either the day is too cloudy and dull or it is too bright and sunny. But remember that all light is good light, and that a key part of photography is using it creatively. The great mountain photographer Galen Rowell (*see pp. 274-75*) put it simply: "I almost never set out to photograph a landscape... my first thought is always of light." In short, you can shoot landscapes in any light conditions. You just have to let the light lead you to the picture.

Vanishing points
Converging parallel lines, such as the tracks in this hay field, are effective for conveying a sense of space and distance in the scene. The off-centre composition energizes the image.

Soaring heights
An outcrop of red sandstone near Issyk-Kul, Kyrgyzstan, has been photographed from below with a row of pine trees in silhouette to propel the energy of the image upwards, towards the blue sky. The composition, which roughly abides by the rule of thirds, also adds impact.

Waiting for the right light
If you press the shutter the first time you see a promising landscape, you may be disappointed with the result. Observe how changes in the light affect the scene. Here, the photographer waited until the shadows fell so that they appeared to emanate, rather intriguingly, from the building.

HARNESSING THE LANDSCAPE

There are simple tricks you can use to improve your landscape photography. One is to exaggerate a format. For example, the panoramic shot (*see p.126*) is popular because it can make something unusual out of the ordinary. Another "trade secret" is to make use of reflections – these can provide visual interest in an otherwise unexceptional image. Remember too that landscape compositions do not have to be divided equally between the land and the sky. You might find the picture works best if you concentrate on the foreground and reduce the sky to a narrow strip, or you may want to create a dramatic effect by emphasizing the vastness of the sky.

Cloud break
Here, the photographer waited until the clouds lifted in the distance, framing the trees on the horizon and allowing a reflection of light to creep over the foreground.

HOW THE MASTERS WORK

Artists have long been inspired by the glorious light and landscapes of the Mediterranean. Franco Fontana (1933–) is one of Italy's foremost photographers and his stunning images of his native land have been published and exhibited worldwide.

Franco Fontana
This classic landscape, taken in Italy in 1978, is characteristic of Fontana's clean, graphic, deceptively simple style. It also demonstrates a complete mastery over perspective, colour, light, and composition.

Analyzing a sunset photograph

Not surprisingly, sunsets were not a popular subject before the advent of colour photography, and even then they were difficult to capture because the lenses of the time were not well protected against flare from the sun.

But with modern, multi-coated lenses, sunsets are an irresistible subject that appear easy to photograph. Yet results often disappoint because of the difficulty of exposing correctly for sunsets, which usually have a wide dynamic range.

EXPOSURE AND FOREGROUND

A common mistake when taking sunset photographs is to underexpose the image, which often results in areas of shadow appearing too dark, with little or no detail. To avoid this, measure the exposure at the part of the scene that is most important – often the area that is at right-angles to the setting sun. Then compose the shot to

include features of interest in the foreground. These were the strategies for the sunset scene shown below, which I photographed in southern Wales. Exposure was metered on the golden sand in the foreground, and I took care to include details such as footprints and reflections in the wet sand, a small stream, rocks, crisp shadows, and seaweed.

The sky may appear too light when exposure is set for the beach. Here, it was darkened during image manipulation.

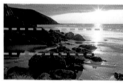

Composing the image
The horizon has been placed in a classic position, roughly one third/two thirds, which gives a balanced composition. It is important to ensure that the horizon is level.

Adding shadow detail
Ensure that shadows hold detail. If necessary, enhance them with imaging software.

Note the diffused flare spot caused by internal reflections in the camera lens.

Including off-centre interest
Ensure that there is an interesting play of light or some other effect even in "quiet" areas of your image.

USING GRADUATED FILTERS

Before digital manipulation, the only way to reduce the brightness of the sky without affecting the foreground was to use a graduated filter, which fades from maximum colour density at one edge to transparent around halfway across. Unfortunately, they often cause lens flare from internal reflections if the sun is in view, and the effect also varies with focal length and aperture. However, it is still a good basis to aid digital manipulation of the image.

No filter attached
This shot was taken with a wide-angle lens with no graduated filter. The sky appears too bright and lacks colour.

Tobacco filter attached
A brown-coloured graduated filter introduces warm tones into the otherwise over-bright and pallid sky.

Working quickly
Even in slow-paced landscape work, timing is all-important. Here, exposure was timed to be just sufficient for the sun to appear past the cloud, but not enough for it to break through fully, as this would create too much flare.

If using film you can reduce the dynamic range of the scene with a gradient or graduated filter, to darken the sky.

Measuring exposure
The exposure was set so that that the mid-tone colours are accurate and nicely saturated.

Selecting a position
The perspective of this shot was chosen to ensure that the silhouettes of the rocks in the middle of the image would appear sharp against a clean background.

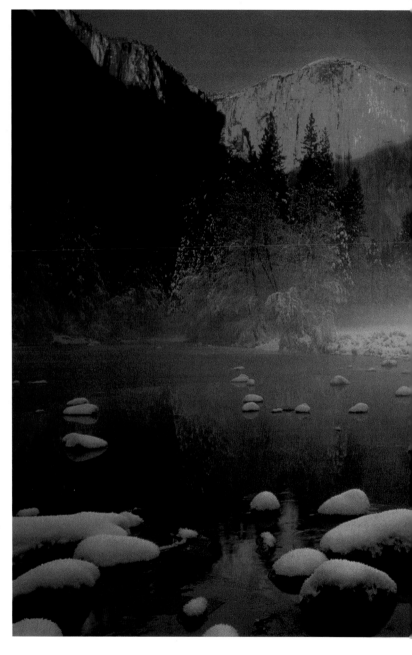

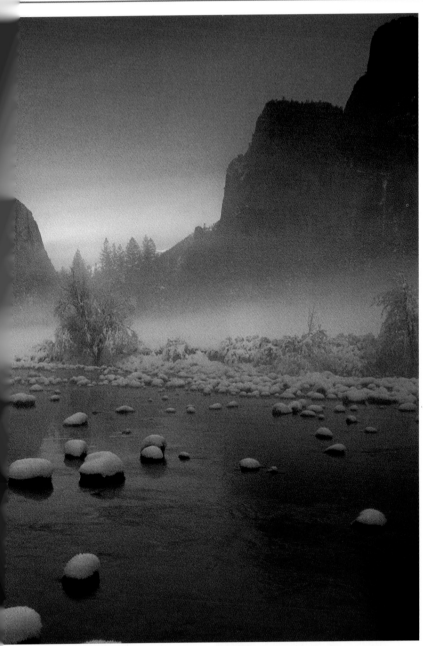

El Capitan and the Merced River in winter
In this striking image, taken by the celebrated
photographer Galen Rowell, the sheer granite
rockface of El Capitan in Yosemite National
Park, California, is set ablaze by the light of the
setting sun. The reflected light spills into the
inky waters of the Merced River.

Plants and gardens

The natural world is one of the most popular subjects for photography, and it is no wonder. Plants, flowers, and gardens are inherently beautiful, and provide an unlimited variety of forms, colours, and compositions. But even such perfect material needs to be worked on, and the challenge for the photographer is to combine technical skill with imagination to create inspiring images.

Flowers and plants

A large part of the skill of plant photography lies in working with a narrow depth of field to focus on the crucial part of the image. But equally important is thinking creatively to create a distinctive image. Try experimenting with a variety of different viewpoints, compositions, and light conditions.

WORKING OUTSIDE

While few things in life are more pleasant than walking around a beautiful garden in the sunshine in a cooling breeze, such conditions are less than ideal for plant photography. Bright sunlight causes lit areas to be very bright or "hot", while areas in shadow are dark. This high contrast is inimical to the accurate rendition of colours needed for the best plant photographs. In addition, the long exposure required for shots with an extended depth of field calls for the subject to stay absolutely still, which can only happen when there is not a breath of air. Partially overcast, still days are best for plant photography, but you can create beautiful images whatever the conditions.

Using backlighting
Flowers with translucent petals look particularly beautiful when photographed from a very low angle against the light.

Creating a painterly effect
Pictures of flowers need not always be pin-sharp. An impressionist view can give a sense of flowers swaying in the wind, moving in and out of focus.

Highlighting texture
The strong sunlight catching these grasses almost burns out the detail and emphasizes their soft, furry texture.

TAKING CLOSE-UPS

When taking close-ups, depth of field reduces rapidly so that when the frame is filled by the flower, it is barely more than a finger width. One way of avoiding this is to use a digital camera with a small sensor, but if you are using a film camera, use the aperture priority mode to allow you to set the aperture (the camera sets the exposure time). Select the highest f/number to give you the smallest aperture, for example f/8 instead of f/4. This may extend the exposure time and increase the risk of camera shake, so use a tripod. Alternatively, use the macro or close-up mode to allow you to focus close to the flower.

With direct flash the light will be too harsh. Instead, use a flash-head that can be tilted to light a reflector, which directs diffused light onto the flowers. Zoom lenses such as the Canon 100–400mm or the Sigma 50–500mm are not too heavy but give very good results.

Isolating details
The longest setting of a zoom lens is excellent for close-ups. This image was taken on a 100–400mm lens set to 400mm.

Using a macro lens
Flowers are one of the most rewarding subjects for close-ups. By using a macro lens and a tripod you can capture minute details.

WORKING INDOORS

Because of the problems of photographing in the open air, many professional flower photographers prefer the controlled environment of the studio. But you do not need an elaborate studio set-up to take successful flower photographs. You need only a table, a plain background, and a good source of light, such as a large window. Indoors you have the advantage of complete stillness so you can make full use of a tripod to capture perfectly sharp images.

Tight framing
By bringing a pot of plants indoors and setting it on a table (*right*) you can frame the image in ways that would be difficult outdoors.

Making a study
Flowers arranged on plain white card and photographed from above make a simple and stylish image, reminiscent of a botanical study.

Trying a different approach
A sheet of muslin hanging over a window acts as a back-projection screen, giving an unusual, abstract view of roses in a glass vase.

Capturing the spirit of a garden

Garden environments range from large, formal landscapes, which are organized with elements and views composed for the visitor, to private gardens, which are very often an unruly compromise between space and resources. The challenge of photographing a garden is not merely to record an attractive, accurate representation, but to find and capture viewpoints that will surprise and delight even someone who has intimate knowledge of the place.

DIFFERENT APPROACHES

More than almost any other kind of location photography, a successful garden photograph should capture the unique *genius locii* – spirit of the place – that distinguishes it from all other gardens. This spirit may be evident only at certain times of the year, in certain lighting conditions, or when viewed from carefully chosen viewpoints. The trick, then, is to approach the garden with an open mind, walk through it slowly, looking at it from a variety of vantage points and perspectives. For some shots you may need to wait for later in the day to get the best lighting. Also try out different formats, the typical horizontal landscape format is not necessarily the best for every picture.

Informal garden
A slightly raised, wide-angle view, provides foreground interest and emphasizes the variety in this densely planted garden.

Formal garden
The garden of interior designer David Hicks merits a formal style of photography. The square format and neat hedges lead the eye to the central sculpture.

PERMISSIONS AND ACCESS

As gardening has become a prosperous industry, owners of gardens have become aware of the monetary value of their properties. If you wish to publish your images or sell them as prints, you are operating in a commercial realm in which it is recommended that you obtain permission prior to photography. If you are not sure of your rights or obligations, you should seek expert advice.

Ornamental features
This image was taken at the Chelsea Flower Show in England, where amateur photography is permitted but commercial photography is restricted to those who have obtained permits.

Colour contrasts
You do not need to show the whole garden to give a flavour of its colourful character and architectural elements.

Sparse compositions
Some designs make a virtue of simplicity and modernism. This garden was photographed using the same approach.

Incidental patterns
With careful framing, details such as the pattern of stones in a path or the shape of steps, are also worth photographing.

EXPLORING VIEWPOINTS

Garden design is all about offering attractive views, which is one reason why gardens are such a popular subject for photography. But simply snapping away at whatever presents itself is likely to produce disappointing results. Successful garden photography requires patience, consideration, and creativity. A view may be dull in one light but entrancing in another. And a small change in viewpoint – crouching down or standing on a bench – may make the difference between an average and a stunning composition.

The very nature of a garden means that at times your viewpoint may be restricted. A zoom lens is ideal for garden photography, as it enables you to control what is in the frame. When composing a wide-angle shot that includes trees or architectural features, keep the camera level – not tilted back or forward – to avoid converging parallels.

Shooting at night
A lamplit garden at night is transformed into a magical, mysterious place. Use a tripod and a long exposure to capture colours accurately.

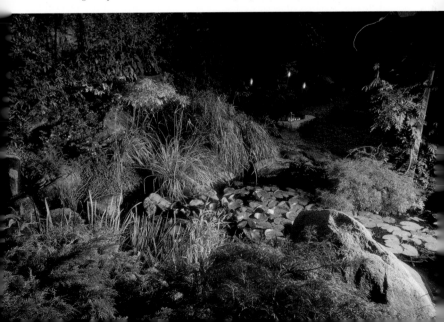

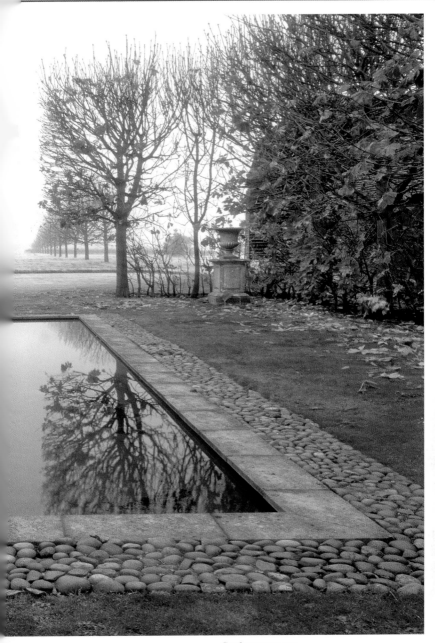

Garden symmetry
The elegant simplicity and spare lines of this garden, with its receding avenue of trees and mirror-like pool, is best represented by an equally refined and symmetrical view.

The nude

Much of photography is arguably the photography of beauty, and the human body – particularly the female form – has enjoyed a favoured, as well as tempestuous, relationship with the camera. There has never been a shortage of models, except in areas where there are legal restrictions on nude photography. A huge variety of approaches have been undertaken, yet the subject holds great potential for further development and innovation.

Lighting conditions

The best lighting for photographing the nude body is soft or diffused. This is because even a small amount of excess light will cause overexposure of the brighter parts of a light-skinned body. With darker skin, the situation is even more difficult to control. Shadows will lose detail while the curves of a body will reflect light, which over-exposes the image. As a result, the softest light with minimal shadows is the easiest to work with. Master photographers such as Lucien Clergue (*see pp. 212–13*) show that bright sunlight can be used, but even highly skilled photographers find it difficult.

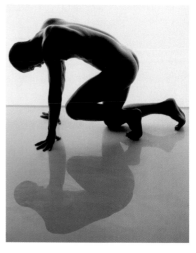

Formal study
The beauty of an athletic figure is shown best through simple outlines and lighting. The reflection adds dynamic drama to the pose.

Backlit figure
The nude figure has been pushed to the periphery in this image, so that it is as much about light and mood as about the body.

COMPOSING THE SHOT

While some photographers create successful images of the whole body, most of the best images limit the view to an almost abstract composition. It is easier to pose the model for a partial view, whereas most poses showing the whole body appear mannered or false.

If you are restricting the shot to just a part of the body it is best to use a medium-length telephoto lens (equivalent of about 70mm–135mm). This stops you getting too close to the model and so ensures that the parts of the body closest to you are not exaggerated.

WORKING TOGETHER

Your model's comfort is paramount. Explain what you want to achieve and then allow them to arrive at the pose themselves. In so doing, you work together to achieve the result you desire. With a digital camera, you can also review the shots with your model. This is reassuring for them, and gives them valuable feedback that will help refine their poses.

Blue diffusion
In this image, intense morning light is diffused by a blue mosquito net. The blue contrasts well with the skin tones, and by focusing past the netting, I created a soft haze over the body.

Dream-like effect
Here the same diffusion technique has been used, but the netting has been arranged to create strong diagonal lines across the body, giving the image an ethereal, abstract quality.

Using props
In this nude study, the subject is shown as much by the shadow as by the body itself. But the clever use of the hoop takes the image into the symbolic realm, suggesting the Olympics and athleticism with striking clarity. Props do not need to be elaborate to be effective.

Covering the shoot

When working on a nude photoshoot, ensure that you give yourself plenty of choices when you reach the picture editing stage (*see pp. 314–15*) by taking as many images as possible. If you create a set-up with good lighting, in which the model is comfortable and you are happy, take lots of photographs from different angles, positions, and distances to "cover" the scene.

CREATING DIFFERENT EFFECTS

Use different lens settings to achieve different effects. Try varying the focal length, the point at which you focus, and the aperture setting. If your lighting is flat, experiment by overexposing, and if your lighting is more contrasty, try underexposing the shot, too.

Alternatively, if you are using a digital camera, try out different white balance settings to vary the colours. Use the highest quality settings on the camera. Skin tones always benefit from the best possible tonal quality, which demands high-resolution image capture. Another effective variant is to introduce deliberate blur or softness into the image using soft-focus or diffusing filters. Finally, do not forget to shoot both vertical (portrait) format pictures as well as horizontal (landscape) format pictures – this will give you a range of choices when you come to select the most successful images.

Using shadows
While faces are usually shown well lit, it can be effective to allow the face to fall partially or wholly into shadow. This simplifies features to their elegant outlines.

Preserving modesty
Many poses can be attractive without having to show more nudity than necessary, or more than is acceptable in many societies. You can still show sensual lines and skin textures.

STAYING WITHIN THE LAW

In some countries, nude photography is not permitted. Wherever you are in the world you need to be fully aware of local traditions and laws. Restrictions on nude photography may apply not only in public places such as beaches, however deserted, but also in your hotel room.

Guarding your pictures
Do not keep a memory card with nude pictures in your camera when travelling through Customs or other inspection points. If anyone checks the camera's operation – routine when security levels are high – they may inadvertently see the pictures. At best it will be embarrassing, at worst you could face delays and questioning.

Soft lighting
Low-contrast or soft lighting as well as the highest quality imaging is needed to render tonal gradations and subtle skin tones accurately.

Diffusion
Softening the image by using filters, special lenses, or image manipulation software imparts a hazy, romantic feel to your nude photography.

Light and shade
Hard light is effective if you want to reveal shapes and lines – as here – rather than concentrating on tones and smooth transitions.

Facial expressions
Inexperienced models may be tempted to smile too much for the camera, while professionals may not smile enough. The best expressions show that the model is relaxed and happy.

Backlit silhouettes
Models reluctant to reveal themselves fully can be photographed in silhouette against a strong light such as a window. The pose will need to show the shape of the body clearly.

Reflected landscape
A magnificent landscape view of the Mungawai
Heads, New Zealand, is reflected in a panoramic
window while the model poses for the camera.

Architecture

Taking pictures of buildings and interiors may seem to be straightforward because they are static, but they are actually technically demanding, and require precise framing and visual ingenuity on the part of the photographer. That said, photographing architecture can be extremely rewarding. In effect, you are re-interpreting the architect's vision using a two-dimensional medium to capture the characteristics of a complex three-dimensional space.

Portrait of a building

Your aim when photographing any building is to create a portrait, and it is as important to understand the architecture as it is to understand the sitter when capturing a human likeness. Whether you are photographing the interior or exterior of a building you should spend some time walking around to get a sense of scale, shape, and space. Two key aspects to successful architecture photography are lighting and spatial organization. Soft lighting, in the form of directional sunlight from a three-quarter angle, is best for capturing textures and form. You can also use the lines of walls and other structures to suggest depth and emphasize shape.

Static composition
This photograph of the marina at Barcelona (*above*) brings out its calm elegance. The linear composition and strong vertical lines emphasizes stability and static weight.

FINDING A SPECIALITY
As your interest in photographing buildings grows, you are likely to develop a special interest. This could range from the gargoyles found on churches across Europe to the decorations on doors of homes in Africa to the vernacular architecture of mountain regions. A specialist interest gives you the impetus to see more of and learn more about a site of architectural interest than the average tourist. Whatever your speciality, it is important to keep notes (these can be embedded into digital images using image management software). This way, as the collection grows, its value as a source of information will increase.

Linear composition
This Pavilion at the 2002 Seville Expo has been photographed to exploit the rhythmic repeating lines but the image lacks a sense of scale.

Stylish interior

If modern interiors are your special interest, shut away your preconceptions. This public convenience in Normandy, France (*above*) is a perfect example of an unexpected photo opportunity. A wide-angle view with the camera held level allows the space to speak for itself.

Using reflections

This shopping arcade (*left*) has been shot from a low viewpoint that exploits the reflections of the glass ceiling in the shop windows to create a sense of light and space.

HOW THE MASTERS WORK

Modernist architecture provides endless scope for creating striking abstract images. The architectural photographer Richard Bryant elevates this approach to an art form. He has been awarded a fellowship of the Royal Institute of British Architects.

Richard Bryant
This image shows a masterful use of light, colour, and repeating graphic elements that draw the eye through overlapping spaces. The tiny figure on the stairs imparts a sense of scale.

Symmetrical composition

The staircase at the British Museum is a perfect example of a strongly symmetrical shape. The picture is enlivened by the random positions of the small figures.

Analyzing an architecture shot

A good way to judge an architecture shot is to consider whether the architect would be pleased with it. Does the image convey the architect's intentions? Does it accurately portray the style of the building? Does the fall of light show off textures and the articulation of space to their greatest advantage? The best architectural photography avoids exaggerated proportions and misleading spatial relationships, while capturing precise details.

CORRECTING CONVERGING VERTICALS

When photographing buildings, such as this Spanish cathedral, a central issue is how to accurately represent the subject. Because of the size of most buildings, a key part of this is ensuring that vertical lines remain parallel. Tilting the camera upwards to take in the full height of the building will magnify the bottom of the image, which causes the building to "loom" due to the converging parallel lines. This effect can be useful for emphasizing scale, but if you wish to avoid it you can use a shift lens. This allows the camera to point horizontally while moving the lens upwards to increase coverage of the upper part of the image. You can also correct the problem with digital manipulation.

Sa Seu, Palma de Mallorca
Pointing the camera upwards caused the sides of the cathedral to converge. I later digitally enlarged the upper part of the image.

Exploiting sunlight
Light falling at an angle of 45° to the main face of the building is ideal as it enhances the textures of the walls. I chose a position to one side of the building to exploit the shadows and highlights to best effect.

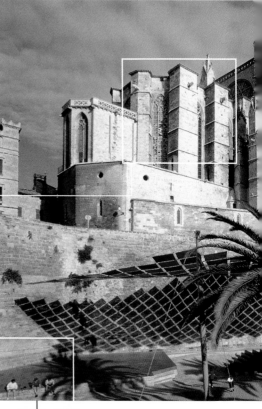

Figures in the foreground
When composing a shot like this it is helpful to include people, to give a sense of scale.

RIGHTS AND ACCESS

Whether you are photographing an ancient monument or a modern shopping centre, always consider your right of access. If you are shooting at an ancient site, check with the relevant authorities to see if photography is permitted. In a shopping centre, restaurant, or gallery, remember that you are on private property owned by a commercial enterprise that has the right to ask you to leave. However, if you are discreet and do not cause an obstruction you are likely to be left alone.

PHOTOGRAPHING IN A SHOPPING MALL
The clean lines, glass and metal structures, and symmetrical patterns of modern shopping malls are excellent for photography. Work swiftly and quietly but try not to look too secretive, and use a compact camera with a true wide-angle lens (equivalent of 28mm).

Thin cloud is excellent for architecture photography. Here the movement of clouds suggests a spreading away from the building.

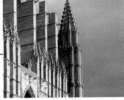

Space for composition
It is important to give a building space to "breathe" visually. Here, careless framing has lost the top of a spire.

When working in bright sunlight, try to ensure that detail is present in any shadows. Otherwise, an area of black may disfigure the image.

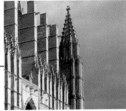

Choosing depth of field
Wide depth of field is the norm for architectural photography – I used a wide-angle lens set to a small aperture (f/11) to extend sharpness from the building to the nearest palm tree.

Avoiding moiré
When using a digital camera, try to avoid fine grid-like patterns such as stonework. This can interfere with the regular grid of the camera's sensor to cause distortion, known as the moiré effect.

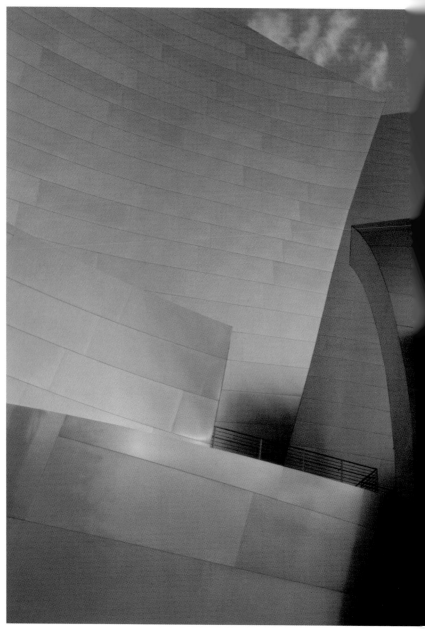

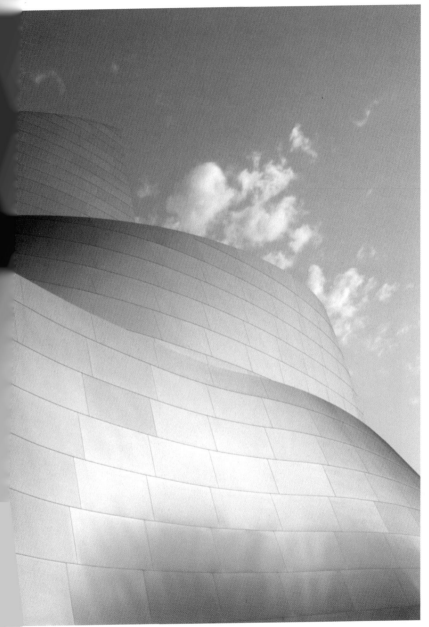

Guggenheim, Bilbao
Framing with simplicity and eschewing all
artifice, the photographer has fully exploited
this magnificent modern structure's sweeping
lines and reflective surfaces.

Art

For some, the term "art photography" is an oxymoron – a marriage of two contradictory elements. But photography can transcend its craft-based nature, by a combination of innovation in vision and use of materials. Art photography can be anything from a concept-driven image that seeks to articulate an art-critical position, to the simple pursuit of an abstract idea.

Defining art photography

From fine-art prints to highly crafted collages, art photography covers a very broad spectrum. In general, work driven by ideas that can be articulated and that have an expressive value beyond the realm of aesthetics and technical perfection is more likely to be accepted as art than a purely observational shot. In addition, art photographs must have physical traits such as permanence and uniqueness.

Morning light
It is the content of a picture and the intentions of the photographer that define an image as art. In this image (*below*), daylight on a bed abstracts into a formalist composition.

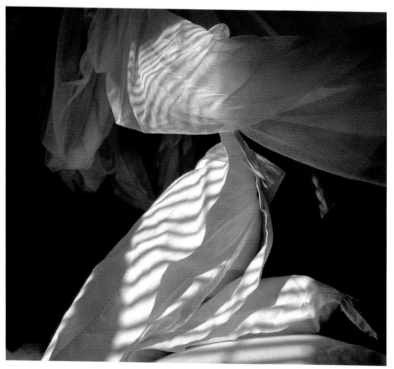

FINDING A THEME

A theme that resonates strongly within you can supply enough creative energy to last a lifetime. It could be as simple as memories of your childhood, portrayed through photographic montages of ephemera, or a place that is special to you, captured in different lights and at different times to convey different moods. Or the project could be more impersonal – investigating the way that light falling through your window can transform the appearance of objects in a room. One interesting approach is to play with scale and concepts of reality by combining three-dimensional objects with photographic images.

Fine print montage
To create this piece, multiple pictures were taken of a tree and blue skies. The prints were cut into small squares, then reassembled to create a large collage that is a unique object.

CREATING AN ART OBJECT
Capturing an image is only the first step towards creating the final art object. If you are shooting a series, allow it to develop in form and content as your ideas change. If you are producing prints, you can make them unique by printing on textured paper and signing and numbering each one. Or you might modify the print by cutting and pasting. Some artists distress their prints by singeing them or spattering them with bleach or paint.

Travel art
Art photography need not be confined to work in a studio or around the home. Here a scene on Taveuni Island, Fiji has been photographed to emphasize the lines, light, and textures.

Optical effects
With art photography you can afford to have fun and experiment. This image exploits the abstract and colourful distortion effects of Christmas lights seen through glassware.

Developing a series

Art photography as an institution carries established rules and ways of working. Central to this is the tradition of exhibiting a series of photographs that are linked by a theme. This comes from the past practice of publishing lithographs or engravings in groups of similar subjects, such as grand houses or fabled lands. Consequently, an exhibition of an artist's work is expected to be a coherent series, or thematically linked.

PURSUING A THEME

Producing a series of images that are related to each other yet vary sufficiently to hold the viewer's interest requires considerable skill and commitment. First, you need to decide on a theme. It does not necessarily have to be original, but it should be something that you believe in. You can find inspiration all around you, in books, objects, people, and places.

Be prepared to pursue your project through practical difficulties, such as access to subjects or limits of timing and budget, as well as conceptual traps. You must be flexible, yet guard the heart of the idea. For example, if you want to explore the emptiness of modern urban spaces, do you include people to counterpoint the soullessness of the space, or do you photograph the space entirely deserted? You may find it hard to depict the space because the only visible feature is the enclosure around it.

SELECTING IMAGES

Picture editing is an important part of producing a series. One way to do this is to surround yourself with images. Put them on every available surface, or repeatedly view them on your computer. Try to allow the pictures to choose themselves – some will bore you, but you will keep coming back to others.

The images below were shot for a series exploring the notion that the shadow, which is regarded as insubstantial, is actually as substantial as the physical object that casts the shadow. But which images work best together and carry the idea forward?

Shadow on porch
The shadow of the tree across the door is so substantial it appears to physically obstruct the entrance. This image is kept.

Shadow and tyres
The shadow on the wall is an attractive, soft silhouette that contrasts with the grime and detritus of the garage. This image is kept.

Shadow on street
The contrast of orange wall and blue sky is too good to lose, but the shadow is too insubstantial an element. This image is put on reserve.

Self-portrait shadow
The human shadow is unique in this series and suggests that the photographer, rather than the shadow, is insubstantial. The image is rejected.

PICTURE ORIENTATION

Which way to hold the camera – vertically for a portrait format, or horizontally for a landscape format – is a perennial question. The natural format for landscapes is the horizontal, so the simplest way to be different is to try shooting landscapes in portrait mode, reducing the width of the scene. By the same token, you can make innovative portraits by photographing in the horizontal landscape format.

Horizontal format
Images taken with a horizontal main axis suggest space and movement. They are also good for cropping – removing much of the top and bottom can create a more dramatic image.

Vertical format
Trying vertical shots as a variant on a landscape view can give surprisingly attractive results.

Shadow of train
A train ride at sunset provides a shadow of the train against the desert. The image is not visually arresting, its message unclear, so it is rejected.

Tree shadow
A shadow falling across a tree brings out its shape and makes it more substantial. But this is not the right concept. The image is rejected.

Shadows on mesa wall
This image with its white-washed walls and attractive lines, is unfortunately not about the substantiality of shadows. It is rejected.

Shadow across street
With its dynamic shapes and colours, this strong image is clearly a front-runner for the project – it is accepted.

Ethereal landscape
The Japanese art photographer Hiroshi Nomura
makes great use of strobe lighting in his work.
Here, a sculpture of mirrored balls in a forest
setting is illuminated with bursts of light.
The image was then digitally enhanced.

TAKING
PHOTOGRAPHY
FURTHER

THE BREADTH, DEPTH, AND VARIETY OF WAYS IN WHICH YOU CAN BE INVOLVED IN PHOTOGRAPHY IS ONE OF ITS MOST ATTRACTIVE FEATURES. WHILE THE "FRONTLINE" WORK OF PHOTOGRAPHY IS REGARDED AS THE MOST GLAMOROUS, IT IS ALSO THE MOST DEMANDING AND STRESSFUL. BUT THERE ARE MANY OTHER WAYS TO TAKE YOUR PHOTOGRAPHY FURTHER.

There is no doubt that reaching the top in the world of photography calls for total dedication (if not obsession), hard work, true creative talent, plus a good dose of luck. But there are plenty of ways in which you can get more satisfaction out of your hobby that do not require quite the same level of endurance and investment in effort.

Checking images
Learning the technical aspects of photography is vital to improving your skills.

Although there is a wide variety of photographic jobs, from staff positions on newspapers and magazines to part-time freelance work for private and business clients, competition for all work is fierce. If you have a particular interest, such as sailing, archaeology, or theatre, you could try specializing in this area. However, while your images may have less competition, there will also be less demand.

Even if you do not wish to work full time, you can still have a great deal of fun, gain much satisfaction, and even earn a little by working professionally. But before you are in a position to charge people for your services, you need to have confidence in your ability.

The best way to gain confidence is to take as many pictures as possible, as often as you can. You need to be constantly and continually framing the world, to view it as if through a lens. This will train you to see life with a photographic eye. You have probably had the experience of seeing something beautiful or humorous and wishing you had your camera with you. The more you think about, and take, pictures, the more you will start to notice much more prosaic things and appreciate their photographic potential, like the forgotten corner of a garden, a deserted alleyway, or the shadows on a wall.

You can increase your confidence in your photography further by attending one of the numerous courses offered worldwide. These are often located in carefully chosen, inspirational settings. Many are taught by tutors who are top-rank practitioners themselves.

Press photography
Although the paparazzi are perhaps the most well-known type of photographers, there is a huge variety of jobs in the profession.

However, it would be wishful thinking to believe that a course alone – even a university course lasting three or more years – is enough to make you a brilliant photographer.

Looking at pictures in depth is vital to your development as a photographer – never take an image at face value. You need to probe under the surface of an image and learn as much about it as possible. One useful technique is to avoid looking at the main subject first, but start at the edge and move slowly across. This is similar to the way in which musicians train themselves to listen for the bass line in a composition: you can always hear the melody over it, but if you listen only to the tune, you easily miss the bass. Working from the periphery gives you the structure of the image, then you can start to analyze it further, looking at technical features such as depth of field, the focal lens used, its tonal qualities and colour.

As your experience in and understanding of photography grows, you will also realize the importance of seeking out, studying, and appreciating the work of the masters of photography. It is helpful to know the background of both the photographer and the subject of the photograph. Ask the standard journalistic questions of what, when, who, and why. What is the photograph about? When was it taken? Who took it and who may have influenced the photograph stylistically? Why might it have been taken in this particular way, and not in another way?

This chapter provides information to support you as you take your study of photography further. It is followed by a glossary of terms and a directory of useful websites, local clubs, galleries, and competitions.

Test-strips and prints
Printing test-strips and hanging them (*right*) is a useful way to compare your prints. It also makes an attractive composition, becoming an image in its own right.

Learning photography
Many photography workshops are held in country houses. Here photographer Ben Edwards discusses his own work.

Turning professional

Working professionally in photography is one of the best jobs in the world. You are, after all, being paid to do something you love and enjoy. Not surprisingly, there are huge numbers of people looking for a career in photography – each year, colleges around the country train many hundreds more photography students than the market can accomodate. Whether this dismays you or whether it hardens your resolve will determine your future.

To study or not?

One of the key questions to ask yourself is whether you should train in photography at a college on a recognized course. In some countries you cannot call yourself a professional photographer unless you obtain a qualification. In others, it may be more efficient to learn through self-study to supplement working as an assistant to a professional photographer.

STUDYING PHOTOGRAPHY

Courses that offer qualifications such as a degree or diploma will need a commitment of one to three or more years of sustained study. Be prepared to learn not only the practical aspects of photography but also about critical art theory. Degree courses generally concentrate on education (understanding photography) more than on training (actually taking photographs).

Another option is to attend a residential course, often run as a summer school, in which you immerse yourself in a wholly photographic environment. Here, learning is highly accelerated. You concentrate on problem-solving, with experts on hand to offer guidance whenever you need it. To make the most of this type of "immersion teaching", you need to continue practising the skills you have learnt as soon as you return home. What is learnt quickly is also quickly forgotten. Intensive courses tend to be very specific – concentrating on landscapes or portraiture or image manipulation – so the resulting knowledge can be fragmentary. If you can afford to, and have the time, it is well worth attending a range of courses to broaden your knowledge.

APPLYING FOR STUDY

To apply successfully to a course, it pays to plan ahead. Most courses only interview and select students at certain times of the year. Make sure that you meet any formal requirements such as educational qualifications. Next, prepare a portfolio to show your work. You will need to plan your finances very carefully – attending a course reduces your ability to earn and is itself a financial drain. Find out all you can about the course – the institution will be impressed if you can demonstrate that your own ambitions match those of the course. If it offers subjects you are not familiar with, for example, media theory, be sure before you apply that you are sufficiently interested in them to study them in depth.

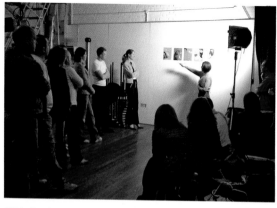

Critical review
Studying photography in a college environment brings you into contact with others, and also exposes your work to supportive but critical review from your peers.

LEARNING AS AN ASSISTANT

The key requirement for a successful career in photography is the same as for finding work as a photographic assistant – versatility. If you have a wide range of skills – even if they are not fully developed – you will be in a better position than someone with only one highly developed skill. While working as an assistant you will improve your skills and progress much more quickly if you continually read instruction manuals, books, and magazines on photography, to supplement the practical experience you acquire. It will also help if you keep up to speed with contemporary culture of all kinds, not only visual.

You should be competent with using computers and standard software such as Adobe Photoshop. Many professional photographers rely heavily on their assistants for their ability to perform administrative and creative tasks on the computer.

Working in all conditions

As a professional you will be expected to produce top-quality results whatever the situation or weather. In the above situation, it was freezing cold, blowing a gale, and the light changed constantly.

BUSINESS SKILLS

While working for a photographer, try to learn not only about the art of photography but also about the business aspect of photography: how to be a professional in a highly competitive world. Learn about working to the highest standards – both artistic and technical – to make extraordinary efforts for your clients. Learn to work honestly and to take your commitments seriously by being punctual for meetings, and ensure you maintain a constant flow of communication with your client and keep to promised budgets and deadlines. The trust that you build up as a consequence of your professionalism will repay you in the form of re-commissions.

SELLING PRINTS

Selling a print is often an encouragement to take the step into professional photography. If someone wants to buy one of your pictures, you should offer them the highest-quality print you can. Use a professional laboratory for colour or black-and-white prints, unless you are highly proficient in the darkroom. Tell the laboratory that the prints are to be sold and ask for the longest-lasting materials. With digital images, you could make the print yourself with an inkjet printer. The best inkjet printers can produce long-lasting prints if you print on high-quality paper.

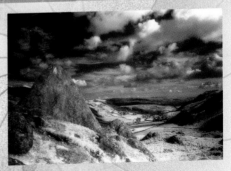

Atmospheric landscape
A landscape photograph such as the above could quite easily find interested buyers. It will also have a longer life – a monochrome print is less likely to fade than a colour version.

Commercial photography

There is a supply of pictures numbering tens of millions worldwide, available for anyone to buy for publications, websites, and even for making personal prints. While the market may seem to be saturated, the demand for images for use in everything from computer games to mobile phones, from computer "wallpaper" to greetings cards, continues to grow relentlessly.

Understanding stock photography

The term "stock photography" is used to describe pictures that are held by agencies or libraries, which sell picture-use rights to publishers, newspapers, television channels and so on. Large picture agencies hold millions of images, and these collections are growing at the rate of hundreds of images each week. Some agencies hold images in a number of categories, from fashion to news and lifestyle. Others are more specialist, for example, offering only steam trains, gardens and flowers, or fine art reproductions.

WORKING WITH PICTURE LIBRARIES

To place your work in a stock picture agency and to obtain a return, your pictures should be of the highest technical quality and must be appropriate to the library's visual style or subject matter. It is very difficult to join the top agencies unless your pictures are not only distinctive and original, but also feature subjects that are in demand. Try visiting the websites of some of the major picture agencies, such as Corbis, Getty, or National Geographic to gain an impression of the type of images that are used.

The system works in the following way. You submit a collection of, say, 100 top-quality images to the agency. If your work is suitable, a number of pictures may be selected (possibly as few as 15) and put into the collection. If and when reproduction rights for one of your images is sold, you will receive a portion of the fee (usually 50 per cent, or less if intermediate agencies are involved) when the agency itself is paid. The beauty of this system is that your pictures can be sold again and again, and the more the agency earns, the more you earn too.

SHOOTING FOR STOCK

Photographing for stock is a discipline in its own right. Technical quality is paramount (*see also pp.310–11*). Digital files will be accepted but may have to be at least 50MB in size and must meet very specific requirements. These requirements vary with different agencies.

To be a successful stock photographer you need to adopt a rigorous commercial approach to your image-making. The principle for the majority of images is to maximize their saleability and longevity. Images suitable for use in advertising

earn very good returns. Alternatively, if it is an image that is repeatedly used (pictures of hand-shakes, for example, can be used to illustrate a range of subjects from advertising to corporate brochures) a fortune can be earned. A snap of a truck racing across a landscape may have more editorial value and more potential uses than a beautiful tropical landscape.

Multi-purpose picture
The subject may seem dull, but an image like this can be used for countless corporate purposes and earn a healthy return.

Public in Florence, Italy
In this picture of tourists relaxing in Florence, Italy, everyone is clearly identifiable. It was taken in a public space, with many different people involved so it was impractical to obtain model releases from everyone. However, if the image had been intended for a high-profile use, such as advertising an international credit card, it would have been advisable to obtain model releases in case of complaint.

IMAGE LICENSING

There are two types of image licensing – rights-managed (RM) and royalty-free (RF). For a rights-managed image, the client pays each time the image is used. As the photographer, you can also specify restrictions on the use of your image, such as no cropping. For royalty-free images, the client can pay a higher fee for a collection of pictures that can be used as many times as desired, without further payment for re-use. The market for such collections is now vast, with millions of images available covering thousands of subjects. It is possible to earn from supplying images to publishers of RF collections, but you will need to take large numbers of images, as your pictures will be purchased outright, and you may receive no further fee for their re-use.

MODEL RELEASE FORMS

A model release is a contract, usually in the form of a written agreement between you and the subject(s) of your picture, which allows you to use images of them, in return for a fee. In the modern, litigious, world, it has become increasingly necessary to obtain model releases if the person is easily identifiable in the picture. In fact, many agencies will only accept images that are fully model-released. However, if you have a crowd scene in which no-one is prominent, it is not usually necessary to obtain model releases.

Typical stock pictures

All the images shown below are highly saleable. The main features they have in common are that they are bright, colourful, technically flawless, their subject matter is clear, and their message is international.

Assuring picture quality

You check a picture's quality – albeit often unconsciously – every time you look at it. We are confronted with hundreds of photographic images each day, and the process of judging the quality of an image has become so ingrained in all of us, it is almost automatic. But as your ambitions grow, a superficial assessment will no longer be enough. You will need to examine each image thoroughly, with a checklist of criteria to consider.

QUALITY CRITERIA

The basic requirements for picture quality are surprisingly well-known to all visually literate people. Our frequent exposure to top-quality images in leaflets, magazines, and posters has trained everyone to be highly critical of the images they view. An effective technique of analyzing your photographs in a deliberate, professional way is to scrutinize a picture from the edge and then work your way across the image. This focuses your attention on areas of the image that might otherwise be neglected.

To meet basic standards, the picture must be sharp. Important details should be clearly defined and not blurred or soft. Exposure should be accurate and neither too dark nor too light overall. Colours should be true-to-life and not exaggerated or too washed out. Neutral colours, such as greys or whites, should appear neutral. Finally, contrast should be accurate, with tonal changes appearing natural, and with smooth transitions between one shade and another.

BASIC IMAGE PROBLEMS

There are a number of basic problems that commonly affect picture quality. These should never be seen in a professionally produced image unless clearly and deliberately intended. You must learn how to avoid them if you are to be taken seriously as a photographer.

Camera movement
This fault causes the image to be unsharp or blurred. Avoid it by using a tripod or steadying your camera before shooting.

Subject movement
Movement in parts of the subject can cause blurring. Avoid it by posing your subject and using a shorter exposure time.

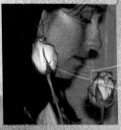

Poor focus
The subject is out of focus, while other details are sharp. This shows poor technical control – learn to focus accurately.

Light fall-off
Uneven distribution of brightness across the image suggests use of inferior-quality lenses or cameras.

Burnt-out highlights
Exposure has been set for mid-tones without taking into account light from the window. This renders highlights too white.

Wide-angle distortion
Objects with a recognizable shape, especially faces, should not be distorted. Avoid using a wide-angle lens.

Acceptable blur
Like all rules, technical requirements can be broken for specific purposes. Here, a professionally-created image exhibits severe blur from subject and camera movement, as well as poor focus. But instead of detracting from the image's appeal, these technical "problems" are used deliberately to create a sense of urban estrangement.

"PRE-FLIGHTING" CHECKS

In the space of a few years before the turn of the 21st century, the practice of delivering images in a digital form grew from rare to nearly universal. Many magazines, agencies, and internet-based operations will no longer accept prints or transparencies. Because of this, it is important to understand how to check or "pre-flight" digital files before delivering them. Ideally, you should ensure that the recipient of the files does not need to work at all on the files before putting them to use. Files of your final image should:
• be printable at 100 per cent size
• be named consistently and helpfully, for example, corresponding to page number or order of appearance on a website
• contain no more data than necessary, that is, contain no extraneous elements such as layers, paths, or spot-colours
• be free of defects such as specks of dust
• be in a format compatible with the systems in use. The most frequently used format is TIFF RGB saved in 24-bit, compressed
• comply with colour-managed workflows to ensure colours reproduce accurately, that is, have an appropriate profile.

File Information			
Name:	DSC00239.JPG	Pixels:	3072 x 2304
Camera date:	10/03/2005 2:27:43 pm	Image size:	20.25 MByte
Modified date:	10/03/2005 2:27:44 pm	Resolution:	72.00
File size:	2.74 MByte	Size:	108.4 * 81.3 cm
Type:	JPEG	Colour:	RGB
Full path:	/Volumes/Big Disk/Pictures/Sony P200		
Content:			

Image caption information
Standard information such as this helps provide technical data, identify date and time of photography, as well as locating the file in the computer system.

INCLUDING IMAGE INFORMATION

Increasingly, when you supply your images to agencies and picture libraries, they will require you to include metadata in your image file. This is information about the image, rather than the image data itself. It needs to be embedded in the image file, and should include the following details:
• your name and contact details, including your telephone number with local and international dialling codes, email address, and website URL if applicable
• captioning information, including the title of the image, the location and time of capture, the occasion – for example, Mardi Gras – the names of anyone featured prominently, and keywords describing the image
• other details, including a copyright notice, whether or not a model release has been obtained, and any restrictions on the image.

AUTOMATING FUNCTIONS

Adding information to a single image is tedious enough, but to do so to hundreds of images requires special software. Fortunately, digital asset management software, such as Fotoware Fotostation, Extensis Portfolio, or iView MediaPro, can add a great deal of useful information to images at the touch of a button. For some purposes, such as news or current affairs photography, your metadata should comply with the IPTC (International Press Telecommunications Council) specifications. See www.iptc.org for full details.

Analyzing a saleable photograph

If someone needs a photograph and is willing to pay for it, that photograph is saleable. This means that just about any photograph can be sold – to the right person. The trick is to try to take pictures that satisfy as many categories of desirability as possible. The focus of an image's saleable qualities needs to be as accurate as its optical focus.

FLEXIBLE CONTENT

An attractive subject – such as this timeless scene of dhows returning to their harbour in Zanzibar – is a splendid foundation for a saleable image. But if, in addition, the image can be cropped into different formats and has individual graphic elements that can be exploited, then its commercial uses are greatly increased. The secret is to keep

shooting – you can never be sure at the time which is the best, most versatile image. This scene provided many lovely shots. But this particular image, with its many ways of cropping, clean groupings, and bold shapes, can be used in many ways. If you have the time, bracket your exposures (*see p.215*) whether using a digital or film-using camera.

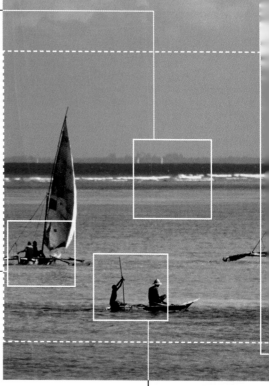

Using tone and colour
Deep blues or azure colours reproduce very well on a computer screen, but are much more difficult to print onto paper. However, the image does not rely on accurate colours. In fact, it would be equally effective in black-and-white, which is another advantage.

Compositional error
The photographer has accidentally framed this image to the right of the scene, leaving too much space to the right and cropping the edge of the boat on the left. It is important to frame generously to avoid such problems.

Peak of action
Good timing and a keen eye allow you to capture key moments. Here, the boy punting the boat imparts a sense of movement and energy to the image.

TOP-QUALITY FORMATS

The most frequently used image format for high-quality reproduction is medium format taken on 120 format roll-film, measuring from 6 x 4.5cm to 6 x 9cm (2¼ x 1¾in to 2¼ x 3½in). They are suitable for greetings cards and calendars, or double-page spreads of magazines. Larger formats such as 5 x 4in are even better. However, 35mm format pictures can be used for these purposes, but only if made with the greatest care.

MEDIUM FORMAT
A close-up of a medium-format image, enlarged at the equivalent of 1m (40in) wide, displays fine detail.

SMALL FORMAT
A scan of a 35mm format transparency, enlarged at the equivalent of 1m (40in) wide, shows inability to hold detail.

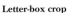

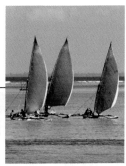

Vertical crop
This image also allows a vertical or portrait-format crop, which takes in the full height of the image and isolates the group of three dhows. The strong horizontal lines of the horizon and the band of deeper water help structure the crop.

Letter-box crop
The letter-box crop – very wide and narrow – is popular for greetings cards and calendars. Images with the space to allow such a crop can be more useful than those with tight composition.

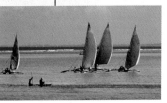

Creating a portfolio

A portfolio is a selection of your best work, which you present when seeking commissions or a position. A "selection" means just that. Do not merely collect your best shots, but bring together only those that meet the direct aim of obtaining work of the kind you wish to gain. Choosing pictures to meet a specific purpose is the art of picture editing.

Picture editing

A picture is the "best" only in relation to a specific use or purpose. Picture editing is the process of examining every picture to evaluate its suitability for the purpose that you have in mind.

SELECTING IMAGES

Suppose you want to create a portfolio of travel photographs on a theme of people at work. Look through all your images and pull out the possibles, such as the images on the right. At a second edit, remove any images that are not entirely relevant to the theme of people at work, such as the smiling girl and children among boats (top row) and colourful clothes (bottom row). You may arrive at a selection such as the images below, from which you will then choose your final pictures.

Weaver in Karimabad, Pakistan

Women in paddy fields in Fushimi, Japan

Men baling straw, Laos

Weaver in Mung-Xai, Laos

Flower seller in Mysore, India

REFINING THE SELECTION

The process of picture editing is to weed out gradually the weaker pictures. With each edit, you will have fewer and fewer pictures, but those that remain will be a refined, strong set. At this point you should look at the overall impression of the images. Notice, for example, that the man on the loom (*left*) stands out as being very blue. You may need to change the colour balance so that he matches the others more closely. Then you may see that all the pictures are at similar distances, showing the full body, leading to a monotony of scale. So perhaps you need to look for shots that are more close-up – like that of the smiling girl – and some that are more distant. And it goes without saying that all the images should be technically perfect.

PRESENTING YOUR PORTFOLIO

Your portfolio should include only the type of pictures that you want to be commissioned to take. There is no point showing flower studies if you want to work as a documentarist. Show enough pictures to demonstrate your talent but no more – too many reveals a lack of confidence. Explain the images only as much as you are invited to, and allow the person reviewing them to do so at their own pace.

The way you present yourself is also important. Dress appropriately, and always be polite. Your work may be rejected today, but you may want to return at a future time with a different set of images, or approach another part of the company, so it is wise to make a good first impression. And always remember to leave your contact details.

Types of portfolio
You can show bare prints from a box, enclose them in transparent sleeves, or display many slides on a single sheet. Use the method that best suits your work and the client.

METHODS OF PRESENTING YOUR PICTURES

There is, unfortunately, no perfect way to present pictures for all occasions. Ideally, you will have different portfolios of pictures presented in different ways to suit the clients you visit, such as mounted prints for galleries and large-format slides for advertising agencies.

METHOD	ADVANTAGES	DISADVANTAGES
Unmounted prints	Most flexible, convenient, least expensive, best view of prints	Prints are easily damaged, may appear too informal
Mounted prints	Presents prints well, helps protect prints if window-mounted, not too costly	Makes portfolio very heavy, impractical for large prints, clumsy to handle
Mounted slides	Inexpensive, lightweight; images can be grouped easily	Difficult to view without lightbox, needs loupe or magnifier to view detail
Plastic sleeves	Inexpensive, protects print	Prints can be hard to see clearly
Large format slides	Impressive and professional-looking, not too bulky	Very costly to produce, fragile unless window-mounted
Disk	Very inexpensive, large number of images can be shown, can be organized into presentations	Requires computer, can be quite slow, possible file incompatibility problems
Laptop	Inexpensive if you already own a laptop, easy to manage and change to suit clients	Can show to only one or two people at a time, image quality may not present work in best light

Exhibiting photographs

As your collection of photographs grows, so too may the urge to share it beyond your immediate circle of friends. Even if you do not wish to approach agencies or organizations directly to seek commissions, there are other ways to show your pictures to a wider audience. You can hold exhibitions in galleries, schools, bars, and restaurants, and maybe even sell individual prints.

Planning your exhibition

How you put together a collection of pictures for exhibition will depend on the venue where they will be displayed and the overall effect you wish to create. The criteria for selecting images for public display is much the same as when you are creating a portfolio. Quality is of the utmost importance. Your pictures need not necessarily all follow a particular theme but you do need to think about how to arrange them to create impact and a strong narrative flow.

Exhibition materials
The majority of materials and tools needed to create an exhibition are inexpensive and widely available.

FORWARD PLANNING

Approach your venue well ahead of time. Commercial galleries generally plan their schedules at least a year ahead, but venues such as a local library or school may show work at shorter notice. Find out about other local events, such as concerts or lectures, to see if your exhibition could be tied in. Be creative with your venue – any public space, such as a railway or bus station, or a corridor in a shopping mall could be used, and indeed may be more suitable for some kinds of work than a gallery. Remember that the presence of your photography alone can transform a location into a gallery. Depending on where you are exhibiting you may need to consider

how best to light your images. In an informal space, however, your options might be limited. It is best to create prints that are large enough to be viewed easily, even from a distance.

BUDGETING

The key to staying within budget is to put on the best show that you can afford, not one that costs more than you can manage. Make a comprehensive list of everything that you will need, and keep updating it. The largest expense is usually the cost of printing and mounting the photographs. But budget for additional costs, such as business cards, leaflets to publicize the show, catering for the opening night, and small "thank you" gifts for people who have given their time and help to make your show a success.

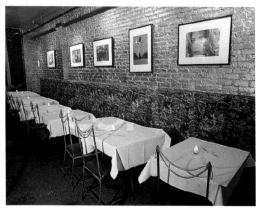

Restaurant gallery
Bars and restaurants make excellent locations for showing photography. They are popular with diners, and it is possible to obtain good sales of prints from busy venues.

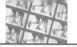

Converting space
Non-gallery spaces, such as this entrance lobby, can be easily converted to house exhibitions by using inexpensive self-standing panels. For this show, the panels were colourfully painted to complement the Central Asian theme of the photographs.

SPONSORSHIP

To help with your finances, you may look for sponsorship. The best approach is to look for a partner, but sponsorships work only when benefits flow both ways. You need to answer the question "What will the sponsor get out of sponsoring me?" The pitch to a sponsor that starts "I can ensure your company gets lots of coverage in local newspapers" is more likely to succeed than one starting with "I need money for a great idea for photography." It is always easier to obtain services, such as printing materials, exhibition space, scanning, processing, and even refreshments than it is to obtain cash. Also, ensure that you ask in good time, because other people also have their own budgets to maintain.

FINAL STEPS

When you have a space booked, sketch the layout of the whole exhibition, and make thumbnail sketches of the prints in their hanging order. This helps you to plan the flow of the narrative. As the big day approaches, don't forget it is your chance to get your work and yourself known. Make full use of it; this is not a time to be diffident. Tell everyone you know and everyone else too. Circulate press releases to local newspapers, local radio or television stations, and specialist magazines such as photography journals. At the opening and in a notice at the show, remember to say thank you. It is likely that the help you received from people was just as valuable as the help you received from your sponsors.

CREATING A WEB PRESENCE

The most effective, least expensive way to exhibit your pictures is to create a presence on the world wide web. And it is technically not at all difficult. If you have access to the internet you can publish your pictures. Picture-sharing websites, many of which are free of charge, only ask that you register with a few clicks of a mouse. But it is much more rewarding to create a website to your own requirements and design.

Most image manipulation software can automatically make web pages from your pictures. You choose the colours, design, and layout, and add in any text you wish. Your internet service provider (ISP) can host or store your web pages as part of their service. Once you have created the pages, follow your ISP's instructions to download the files to their computer. Give all your friends, acquaintances, and business contacts the address of the website, and leave them to look at your pictures and show them to their friends at leisure and from anywhere in the world.

Personal web page
A simple web page design, with neutral colours and minimal text, is best for showing off your pictures.

Diagnosing problems

It is helpful to be able to diagnose image problems as the first step to finding a solution that either prevents, or lessens the likelihood of, the problem occurring again. The most common film problems are poor exposure or development, or a combination of both. Digital problems (*see pp.320–21*) vary a great deal in nature, while printing problems (*see p.322*) form a separate group.

BLACK-AND-WHITE PROCESSING AND PRINTING PROBLEMS

The first set of problems considered here are various combinations of exposure with development. Study them carefully and you will see that some problems can be turned to your advantage in certain circumstances. Other problems – from surge marks to light fog – are caused by poor handling, and should be avoided at all times.

PROBLEM	SYMPTOM	SOLUTION
Thin, flat negative	This negative is very thin, with little density even in bright areas (highlights) of the image. This is because of underexposure combined with underdevelopment, so that there is insufficient time for density to build up in the highlights.	Give full exposure, particularly if the subject contrast is low. If in doubt, expose for areas a little darker than mid-tone grey. Develop according to instructions, following directions for dilution, agitation, and temperature as accurately as possible.
Thin negative	The negative is thin, with little detail in the mid-tones, but highlight areas appear to have good density. This is caused by underexposure combined with correct or sufficient development.	Expose so that shadow areas with important detail are fully exposed. In this image, the bright background caused the girl's face to be underexposed. Extra development may rescue some shadow details.
Flat negative	Highlight densities appear correct but overall the image appears flat and low in contrast. This is caused by giving a correct exposure, followed with underdevelopment sufficient to build density in the highlights, but not to increase contrast.	Develop your negatives to give the contrast that you prefer to print with – the exact contrast is largely a matter of personal taste. A little underdevelopment can be used to reduce the contrast of negatives of high-contrast scenes.
Contrasty negative	Giving the image correct exposure at the time of capture but overdeveloping when processing results in a very contrasty negative. The highlights are blocked out to solid black and mid-tones are very heavy. It will be very difficult to make a good print.	Print on soft (low-contrast) paper or a low-contrast grade of paper to compensate for the high contrast of the film. To avoid the problem in future, slightly underdevelop a film exposed in a high-contrast situation, avoiding over-development at all costs.
Heavy negative	This image shows poor shadow details yet the overall density of the image is high – it appears a dark grey. The cause is underexposure, which failed to capture shadow details, combined with overdevelopment, which created density over the whole image.	It is best to give correct exposure and development, but underexposure may be necessary in poor lighting conditions. Extra development may be given to compensate, to create a usable negative. This is the basis of "push-processing".

Flat, heavy negative	A negative that is relatively low in contrast or flat, but with normal or high density overall, is likely to result from overexposure and underdevelopment.	In highly contrasty lighting conditions, full development may not give the best print. Give extra exposure when photographing to allow for reduced development so that the contrast of the negative is reduced. This is the basis of "pull-processing".
Very dense negative	Overexposure combined with overdevelopment will give rise to very dense negatives with high contrast. These negatives can be all but impossible to print. And they are also all but impossible to scan properly.	Avoid compounding overexposure by overdeveloping the negative. In extreme cases bleaching solutions may be applied to reduce overall density. Professional drum-scanning may also help to improve the quality of the image.
Surge marks	There is increased density in this negative, in a pattern that corresponds to the holes in the film. These are caused by over-agitation that causes developer to rush through the sprocket holes of the film with great turbulence and give extra local development.	Reduce agitation or ensure that you invert the tank fully during agitation. Do not shake the tank from side to side. Alternatively, agitate by twirling the spirals or by stirring the developer.
Water marks	Irregular crescent-shaped or round areas of lightness in a print are usually caused by lime deposits from droplets of hard (calciferous) water drying on the film.	When you have reached the end of film processing and have a clean film, soak it in a bath with wetting agent, gently shake off any excess water and hang it to dry. If possible, wipe off the water using a photographic squeegee.
X-ray marks	This area of a black-and-white film should be clear but it carries patterns that repeat across the roll of film. It has been caused by x-rays used to check luggage kept in the cargo hold of an aircraft. These are much more powerful than those used for hand luggage.	Never place film in luggage that will be carried in the cargo hold. Do not use x-ray protective bags, as airport security will increase the power of the x-rays to penetrate the bags. Always carry unprocessed film – exposed or unexposed – in hand luggage.
Air bubbles	A small number of black or grey dots, sometimes with a darker centre, are scattered randomly over the film. Air bubbles were trapped when developer was poured in, slowing development at that point to cause a reduction in density in the negative.	Check that the lid is fastened tightly, then tap the developing tank firmly against the bench after developer has been added and the lid has been fastened. This dislodges any air bubbles that may be stuck on the side of the film.
Light fogging	Some parts of the image are white, right at the edge of the film. With colour film, there may be irregular bands of colour. The film has been "fogged" with light – light has been let in before development.	Ensure you load your camera away from direct light. If you are walking outdoors on a sunny day, turn your back to the sun to load the camera. Keep rolls of film away from direct light.

COMMON DIGITAL IMAGE PROBLEMS

Digital image problems fall into two broad categories. There are those that are caused by inappropriate action from the operator or a device, such as a scanner, and there are problems, known as artefacts, caused by the nature or limitations of the digital image itself, or its processing. Artefacts include moiré effects, blocked shadows, and posterization.

PROBLEM	SYMPTOM	SOLUTION
Soft scan	The scanned image appears unfocused and lacking in detail. Colours may also appear washed out and blended together. The scanner may not be properly focused on the original.	Focus manually if the scanner controls allow it. Or change the mount for the transparency to help it lie flat, and re-scan. If possible place the transparency between glass holders and re-scan.
Aliasing	Angled lines and details appear to be jagged or saw-toothed in profile. Details are lost and sharp edges in the image appear indistinct. The resolution of the image acquisition – either scanner or digital camera – is not sufficient to define the details fully.	Increase the resolution of the scan or your camera. If you obtained this result from making the file larger, you may have increased the file size by too much. If so, set a smaller increase.
Newton's rings	Multi-coloured concentric rings or patterns around a central core occur singly or there may be several. These are Newton's Rings, caused by a small amount of air trapped between scanner and original behaving like a prism.	If scanning a slide, place it in a frame so that it does not touch the scanner glass. If scanning a film-strip, raise it off the glass with a sheet of paper with a window cut out of it. Ensuring the glass is perfectly dry may also help.
Print moiré	A new pattern of dots emerges when printed material is scanned. The pattern may disappear if the file is printed or viewed at a different size. There is a clash between the pattern of the printed material and that of the scanner.	Rotate the original by a small amount – 5 degrees, for example – and scan again. If the pattern persists, rotate a little more and re-scan. Alternatively, change the resolution and re-scan. There will be a setting at which the pattern disappears.
Noise in shadows	Dark areas of the scan or digital camera image appear speckled with darker and lighter spots. This is shadow noise, caused by the system's inability to represent dark areas accurately.	If the problem is a result of scanning you will need to upgrade your scanner to extract details from the shadows. If the problem originates in the digital camera, ensure you set the lowest sensitivity and highest quality, or use a better-quality digital camera.
Scanner jitter	Scans show jagged lines with the wrong colours or details, which appear to be out of position. This is visible only at high magnification and it is caused by irregular movement of the scanning head.	Re-scan with the original turned round and see if the problem is repeated. If it is, you may have a defective or, more likely, a poor-quality scanner. You will need to have the scanner repaired or use a superior-quality scanner.

JPEG artefacts	The image viewed in close-up appears to be arranged in blocks of similar colour, which obscure or break up details. These are the JPEG kernels or groups of pixels used to compress the image.	If you use JPEG compression to reduce your file size, you should set the highest quality that gives the size of file you wish to work with. Or set the highest compression that does not cause visible artefacting.
Moiré from screen	Irregular patterns such as concentric rings or wavy bars appear across the image. These patterns disappear at certain magnifications. They are caused by a clash between any grid-like pattern in the subject with the monitor's own grid.	No solution is needed if the final output is to print, as screen moiré has no effect on print. But if output is to screen, you may need to work at a different resolution. Try rotating the image by 5–15 degrees, or blur the image a little.
File error	Images take longer than usual to open, thumbnail images do not correspond to the actual image or the images appear garbled, as shown here. The file is corrupted and data is missing or is unreadable.	This occurs when the medium storing the file, such as a hard-disk or memory card, is faulty. There may be incompatibilities between the memory card and the camera in which it is used. Back up all data and replace any card or disk that may be unreliable.
Poor data	Images appear patchy, with uneven areas of colour. On manipulation, images do not appear as expected. This happens when there is not enough data for the image – there are many gaps and holes in the data.	If the image is a scan, re-scan the image at a higher resolution. If the image is a manipulated version derived from a digital camera, revert to the original image. If this is the original image, there is nothing you can do to increase the amount of data.
Over-sharpened	Images may be nicely sharp but can also have light margins at the edges, known as haloes, and hard details, with little or no blurring. Small dots appear as sharply-defined squares. The image has been over-sharpened using Unsharp Mask.	Use Unsharp Mask sparingly to improve image sharpness, and only as the final step of image manipulation. If you are preparing images for use by a client, do not apply Unsharp Mask unless specifically asked to do so.
Posterization	Transitions of tone or colour in the subject appear to be stepped or banded, with sudden changes in colour or density. There is insufficient image data to produce smooth changes, due to low resolution or excessive image manipulation.	Smooth skin tones need the highest resolution if realism is required. Capture or scan your image at the highest quality settings. Avoid excessive image manipulation such as extreme changes in contrast, exposure, or colour balance.
Blocked shadows	Shadows appear to go black suddenly, with no transition zone of darker shadows. There is no detail in the shadows. This is caused by the way some basic scanners and digital cameras encode brightness information.	Give ample exposure to shadow regions while avoiding over-exposure in brighter parts. Use high-quality scanners or digital cameras. If possible, process digital camera images as RAW files instead of as JPEGs.

COMMON DIGITAL PRINTING PROBLEMS

Printer problems fall broadly into three categories. There are those that are caused by inadequate communications or other incompatibilities between the printer and computer or software, there are problems caused by printer faults, and finally, there may be incompatibilities between the printer and media used for printing.

PROBLEM	SYMPTOM	SOLUTION
Loss of coverage	The printer works well but suddenly prints uneven lines of ink, or the colour balance changes. The computer or printer may have run out of memory, one or more of the cartridges may have run out of ink, or some nozzles may have become blocked.	Avoid using the computer for other tasks while printing if you are working with large files or have many programs running. Run the cleaning program for the printer or replace the ink cartridges.
Ink pooling	The ink appears to lie on the surface of the paper, pools into puddles of ink, and will not dry. You are using an unsuitable paper or one that is not compatible with your printer.	Use only the manufacturer's recommended papers when you first use your printer. With experience, you can experiment with other papers. Photographic printing papers are generally unsuitable for inkjet printers.
Gibberish text	The printer outputs gibberish text that can go on for many pages. You may have sent the wrong type of file to the printer (the example shown is a facsimile). Or, the printer may have crashed and tried, unsuccessfully, to reconstruct an image.	Turn off the printer, wait a few seconds, and turn it back on. You may need to delete the spool file (see your printer instructions). You may also need to check that you are printing to the correct communications port.
Uneven coverage	Even areas of tone appear uneven, with gaps or streaks and visible lines. You are using a low-quality printer or one with blocked nozzles, poor-quality ink cartridges, or low-quality paper, or a combination of all three.	Set your printer to "quality" rather than "speed" printing, use matt or textured papers, use the manufacturer's own ink cartridges, and do not re-use ink cartridges. Introducing a little noise into the image can also improve results.
Dithered colours	The image appears to be made up of fine patterns of colours arranged into bands. The image is "dithered", that is, a few colours are used in patterns to simulate a greater range of colours.	Set the printer to print continuous tone, not dithered colours, and not graphics or poster colours.
Poor details	Fine details in the image appear blurred and hard to distinguish. Subtle changes in colour appear banded or sudden. The printer is set to a low resolution, the image size is too small for the output size, or you are using textured paper or printing onto the wrong side.	Use an image size adequate for the printed, output size. Set the printer to highest quality. Use paper with a smooth or glossy surface suitable for your printer, and ensure you use the correct side.

Glossary

Photography is full of terms describing everything from equipment to techniques. While you may not come across all of them, a knowledge of the language will help you to get the best from your photography.

24-bit Measure of the size or resolution of data that a computer program or component works with.

6500 White balance setting that corresponds to normal daylight. It appears warm compared to 9300.

9300 White balance setting that is close to bright daylight. It is used mainly for visual displays.

additive colour Combining or blending two or more coloured lights in order to simulate or give the sensation of another colour.

additive primaries The additive primary colours are red, green, and blue. When all three are added together white light is produced.

AE Abbreviation for Automatic Exposure.

AF Abbreviation for Auto-Focus.

ambient light The available light that is not under the control of the photographer.

analogue A non-digital effect, representation, or record that varies in strength.

anti-aliasing A method of smoothing the diagonal lines in a digital image to avoid a "staircase" effect caused by the edges of individual pixels.

aperture The lens setting that controls the amount of light entering the lens of the camera.

aperture priority An automatic exposure mode that varies the shutter time as required.

APS (Advanced Photo System) A sprocketless compact film format widely used with compact cameras and some SLRs.

artefact Any information on a digital image that is unwanted.

attachment A digital file that is attached to an email.

auto-focus Camera systems that automatically focus the image.

background The bottom layer of a digital image; the base.

backlighting Lighting the subject from behind with the light source facing the camera.

back-up Copy of a digital file that is kept in case of damage to, or loss of, the original.

bicubic interpolation A type of interpolation in which the value of a new pixel is calculated from the values of the eight pixels that are adjacent to it.

bilinear interpolation A type of interpolation in which the value of a new pixel is calculated from the values of the four adjacent pixels on the left, right, top, and bottom.

black An area of an image with no colour or hue because it has absorbed most or all of the light.

bleed (1) A photograph or graphic object that extends off the page when printed. (2) The spread of ink into fibres of the paper, which causes dot gain – dots print larger than intended.

Bluetooth A standard for high-speed wireless radio connections between electronic devices, such as mobile phones, keyboards, and laptop computers.

BMP (Bit MaP) A file format for image files native to Windows.

bracketing Taking a range of shots and deliberately under- and overexposing in order to find the best exposure.

brightness (1) A quality of visual perception that varies with the amount or intensity of light. (2) The brilliance of a colour related to hue or colour saturation.

browse To look through a collection of digital material, such as images or web pages.

brush An image-editing tool used to apply effects such as colour, blurring, burn, dodge, and so on.

burning-in A digital image-manipulation technique that mimics the darkroom technique of the same name. This method gives a selected part of the image extra exposure, making it appear darker.

byte A unit of digital information that is the standard unit for measuring the memory capacity of a digital storage device.

camera exposure The quantity of light reaching the light-sensitive film or light sensor in a camera. It can be varied by adjusting the aperture of the lens and the duration of the exposure.

CC (Colour Correction) filter A filter used to make small changes in colour.

CCD (Charge-Coupled Device) A type of imaging sensor found in digital cameras.

CD-R (Compact Disc-Recordable) A type of CD suitable for storing data such as images.

CD-ROM (Compact Disc-Read Only Memory) A type of CD used to supply software or collections of images.

CD-RW (Compact Disc-ReWritable) A type of CD that can be used more than once by erasing contents prior to re-recording.

centre-weighted metering A type of metering that gives more importance to the central areas of an image.

channel A set of data used by image manipulation software to define colour or mask.

close-up lens An attachment lens used to enable normal lenses to work close up.

clone To copy part of an image and paste it elsewhere on the same image or onto another image.

CMYK (Cyan, Magenta, Yellow, Key black) The primary inks used in desktop and commercial printing that are used to simulate a range of colours.

ColorSync A proprietary colour-management software system that ensures the colours seen on the screen match those to be reproduced.

colour A quality of visual perception characterized by hue, saturation, and lightness.

colour balance The relative strengths of colours in an image.

colourize To add colour to a greyscale image without changing the original lightness values.

colour cast A tint of colour that covers an image evenly.

colour gamut The range of colours that can be produced by a device or reproduction system.

colour management A system of controlling the colour output of all devices in a production chain.

colour temperature The measurement of the colour of light.

compositing A picture processing technique that combines one or more images with a basic image.

compression The process of reducing the size of a digital file by changing the way the data is coded.

Constructivism An abstract European art movement of the early 20th century focusing on architectural and machine-like forms.

contrast A measure of the difference between the lightest and darkest parts of an image.

crop (1) To remove part of an image in order to improve composition, fit the image in the available format, or square up the image to the correct horizon. (2) To restrict a scan to the required part of an image.

Dadaism An art movement founded in 1916 in Zurich, by a group of poets, writers, and artists who sought to challenge what they saw as a smug art establishment. With an emphasis on the illogical, absurd, and provocative, the movement claimed to be a way of life rather than an artistic style.

DSC Abbreviation for Digital Stills Camera.

D-SLR Abbreviation for Digital Single Lens Reflex.

definition Subjective assessment of the clarity and the quality of detail visible in an image.

delete To remove an item from an image or an electronic file from the current directory.

depth of field The measurement of how much of an image is acceptably sharp, from the nearest point to the camera which is acceptably sharp to the furthermost point which is acceptably sharp.

diaphragm The apparatus in the lens that forms the aperture.

differential focusing Focusing on a subject and rendering some parts sharp, some parts unsharp.

diffuser An accessory that softens light or the image.

digital manipulation The process of changing the characteristics of a digital image using a computer and software.

direct vision finder Type of viewfinder in which the subject is observed directly, for example, through a hole or optical device.

display A device such as a monitor screen, LCD projector, or LCD panel on a camera that provides a temporary visual representation of data.

dodging Technique for controlling local contrast during printing by reducing selectively the amount of light reaching parts of the image that would otherwise print too dark, and its digital equivalent.

dpi (dots per inch) The number of dots that can be addressed or printed by an output device; indicative of how much detail (or resolution) the device gives.

driver Software used by a computer to control or drive a peripheral device such as a scanner, printer, or removable media drive.

drop shadow Graphic effect in which an object appears to float above a surface, leaving an off-set fuzzy shadow below it.

duotone (1) Photo-mechanical printing process using two inks to increase tonal range. (2) Mode of working in image-manipulation software that simulates the printing of an image with two inks.

DVD (Digital versatile disc) An electronic storage medium, of which there are many variants.

DX coding A system of metallic markings on the canisters of 35mm film that code the film-speed information to be read by cameras.

electronic viewfinder An LCD screen, viewed under an eyepiece, showing the view through the camera lens.

enhancement A change made to one or more qualities of an image, for example, increasing the colour saturation or sharpness.

EPS (Encapsulated PostScript) A file format used for graphics.

EV (Exposure Value) A system for relating aperture and shutter settings to brightness values.

evaluative metering A type of metering system which divides a scene into a number of sections and measures the brightness in each in order to determine the final exposure.

EVF See *electronic viewfinder*

exposure Process of allowing light to reach light-sensitive material to create the image.

f/number Setting of lens diaphragm that determines amount of light transmitted by lens.

f-stop (f-number stop) The f/number or aperture setting.

file format Method or structure of computer data.

fill in (1) To illuminate shadows cast by the main light by using another light-source or reflector to bounce light from main source into shadows. (2) In image manipulation, to cover an area with colour using the bucket tool.

film speed The sensitivity of film to light, measured by the ISO number.

filter Software that is used to convert one file format to another or to apply effects to an image.

FireWire Proprietary name for IEEE 1394, the standard for high-speed cable connection between devices.

flare A non-image forming light caused by internal reflections within the lens.

flash (1) To illuminate with a very brief burst of light. (2) Equipment used to provide a brief burst of light. (3) Type of electronic memory used in, for example, digital cameras.

flatten To combine multiple layers and other elements together into a single background layer.

focal length The distance from the centre of a lens to its point of focus on the film or digital sensor, when the lens is set to infinity. Usually measured in millimetres.

focus To bring an image into focus by adjusting the distance setting of the lens.

gamma In monitors, a measure of the correction to the colour signal prior to its projection on screen. A high gamma gives a darker overall screen image.

GIF (Graphic Interchange Format) A highly compressed file format designed for use over the Internet.

graduated filter A type of filter that varies in strength from one side to the other.

grain Small particles of silver or colour that make up an image.

greyscale A measure of the number of distinct steps between black and white in an image.

highlights The brightest or lightest parts of an image.

hot-pluggable Connector or interface, such as USB and FireWire, that can be disconnected or connected while computer and machine are switched on.

hue Name for the visual perception of colour.

IEEE 1394 See *FireWire*

ILink Proprietary name for IEEE-1394, the standard for high-speed cable connection between devices.

infinity Lens focus setting at which, for all practical purposes, the light rays enter the lens parallel to each other.

interpolation Method of inserting pixels into an existing digital image using existing data.

iris The hole created by the lens diaphragm to admit light into the camera.

IS (Image Stabilization) Lens
A lens with integral sensors to correct camera shake and so give better sharpness without using a tripod.

ISO (International Organization for Standardization) Body that sets standards for measures such as film speeds.

IX240 Name given to standards defining the APS film format.

JPEG (Joint Photographic Expert Group) A lossy data compression technique that reduces file sizes.

Jugendbewegung (Youth Movement) Term used to describe a loosely coordinated network of youth groups, active in Germany from around 1900 to the 1930s, that shared a love of the outdoors.

k (1) A binary thousand, sometimes used to denote 1024 bytes. (2) Key ink in the CMYK process. (3) Degrees Kelvin, which measure colour temperature.

key tone The principal or most important tone in an image, usually the mid-tone between white and black.

large format A format of film or print that is larger than medium format.

layer A part of a digital image that lies over another part of the image.

layer mode Picture-processing or image-manipulation technique that determines the way that a layer in a multi-layer image combines or interacts with the layer below.

LCD (Liquid Crystal Display)
A display using materials that can block light.

lens hood An accessory for the lens that shades it from light and protects it from rain.

light meter A device used to calculate camera settings in response to light.

lossless compression A computing routine, such as LZW, that reduces the size of a digital file without reducing the information.

lossy compression A computing routine, such as JPEG, that reduces the size of a digital file but also loses some information or data in the process.

lpi (lines per inch) A measure of resolution used in photo-mechanical reproduction.

Macro Focusing in the close-up range but with the subject not magnified.

Manual exposure Setting the camera exposure by hand.

marquee Selection tool used in image manipulation and graphics software

mask Selecting parts of an image to restrict the area that digital manipulation will affect.

megabyte One million bytes of information.

megapixel One million pixels. Used to describe a class of digital camera in terms of sensor resolutions.

Memory Stick Widely available USB-compatible portable storage drive, made by Sony.

moiré A pattern of alternating light and dark bands or colours caused by interference between two or more superimposed arrays or patterns, which differ in phase, orientation, or frequency.

monochrome Photograph or image made up of black, white, and greys. May or may not be tinted.

motordrive An accessory or camera feature that winds on automatically after every exposure.

ND (Neutral-Density) filter A filter used to reduce the amount of light entering the lens.

nearest neighbour A type of interpolation in which a new pixel's value is copied from the pixel nearest to it.

noise Irregularities in an image that reduce information content.

opacity A measure of how much of an image can be "seen" through a layer or layers.

open flash A flash exposure technique in which the shutter is set to open before the flash is fired.

operating system The software program that coordinates the computer.

optical viewfinder A type of viewfinder that shows the subject through an optical system, rather than via a monitor screen.

out-of-gamut Colours from one colour system that cannot be seen or reproduced in another.

output Hard-copy print-out of a digital file.

paint To apply a colour, texture, or effect with a digital "brush".

palette (1) A set of tools, colours, or shapes. (2) A range or selection of colours in an image.

panning Moving the camera horizontally to follow the action.

panoramic A view obtained by rotating a lens to see a wide area.

partial metering Metering that measures from a part of the image, usually in the centre.

passive autofocus A type of autofocus in which the image is analyzed for sharpness.

peripheral A device such as a printer, monitor, scanner, or modem that is connected to a computer.

photomechanical halftoning A technique that is used to represent continuous-tone originals, such as

photographs, as a grid of dots of ink that vary in size.

photomontage A composite photographic image made from the combination of several other images.

Photo-secession group An influential group of early 20th-century photographers, led by Alfred Stieglitz, who aimed to elevate photography to a fine art.

PICT A graphic file format used on Mac OS.

pixel A picture element. It is the smallest unit of digital imaging.

pixelated The appearance of a digital image whose individual pixels are clearly discernible.

plug-in Application software that works in conjunction with a host program into which it is "plugged" so that it operates as if part of the program itself.

polarizer A type of filter that polarizes the light passing through it. Mainly used to darken sky or remove reflections from water.

posterization Representation of an image that results in a banded appearance and flat areas of colour.

ppi (points per inch) The number of points seen or resolved by a scanning device per linear inch.

predictive autofocus A type of autofocus that calculates the speed of a moving subject in order to set the correct focus point for the moment of exposure.

prefocusing A technique of setting focus first before re-composing a photograph to take the shot.

pre-scan A quick view of the photograph or object to be scanned, taken at a low resolution to allow re-cropping of the scan.

program exposure A type of autoexposure control in which the camera sets both shutter time and aperture.

pull processing The process of giving extra exposure to film followed by reduced development to compensate and obtain lower-contrast negatives than normal.

push processing The process of giving reduced exposure to film followed by extra development to compensate and obtain higher-contrast negatives than normal.

RAM (Random Access Memory) A computer component in which information can be stored or rapidly accessed.

rangefinder A focusing system that places two images of the same scene, viewed from slightly different viewpoints, into the viewfinder. The focusing ring on the lens is turned to move the two images together. When the images overlap the scene is in focus.

reflected light reading The most common type of light reading, which measures the light reflected from the subject.

re-sizing Changing the resolution or file size of an image.

resolution A measure of how much detail an optical system can see.

retouching Changing an image using bleach, dyes, or pigments.

RGB (Red, Green, Blue) The colour model that defines colours in terms of relative amounts of red, green, and blue components.

sabattier effect A darkroom effect in which tones are partially reversed.

scanning Process of turning an original into a digital facsimile, creating a digital file of specified size.

shutter priority A type of auto-exposure in which the user sets the shutter while the camera sets the aperture automatically.

SLR (Single Lens Reflex) A type of camera where the photographer looks through the viewfinder to see exactly the same image that will be exposed onto the film or sensor.

stair-stepping Jagged, rough, or step-like reproduction of a line or boundary, which was originally smooth.

standard lens A lens of focal length roughly equal to the diagonal of the picture format.

stop (1) A step in processing that halts development. (2) A unit of exposure equal to a doubling or halving of the amount of light.

subtractive primaries The three colours (Cyan, Magenta, Yellow) that are used to create all other colours in photographic printing.

Suprematism An abstract art movement, developed in the early 20th century in Russia by Kazimir Malevich extolling the supremacy of sensation and feeling in art. Images are often geometric and use a limited colour palette.

Surrealism An art movement, founded in 1924 by André Breton, that emphasized the role of the unconscious in creative activity.

system requirement The specification defining the minimum configuration of equipment and version of operating system needed to open and run particular application software or devices.

telephoto lens A type of lens with a focal length that is longer than the physical length of the lens. It is used to make distant objects appear larger.

thumbnail A representation of an image as a small, low-resolution version.

TIFF A very widely used digital image format.

tint (1) Colour that can be reproduced with process colours; a process colour. (2) An overall, usually light, colouring that tends to affect areas with density but not clear areas.

transparency adaptor Accessory light-source that enables a scanner to scan transparencies.

TTL (Through The Lens) metering A metering system that reads through the taking lens.

upload Transfer of data between computers or from network to computer.

USB (Universal Serial Bus) The standard port design for connecting peripheral devices, such as a digital camera, printer, or telecommunications equipment to a computer.

USM (UnSharp Mask) An image-processing technique that improves the apparent sharpness of an image.

UV filter (Ultra-Violet filter) A type of lens filter that stops ultra-violet rays passing through.

Vignetting The technique of darkening the corners of an image through the obstruction of light rays.

warm-up filter A type of lens filter used to increase the yellowness of an image.

white balance A shade of white (warm, cold, neutral) used as a standard white.

wide-angle converter A lens accessory that increases the angle of view of the lens to which it is attached.

Zip Proprietary name for a data storage system. Also method of compressing files.

zone system A technique that combines exposure measurement with film development to match film optimally with the subject.

zoom lens A type of lens in which the focal length can be altered without changing focus.

Directory

There is a wealth of resources available for the photographer, from technical advice to online photographic services. This Directory aims to give you a starting point, and additional information has been given where possible. Major photographic competitions have also been listed.

USEFUL WEBSITES

NEWS, INFORMATION, AND REVIEWS

www.allthingsphoto.com
All Things Photo is a portal to photography sites.

www.bjphoto.co.uk
Website of the British Journal of Photography, this is an excellent source of links and current photography, and is constantly updated.

www.ephotozine.com
A rich site for film-based and digital photographers. Contains a mixture of reviews, news, forums, and galleries.

www.dpreview.com
Digital Photography Review: up-to-date, highly detailed and informative reviews of digital cameras, as well as news and information.

www.internetbrothers.com/phototips.htm
Basic information and advice on digital photography presented in a simple way.

www.megapixel.net
The Megapixel site offers information and a mix of news, reviews, and retailer links.

www.shutterbug.net
Wide-ranging photography resource run by the American magazine of the same name.

www.totaldp.com
News, information, reviews, sample images from review cameras, and a good set of links, from Total Digital Photography magazine.

www.photographymonthly.com
Website of *Photography Monthly* magazine, containing reviews, tips, and links to other sites.

www.zonezero.com
A superb site offering a mixture of photography and digital photography, electronic books, and debates.

www.photolinks.com
Directory website containing links to a host of on-line photography resources.

TECHNICAL INFORMATION

While technical information is easy to obtain on the internet, the quality can vary. Visit the website of the manufacturer of your equipment or software before visiting any others. The folllowing sites are also very informative.

General sites

www.dcresource.com
Reviews, sample images, and buyers' guides to digital cameras.

www.dpcorner.com
General information on digital photography and cameras, glossary, and features on photographers.

www.imaging-resource.com
Well run and reliable digital photography site combining getting started and how-to features with product news, up-to-date reviews, a useful photo-lessons section, and a newsletter.

www.photodo.com
An eccentric site notable for its wide range of detailed lens tests – it is a useful basis for shopping once you learn how to read the charts.

www.shortcourses.com
A sound educational site covering many aspects of digital photography, with links to other resources.

www.lomoaustralia.com
Australian Lomographic Society

www.australianphotographicsociety.org.au
Australian Photographic Society

www.buy-n-shoot.com
Buy-n-Shoot.com

www.digitalcamera.com.au
Digital Camera

www.photoreview.com.au
Photo Review Australia

Portfolio sites

www.photos-fotango.com
Photo-processing services

and a site that hosts portfolios of images free of charge.

www.printroom.com
Free membership gives on-line albums that are available for private (password-protected) or public viewing.

www.smugmug.com
Low-cost portfolio hosting in a straightforward site, offering password-protected access if required.

Panoramas

www.panoguide.com
A specialist site devoted to the creation of panoramas, covering equipment, techniques, and software. Also features a gallery.

Inkjet printers

www.epson.co.uk
Helpful technical guides for troubleshooting your printer.

www.inkjetmall.com
Resources, techniques, products, and services relating to ink-jet products.

www.piezography.com
Leading source of inks for black-and-white printing, with sound technical support.

www.wilhelm-research.com
Reports of tests on inks and papers to help judge quality, longevity, and other attributes.

Underwater photography

www.aquapac.com
Suppliers of underwater housings for cameras, with Webzine.

www.wetpixel.com
Information for underwater digital photography, including specialist equipment, diving updates, and portfolios of images.

Photojournalism

www.digitaljournalist.org
A first-rate site with excellent features by leading photographers.

www.foto8.com
A showcase of the work of young photojournalists.
www.robgalbraith.com
Invaluable site of the guru of digital-photojournalism, offering technical information and links.

RESOURCES FOR DISABLED PHOTOGRAPHERS

www.joeclark.org/access
www.microsoft.com/enable
www.store.pentrom.com
www.madentec.com
The first two sites offer information for the disabled. The others describe and sell adaptive technologies, which are designed to improve accessibility of computing to those with disabilities. Such products include voice-activated commands, audible documents, adapting keystrokes, and motion-activated sensors.

MANUFACTURERS WEBSITES

Many of the multinational manufacturers provide different websites for each of their sales regions. It may be worth visiting those outside your region, since the quality and information can vary greatly between sites.

Agfa
www.agfa.com
Cameras, scanners, film

Apple
www.apple.com
Computers, displays, audio

Belkin
www.belkin.com
Products for connecting devices, including card readers

Canon
www.canon.com
Cameras, lenses, accessory systems, digital cameras, printers, and scanners

Casio
www.casio.com
Digital cameras

Contax see **Kyocera**
Digital film and scanners

Epson
www.epson.com
Printers, digital cameras, scanners, driver downloads

Formac
www.formac.com
Monitors, media drives, and converters

Fuji
www.fujifilm.com
Digital, film, and medium-format cameras

Hasselblad
www.hasselblad.com
Medium-format cameras with lenses and accessory systems

Heidelberg
www.heidelberg.com
Scanners, fonts, colour software

Hewlett-Packard
www.hp.com
Printers, ink-jet papers, scanners, digital cameras, computers

Jobo
www.jobo.com
Digital scanning camera
backs, darkroom, and
other accessories

Kodak
www.kodak.com
Digital cameras, film
cameras, film, printers

Konica
www.konica.com
Digital and film cameras

Kyocera
www.kyocera.com
Digital and film cameras

LaCie
www.lacie.com
Storage drives and media
displays

Leica
www.leica.com
Cameras, lenses, and
accessory systems

Lexar
www.lexar.com
Memory cards and readers
for digital cameras

Lexmark
www.lexmark.com
Printers

Microtek
www.microtek.com
Scanners

Minolta
www.minolta.com
Cameras, lenses, and
accessory system, digital
cameras, film scanners

Nikon
www.nikon.com
Cameras, lenses, and
accessory system, digital
cameras, film scanners

Olympus
www.olympus.com
Cameras and lenses,
digital cameras, printers,
removable storage

Panasonic
www.panasonic.com
Digital cameras and
electronic devices

Pentax
www.pentax.com
Cameras and lenses,
digital cameras, medium-
format cameras and lenses

Ricoh
www.ricoh.com
Digital and conventional
cameras

Rollei
www.rollei.de
Compact AF 35mm and
digital cameras, superb
medium-format cameras,
and lenses

Samsung
www.samsung.com
Digital cameras and
camera phones

SanDisk
www.sandisk.com
Memory cards, photo
viewers, card readers

Sigma
www.sigmaphoto.com
Digital SLR cameras and
lenses

SmartDisk
www.smartdisk.com
Storage devices and media
readers

Sony
www.sony.com
Digital cameras,
computers, accessories,
devices

Toshiba
www.toshiba.com
Digital cameras and
electronic devices

Umax
www.umax.com
Scanners

UK CLUBS AND SOCIETIES

**The Royal Photographic
Society**
Fenton House
122 Wells Road
Bath BA2 3AH
England
Tel: 01225 462841
Fax: 01225 448688
www.rps.org.uk

CameraClub.co.uk
www.cameraclub.co.uk
A comprehensive site that
includes entries for over
800 camera clubs across
England, Scotland, and
Wales. Features a search
facility for finding your
nearest camera club.

**The Disabled
Photographers Society**
PO Box 130,
Richmond,
Surrey TW10 6XQ
Tel: 01256 351990
www.dps-uk.org.uk
The DPS is a charity that
offers technical advice and
support to disabled
photographers, and can
supply or advise on camera
supports and modifications
to make photography
possible. It also distributes
donated photographic
equipment to members,
including cameras and
darkroom equipment.
Holds an Annual Exhibition
of members' work.

**The Photographic Alliance
of Great Britain**
www.pagb-photography-
uk.co.uk
National association of
regional photographic
organizations. The website
of each regional body
includes contact details for
a network of local clubs.

**Chilterns Association
of Camera Clubs (CACC)**
www.cacc.fsnet.co.uk

Covering Buckinghamshire, Oxfordshire, Berkshire, and Hertfordshire.

East Anglian Federation of Photographic Societies (EAF)
www.eafphotoclubs.co.uk
Covering Bedfordshire, Cambridgeshire, Essex, Norfolk, Suffolk, and Hertfordshire.

Kent County Photographic Association (KCPA)
www.kcpa.co.uk

Midland Counties Photographic Federation (MCPF)
www.mcpf.co.uk
Covering Gloucestershire, Herefordshire, Leicestershire, Northamptonshire, Rutland, Shropshire, Staffordshire, Warwickshire, Worcestershire, and the West Midlands.

Northern Counties Photographic Federation (NCPF)
www.dave.coates.photoshot.com/NCPF.html
Covering Cleveland, Cumbria, Durham, Northumberland, and Tyne and Wear.

North and East Midlands Photographic Federation (NEMPF)
http://homepage.ntlworld.com/david.gibbins/nempf
Covering Derbyshire, Lincolnshire, and Nottinghamshire.

Northern Ireland Photographic Association (NIPA)
www.niphoto.co.uk
Covers clubs in Northern Ireland.

Scottish Photographic Federation (SPF)
www.scottish-photographic-federation.org
Serves clubs in Scotland.

Southern Photographic Federation (SPF)
www.southphotographicfed.org.uk
Includes Berkshire, East Dorset, Hampshire, West Sussex, East Wiltshire, Isle of Wight, and the Channel Isles (Jersey and Guernsey)

Western Counties Photographic Federation (WCPF)
www.wcpf.org.uk
Includes Cornwall, Devon, part of Dorset, Somerset, part of Wiltshire and South Gloucestershire.

Welsh Photographic Federation (WPF)
www.thewpf.co.uk
Covers clubs in Central and South Wales.

Yorkshire Photographic Union (YPU)
www.ypu.org.uk
Includes clubs in Yorkshire.

CLUBS AND SOCIETIES AROUND THE WORLD

Photographic Society of America (PSA)
3000 United Founders Blvd., Suite 103, Oklahoma City, OK 73112-3940, USA
Tel: +1 (405) 843 1437
Fax: +1 (405) 843 1438
www.psa-photo.org

Adelaide Camera Club Inc
PO Box 494
North Adelaide, South Australia 5006
Tel: +61 08 8348 7252
info@adelaidecameraclub.org.au
www.adelaidecameraclub.org.au

The Canberra Photographic Society Inc. (Australia)
GPO Box 857
Canberra, Australian Capitol Territory 2601
Australia
Canberra_photographic@hotmail.com
www.cenart.net/cps.htm

Darwin Camera Club (Australia)
PO Box 4087
Darwin
Northern Territory 0801
Australia
Tel: +61 0416 137 417
info@darwincameraclub.org.au
www.darwincameraclub.org.au

Federation of Camera Clubs (NSW) Inc. (Australia)
www.photographynsw.org.au
6 Yanco Close
French's Forest
New South Wales 2086
Australia

Melbourne Camera Club (Australia)
PO Box 1180,
South Melbourne, 3205, Victoria
Australia
Tel: +61 03 9696 5445
www.melbournephoto.org.au

Queensland Camera Group Inc. (Australia)
PO Box 418
Toowong,
Queensland 4066
Australia
Tel: +61 07 3376 1747
gaye@cisbrisbane.com
www.qcg.org.au

West Australian Photographic Federation Inc
22 Watsonia Road
Gooseberry Hill,
Western Australia 6076
Australia

Tel: +61 08 9454 5251
www.wapf.org.au

**Photographic Historical
Society of Canada**
Box 54620, RPO
Avenue/Fairlawn,
Toronto, Ontario,
M5M 4N5
Canada
www.phsc.ca

**International Federation of
Photographic Art**
www.fiap.net
FIAP is an international
federation of national
associations of
photography, representing
more than 85 national
associations and nearly
one million individual
photographers.

**Irish photographic
federation**
http://homepage.eircom.
net/~ipf
Federation of local camera
clubs in the Republic of
Ireland.

**Photographic Society of
New Zealand (PSNZ)**
PO Box 98 Wanaka
Central Otago
New Zealand
www.photography.org.nz
Includes details of
exhibitions and local clubs
throughout the North and
South Islands.

**Krugersdorp Camera Club
(South Africa)**
PO Box 529,
Krugersdorp 1740,
Republic of South Africa
Tel: +27 (0)11 660 1615
www.kameraklub.co.za

PHOTOGRAPHY
GALLERIES: ENGLAND

**Royal Photographic
Society**
The Octagon
Milsom Street

Bath BA1 1DN
Tel: 01225 462 841
rps@rps.org
www.rps.org

Ikon
1 Ozells Square
Brindley Place
Birmingham B1 2HS
Tel: 0121 248 0707
art@ikon-gallery.co.uk
www.ikon-gallery.co.uk

**National Museum of
Photography, Film &
Television**
Bradford BD1 1NQ
Tel: 0870 7010 200
nmpft@nmsi.ac.uk
www.nmpft.org.uk

Watershed Media Centre
1 Canons Road
Bristol BS1 5TX
Tel: 01179 276 444
info@watershed.demon.
co.uk

Folly
26 Castle Park
Lancaster LA1 1YQ
Tel: 01524 388 550
info@folly.co.uk
www.folly.co.uk

Open Eye Gallery
28–32 Wood Street
Liverpool L1 4AQ
Tel: 0151 709 9460
info@openeye.org.uk
www.openeye.org.uk

artandphotographs
13 Mason's Yard
St James's
London SW1Y 6BU
Tel: 020 7321 0495
info@artandphotographs.
com
www.artandphotographs.
com

**The Association of
Photographers**
81 Leonard Street
London EC2A 4QS
Tel: 020 7739 6669
general@aophoto.co.uk
www.the-aop.org

Atlas Gallery
49 Dorset Street
London W1U 7NF
Tel: 020 7224 4192
info@atlasgallery.com
www.atlasgallery.com

Barbican Art Gallery
Barbican Centre
Silk Street
London EC2Y 8DS
Tel: 020 7588 9023
artinfo@barbican.org.uk
www.barbican.org.uk/art/

Dazed & Confused Gallery
112-116 Old Street
London EC1V 9BD
Tel: 020 7336 0766
www.dazed@confused.co.uk

Focus Gallery
3-4 Percy Street
London
W1T 1DF
Tel: 020 7631 1150
info@focusgallery.co.uk
www.focusgallery.co.uk

Hamiltons
13 Carlos Place
London W1Y 2EU
Tel: 020 7499 9493
photography@
hamiltonsgallery.com
www.hamiltonsgallery.com

Getty Images Gallery
3 Jubilee Place
London SW3 3TD
Tel: 020 7376 4525
hulton.gallery@getty-
images.com

**Michael Hoppen
Photography Ltd**
3 Jubilee Place
London SW3 3TD
Tel: 020 7352 3649
gallery@
michaelhoppengallery.com
www.michaelhoppengallery
.com

The Photographers' Gallery
5 & 8 Great Newport Street
London WC2H 7HY
Tel: 020 7831 1772
www.photonet.org.uk

Photofusion
17a Electric Lane
London SW9 8LA
Tel: 020 7738 5774
info@photofusion.org
www.photofusion.org

Proud Central
5 Buckingham Street
London WC2N 6BP
Tel: 020 7839 4942
info@proud.co.uk
www.proud.co.uk

Proud Camden
10 Greenland Street
London NW1 0ND
Tel: 020 7482 3867
info@proud.co.uk
www.proud.co.uk

Shine Gallery
3 Jubilee Place
London SW3 3TD
info@shinegallery.org.uk

Tristan's Gallery
49 Molesworth Street
Wadebridge
Cornwall PL27 7DR
Tel: 01208 815767
photo@tristangallery.com
www.tristansgallery.com

The Special Photographers Company
236 Westbourne Park Road
London W11 1EL
Tel: 020 7221 3489
info@specialphotographers
.com
www.specialphotographers
.com

The Spitz
109 Commercial Street
Old Spitalfields Market
London E1 6BG
020 7392 9032
mail@spitz.co.uk
www.spitz.co.uk/gallery

Tom Blau
21 Queen Elizabeth Street
London SE1 2PD
Tel: 020 7490 9171
info@tomblaugallery.com
www.tomblaugallery.com

The Victoria & Albert Museum
Cromwell Road
South Kensington
London SW7 2RL
Tel: 020 7942 2000
vanda@vam.ac.uk
www.vam.ac.uk

Zelda Cheatle
99 Mount Street
London W1Y 5HF
Tel: 020 7408 4448
photo@zcgall.demon.co.uk
www.zcgall.demon.co.uk

Side Photographic Gallery
9 Side
Newcastle-upon-Tyne
NE1 3JE
Tel: 0191 232 2208
sidegallery@hotmail.com
www.amber-
online.com/gallery

Site Gallery
1 Brown Street
Sheffield
S1 2BS
0114 281 2077
info@sitegallery.org
www.sitegallery.org

Focal Point Gallery
Central Library
Victoria Avenue
Southend
SS2 6EX
01702 612 621
admin@focalpoint.org.uk
www.focalpoint.org.uk

Impressions Gallery
29 Castlegate
York YO1 9RN
Tel: 01904 654 724
enquiries@impressions-
gallery.com
www.impressions-
gallery.com

PHOTOGRAPHY GALLERIES: WALES

Ffoto Gallery
Chapter Arts Centre
Market Road
Canton

Cardiff CF51QE
Tel: 02920 341 667
info@ffotogallery.org

PHOTOGRAPHY GALLERIES: SCOTLAND

Stills Gallery
23 Cockburn Street
Edinburgh EH1 1B
Tel: 0131 622 6200
info@stills.org
www.stills.org

Street Level Photoworks
26 King Street
Glasgow G1 5QP
Tel: 0141 552 2151
info@sl-photoworks.
demon.co.uk
www.slphotoworks.demon.
co.uk

PHOTOGRAPHY GALLERIES: NORTHERN IRELAND

Belfast Exposed Photography
The Exchange Place
23 Donegall Street
Belfast BT1 2FF
Tel: 028 9023 0965
info@belfastexposed.org
www.belfastexposed.com

PHOTOGRAPHY GALLERIES: REPUBLIC OF IRELAND

Gallery of Photography
Meeting House Square
Temple Bar
Dublin 2
Ireland
Tel: 00 353 16 714 654
gallery@irish-photography.
com
www.irishphotography.com

National Photographic Archive
Meeting House Square
Temple Bar
Dublin 2
Ireland
Tel: 00 353 16 030 374

photoarchive@nli.ie
www.nli.ie/fr_arch.htm

Foto~art8
events@fotoart8.com
www.fotoart8.com

Velka
22 South William Street
Dublin 2
Ireland
Tel: 00 353 16 703 058
info@velkagallery.com
www.velkagallery.com

PHOTOGRAPHY GALLERIES: AUSTRALIA

Australian Centre for Photography
257 Oxford Street
Paddington, New South
Wales 2021
Australia
Tel: (612) 9332 1455
info@acp.au.com
www.acp.au.com

Centre for Contemporary Photography
205 Johnston Street
Fitzroy, Victoria 3065
Australia
Tel: (613) 9417 1549
ccp@alphalink.com.au
www.ccp.org.au

PhotoAccess Arts Centre
Corner of Manuka Circle &
New South Wales Crescent
Griffith, Australian Capitol
Territory 2603
Australia
(Tel: 612) 6295 7810
contact.us@
photoaccess.org.au
www.photoaccess.org.au

PHOTOGRAPHIC COMPETITIONS

London Photographic Awards (LPA)
www.london-photographic-
awards.com
Tel: 020 8392 8557
Website that runs a variety
of competitions on
different themes. Prizes
include inclusion in the
LPA Photographer's
Directory, and an online
profile and portfolio for
each winner to display
current work. The work of
all entrants is displayed in
the entrants gallery.
Submission is by electronic
upload to the website only.

BJP/Nikon Endframe Dream Project challenge
Endframe/BJP
Haymarket House
28–29 Haymarket
London SW1Y 4RX
www.bjp-online.co.uk
Open to professionals,
amateurs, and students,
Endframe is a rolling
competition that accepts
portfolios throughout the
year, with submissions
reviewed and research
bursaries granted for the
two best Dream Proposals
at the end of each quarter.
At the end of the year, an
award is given to the best
of the eight Dream Project
proposals, and the winner
is commissioned to
photograph their Dream
Challenge.

Ian Parry Scholarship
Rebecca McClelland,
The Sunday Times
Magazine
Picture Desk
1 Pennington Street
London E98 1ST
www.ianparry.org
Set up in memory of
Ian Parry, a young
photojournalist who died
on assignment for *The
Sunday Times* in Romania
in 1989, this scholarship
aims to support young
photojournalists around
the world. Entrants must
be attending a full-time
photography course or be
under the age of 24, and
must submit a portfolio of
work and a brief synopsis
of a project they would
undertake if they won the
scholarship. The prize is
some Nikon camera
equipment, a prize from
www.image.net, and a
further contribution
towards the costs of the
assignment. Vouchers
from Metro Imaging are
awarded to the winner,
and cash prizes to
highly commended and
commended entrants.

Panasonic Lumix Award
www.panasonic-
europe.com/lumix/awards
Open to digital capture
only, with first prize of a
VIP trip to the Monaco
Grand Prix.

Schweppes Photographic Portrait Prize
Exhibitions Department
National Portrait Gallery
St Martin's Place
London WC2H 0HE
Tel: 0870 112 6772
www.npg.org.uk/
schweppesprize
This competition provides
an important platform for
portrait photographers,
from gifted amateurs and
students, to professionals
of all ages. The winner
of the Schweppes
Photographic Portrait Prize
receives a cash prize, the
Deloitte Award (which
offers a smaller cash
prize) is awarded to
photographers aged 25 or
under, and one or more
cash prizes are awarded at
the judges' discretion. In
addition, the winners' work
is displayed in an
exhibition at the National
Portrait Gallery, before
touring at various other
galleries in the UK.

The *Telegraph* Travel Photography Awards
Telegraph Travel
Photography Awards
PO Box 7778

Colchester CO2 8WH
Contact the *Telegraph's*
Promotions Department on
020 7538 7988.
Sponsored by the Royal
Photographic Society and
Jessops, this competition
awards a cash prize and a
commission for the
Telegraph's Travel section
to the overall winner, while
category winners are
awarded a two-week
photographic trip to a long-
haul destination, as well as
Jessops vouchers.

Travel Photographer of the Year
PO Box 2716
Maidenhead
Berkshire SL6 7ZN
info@tpoty.com
www.tpoty.com
With an optional small
donation on top of your
entry fee given to selected
charities each year, the
TPOTY award emphasizes
the responsibility of
travellers to respect the
people and environments
of the countries they travel
in. With five categories
(Human Spirit, Traveller's
Tales, Go Beyond, Natural
World, and A Moment of
Freedom), prizes are given
to winners, runners-up,
highly commended
entrants, as well as the
titles of Travel Photographer
and Young Travel
Photographer of the Year.

Wanderlust and *The Independent* Travel Photographer of the Year
www.wanderlust.co.uk/co
mpete/potycomp.html
Amateur category winners
are awarded with flights for
two to Australia on a
photographic commission
and a cash prize plus a
commercial contract with
The Travel Library for
Professional winners.

Wildlife photographer of the Year Award
The Natural History
Museum
Cromwell Road
London SW7 5BD
Tel: 020 7942 5015
Fax: 020 7942 5084
wildphoto@nhm.ac.uk
www.nhm.ac.uk
Organized by the Natural
History Museum and *BBC
Wildlife Magazine*, this
annual competition aims
to showcase the best
nature photographs to a
worldwide audience, and to
inspire people to care for
the future of the planet.
Amateurs and professionals
compete for the prizes —
12 adult and three junior
categories – with awards
for the overall winner,
overall junior winner, and
three special awards.

Geographical Photographer of the Year
Geographical Magazine
Winchester House
259–269
Old Marylebone Road
London, NW10 5XA
Tel: 020 7170 4360
Fax: 020 7170 4361
magazine@geographical.
co.uk
www.geographical.co.uk
Organized by *Geographical
Magazine*, the publication
of the Royal Geographical
Society, this competition is
open to amateurs and
professionals. Prizes are
awarded to overall 1st and
2nd places, and winners of
each of six categories. An
exhibition is mounted at
the Royal Geographical
Society in London.

BBC Countryfile Photography competition
Photographic Competition
Countryfile,
BBC, Birmingham
B5 7QQ
www.bbc.co.uk/nature/
environment/programmes/
countryfile
A themed competition
organized by the BBC TV
programme. The twelve
winning entries are
reproduced on a calendar,
which is sold for charity.
There are additional prizes
for the judges favourite,
and the picture voted best
by the programme viewers.

Luis Valtueña International Prize for Humanitarian Photography
Premio Internacional de
Fotografia Humanitaria Luis
Valtueña,
C/Andrés Mellado,
31 bajo.28015 Madrid,
ESPANOL
Tel: +34 91 543 60 33
luisvaltuena@
medicosdelmundo.org
www.medicosdelmundo.
org/luisvaltuena
Organized by Spanish NGO
Medicos del Mundo, this
competition is for pictures
that express hope and
solidarity in desperate
situations. The prize is
named after one of four
Medicos del Mundo
employees who died
during humanitarian work.

ANZANG Nature and Landscape Photographer of the Year
ANZANG Nature
GPO Box 2828
PERTH, Western Australia
Australia 6001
Tel: +61 (0)89321 3685
compete@anzangnature.com
www.anzangnature.com

The Citigroup Private Bank Australian Photographic Portrait Prize
Art Gallery of New South
Wales
Tel: +61 02 9225 1700
entries@ag.nsw.gov.au
www.artgallery.nsw.gov.au
/aboutus/art_prizes/
cpbappp

Index

A

Abbas 108-9
Abbott, Berenice 62
abstraction 152, 277
 architecture 289
 art photography 294
 black-and-white 202
 filter effects 171
 viewpoint 193, 231
accessories 146-7
actinograph 80
Adams, Ansel 23, 26-7, 95, 104
Adams, Eddie 101
additive colour 82
Adobe Photoshop 110, 151, 161, 161, 307
advertising 16, 87, 102-3, 106-7
 photographers 34, 45
 stock photographs 308
air bubbles 319
aliasing 320
Alvarez Bravo, Manuel 28, 49
amateur photographers 7, 93, 101, 112, 264
analyzing photographs 304, 310
Andriesse, Emmy 259
animals 233, 236, 240-45
 see also wildlife
Apagya, Philip Kwame 200-01
aperture 225, 226
aperture priority 219, 277
Araki, Nobuyoshi 29
Arbus, Diane 29
Archer, Frederick Scott 76
architecture 133, 288-93
 camera 126
 converging verticals 290
 rights of access 291
Arnold, Eve 24, 30
art photography 80-81, 294-9
 art effect filters 151, 170
 art movements 71, 94-5
 holography 107
asset management software 311
assistant, photographic 307
Autochrome process 88
auto-exposure 105, 231
auto-focus 123, 125, 144, 224, 230, 259

B

backgrounds 201
 blurred 56, 136, 260
 extraction 175
 portraits 234
backlighting 276, 282
 silhouettes 285
back-projection 277
bags, camera 147
Bailey, David 100
ballet 253
Bar-Am, Micha 262-3
Barnack, Oskar 92
Barnett, Heather 113
Barton, Mrs G.A. 88
Beato, Felice 31
Beaton, Cecil 13
Benson, Harry 106
birds 48, 52-3, 71, 240
black-and-white 110, 202-7
 burning in/ dodging 136-7
 darkroom 132-7
 digital photography 205
 documentary photography 253
 film 128, 129, 203, 307
 ink-jet printing 178
 printing 134-5
 problems 318-19
 processing 132-3
blends 177
Blossfeldt, Karl 31
Bluetooth 156
blur 114-15, 185, 311
 background 56, 136, 260
 motion 46, 56, 218, 310
 soft-focus effect 284
Borden, Harry 113
Bourdin, Guy 32-4, 101
Bourke-White, Margaret 24, 35, 99
Bourne, Samuel 83
Box Brownie camera 87
bracketing 215, 312
Brandenburg, Jim 196
Brandt, Bill 36
Brassaï 50, 96-7
brightness 185
 black-and-white 203
 burning-in/ dodging 136-7
 digital adjustment 151, 165, 261
Zone System 27
Brodovitch, Alexey 30
Brownell, Frank 87

B (continued)

Bryant, Richard 289
bubble-jet printer 178
buildings, see architecture
burning-in 136-7
Burrows, Larry 101
business skills 307

C

calling cards 72, 77
Calotype process 75, 76
camera, digital 119, 138-43, 231
 advanced 141
 colour reproduction 196
 compact 140, 141
 direct-to-CD 141
 features 138
 first 110
 high-resolution 141
 ISO numbers 128
 lens 139
 memory cards 139
 performance 139
 pixel count 139
 sensor 139
 SLR 142, 265
 ultra-compact 140
 zoom 259
camera, film 119-20, 122-7
 auto-focus 123
 compact 92, 123, 259
 disposable 123
 electronic circuitry 105
 large-format 104, 127
 loading 319
 mass-produced 87
 rangefinder 123, 253
 on safari 242
 SLR 94, 124-5
 specialist 126-7
 TLR 94
 viewfinder 46, 122-3
camera movement 310
camera obscura 72, 74
camera phones 72, 113, 140
camera-shake 224, 243, 277
Camera Work 37, 65
Cameron, Julia Margaret 37, 81
Cameron, Regan 238-9
candid photography 29, 44, 86
Capa, Robert 38-9, 50, 203
capturing the moment 241, 260, 265, 266
careers in photography 306-7

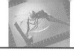
Carlyle, Thomas 37
Cartier-Bresson, Henri 40-41, 50, 95, 190
 and Magnum 38, 40
 picture essays 99
Cavalier, Steve 107
celebrities 13, 30, 44, 54, 92, 106
censorship 76
character, capturing 259
characteristic curve 80
chiaroscuro 81, 253
children 250-51, 258-63, 265
 capturing character 259
 settling 258
Chung, Chien-Min 256-7
cityscapes 19, 65, 66
Claridge, John 107
Claudet, Antoine 82
Clergue, Lucien 212-13, 282
close-up photography 95, 240, 241
 flowers 120, 277
 macro lens 145
clubs and societies 331-3
Color Balance tool 166-7, 204, 215
Color Range tool 175
colour balance 151, 166-7, 197
colour casts 166-7
colour contrast 190, 194-5, 197, 199
colour film 128, 129
colour management 180
colour photography 196-201
 additive colour 82
 advertising 102-3
 Autochrome process 88
 colour reproduction 310, 312
 digital imaging 139, 196, 199
 exposure 198-9
 hand-colouring 82
 history 82, 88, 104
 image manipulation 166-7
 lens filters 145
 nature photography 48
 photojournalism 110-11
 trichrome 82, 88
colour wheel 197
commercial photography 265, 278, 308-13
competitions 335-6
composition 185, 188-95
 black-and-white 203
 landscapes 271
 nudes 282

 rule of thirds 188, 258, 270, 272
 structure 188-91
 viewpoints 192-3
computers 72, 151, 307
 avoiding injury 155
 connections and ports 156
 electrical arrangements 155
 workroom 154-5
Constructivism 63
contrast 310
 colour 190, 194-5, 197, 199
 digital manipulation 151
 light 208, 209, 215
 problems 318
 variable contrast paper 135
contre-jour images 216
converging parallels 270, 279, 290
courses 303, 306
Cousteau, Jacques 100
creativity 231-2
Crimean War 76
cropping 242
 digital 151, 152, 164
 letter-box 164, 313
 vertical 313
Cruz, Valdir 42

D

Dadaism 48, 71, 94
Daguerre, Louis 74-5, 76
Daguerreotype 74, 75, 80, 82
Daily Graphic 86
Dalton, Stephen 24, 42, 71
dance 15, 253, 255
darkroom
 burning-in/dodging 136-7
 drying prints 135
 fixing 132, 135
 printing 134-5
 problems 318-19
 processing 132-3
 setting up 130-31
 washing 132, 135
 working in 131
Davidson, Bruce 99
Delaroche, Paul 80
depth of field 185, 219, 224-5
 architecture 291
 controlling 225
 digital camera 139
 narrow 240, 276
development 131
 darkroom equipment 130
 film processing 134
 overdevelopment 318, 319

printing 135
 problems 318-19
 underdevelopment 318, 319
 Zone System 27
diagonals 189, 190
diffusers 210
diffusion 283, 284, 285
digital manipulation 104-5
 black-and-white 205
 brightness 165, 261
 burning-in 217
 colour control 166-7
 converging verticals 290
 enhancing shadows 152, 237
 exposure adjustments 215
 filter effects 170-73
 layers and blends 176-7
 portraits 235
 red-eye 211
 selections and masks 174-5
 sharpness 168-9
 size and shape 164
 software 110, 151-2, 160-61, 307
 toning 204
digital photography 72, 110, 120, 151-81
 close-ups 277
 colour 180, 199
 equipment 154-5
 file transfer 156-7
 film to digital 158-9, 268-9
 image file size 159, 164
 nudes 282, 284
 perfect print 180-81
 pre-flighting 311
 printing 178-9, 322
 problems 320-22
 storage 154, 157
 workroom 154-5
 see also camera, digital
Diorama 74
disposable cameras 123
distortion 98, 170
 moiré effect 291
 wide-angle 36, 246, 249, 266, 310
documentary photography 252-7
 history 86, 88-9, 93
 narrative style 254-5
 photographers 30-31,42-3
Doisneau, Robert 231
Donovan, Terence 100
Doubilet, David 43

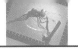

double exposure 151, 227
Driffield, Vero Charles 80
Du Hauron, Louis Ducos 82, 88
Dupain, Max 43
dust 242, 265
dye sublimation printer 178, 179

E

Eastman, George 87
Edgerton, Harold 42, 99, 100, 211
Eggleston, William 104
Eisenstaedt, Alfred 23, 44, 106
electronics, camera 105, 119
Emerson, Peter Henry 81
endoscopy 105
enlarger 131, 134
equipment
 accessories 146-7
 caring for 265
 darkroom 130-31
 workroom 154-5
 see also camera; lenses; lighting
Ermanox camera 92
Erwitt, Elliott 45
Evans, Walker 93
events 246-51
EVF (Electronic Viewfinder) camera 142
exhibitions 98, 316-17
exposure 185, 214-21, 231, 310
 auto- 105
 black-and-white 202
 bracketing 215, 312
 burning-in/dodging 136-7
 for colour 198
 digital adjustment 151, 152, 165
 double 151, 227
 exaggerated 214
 light conditions 208-9
 long 218, 219, 227
 metering systems 216
 nudes 282, 284
 overexposure 214, 319
 problems 318
 short 218
 sunsets 272, 273
 time exposure 186, 220-21
 tungsten lighting 203
 underexposure 214, 272, 318
 Zone System 27

extraction 175
eyes 235, 261
eye contact 58, 267

F

f/number 277
Family of Man exhibition 98
Farm Security Administration 93
fashion photography 108-9
 history 89, 98, 100-101
 photographers 32-4, 36
feathering 174
Feininger, Andreas 55, 71
Fenton, Roger 76
field of view 223
film 87, 92, 128-9
 black-and-white 128, 129, 203
 colour reproduction 196
 digital conversion 158-9
 problems 318
 roll-film 87, 92
 on safari 242
 types 129
film format 128
 35mm 92, 94, 124
 60mm 92
 medium-format 94
film scanner 158
film speed 80, 128
 for domestic lighting 203
 fast 106
filters
 digital manipulation 170-73
 graduated 273
 lens 145, 226
 soft-focus 284
fine-art, see art
FireWire 156
flare 216-17, 272, 273
flash 48, 99, 210
 accessories 147
 bounced 246
 built-in 210
 close-ups 277
 fill-in 210
 hotshoe-mounted 147, 246
 indoor 210
 off-camera 210, 211
 outdoor 51, 210
 portraits 235
 red-eye 211
 swivel-headed 246
flat-bed scanner 158-9
flat-bed technical camera 126
flowers 231, 276-7

close-ups 120, 277
outdoors 276
special effects 172-3, 226
studio set-up 277
focal length 144, 222-3, 226
focusing 185, 224, 231, 310
 automatic 224
 portraits 235, 258
focusing screen 94
Fontana, Franco 271
food 254-5
format, portrait/landscape 297
 see also film format
Fortune 35
Fox Talbot, William 75-7
framing 235, 261, 277, 312
 architecture 288, 291, 293-3
Frank, Robert 99
freezing movement 99, 218

G

Gabor, Denis 107
galleries 316-17, 333-5
gardens 278-81
gelatin filters 145
Germany 93
glass plates 74, 76, 83
Glenn, John 100
Glinn, Burt 99
Goebbels, Joseph 93
grain 185, 203
greyscale 202, 205
Group f/64 71, 95
group portraits 37, 40, 249
Grundy, William 78-9
Gruyaert, Harry 111

H

Haas, Ernst 46-7, 186, 192, 196, 208
Haeberle, Ronald 101
half-toning 86
halo effect 235
Halstead, Dirck 106
hand-colouring 82, 90-91
hard disk drives 157
Harper's Bazaar 30, 98
Harvey, David Alan 250-51
Heartfield, John 48
high-key images 214, 215
highlights
 burning-in 137
 burnt-out 310
 digital manipulation 152
 exposure 214, 216
high-speed photography 42

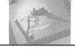
Hine, Lewis 89
holography 107
horizon 272
Hosking, Eric 48
Hosoe, Eikoh 49
Hubble telescope 111
hue 198
humour 45, 48, 86, 232, 243
Hurter, Ferdinand 80

I, J, K
Illustrated London News 88
image files
 adding information 311
 pre-flighting 311
 size 151, 152, 159, 164
image licensing 309
image management 288
image manipulation 98, 107
 see also digital
 manipulation
industrial photography 35,
 41, 252
Ingram, Herbert 88
inkjet printer 178, 307
instant photography 95
interiors 44, 167, 211, 289
internet 72, 110, 113
 picture storing 157
 websites 315, 317
ISO numbers 128
Iturbide, Graciela 49
Jackson, William Henry 83
JPEG images 321
Kertész, André 50
Kline, William 99
Kodak 87, 110

L
Land, Edwin 95
landscapes 26-7, 270-75
 black-and-white 203, 205
 composition 188
 large-format camera 127
 lenses 144, 145
 people in 265, 286-7
Lange, Dorothea 93
Lanting, Frans 51, 52-3
large-format 120
 camera 104, 127
Lartigue, Jacques Henri 86
laser printer 178
Lasso tool 174
layers 151, 176-7
LCD screen 138, 139, 142
leading lines 235
legal restrictions 284
Leica cameras 38, 50, 92, 94,

98, 192
 rangefinder 123, 253
lens filters 145
lenses 105, 119
 35mm 144
 50mm 222
 anatomy 144
 caring for 265
 digital camera 139, 144
 event photography 246
 field of view 223
 flare 272
 focal length 144, 222-3
 interchangeable 144-5
 large aperture 76
 long 72, 106, 242
 movement 126
 stabilized 243
 standard 144
 standardizing 41
 types 144-5
 using 222-5
 wildlife photography 145,
 242
 see also individual types
LeRoy, Catherine 101
Levels control 165
Lichfield, Lord 101
Liebovitz, Annie 54
LIFE 30, 35, 44, 46, 55, 99
light 119, 196, 208-13
 brilliant 208
 contrasty 208, 209, 215,
 266-7, 276, 319
 fall-off 310
 flat 209
 landscapes 270-71
 soft/hard 209, 285, 288
 types 208-9
light fogging 319
light trails 220-21, 227
lighting 210-11
 architecture 288, 290
 chiaroscuro 253
 colour balance 166
 digital workroom 154
 domestic tungsten 203
 exhibitions 316
 nudes 282, 285
 portable units 211
 portraits 235
 underwater 100
 see also flash
Lissitzky, Eliezer 94
List, Herbert 55
longevity 307, 308
low-key images 24
low light 146

Lumière brothers 88
luminance 217

M
macro lens 145, 277
magazines 30, 71, 98-9, 101,
 106
magic lantern 84-5
Magic Wand tool 174
Magnum 30, 38, 46, 55, 59
Magritte, René 67
Martin, Paul 89
masks 174-5
Mason, Leo 56
mass-production 80, 92
Maxwell, James Clerk 82
McCullin, Don 57, 99, 101, 191
McCurry, Steve 58
medium-format 94, 313
 camera 125, 127
Meiselas, Susan 59
memory card readers 157
memory cards 139
metadata 311
Meyer, Baron de 89
mid-tones 214
Mili, Gjon 211
Miller, Lee 62
Mishima, Yukio 49
Misrach, Richard 104
mobile phones 72, 113, 140
model release forms 265, 309
models 282
Modernism 43, 71, 279
moiré effect 291, 320, 321
monitor
 calibrating 180
 moiré effect 321
 settings 181
motion 83
 blurring 46, 56, 218
 dissecting 211
 freezing 218, 219
 shutter speed 218
motor-drive 106
movement, see motion
moving images, sequential 83
Munkacsi, Martin 40
Muybridge, Eadweard 83
Mydans, Carl 93

N, O
NASA 100, 105
National Geographic 43, 58,
98
nature photography 19
 birds 48
 botanical 31

high-speed 42
lenses 72
photographers 31, 42, 48, 51-3
Nazi Germany 93
negative 75, 76, 128
working in 133
New York Tribune 89
news photography, see photojournalism
newspapers, illustrated 86
Newton, Helmut 101
Newton's Rings 320
Niépce, Nicephore 74
night photography 279
printing images 181
noise 181, 185, 320
notes 288
nudes 214, 282-7
photographers 36, 49, 212-13
Observer 56, 57
Orr, Edwina 107
O'Sullivan, Timothy 84-5
outdoor working 307
flowers 276

P, Q

panoramas 120, 152, 271, 286-7
panoramic camera 126
paparazzi 12, 106
paper, photo 75, 76, 87, 135
printer 179, 181
Paris Match 99
patterns 279
Penn, Irving 99, 203
pentaprism 94
Peress, Gilles 59
perfection 81, 95, 180-81
permissions 278
perspective 192-3, 222
children 258
portraits 235
pets 241
photo-etching 113
photograms 62
photojournalism 98-9, 110-11, 112-13, 258
camera 123
colour 110-11
composition 189
Photomix 160
photomontage 48, 94, 295
picture drives 157, 265
picture editing 296, 314-15
picture essays 99
picture libraries 308

Picture Post 36, 55, 98
picture quality 185, 310
pixellating filters 171
pixels 139
plants 31, 276-7
leaves 27, 47
outdoors 276
studio set-up 277
see also flowers
Polar Coordinates filter 170
polarizing filter 145
Polaroid camera 95
politics 88, 93
portfolios 306, 314-15
portraits 72, 77, 107, 234-9
children 258-63
groups 37, 40, 249
lenses 144, 145
locations 237
photographers 29, 37, 54, 64, 234
red-eye 211
setting up shot 234-5
studio 77
posterization 321
posters 164
previsualization 27, 186
printers 178-9, 181
problems 322
printing, darkroom 134-5
prism filter 226
problems
basic 310, 318-22
digital imaging 320-21
digital printing 322
processing/printing 318-19
processing
darkroom 132-3
problems 318-19
professional labs 72, 307
push/pull 318, 319
professional photography 303, 306-7
professionalism 307
projects 186
propaganda 93
props 283
publishing images 265, 278
internet 317
pull processing 319
push processing 318
quality criteria 185, 310

R

radial composition 189
Rai, Raghu 60-61
rainbow filter 226
rangefinder camera 123, 253

Ray, Man 36, 62, 95
rayograph 62
red-eye 211
reflections 186, 192, 242
architecture 289
landscapes 271, 286-7
nudes 282, 286-7
reflectors 147, 277
Rejlander, Oscar Gustav 81
remote control 56
resolution 168, 320
Riboud, Marc 189
Riis, Jacob 89
Robinson, Henry Peach 80, 81
Rodchenko, Alexandr 63, 192
Rodero, Cristina Garcia 247
Rodger, George 38
roll-film 87, 94
Rolleiflex camera 94, 192
Rowell, Galen 270, 274-5

S

Sabattier Effect 62
safaris 242-3
Salgado, Sebastião 63, 203
Salomon, Erich 92
Sander, August 64
satellite imaging 72, 105
scale 264, 288, 289, 290
scanner 158-9, 179
problems 320-21
Scianna, Ferdinando 114-15
science 105, 113
scrapbook, digital 160
Secessionists 71
selections 174-5
self-timer 146
selling prints 307, 312-13, 316
permissions 278
sensitometry 80
sensor 139, 144, 265
sepia toning 152, 204
series art photography 294, 296-7
documentary 254-5
events 246-7
Seymour, David "Chim" 39
shadows 28, 192, 271
blocked 321
burning-in/dodging 136, 217
colour 199
detail 237, 261, 272
digital manipulation 152, 237, 272
exposure 214, 216
noise 320
nudes 282, 283, 284

portraits 237
projected 212-13
as theme 296-7
Shahn, Ben 93
sharpness 185, 267, 310
digital manipulation 152,
168-9
over-sharpening 321
Sherman, Cindy 107
shift lens 290
shopping malls 186, 291
Shore, Stephen 104
shutter priority 219
shutter speed 218-19
Sidibe, Malick 15
silhouettes 285
Singh, Raghubir 186, 193
single-lens-reflex, see SLR
skies, printing 181
slide film 129
slides
exposure 208
scanning 159
SLR camera 124-5
digital 142, 265
first 94
lenses 144
Smith, William Eugene 64, 99,
185
snapshots, see candid
photography
Snowdon, Lord 101
Sochurek, Howard 104-5
soft-focus effect 284
space 14, 100, 105, 111
special effects 226-7
digital manipulation 170-71
in-camera 227
lens filters 145, 226
Spherize filter 170
sponsorship 317
sport 16, 56, 99
digital photography 143
lenses 72
spot-meter 217
spy camera 127
Steele-Perkins, Chris 111
Steichen, Edward 98
stereoscopes 82
Stern 106
Sternfeld, Joel 104
Stieglitz, Alfred 62, 65, 208
Camera Work 37, 65
still-lifes 47, 66
Strand, Paul 26, 95
stroboscope 42, 99, 211
stock photography 308, 309
studying photography 306

Stryker, Roy 93
subject movement 310
Sudek, Josef 66
sun, shooting against 216
sunsets 272-5
super-telephoto lens 56
surge marks 319
Surrealism 28, 34, 36, 55, 67,
94
symmetry 189, 280-81, 289

T
technology 72, 231
telephoto lens 56, 145, 222-3
nudes 282
super-/ultra- 56, 223
Tennyson, Lord Alfred 37
test-strips 305
texture 194-5, 276, 288, 290
texturizing filters 171
themes 294, 296-7
thirds, rule of 188, 258, 270,
272
Time 99, 106
time exposures 186, 220-21,
227
TLR camera 94
tone 185, 186, 196
digital manipulation 151,
152, 204
gradations 267
sepia 152, 204
topographical photography
104
Tournassoud, Jean-Baptiste
88
transparencies, see slides
travel photography 83, 264-9
amateur 112, 264
art 295
lenses 145
photographers 31, 49, 58
trichrome theory 82
tripods 145, 146, 224
twin-lens reflex, see TLR

U, V
underwater photography 19,
43
camera 127
lighting 100
USB 156
Vandivert, William 38
vanishing points 270
Vanity Fair 54
Victoria, Queen 77
video 107, 110
digital stills 142

Vietnam War 14, 57, 101
viewfinder 41
viewfinder camera 46, 122-3
electronic (EVF) 142
viewpoint 186, 192-3
creative 63, 193, 231
gardens 279
Virilio, Paul 15
Vishniac, Roman 93
Vogue 34, 98

W
war photography 112
Crimean War 76
photographers 38-9, 57, 59
Vietnam War 57, 101
World War I 88
World War II 39, 40, 45, 98
water marks 319
Webb, Alex 111, 209
websites 315, 317, 329-31
Weegee 98
Weston, Edward 26, 65, 95,
104
Wet Collodion process 76
white balance 166, 167, 267,
284
wide-angle lens 144, 222-3
distortion 36, 246, 249,
266, 310
ultra- 120, 223, 246
zoom 145
wildlife 51, 162-3, 196, 240
camera and lens 145, 242
safari 242-3
workshops 304, 306
World War I 88
World War II 39, 40, 45, 98
Wulz, Wanda 72

X, Y, Z
x-rays 28, 319
Yevonde, Madame 234
Young, Thomas 82
Zone System 26, 27
zoom lens 105, 144, 192, 223
built-in 122, 138
close-ups 277
digital camera 259
event photography 246
focusing 224
garden photography 279
long-exposure zooming
227
telephoto 145
wide-angle 145
Zoopraxiscope 83
zoos 241, 244-5

Acknowledgments

Author's acknowledgments

To all the team at Dorling Kindersley, in particular Nicky Munro and Jenisa Patel, my very appreciative thanks for your hard work on a demanding project. Also thanks to picture researchers Carolyn Clerkin and Anna Bedewell for their dogged persistence, which enabled us to obtain the great photographs used in this book.

Many thanks to Alice Hunter, Cicely Ang, and Louise Ang for their contributions to the research. Thanks also to Ruth Silverman of Ruth Silverman Gallery, Berkeley, California, and Fifty One Fine Art Photography, Antwerp for their help with research.

And to Wendy, as always, my strength, support and inspiration – this book is as much hers as anyone else's.

Publisher's acknowledgments

Dorling Kindersley would like to thank the following people for their help in the preparation of this book:
Editorial: Corinne Asghar and Linda Martin
Design: Mark Cavanagh, Karen Self, and Karen Constanti
Illustrations: Patrick Mulrey
Proofreading: Constance Novis
Indexing: Chris Bernstein

The publisher would like to thank the following for their kind permission to use images of their products:

ACDSee, Adobe, Agfa, ArcSoft, Inc., Canon, Case Logic Europe, Corel, Cullmann, Epson, Extensis, Fuji Photo Film (UK) Ltd, Gossen, Hasselblad, ILFORD, Jessops, Konica Minolta, LaCie, Leica Camera Ltd, Lexar Media Inc., Linhof and Studio Ltd, Manfrotto/DayMen International, Microtek, Minox GmbH, Nikon UK Ltd, Olympus, Pentax, Ricoh, Roxio - a division of Sonic Solutions, SANYO Europe Ltd, Sony UK Ltd, Tamron Europe GmbH, Tatung (UK) Ltd

- Images of Nature: Frans Lanting (bl, br, cla). Frans Lanting Photography: (tl). **52-53** FLPA - Images of Nature: Frans Lanting/Minden Pictures. **54** Associated Press: John Froscauer (tl). Annie Leibovitz: nbpictures (bl, bcl). **55** Magnum: Herbert List (bl, br, tl). **56** Corbis: Leo Mason (b, cl). Leo Mason: (tl). **57** Corbis: Zen Icknow (tl). Don McCullin: (bl). V&A Images: Don McCullin (br). **58** Magnum: Rene Burri (tl); Steve McCurry (bl, br, cr). **59** Magnum: Susan Meiselas (bl, br, cl, tl). 60 Greenpeace: (tl). **60-61** Magnum: Raghu Rai. **61** Magnum: Raghu Rai (tl, tr). **62** akg-images: (tl). www.bridgeman.co.uk: Man Ray Trust/ADAGP, Paris and DACS, London 2005 (br). Réunion Des Musées Nationaux Agence Photographique: Man Ray Trust/ADAGP, Paris and DACS, London 2005 (bl). **63** Magnum: Bruno Barbey (clb). Novosti (London): (tl). Sebastiao Salgado: Amazonas/nbpictures (br). Photo Scala, Florence: The Museum of Modern Art, New York/DACS 2005 (cr). **64** Bildarchiv Preußischer Kulturbesitz, Berlin: (tl). Corbis: Philip Gould (clb). The J. Paul Getty Museum, Los Angeles: Die Photographische Sammlung/SK Stiftung Kultur - August Sander Archiv, Cologne: DACS, London, 2005 (cr). Magnum: W. Eugene Smith (bl). **65** Corbis: Bettmann (tl). The J. Paul Getty Museum, Los Angeles: Estate of Georgia O'Keeffe (cl). Science & Society Picture Library: (bl, br). **66** Corbis: Miroslav Zajic (tl). Réunion Des Musées Nationaux Agence Photographique: CNAC/MNAM Dist. RMN/Adam Rzepka (bl, br). **67** Réunion Des Musées Nationaux Agence Photographique: Shoji Ueda (clb, clb, cr). Uniphoto: (tl). **68** Ed van der Elsken. **68-69** Nederlands fotomuseum (b). **70** Getty Images: Andreas Feininger/Time Life Pictures. Stockbyte: (tl runner). **71** N.H.P.A: Stephen Dalton. **72** Archivi Alinari: Wanda Wulz (tc). Getty Images: Adri Berger (br). Science & Society Picture Library: NMPFT - Kodak Collection (bc). **73** NASA: Goddard Space Flight Center. **74** Corbis: Bettmann (bc). **75** akg-images: Société Française de Photographie (tc). Science & Society Picture Library: NMPFT (bl). **76** Science & Society Picture Library: NMPFT. Topfoto.co.uk: (ca). **77** Science & Society Picture Library: Science Museum Pictorial (tc, tr). Topfoto.co.uk: Harlingue/Roger-Viollet (bc). **78-79** Getty Images: William Grundy/London Stereoscopic Company. **80** Harry Ransom Humanitites Research Center, The University of Texas at Austin: Gernsheim Collection (bc). Science & Society Picture Library: Science Museum (ca). **81** akg-images: Archie Miles Collection, Coll. Archiv f. Kunst & Geschichte/Archie Miles. (bc). Corbis: Stapleton Collection/Peter Henry Emerson (t). **82** George Eastman House: (b). Science & Society Picture Library: NMPFT (tc). **83** Corbis: Samuel Bourne/Historical Picture Archive (bl). Science Photo Library: Eadweard Muybridge Collection/Kingston Museum (t). **84-85** Corbis: Timothy H. O'Sullivan. **86** www.bridgeman.co.uk: Stapleton Collection, UK/Jacques Henri Lartigue © Ministere de la Culture - France/AAJHL (br). Mary Evans Picture Library: (cr). popperfoto.com: (cl). **87** Corbis: Bettmann (tr). Science & Society Picture Library: NMPFT - Kodak Collection (bc). **88** Corbis: Bettmann (br). Science & Society Picture Library: NMPFT (cl). **89** Corbis: Condé Nast Archive/Baron de Meyer (br); Bettmann/Jacob August Riis (tr). Getty Images: Lewis W. Hine/National Archives/Time Life Pictures (tl). **90-91** Archivi Alinari. **92** Oskar Barnack Archive/Leica Camera AG: (tr). Getty Images: Erich Salomon (b). **93** akg-images: Hedda Walther (br). Corbis: Dorothea Lange (tl); Hulton-Deutsch Collection (b). **94** www.bridgeman.co.uk: El Lissitzky (bc). Science & Society Picture Library: NMPFT (tl, tc). **95** Corbis: Bettmann (br). The J. Paul Getty Museum, Los Angeles: Edward Weston (tl). Science & Society Picture Library: NMPFT (bl). **96-97** Réunion Des Musées Nationaux Agence Photographique: Michele Bellot/Estate Brassai. **98** Getty Images: Michael Rougier/Time Life Pictures (tr); Weegee (Arthur Fellig)/International Centre of Photography (br). The Museum Of Modern Art, New York: (cl). **99** Magnum: Burt Glinn (tl). Science Photo Library: Professor Harold Edgerton (br). **100** Magnum: David Hurn (bc). NASA (tl). popperfoto.com: (tr). **101** Getty Images: Larry Burrows/Time Life Pictures (br); Ronald S. Haeberle/Time Life Pictures (tr). **102-103** Getty Images: Lambert. **105** Canon (UK) Ltd: (br). Corbis: Howard Sochurek (tl). NASA: Langley Research Center (cr). Science Photo Library: Edelmann (tr). **106** akg-images: Gruner & Jahr (tc). Getty Images: Neal Preston/Camera 5/Time Inc/Time & Life Pictures (tl); Tim Graham (bc). **107** Steve Cavalier: (tl). Cindy Sherman: (tr). Science Photo Library: Philippe Plailly (bc). **108-109** Magnum: Abbas. **110** Apple: (c). Getty Images: Andrew Wong (br). **111** Magnum: Chris Steele-Perkins (tl). NASA: European Space Agency and H. E. Bond (br). **112** Corbis: Channel Island Picture Agency (tl). Getty Images: Chung Sung-Jun (bc). Harry Borden: (tl). **114-115** Magnum: Ferdinando Scianna. **116-117** Getty Images: Joel Sartore (b). **118** Corbis: Lightscapes Photography, Inc. Alamy: Chris Ivin (tl). **120** Wendy Gray: (br). **126** Jon Arnold: (cl). **140** Getty Images: AFP Photo/Jung Yeon Je (bc, br). **143** Rex Features. **148-149** Catherine McIntyre: Catherine MacIntyre (b). **184** Andy Mitchell. Image Source: (tl runner). **186** Getty Images: Ernst Haas (c). Andy Mitchell: (bl). Succession Raghubir Singh: (br). **189** Magnum: Marc Riboud (br). **193** Succession Raghubir Singh: (br). **196** FLPA - Images of Nature: Jim Brandenburg/Minden Pictures (bl). **200-201** P.K Apagya/Fifty One Fine Art Photography: apagya. **209** Magnum: Alex Webb (bl). **212-213** Lucien Clergue. **220-221** Rajnikant Patel. **227** Andy Mitchell: (br). **230** Jamie Jeeves. Getty: Photodisc Green/Jim Wehtje (tl runner). **234** Yevonde Portrait Archive: (br). **235** Corbis: David H. Wells (tl). DK Images: Angus Beare Collection (br). Getty: Photodisc Blue/Mel Curtis (tr). Photolibrary.com: Workbookstock.Com Co/Op Service/Arwen Mills Roxann (bl). **238-239** Corbis: Regan Cameron. **240** Corbis: Stuart Westmorland (bl). **241** Getty Images: David Maitland (cr). Andy Mitchell: (tl). **242** Getty Images: John Kelly (bl). **243** Alamy Images: Papilio/Robert Pickett (tr). Getty Images: Paul Souders (cl). **250-251** Magnum: David Alan Harvey. **252** Magnum: Peter Marlow (bl, br, cr). **253** Jamie Jeeves: (tl, tr). Patrick Baldwin: (bc). **256-257** Panos Pictures: Chien-min Chung. **258** Zefa Visual Media: Masterfile/ David Muir (cr). **259** Corbis: Tracy Kahn (cl). Prentenkabinet, University Library, University of Leiden, The Netherlands: Emmy Andriesse (bl). Zefa Visual Media: Grace (cr). **261** Photolibrary.com: Plainpicture (tr). **262-263** Magnum: Micha Bar Am. **264** Getty Images: Tim Thompson (tr). Franco Fontana: (tr). **274-275** Corbis: Galen Rowell. **276** DK Images: Jacqui Hurst (tr). **277** Getty Images: Richard During (tr). **278** DK Images: Lindsey Stock (bl). **279** DK Images: Jacqui Hurst (tr).**282** Corbis: Wartenberg/Picture Press (cra). **283** Corbis: Julie Dennis Brothers (cr). Pixtal: Christopher Gray (tr). **284** Getty Images: Hans Neleman (bl). Pixtal: Christopher Gray (cl, cr). **285** Pixtal: Christopher Gray (bl, br, tc, tl, tr). **288** Arcaid.co.uk: John Edward Linden (bl). **289** Arcaid.co.uk: Richard Bryant (br). Millennium Images: Paul Freeman (bl). **292-293** Alamy Images: Ambient Images Inc/Larry Brownstein. **298-299** Getty Images: Hiroshi Nomura. **300-301** Alamy Images: Directphoto.org. **302** Getty Images: VCL/Spencer Rowell. InMagine: Image100 (tl runner). **303** Magnum: PG (c). **308** Getty: Photodisc Green (bl). **309** DK Images: Jerry Young Collection (cbr). **311** Photolibrary.com: Plainpicture (tl). **316** Corbis: Kevin Fleming (bl).

All other images © Dorling Kindersley.
For further information see: www.dkimages.com